RADIANCE
AND
REFLECTION

RADIANCE AND REFLECTION

MEDIEVAL ART FROM THE RAYMOND PITCAIRN COLLECTION

Jane Hayward and Walter Cahn

with

Peter Barnet

Michael Cothren

Faye Hirsch

Charles T. Little

William D. Wixom

The Metropolitan Museum of Art
New York

This catalogue has been published in conjunction
with the exhibition "Radiance and Reflection:
Medieval Art from the Raymond Pitcairn Collection,"
held at The Cloisters, The Metropolitan Museum of Art,
New York, February 25– September 15, 1982.

Copyright © 1982 by The Metropolitan Museum of Art

Library of Congress Cataloging in Publication Data

Hayward, Jane.
 Radiance and reflection.
 Catalog of an exhibition held at the Metropolitan Museum
of Art, New York.
 Bibliography: p.
 Includes index.
 1. Sculpture, Romanesque—France—Exhibitions.
2. Sculpture, French—Exhibitions. 3. Glass painting and
staining, Gothic—France—Exhibitions. 4. Glass painting and
staining—France—History—Exhibitions. 5. Art, Medieval—
Exhibitions. 6. Pitcairn, Raymond, 1885- —Art collections
—Exhibitions. I. Cahn, Walter. II. Metropolitan
Museum of Art (New York, N.Y.) III. Title.
NB543.H39 734'.24'07401471 81-22519
ISBN 0-87099-298-8 AACR2

Published by The Metropolitan Museum of Art, New York

Bradford D. Kelleher, Publisher

John P. O'Neill, Editor in Chief

Ellen Shultz, Editor

Dana Levy, Designer

Front cover: *King,* from The Tree of Jesse Window, Abbey of
 Saint-Denis, no. 72

Frontispiece: *King,* from The Tree of Jesse Window, Cathedral
 of Saint-Gervais-et-Saint-Protais, Soissons, no. 52

Back cover: *Apostle Paul,* probably from a Parisian church,
 no. 76, and colorplate XV

Contents

Foreword

The Romanesque and Gothic art that was assembled by Raymond Pitcairn in the early part of this century represents the world's finest and most extensive collection of medieval sculpture and stained glass still in private hands. Raymond Pitcairn's activities as a collector began with an architectural commission—the creation of a cathedral for the General Church of the New Jerusalem in Bryn Athyn, Pennsylvania. His motives for collecting monumental sculpture and stained glass were twofold: He sought definitive exemplars from the "Age of the Cathedrals" to inspire his craftsmen to make the new cathedral a fitting place of worship, and he delighted in the simple pleasure of possessing unique and beautiful objects.

In fewer than forty years, he energetically acquired more than 330 sculptures, over 260 panels of stained glass, and a smaller, but significant, number of treasury arts. At a time when the architectural arts of the Middle Ages were not popular, the only other collector who shared this approach on an equally grand scale was George Grey Barnard, whose complete architectural ensembles and sculpture served as the foundation for The Cloisters museum. It is most appropriate, therefore, that the first comprehensive exhibition of the Pitcairn collection should take place at The Cloisters.

The title of this exhibition, "Radiance and Reflection," evokes the essence of medieval art. Natural light, whether reflected from the carved surfaces of sculpture or radiating from the stained-glass windows of churches, was equated by theologians of the Middle Ages with divine light. Medieval art exploited these light effects, which constantly transformed, modified, and re-created the image. To paraphrase the eminent art historian Henri Focillon, Romanesque sculpture is a delicate mesh of deep shadow, close knit and continuous, in which a labyrinth of ornament and image hugs the stone block from which it is carved. In Gothic sculpture, these complications are replaced by more tranquil surfaces, and by modeling in large, simple planes, on which light falls without complexity. Twelfth-century

stained glass retains the monumentality of Romanesque calligraphy, its radiant forms shaped in accordance with the demands of the field. In thirteenth-century windows, these forms are multiplied and distributed over immense solar tapestries, which set the Scriptures, as well as profane history, against the open sky. The epic fervor of the twelfth century has given way, in both sculpture and glass, to a kind of reserved majesty, an image of life bathed in light. Through the splendid works of art in the Pitcairn collection, we are offered a glimpse of these qualities of which Focillon has written. The variety and originality of medieval creativity embodied in these masterpieces make them a continual source of refreshment to the eye and to the spirit.

Until now, the Pitcairn collection has been little known, even to scholars of medieval studies. Only a small sampling from Bryn Athyn has been seen by the general public, through loans to the Philadelphia Museum of Art in 1931, and at three, more-recent exhibitions at The Metropolitan Museum of Art—"Medieval Art from Private Collections" (held at The Cloisters in 1968), "The Year 1200" (part of the Metropolitan Museum's centennial celebration in 1970), and "The Royal Abbey of Saint-Denis in the Time of Abbot Suger, 1122–1151" (at The Cloisters in 1981). For "Radiance and Reflection: Medieval Art from the Raymond Pitcairn Collection," Jane Hayward, Curator at The Cloisters, and an expert in the field of medieval stained glass—and the mastermind behind this exhibition—has selected 122 splendid works of medieval art from the Glencairn Museum in Bryn Athyn.

Our gratitude to the Pitcairn family naturally must supersede all other acknowledgments, but I do wish to give special thanks not only to Miss Hayward, but to Walter Cahn, Professor in the Department of the History of Art at Yale University, for preparing the enlightening catalogue that accompanies the exhibition, and to Ellen Shultz, for her excellent editing of their illuminating texts.

Philippe de Montebello

Authors' Preface

The medieval sculpture and stained glass selected for this exhibition will be unfamiliar to nearly everyone. Although the existence of the collection assembled by Mr. Raymond Pitcairn has been known to specialists in the field, only a few have been privileged to see it. One of the earliest of these fortunate viewers was Arthur Kingsley Porter, who, occasionally, seems to have advised Raymond Pitcairn on the latter's purchases. Kingsley Porter mentioned several works in the Pitcairn collection in his influential *Romanesque Sculpture of the Pilgrimage Roads*, published in 1923. In the early 1930s, some sculpture from the collection was exhibited, briefly, at the newly constructed Philadelphia Museum of Art in Fairmount Park. A number of works remained there, through a long-term loan arrangement between the museum and the Glencairn Foundation, but the bulk of the works were returned to Bryn Athyn, where they would soon be joined by additional purchases made in the following years. Eager for privacy, from time to time Raymond Pitcairn might receive a well-recommended visitor, or answer a written scholarly query, but no more. Adolph Goldschmidt and Walter Cook published a twelfth-century Spanish ivory in the collection; Jean Lafond, a glass panel from the Legend of the Seven Sleepers of Ephesus window at Rouen Cathedral; and Louis Grodecki, panels from Soissons and Saint-Denis. In 1968, some sculptures and glass were lent anonymously to the exhibition "Medieval Art from Private Collections," at The Cloisters. More recently, permission was granted to the Metropolitan Museum's curators to inventory the Romanesque and Gothic sculpture and the stained glass at the Glencairn Museum in Bryn Athyn, and the Glencairn material in Philadelphia.

When the research on the collections, which would lead to this exhibition, began, nearly five years ago, Mrs. Raymond Pitcairn was still alive. It is a pleasure to recall her interest in our work and the continuing enthusiasm of her family. We especially wish to

thank Lachlan Pitcairn, Secretary of the Glencairn Foundation, who initially was responsible for making the collections available for study and for eventual exhibition at The Cloisters. We are grateful, as well, for the assistance of Michael Pitcairn and Miss Creda Glenn, and to the staff at Glencairn, particularly Joyce Bellinger and Santi Nadal.

The support of the Trustees of the Academy of the New Church in lending to this exhibition is gratefully acknowledged. E. Bruce Glenn, Director of Research and Resources, generously provided information for the Introduction to this catalogue. Nishan Yardumian and Martha Gyllenhaal of the Academy faculty helped with the photography of objects.

We also thank the Philadelphia Museum of Art for contributing sculpture on loan to them from the Pitcairn collection, and appreciate the assistance of Jean Sutherland Boggs, Director, and David DuBon, Curator of Medieval and Renaissance Decorative Arts.

Martin Pryke, Director of the Glencairn Museum, was a constant source of encouragement; without his friendship and cooperation, this exhibition could not have taken place. Both Lisa McQueen, Secretary, and Naomi Pryke, who accessioned the medieval collections, aided our research.

We acknowledge the help of our colleagues Pamela Z. Blum, Madeline H. Caviness, William Clark, William H. Forsyth, Louis Grodecki, Charles T. Little, Clark Maines, Léon Pressouyre, Anne Prache, Virginia C. Raguin, David Simon, and Neil Stratford, in sharing information on objects in the collections.

Peter Barnet, Maureen Burke (who collaborated on entry no. 32), Deborah Deacon, Faye Hirsch, Gloria Gilmore-House, Deborah Kraak, and Kathleen Nolan served as research assistants during various phases of the work.

Special thanks are due to Michael Cothren, who, as Chester Dale Fellow at The Metropolitan Museum of Art, helped to chart the restorations of the stained glass and to catalogue the collection; Suse Childs, Assistant Museum Librarian, The Cloisters, who catalogued the vast collection of sculpture; and Mary Prevo, special assistant for the exhibition, who compiled the bibliography for the catalogue, prepared the labels and worked tirelessly to make this exhibition possible.

Jane Hayward

Walter Cahn

Acknowledgments

The Metropolitan Museum of Art

David Adams
Library Assistant, The Cloisters

Barbara Drake Boehm
Senior Administrative Assistant, Department of Medieval Art

Eugene J. Boggia
Associate Manager of Security, The Cloisters

John Buchanan
Registrar

Fred T. Catapano
Assistant Manager for Operations, The Cloisters

Suse Childs
Assistant Museum Librarian, The Cloisters

Carlie Cleveland
Assistant Conservator, Department of Objects Conservation

Mark D. Cooper
Manager, Photograph Studio

Colorplates

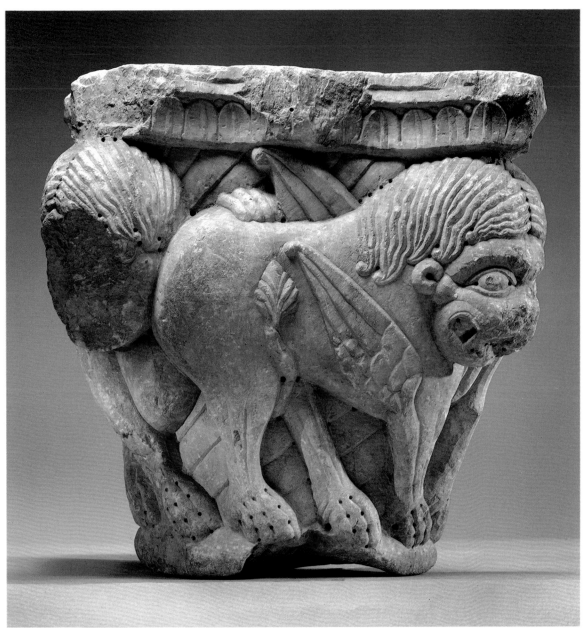

COLORPLATE I Capital, from Roussillon, no. 6(A)

12

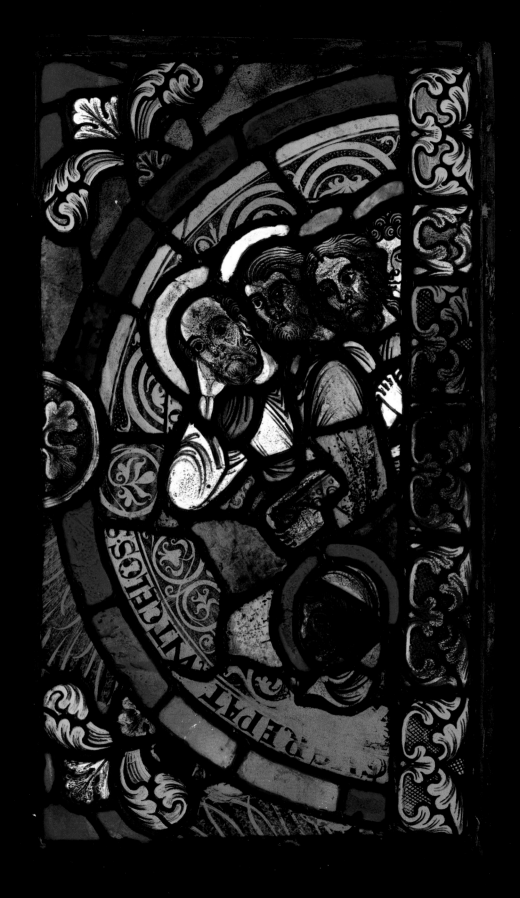

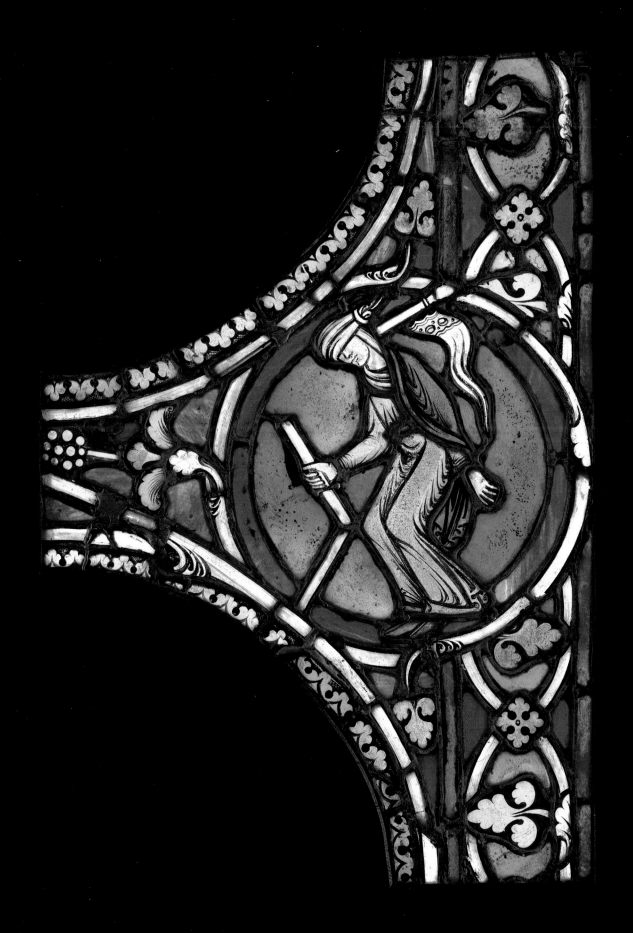

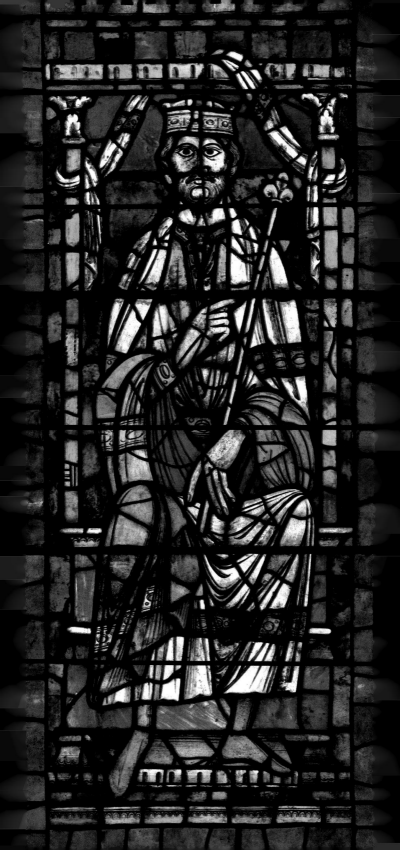

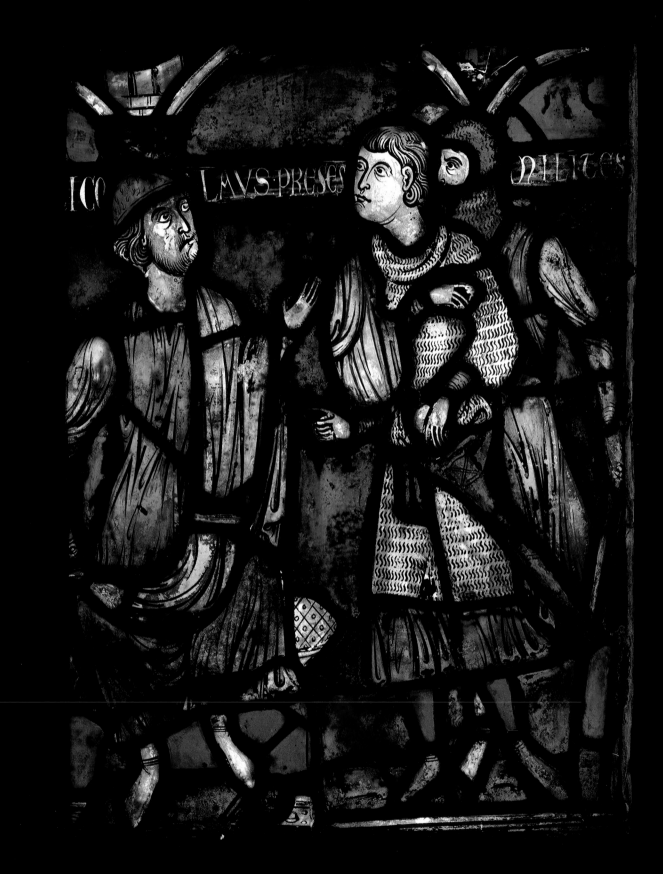

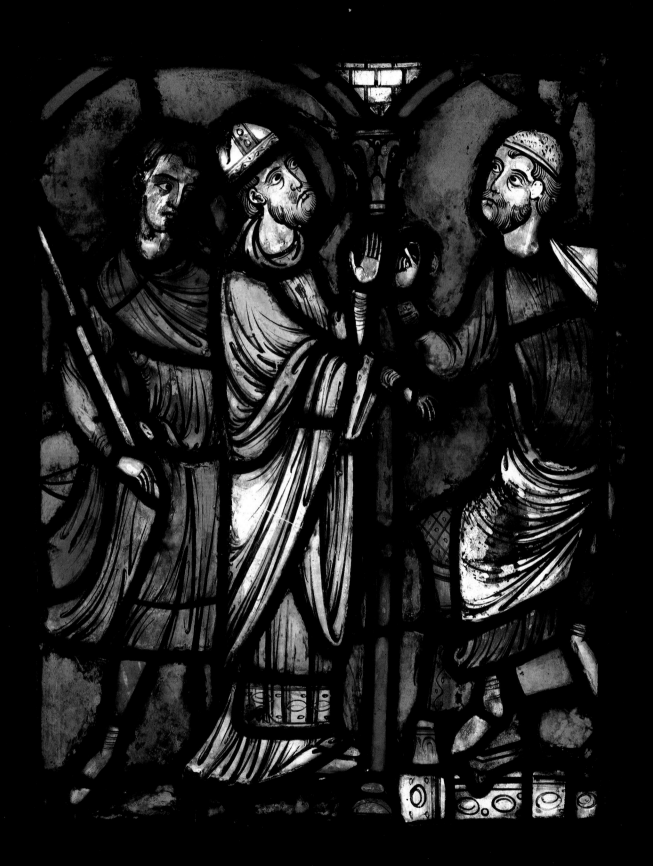

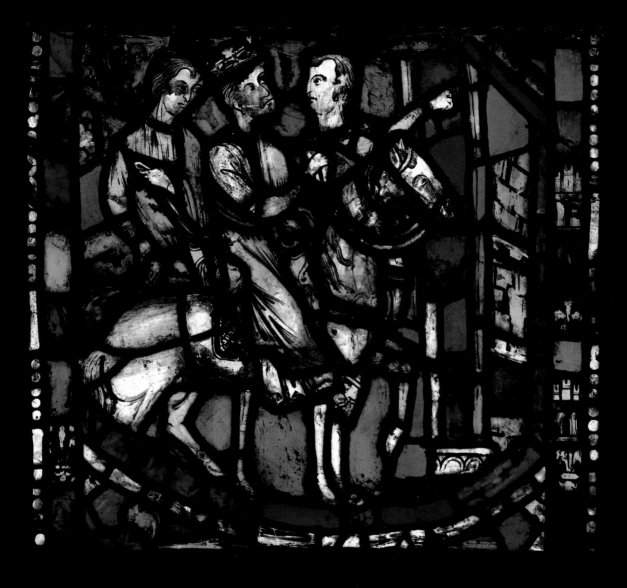

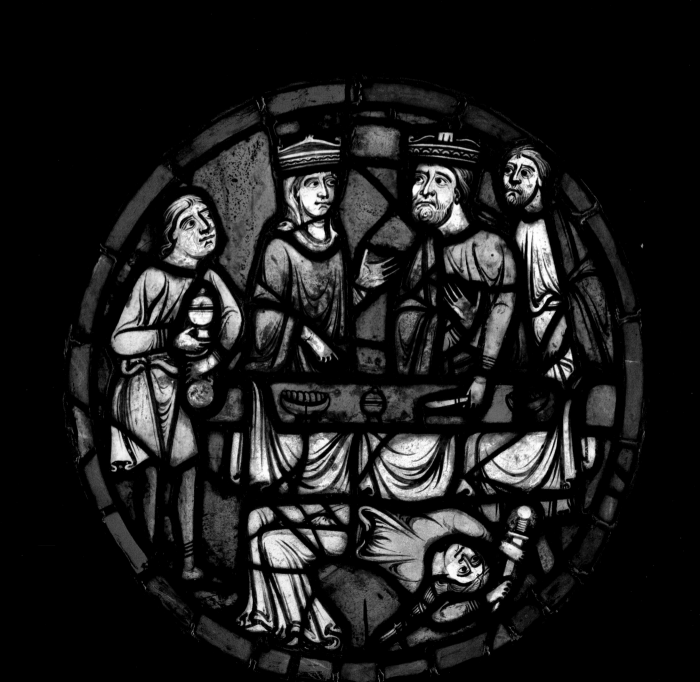

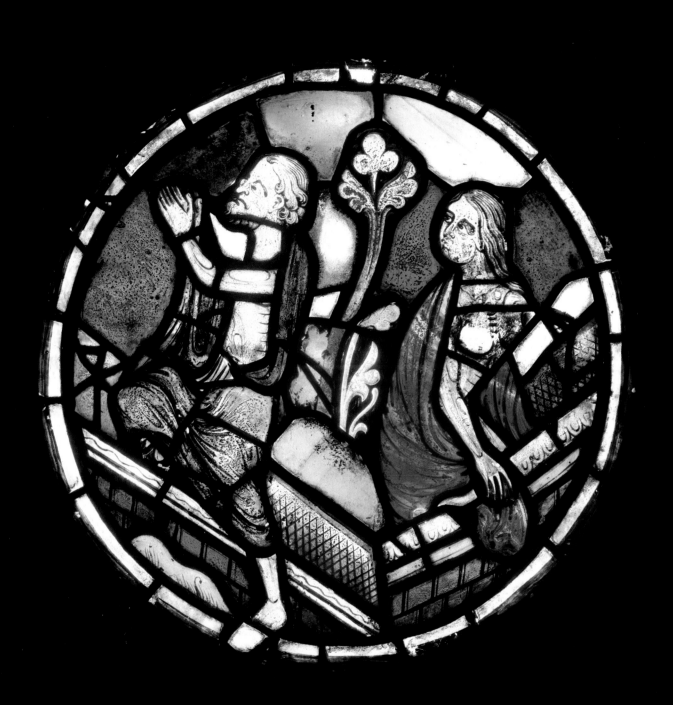

COLORPLATE XI *Prophet* (Isaiah?), from
The Sainte-Chapelle, Paris, no. 74

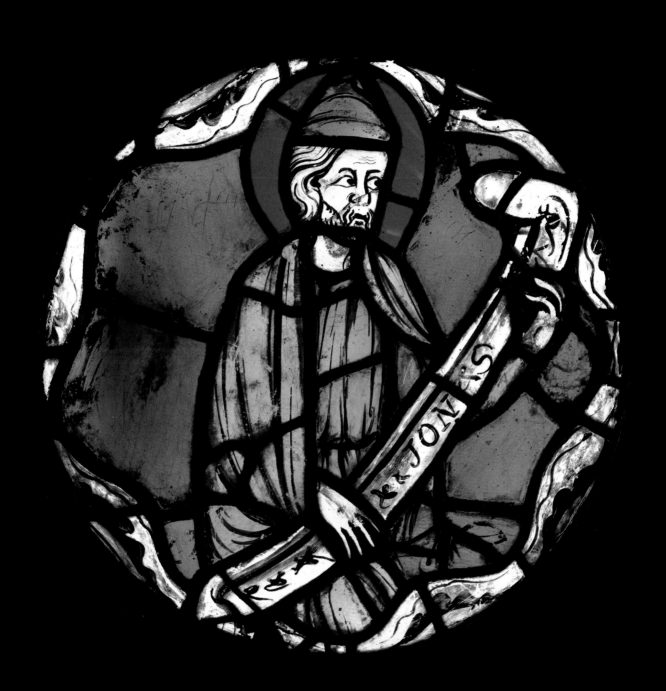

26

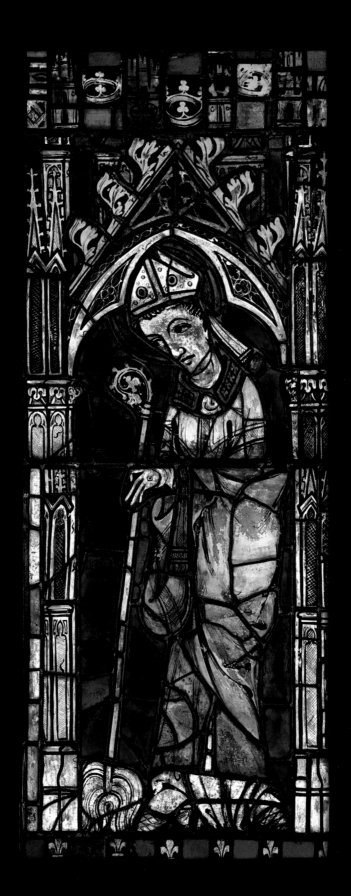

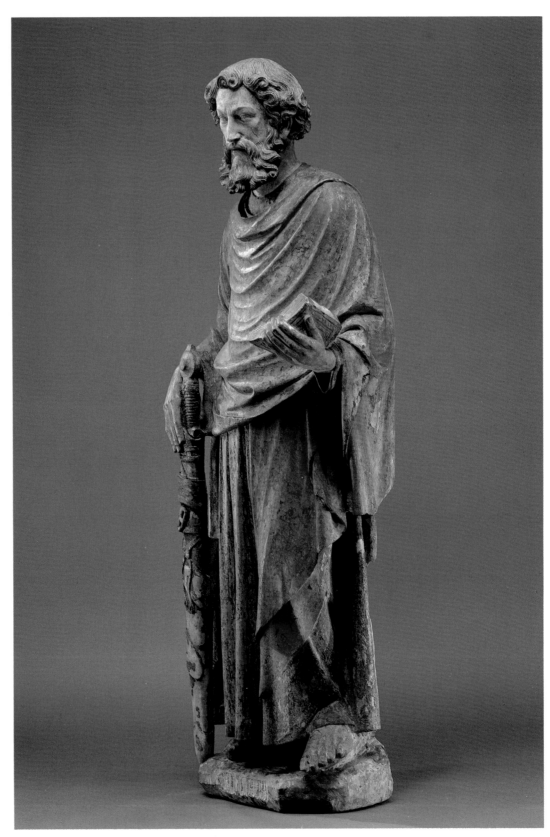

COLORPLATE XV *Apostle Paul*, probably from a Parisian church, no. 76, and back cover

RADIANCE
AND
REFLECTION

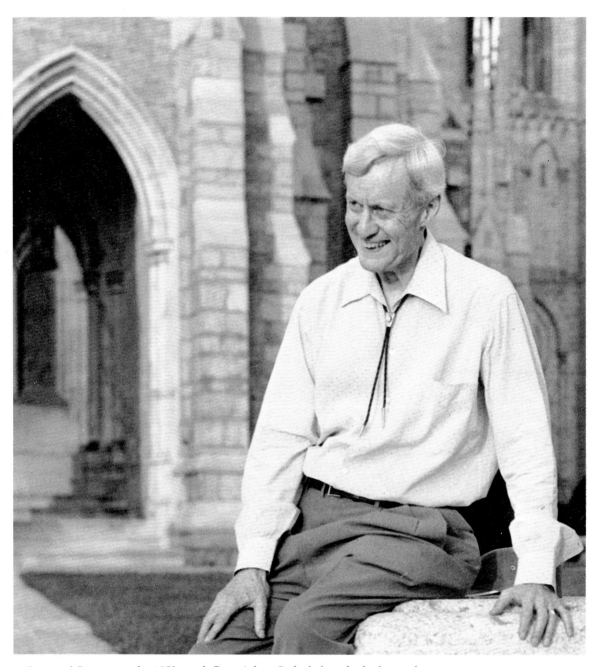

1. Raymond Pitcairn in the 1950s, with Bryn Athyn Cathedral in the background

Introduction

Of all the works of art created by the hands of men, there are none that seem to live, through the human spirit that breathes within their every part, as do the marvelous churches and cathedrals of the Middle Ages. [1]

Raymond Pitcairn

When Raymond Pitcairn first wrote to Ralph Adams Cram, distinguished head of the Boston architectural firm of Cram and Ferguson, in 1912, to solicit his interest in the construction of a cathedral for the General Church of the New Jerusalem in Bryn Athyn, Pennsylvania, it is unlikely that he imagined that he, himself, would become the architect, or that, as a result of the building, he would acquire one of the richest and certainly one of the most concentrated collections of medieval art in this country. The Pitcairn collection spans only two centuries—from 1100 to 1300—of the thousand years that are generally designated as the Middle Ages and its emphasis is on the art of France. Also included in the collection are a few pieces that are later in date, or of other than French origin, yet the vast majority of examples not only falls within this period, but is also further limited to the mediums of sculpture and stained glass. The reasons for this are quite simple; the art collected in Bryn Athyn initially was a by-product of the unique methods of construction employed for the cathedral.

Cram's preliminary designs for the new building hardly had been approved by the church committee—which included the donor John Pitcairn and his son Raymond, who had been put in charge of the project—when the Boston office was asked to provide a scale model. Although contrary to usual architectural practice, models would be the key to the artistic philosophy of building in Bryn Athyn and to the formation of the collection. "My lack of training in draftsmanship and the reading of architectural drawings," Raymond Pitcairn wrote, "I endeavored early in the work to offset through dealing with the designs in the form of scale and full sized models." [2] This was a practical explanation, but the use of models was also a necessary means toward the concept of organic growth envisioned for the building. In developing his ideas on architecture and in preparing for the construction of the cathedral, Raymond Pitcairn had been greatly influenced by the writings of Arthur Kingsley Porter. In Porter's two-volume work, *Medieval Architecture*, first published in 1909, he had suggested that Gothic builders had employed full-sized models in addition to sketches in working out their designs. [3] At Bryn Athyn, structural elements were detailed, full scale, in plaster, tried out in place on the building, and studied *in situ* for further modification (fig. 2). [4]

2. A full-scale plaster model of a gable in place on the south porch of the cathedral, viewed by Ralph Adams Cram and Raymond Pitcairn

Essentially, this was medieval practice, without the medieval organization that had made such a method of building possible.

Porter discussed at length the role of the medieval architect in relation to the actual construction of his buildings, stressing the presence of these master builders on the site, in order to supervise the work.[5] He also mentioned the close relationship between architect and client, and, in enumerating the responsibilities of the latter, he cited Abbot Suger's involvement with the construction of the Abbey of Saint-Denis—specifically, his procurement of the building materials and his overseeing of the direction of the work. Porter also noted, "That disagreements, disputes, and misunderstandings of various kinds should arise was only natural, but in all such altercations the ecclesiastical authorities always retained the upper hand," and he further speculated on how much freedom was accorded the individual carver in the sculptural decoration and ornament of the building, noting that the overall unity of conception implied that, in the Middle Ages, the arts were not separated.[6] Porter's theories closely paralleled Raymond Pitcairn's own ideas on how the direction of construction in Bryn Athyn should progress, yet he was faced with serious difficulties. Cram, the architect-in-charge, rarely visited the site, preferring to leave minor changes and details to an assistant in his New York office. On the matter of a general contractor, he had acceded to an overseer in residence on the site, rather than engaging the New York firm that he had originally recommended, and he even had suggested following the "guild system" for the decoration and the furnishings of the building. It is doubtful that Cram foresaw the implications in this suggestion, but Raymond Pitcairn accepted it literally and with enthusiasm. A cluster of shops began to grow around the rising cathedral like the *chantiers* of the Middle Ages. While this included a design office, where a number of draftsmen sent down from Boston and New York developed the building's architectural details, looming ever larger in the process of construction was the model shop. Although it held no official status or precedent in modern practice, nevertheless, it was to be the place where many elements of the design were actually developed. Cram originally had designed an English parish church in the Perpendicular Style, but the Bryn Athyn Cathedral, as it stands today, is quite different from that initial plan (fig. 3). Cram's buildings, though architecturally "more correct"

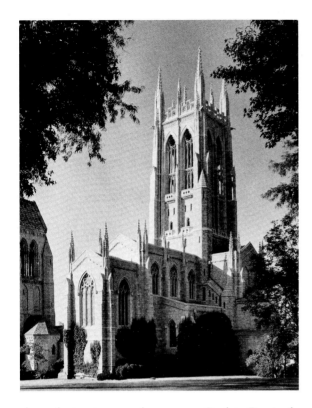

3. The cathedral of the General Church of the New Jerusalem, Bryn Athyn, Pennsylvania

than their nineteenth-century Gothic Revival predecessors, are currently adjudged dull and flat.[7] It was precisely these qualities of the original design for the Bryn Athyn Cathedral that Raymond Pitcairn considered to be the products of the modern architect's straightedge and T square, and that he systematically attempted to eliminate by employing three-dimensional replicas.

Cram paid his last visit to the site in the fall of 1916 and the services of the firm of Cram and Ferguson finally were terminated in the spring of 1917. From that time until the dedication of the cathedral on October 5, 1919, Raymond Pitcairn was solely in charge of the development of its architectural program. Before the project was even started, however, he had begun to prepare himself for an active part in the construction. He made frequent trips to New York, to the Morgan collection of medieval art at the Metropolitan Museum and to the reading room of the Avery Architectural Library at Columbia University.[8] When George Grey Barnard opened his Cloisters to the public in 1914, Raymond Pitcairn was a frequent visitor. He began to amass his own library of books and photographs, to subscribe to architectural journals, and to attend lectures on art and architecture. Among the most significant of these was a lecture given by William Henry Goodyear in 1915. Goodyear, a former curator at the Metropolitan and subsequently at The Brooklyn Museum, had developed the theory that the intentional curves or deviations in medieval architecture paralleled those of Greek buildings.[9] His speculations on these refinements, as he called them, had gained wide acceptance among scholars in America but not in Europe. Porter, himself, had doubted the validity of these ideas, but Raymond Pitcairn was so convinced by them that he asked Cram to incorporate similar refinements in the design of the Bryn Athyn church. He was told, however, that the building was too small, though Cram did agree to slope the nave floor toward the west. The bowing of the clerestory walls and the varying radii of the nave arches were additional adjustments that were made later.

Mrs. John Pitcairn had fostered her son's abiding enthusiasm for architecture through her own interest in art and in landscape design.[10] From the age of three, the boy had been taken, almost annually, to Europe, a practice that continued until his marriage in 1910. For him, the great

medieval churches of Europe were the essence of beauty and spiritual achievement in building. Although his only practical experience had been in constructing a photographic studio and an apartment for himself, with the help of day laborers, in 1911, he had learned how to use models for the more complicated elements of a structure. Throughout the entire process of designing the cathedral, Raymond Pitcairn, himself, never touched pencil to paper, but he encouraged the other craftsmen who were part of the building operation to offer their suggestions.[11] In Bryn Athyn there was a remarkable spirit of cooperation among all those who worked on the cathedral and an intense interest in all facets of the work. Most of the chief craftsmen were local residents. Some, like Harry Bowman, head of the wood-carvers' shop, were established masters, but many were only recently out of art school. Winfred Hyatt, who made many of the stained-glass windows, and Parke Edwards, who designed the metalwork, had only just begun their professional careers. Like Suger—whose treatise on the rebuilding of the Abbey of Saint-Denis in the twelfth century had been partially translated by Kingsley Porter—Raymond Pitcairn had chosen these craftsmen himself, and, also like Suger, he had selected and opened the quarry in Bryn Athyn for the building stone and had located trees in the woods and fields nearby for the roof timbers.[12] In fulfilling his responsibility to the church committee, Raymond Pitcairn probably likened his own participation in the project to that of Suger's at Saint-Denis, so that the transition that occurred when Cram left in 1917 did not impede the work. The design of the cathedral, in fact, had been taking shape on the site for some time—the only practical means of circumventing the delays caused by an absentee architect.

Plaster models had served effectively in the creation of moldings and piers and even in the more complex, carved portions of the building, such as the window tracery, the capitals, the pinnacles, and the rosette cornice that surrounds the nave. Gothic carving is largely decorative rather than figural. By June 1917, an entirely new problem had arisen. The building was ready to be enclosed, and temporary, diamond-shaped, colorless quarries were placed in all of the windows. Raymond Pitcairn had been concerned about the stained glass for the cathedral for some time. In March 1914, Charles J. Connick, an eminent glass painter from Boston, had been invited to Bryn Athyn, but he declined, recommending, instead, that a guild be formed locally to make the windows. [13] Perhaps it was this suggestion that brought Winfred Hyatt, and later Lawrence Saint, to Bryn Athyn. Both men would be sent to Europe to study stained glass, and to draw and photograph it in the churches there.

Raymond Pitcairn wanted the windows in Bryn Athyn to emulate the pure, vibrant colors, and the powerful, abstract designs of the Early Gothic stained glass that he had seen in France. A few designers, Connick among them, strove for pure color in their windows, but in industrialized, prewar America the art of making hand-blown glass virtually had disappeared.[14] Machine-rolled sheets of glass had replaced the costly hand-blown process. The vast majority of windows was still made of opalescent glass. Louis Comfort Tiffany remained the most revered designer of glass in the country, and he had been forced to produce his own glass in his Corona Glass Works on Long Island in order to achieve the quality that he desired.[15] It was to Tiffany that Raymond Pitcairn turned for help and it was on Tiffany's advice that he procured the services of John Larson, a Long Island glassmaker.[16] In 1916, Larson began his lengthy experiments to duplicate the colors and textures of medieval stained glass, but it was not until 1922 that he was persuaded to set up his furnace in Bryn Athyn.

Though Larson was able to reproduce the special qualities of medieval glass, and Hyatt and Saint were qualified to judge the results, there were no models in Bryn Athyn to serve as criteria. Upon Hyatt's return from Europe in 1915, Raymond Pitcairn began to travel to New York with him and with other members of his growing force of glass specialists, in order to visit the Decorative Arts department at the Metropolitan Museum and the collection of his friend Henry C. Lawrence. Lawrence, a stockbroker, had not begun to collect medieval stained glass until 1912, but by 1918 he had amassed a collection of about forty pieces from European dealers, who contacted him when they came to New York. In Lawrence's midtown residence, the group from Bryn Athyn could

examine in detail and at leisure the color, texture, and painting style of Early Gothic glass. Cram's original plans for the cathedral glazing had been for color in the chancel, grisaille in the nave aisles, and a combination of both in the clerestory.[17] Although the Lawrence collection contained a considerable number of full-color panels there was almost no grisaille.

One of the first problems facing Raymond Pitcairn in executing the windows for the church was the expansion of the design team. Hyatt had been trained as a painter and had studied the glass of European churches but he had had almost no experience working in stained glass. Conrad Howard, who had been trained to make stained glass at the William Morris Studios in England, came to Bryn Athyn in the summer of 1915.[18] Together with Rowley Murphy, a classmate of Hyatt's at art school, he set up a kiln in the glass shop and began experimenting by remelting commercial glass to increase its texture, an impractical process from a production point of view. Designing the windows was an even greater problem. Howard suggested that they copy one of Lawrence's panels in order to approximate the character of medieval painting, but Raymond Pitcairn was against this idea. A copy was acceptable for the purposes of studying color, texture, and technique, but, as in the construction of the cathedral, he believed that the design should be original. Hyatt had already developed full-sized cartoons for the chapel windows that were to be executed by Howard, when Larson began his experiments in blowing glass. Howard was called back unexpectedly to England for military service, which again left the glass shop shorthanded. The situation changed the following summer when Lawrence Saint came to work in Bryn Athyn. Saint was an accomplished glass designer and the co-author of a well-known book on medieval windows.[19] At Saint's arrival—after nearly two years of work—not a single window had been set in the cathedral, and it was decided to install temporary glazing and to proceed slowly with the windows. Just how slow this progress was can be deduced by a comment made by Saint much later: "In the eleven years I spent at Bryn Athyn," he said, "I made only six windows: three figures, two small roses and one grisaille."[20]

One of the first tasks that Larson undertook in 1916 was to make a grisaille glass that would approximate thirteenth-century examples, and, according to Hyatt's reports, he was having difficulties.[21] Larson would make a batch of samples, send them to Hyatt in Bryn Athyn, and then Hyatt would comment on the results. Hyatt, however, had no models at hand with which to compare Larson's efforts and to assist him in his judgments. The solution arrived in April 1916, in the person of the English dealer Grosvenor Thomas. Raymond Pitcairn had been introduced to Thomas in New York by Henry Lawrence, and had purchased from him two English grisaille panels, one of which was from Salisbury (no. 90). Perhaps it was because the Salisbury panel was the exact width of the lights in the aisles of the Bryn Athyn Cathedral, or because it was the first medieval work of art acquired by Raymond Pitcairn, that he permitted Hyatt to copy its design for one of the windows of the north aisle. Of all the glass that eventually would be purchased, however, this was the only case of an example being copied.

Raymond Pitcairn's tastes were changing and he was becoming more and more attracted to art of the earlier medieval periods—to the Gothic style of the twelfth century and to the Romanesque. He had already planned to add to the cathedral a council hall and eventually a choir hall, which he wished to build in these earlier styles. The method of construction was to follow that used for the cathedral, but actual examples of Romanesque sculpture were needed to convey its spirit to the stone carvers. Romanesque carving was both figural and symbolic. The success of the grisaille panels as models for the new glass suggested that, similarly, he acquire Romanesque stonework to serve as models for the new sculpture. Yet, there was still the problem of obtaining comparative examples of old glass for the full-color windows of the cathedral clerestory. The source was, once again, a contact made through Lawrence—the Parisian dealer Henri Daguerre. Raymond Pitcairn first wrote to Daguerre in 1919, to inquire about the availability of twelfth- and thirteenth-century glass, and later, with regard to acquiring Romanesque sculpture.[22] Upon Daguerre's arrival in New York the following year, Raymond Pitcairn purchased four panels of stained glass—which he recognized were not of the highest quality but, nevertheless, might help in the development of the windows in Bryn

Athyn—and also a capital from Saint-Guilhem-le-Désert (no. 14) that he later mentioned as a continual source of delight. The same year, Hyatt was sent abroad once again to study glass, this time with a letter of introduction to Daguerre and the authorization to contact dealers and to purchase glass if any were available.

A significant event that was to change Raymond Pitcairn's attitude toward acquiring works of art occurred the following year. In 1921, Henry Lawrence, whose collection had been the inspiration for the work in Bryn Athyn, died after a long illness, and his medieval stained glass was auctioned at the American Art Galleries in New York. In characteristic fashion, Raymond Pitcairn made preparations to acquire significant examples from the collection that he had long admired. A letter to Hyatt, then in England, gives the details.[23] Several days before the actual sale, Raymond Pitcairn consulted experts in New York, including Russell Plimpton, assistant curator of Decorative Arts at the Metropolitan, about current prices of glass. He realized that the competition would be heavy but decided against having a dealer bid on his behalf. "I felt in my bones," he wrote, "that the Lawrence sale would establish new values for thirteenth-century glass."[24] His suspicions were confirmed by the number of collectors and dealers that he saw in the showrooms at the pre-sale exhibition. At that point he sent an urgent cable to Hyatt in Paris, requesting that he canvass the dealers for important pieces of stained glass and cable his reply. The day of the sale, Raymond Pitcairn left Bryn Athyn early, accompanied by his friends Kesniel Acton, a corporate lawyer, who would do the actual bidding, and Newlin Brown, an "additional witness." The atmosphere was tense when they arrived at the galleries. Hardly a museum director or collector of any importance was absent. The dealers were all there, including the formidable connoisseur Joseph Duveen. Annotated catalogues of the sale tell the story.[25] Bidding for the stained-glass collection became a duel between Duveen and Pitcairn. When it was all over, Raymond Pitcairn had won. He had come away with twenty-three panels, including the prized King (no. 52), the most important piece of French stained glass that had ever been sold in America. "At the end of the sale I went to the auctioneers and asked for the King, which we took in a taxicab to the Pennsylvania Station—tempo, that of a funeral." The imperturbable Niel Acton was so excited that he was unable to eat any dinner, but Raymond Pitcairn's triumph was still not over. Awaiting his return from New York was a cable from Hyatt with news of still other important panels available at Bacri Frères. The reply was immediate: "Take options," he cabled.[26] Raymond Pitcairn had become an art collector!

Four months later, George Grey Barnard was in the midst of one of his periodic financial crises and was fearful that his Cloisters museum would be sold for assessment.[27] Desperate for money, Barnard wrote to Raymond Pitcairn, offering him three capitals from Saint-Michel-de-Cuxa (nos. 5B, 6A,B). They were purchased without delay and, together with the one from Saint-Guilhem, they formed the beginnings of the Pitcairn collection of Romanesque sculpture. Five pieces of stained glass and sculpture were bought from Georges Demotte, as well as twenty pieces of glass and two more sculptures from Joseph Brummer. The inventories are incomplete for these early years (1916–22) and pieces can be traced only through dealers' marks, but several of the identified Brummer purchases are in the present exhibition (nos. 58, 77, 88, 89, 92). The stained glass from Demotte and Brummer was selected in Paris by Winfred Hyatt, and his choices were guided by the needs of the Bryn Athyn Cathedral glazing program. Most of the pieces are decorative grisailles or ornamental borders that could be used to study glassmaking techniques.

After cabling Bryn Athyn, Hyatt had gone directly to Chartres to finish the reports that he was writing on the glass in the cathedral there. Consequently, he had never received the return cable and was quite unaware of the urgency of the situation. When he arrived back in Paris, several days later, he frantically tried to secure the desired options, but it was too late. The French dealers had already heard of the prices paid at the Lawrence sale and had refused to abide by prior offers. This was exactly what Raymond Pitcairn had anticipated and what he had tried to avoid through immediate action.

Hyatt was not the only member of the Bryn Athyn glass team studying abroad that year. Paul Froelich had been commissioned to copy the drawings of medieval windows in the Trocadéro museum in Paris and those by Charles Winston in The British Museum, as well as to look for possible additions to the collection, with a wary eye for the excellent forgeries that were beginning to come on the market.[28] Froelich located nine panels at the shop of the Paris dealer François Haussaire, a former glass restorer from Reims, and photographs were sent home for approval. The glass was duly purchased but, before it could be exported, it was stopped by the French government. Five panels were allowed to leave the country but four were impounded. Raymond Pitcairn eventually gave one of them to the Trocadéro museum, but he learned from this experience and it was never repeated.

Fifty-six objects were added to the collection in 1922, partly because Raymond Pitcairn went abroad, himself, that year. He had become well known in the art world by that time, but there were few dealers that he actually trusted. One of these was Joseph Brummer. Brummer came to New York annually and had visited Bryn Athyn. He had also helped on many occasions with the shipping of objects or else stored them in his shop for later delivery to Bryn Athyn. His integrity was unquestioned, so that before Raymond Pitcairn decided to travel to Europe, he entrusted Brummer with the responsibilities of previewing the art that was for sale by other dealers, of informing him of the best objects, and of making arrangements for his visit.[29] Above all, no one was to be told in advance of his arrival and any correspondence by cable concerning works of art was to be sent in code to insure confidentiality. Brummer was given a "little pink code book" to use for this purpose. Few of the dealers knew Raymond Pitcairn by sight and this was an advantage. At the last moment, his plans had to be postponed, but he was able to cable Brummer in October, "Arrival Paris, tell nobody." Most of the purchases made on this trip were Romanesque sculpture, including the Bust from Parthenay and the Fragment of a Relief (nos. 18, 17), but, in 1922, he also bought his first important piece of Gothic sculpture, the polychromed standing figure of Apostle Paul (no. 76).

Even more important than additions to the collection, however, was the opportunity to revisit the medieval monuments that he loved.[30] In Paris, he went to the Trocadéro museum, where the glass that had been removed from churches during the war was being kept pending restoration of the buildings, and where many of the nineteenth-century cartoon drawings that had been made to facilitate the repairing of the windows were on file for study, and he visited Notre-Dame again, one of his favorite cathedrals. He went to Saint-Denis and saw Suger's splendid façade and choir, not knowing at that time that he would soon add glass and sculpture from the abbey to his own collection. He stopped at Canterbury on his way to London and met Samuel Caldwell, who was restoring the windows there. Joseph Brummer had the task of collecting and shipping the purchases to America—some fifteen crates of Romanesque sculpture.

Upon his return home, Raymond Pitcairn's approach to the problem of duplicating the qualities of medieval glass became more scientific. Larson had finally been persuaded to move to Bryn Athyn so that glass could be blown on the site. Ariel Gunther, a young student at the Academy in Bryn Athyn, became his apprentice and later took charge of the kiln. Kingsley Porter translated the third book of Theophilus's treatise, written in the twelfth century, on the making of stained-glass windows, for the benefit of the glass workers in Bryn Athyn,[31] who were also provided with a translation of Viollet-le-Duc's article on *Le Vitrail* from his *Dictionnaire de l'Architecture*—at that time, the only investigation of the optical properties of medieval glass.[32] The first addition to the cathedral, the council hall, had been started in 1920, and the newly acquired Romanesque sculpture in the collection was being studied for form and technique by the stone carvers. Two impost blocks, supposedly from Saint-Denis (see no. 30), were purchased in 1923, and, again, there was an instance of actual copying; the design from one of the Saint-Denis pieces was used for an impost block in the council chamber.

Raymond Pitcairn continued to collect extensively throughout the decade and well into the 1930s. After that, he would purchase an occasional piece of sculpture or stained glass of exceptional quality. Among the more important objects added to the collection were the three large stained-glass windows, including the Seated King from Braine (no. 46), that were purchased from Bacri Frères of Paris in 1922. Bacri was among the antique dealers who had increased their prices following the Lawrence sale, but who had previously offered the same objects to Hyatt at much lower figures. Lawrence Saint had seen the King and the two other large windows in Paris and had urged Raymond Pitcairn to purchase them; he did, finally, acquire them, but not without reminding Jacques Bacri of the latter's former deviousness.[33] The Column Statue of a Haloed Queen from Provins (no. 31) was purchased in 1923 from Georges Demotte, shortly before his death. Especially for important pieces, Raymond Pitcairn always asked a dealer to supply him with their provenances, where possible. In this particular case, the elder Demotte had died without furnishing this information. His son, who had taken over the firm, had no knowledge of the source of the sculpture, nor were there any records of it among his father's papers. After considerable research and some delay, Lucien Demotte finally produced not only the previous ownership, but also a reference to the engraving by which the column statue could be traced to the destroyed portal at Saint-Thibaut. It is ironic that all of the facts were not widely known until the Queen was published in 1970.[34] It took fourteen years to locate the Crusades panel from Saint-Denis (no. 27), from the time of its first appearance on the art market in 1923 until it finally came to Bryn Athyn in 1937,[35] but Raymond Pitcairn was not always so successful in tracking down the whereabouts and obtaining a work of art.

Every collector always experiences one memorable failure in the process of building his collections. Raymond Pitcairn's disappointment followed his attempt to purchase one of the most beautiful pieces of medieval sculpture ever carved (fig. 4). For the purposes of anonymity, his negotiations were conducted through an agent, to whom he wrote, "It occurs to me that you might obtain for me a piece of sculpture in which I am interested. I had hoped to see the owner of it while I was in France but was unable to make the trip to Autun for this purpose. Mr. Victor Terret is the owner of this piece which he keeps in his house. He lives in the little village of Perrecy-les-Forges near Autun. The subject of the sculpture, which I have neglected to mention, is Eve and to identify it, I am enclosing a photograph."[36] Negotiations proceeded for some months, during which time Abbé Terret, a parish priest in Autun and a local archaeologist, described how he had found the bas-relief of Eve mortared, face inward, into the wall of a house; he had been permitted to remove the stone in exchange for paying the owner's debts. Abbé Terret must have exaggerated somewhat, since the sculpture had been discovered during the demolition of a house in 1856, when he would have been only a small child.[37] There was no question, however, that he owned the sculpture, but he flatly refused to sell it. He did indicate, though, that, from the similarity of the stone, he also knew that the companion relief of Adam was located in the foundation of another house in Autun. Though Raymond Pitcairn expressed keen interest, Abbé Terret never revealed the whereabouts of Adam, and the sculpture has not been found. Eve is now the property of the Musée Rolin in Autun. Perhaps the small Head of a King (no. 21) in the Pitcairn collection, unmistakably in the style of Gislebertus, the master of Autun, was some consolation for her loss.

Raymond Pitcairn not only collected medieval art; he also acquired source materials for his collection. In addition to his library and his thousands of photographs, he purchased engravings of medieval architecture, casts of Early Gothic sculpture, and drawings of a very special kind. In the course of their experiments to duplicate the properties and techniques of medieval stained glass, several of the young glass painters from Bryn Athyn had been sent abroad, as mentioned earlier, to study the windows in the churches and museums, which they had done by making sketches. As early as 1922, however, Raymond Pitcairn had written to Haussaire, inquiring about the existence of old drawings of stained-glass windows. Haussaire replied by sending a roll of some eighty full-scale watercolors, more than half of which were the cartoon drawings for Louis Steinheil's restoration of the chapel of the Virgin in the cathedral of Le Mans in 1858 (cf. no. 65). The others were later

4. Gislebertus. *Eve*. Fragment of the lintel from the north portal, Cathedral of Saint-Lazare, Autun. About 1130. Limestone. Height, 72 cm. (28⅜ in.); width, 132 cm. (52 in.); depth, 32 cm. (12⅝ in.). Musée Rolin, Autun

and in black ink with color notes. They were probably the cartoons for Félix Gaudin's restoration of the Saint Eustace window in Chartres, completed after World War I. By far the richest group, from an archaeological point of view, came from Michel Acézat in 1925. Acézat, also a glass restorer, probably had acquired these drawings from the glass painter Nicolas Coffetier, who had worked with Steinheil in Le Mans. Included were twelve watercolors from the restoration of the Sainte-Chapelle (cf. no. 74) that had begun in 1848. Some of these are signed by Steinheil and some by an assistant named Weber. There are also two scenes in black and brown ink, signed by Alfred Gérente and dated 1854, for a window devoted to the life of Saint Theodocius. This window was made for the choir of the cathedral of Amiens. Five full-scale cartoons of the lancets beneath the north rose of Chartres were made by Albert Bonnot for the restoration of 1886. The twenty ink cartoons of the choir windows of Saint-Denis have special historical importance, since they clearly indicate the restorations that were made to Suger's panels by the Gérentes beginning in 1847 (figs. 5, 6). Each piece added has a scored mark in the middle of the line indicating the lead that was used to trace the pattern for the piece of glass to be inserted. In some cases, two cartoons were made for a single panel: one showing the original glass and the other the replacement pieces (figs. 7, 8). Except for the Tree of Jesse window, restored by Henri Gérente (d. 1849), most of Suger's glass is recorded among these drawings. Some of the cartoons for the Infancy window are missing, but there are drawings for both the Crusades and the Charlemagne panels (cf. nos. 27, 28).

By the mid-1920s, space to house his burgeoning collection had become a problem for Raymond Pitcairn. The Haloed Queen from Provins was tied to the newel post of the stairway at Cairnwood, his father's home (in which he still lived), but most of the collection was stored in outbuildings on the estate.[38] As early as 1922, he wrote to his brother Theodore that he was considering building a studio, similar to Barnard's Cloisters, for the collection.[39] By 1926, he realized that even more space would be needed, and, in a letter to Dikran Kelekian, he said that he was contemplating building a "little castle for the collection."[40] Glencairn, which was also to be his home, was begun in 1928 and took twelve years to complete, since, like the cathedral, it was built according to his

41

5. Alfred Gérente. *The Annunciation*. Cartoon drawing of fragmentary remains of 12th-century stained glass from the Abbey of Saint-Denis. About 1855. Brown and black ink on paper. Height, 65.7 cm. (25⅞ in.); width, 85.5 cm. (33 11/16 in.). Glencairn Museum, Bryn Athyn, Pennsylvania, 07.DR.254

6. Alfred Gérente. *The Quadriga of Aminadab*. Cartoon drawing of 12th-century stained glass from the choir, Abbey of Saint-Denis. About 1855. Brown and black ink on paper. Height, 70 cm. (27 9/16 in.); width, 65.7 cm. (25⅞ in.). Glencairn Museum, Bryn Athyn, Pennsylvania, 07.DR.262

concept of organic growth (fig. 9).[41] Following the principles established by George Grey Barnard at his Cloisters in New York, a number of architectural elements and medieval sculptures in the collection were built into the structure of Glencairn. Before his death in 1966, Raymond Pitcairn wisely decided that Glencairn should become a museum. After his wife's death in 1979, the house was bequeathed to the Academy of the New Church; it is now the Glencairn Museum, and the permanent home of the Pitcairn collection.

Raymond Pitcairn never returned to France after 1922. Instead, the dealers came to him. Most of them traveled to Bryn Athyn at one time or another, or, on their annual trips to New York, they brought works of art with them for his inspection. By the mid-1920s, a number of European firms had branch offices in New York that Raymond Pitcairn visited regularly. Some would hold exhibitions of their collections in New York that he would attend.[42] Others would send photographs, and if a piece interested him it would be shipped across the Atlantic on approval. Unlike his American contemporary William Randolph Hearst, also a collector of medieval art in the 1920s, who employed agents and who never saw many of the things that were bought for him, Raymond Pitcairn made his own selections. Even when one of his employees, such as Hyatt or Saint, was authorized to purchase in his name, he reserved the right to return anything that he did not like. He loved medieval art, and for him collecting was an expression of his personal taste.

In the years preceding the formation of the Pitcairn collection in the third and fourth decades of this century, little interest had been shown in this country in the monumental arts of the Middle Ages.[43] Mrs. Jack Gardner's new home on the Fenway in Boston was completed in 1903, but the Venetian architectural elements built into the structure and even the few examples of medieval glass and sculpture that she owned were far overshadowed by her dazzling collection of paintings. J. Pierpont Morgan's medieval sculptures were exhibited at the Metropolitan Museum but it was his great collection of liturgical art that attracted attention. The single exception was George Grey

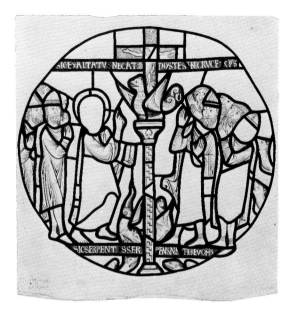

7. Alfred Gérente. *The Raising of the Brazen Serpent.* Cartoon drawing for the 1854 restoration of The Life of Moses window, Abbey of Saint-Denis. About 1855. Brown and black ink on paper. Height, 71.8 cm. (28¼ in.); width, 65.7 cm. (25⅞ in.). Glencairn Museum, Bryn Athyn, Pennsylvania, 07.DR.260

8. Alfred Gérente. *The Raising of the Brazen Serpent.* Cartoon drawing for the restoration of The Life of Moses window, Abbey of Saint-Denis. About 1855. Brown and black ink on paper. Height, 74 cm. (29⅛ in.); width, 69.6 cm. (27⅜ in.). Glencairn Museum, Bryn Athyn, Pennsylvania, 07.DR.261

Barnard, who had opened his Cloisters on the northern tip of Manhattan island in 1914.[44] Barnard's interest in medieval sculpture had grown out of the necessity of providing a living for his family and financing his own activities as a sculptor. By 1906, he had found it profitable to travel through the French countryside, buying up "old stones" from abandoned abbeys and churches and then selling these architectural fragments to dealers and collectors in Paris. Gradually, he had amassed his own collection, which he brought to New York just ahead of the new French laws classifying monuments, after having taught the French dealers that there was a profit to be made in medieval "stones" and glass.

Interest in Gothic art had never really died out in England. John Christopher Hampp, a wool merchant traveling on the Continent following the Treaty of Amiens in 1802, as a sideline, had been able to collect stained glass from disaffected churches and even to buy directly from such collectors as Alexandre Lenoir, and he found a ready market for this glass in English country houses and parish churches.[45] English collectors of medieval art, such as Sir William Burrell in the 1920s, rarely had to venture outside of England to form their enormous collections.[46] Grosvenor Thomas, from whom Raymond Pitcairn bought his first object, obtained most of what he sold in England. At Thomas's death in 1923, his son Roy opened his own gallery in New York with an exhibition of stained glass, from which still other examples were added to the collection in Bryn Athyn.[47] Roy Thomas's English partner, Maurice Drake, became Burrell's agent, but there were other, more personalized collections being formed in America, such as that of Henry Walters in Baltimore; his acquisitions of medieval art were extensive during the mid-1920s. Clarence Mackay's collection of armor was famous throughout the world, but he also owned stained glass. Most of what Duveen bought at the Lawrence sale ended up in the Mackay collection, but, as Otto von Kienbusch was to do in the 1930s, Mackay's stained glass was used mainly as a backdrop for his arms and armor. George D. Pratt, whose stained glass would later become the largest single bequest of its kind to the Metropolitan Museum, was also interested in armor.

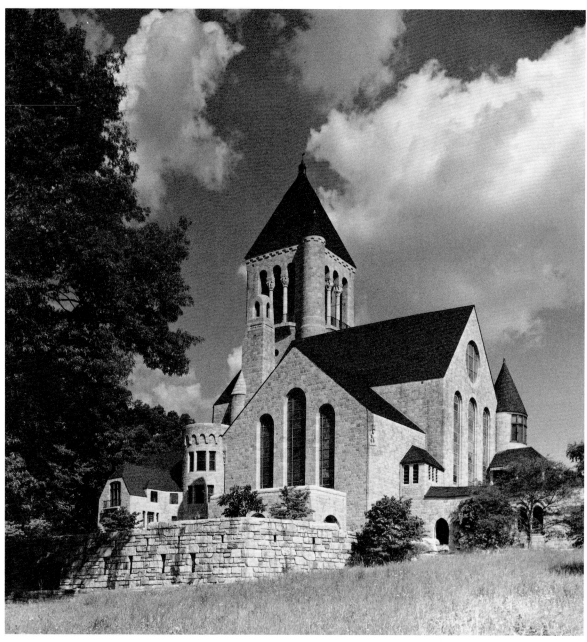

9. Glencairn, the home of Raymond Pitcairn. Now the Glencairn Museum of the Academy of the New Church, Bryn Athyn, Pennsylvania

Yet, except for Barnard, few American collectors appreciated the type of material that first started Raymond Pitcairn on the road to collecting. Those private collectors or museums in this country that began to acquire medieval art in the early 1920s would buy an enameled coffret but not a corroded panel of ornamental stained glass. They would purchase a Gothic figural sculpture but not a carved architectural fragment. Medieval art in these categories was hard to sell, even in Europe. There had been so little interest in medieval ornament that most of it had remained unprotected in churches during World War I. This was precisely why, following the war, so much was available—had there been a market. Kingsley Porter's letter to Henry Lawrence in 1917 stating that "all of the windows of any importance in the war zone had been safely removed for protection," even reflected the scholarly opinions of the time.[48] In the enormous effort at restoration that took place in the aftermath of the war, little attention was paid to the fragments of grisaille glass that still hung in the windows, or to the broken, carved blocks that lay in the rubble on the pavements of churches. Though it was cheaper to reglaze and recarve than to fit these pieces into the fabric of rebuilding, the restorers saved them and sold them to dealers, who, in turn, brought them to Bryn Athyn and to other collectors. It did not take long to build a market. By 1922, Joseph Brummer had written to Raymond Pitcairn that "Romanesque and Gothic objects are 'à la mode' all over Europe."[49] At first, however, this interest in purely ornamental sculpture and glass was fairly limited, but during the early 1920s so much of it came to Bryn Athyn that no other collection of medieval art in the world is as rich in ornament.

There were other reasons for the lack of popularity, among collectors, of medieval stained glass and sculpture. Both are architectural rather than decorative arts, which were created as elements of a structure rather than as isolated, transportable objects. The monumental arts of the Middle Ages were part of the very fabric that they adorned, and thus lent themselves poorly to a preconditioned environment. Throughout the history of collecting, both in this country and abroad, portable arts or furnishings, the precious arts, illuminated manuscripts, and paintings have always been favored. It was not until George Grey Barnard built his collection into the very structure of his museum that collectors realized the potential splendor of medieval monumental art. William Randolph Hearst used the same approach as Raymond Pitcairn did at Glencairn—and that James Rorimer would follow at The Cloisters museum (which had acquired most of the Barnard collection). By and large, it was the museums in the United States, rather than the private collectors, that ultimately built the great collections of the architectural arts of the Middle Ages. In his early years of collecting, Raymond Pitcairn's acquisitions of sculpture and glass made him unique among collectors of medieval art in this country, for Barnard had temporarily ceased his own collecting. The special purposes underlying the initial purchases at Bryn Athyn may have been overemphasized in these pages, but it is hardly likely, were it not for the ultimate goal of building the cathedral, that the Pitcairn collection would be so strongly focused on the architectural arts. In the 1950s, at the end of his career as a collector, Raymond Pitcairn said that, perhaps, he had made a mistake in not broadening his interests to include art of the entire Gothic period, but that, by then, it was too late. Export laws and the fierce competition of an active art market had made all but the occasional acquisition impossible. The few later examples of sculpture, glass, and works in other mediums in the Pitcairn collection were added during the construction of Glencairn, but the core of the collection—the Romanesque sculpture and the Early Gothic stained glass—was formed at the only time in this century when acquiring works of art of quality and, specifically, of the medieval period, was possible.

Jane Hayward

NOTES

1. "Christian Art and Architecture for the New Church," *New Church Life,* October 1920, 618.

2. Quoted in E. Bruce Glenn, *Bryn Athyn Cathedral, the Building of a Church,* Bryn Athyn, Pennsylvania, 1971, 30.

3. Arthur Kingsley Porter, *Medieval Architecture, Its Origins and Development,* 2nd ed., II, 1912, 186–87. The idea of using models for architectural constructions is further considered by John Fitchen, *The Construction of Gothic Cathedrals,* Oxford, England, 1961, 301–2.

4. The history and methods of construction of the cathedral are given in detail in Glenn, *Bryn Athyn Cathedral,* 29–80, which has formed the basis for the information included here.

5. Porter, *Medieval Architecture,* 184–93.

6. Ibid., 189.

7. Henry Russell Hitchcock, *Architecture of the Nineteenth and Twentieth Century,* Baltimore, 1968, 400; "Art of the United States. Architecture," in "Americas: Art since Columbus," *Encyclopedia of World Art,* I, 1968, 265–66.

8. Information from the letter books of 1914–19, containing Raymond Pitcairn's correspondence.

9. William H. Goodyear had begun to develop his theories on architectural refinement as early as 1904. His most important publication is "Architectural Refinements, A Reply to Mr. Bilson," *Journal of the Royal Institute of British Architects,* 3rd series, XV, 1907, 107. In 1906, John Bilson's "Amiens Cathedral and Mr. Goodyear's 'Refinements'. A Criticism," had appeared on page 397 of the same journal, expressing contrary opinions.

10. Jennie Gaskill, *Biography of Raymond Pitcairn,* Bryn Athyn, Pennsylvania, privately printed, n.d., 15, 155.

11. Letter to Ralph Adams Cram from Raymond Pitcairn, August 31, 1917.

12. Porter's partial translation of Suger's text appears in *Medieval Architecture,* II, 1912, 193–99.

13. Cynthia Hyatt Walker, "Winfred Sumner Hyatt—In Retrospect," 7, unpublished manuscript submitted to *Stained Glass,* the quarterly of the Stained Glass Association of America. I am grateful to Mrs. Walker for permitting me to read her typescript, from which much of my discussion of the glass painters—and of Hyatt, in particular—as well as of the early glass experiments in Bryn Athyn, are drawn.

14. Charles J. Connick, *Adventures in Light and Color,* 1937, 132–36, 256–57, describes the quality of commercial glass during the early twentieth century.

15. For Tiffany's experiments with glass see Hugh F. McKean, *The Lost Treasures of Louis Comfort Tiffany,* New York, 1980, 30–35.

16. The letter book for 1916–19 contains a letter dated April 2, 1917, to A. J. Nash, director of the Tiffany Furnaces, Corona, New York, whom Tiffany had suggested be contacted.

17. Cynthia Hyatt Walker, "Winfred Sumner Hyatt," 6, unpublished ms.

18. Ibid.

19. Lawrence B. Saint and Hugh Arnold, *Stained Glass of the Middle Ages in England and France,* London, 1913.

20. Glenn, *Bryn Athyn Cathedral,* 140.

21. "Notes on Glass by Winfred Hyatt" for December 15, 1916, in correspondence files, the Glencairn Museum, Bryn Athyn, Pennsylvania.

22. The letter books of 1919–20 contain correspondence with Daguerre.

23. A letter to Winfred Hyatt dated February 21, 1921, in the letter book for 1921, gives the most graphic and detailed description of the Lawrence sale.

24. Hyatt letter; see note 23 *supra.*

25. *Gothic and other Ancient Art collected by the Late Mr. Henry C. Lawrence,* sale catalogue, American Art Association, New York, 1921. (Annotated copy in The Metropolitan Museum of Art library.)

26. Cables quoted in Hyatt letter; see note 23 *supra.*

27. For the most recent and perhaps the most illuminating account of George Grey Barnard's activities as an art collector, see J. L. Schrader, "George Grey Barnard: The Cloisters and The Abbaye," *The Metropolitan Museum of Art Bulletin*, XXXVII, 1979, 2–52. The incident referred to is described on page 34.

28. Correspondence with Paul Froelich from July 7 to December 9, 1921, regarding the panels of stained glass, is in the letter book for 1921.

29. Correspondence with Joseph Brummer relating to the European trip and the list of objects purchased from June 1, 1922, to March 20, 1923, appears in the letter books for 1922–23.

30. Raymond Pitcairn's Itinerary, with notes on conditions in Europe by Lawrence Saint, is contained in his personal files.

31. A letter to Arthur Kingsley Porter, mentioning Porter's translation of Theophilus for use in Bryn Athyn, is in the letter book of 1918. (The whereabouts of Porter's translation are unknown.)

32. Eugène-Emmanuel Viollet-le-Duc, *Dictionnaire raisonné de l'Architecture*, IX, Paris, 1854–68, 373–462.

33. Letter to Bacri Frères, July 11, 1922, in the 1922 letter book.

34. Léon Pressouyre, "Réflexions sur la Sculpture du XIIème Siècle en Champagne," *Gesta*, IX/2, 1970, 23–25, n. 59, fig. 21.

35. Though the history of the Crusades panel was known, it was not until the recent discovery of Alfred Gérente's drawing (fig. 17) in the Pitcairn collection that it was possible to prove that the piece had been sent to Gérente's studio, and that it was there that Gérente made the group of heads on the right and substituted them for the original group published by de Lasteyrie. The original group of heads was then incorporated into the copy by Gérente that is now in the Museo Civico in Turin.

36. The correspondence files in Bryn Athyn include letters from February 7, 1923, to May 15, 1925. Porter had known of the sculpture but it was not included in his *Romanesque Sculpture of the Pilgrimage Roads*, Boston, 1923.

37. See Denis Grivot and George Zarnecki, *Gislebertus, Sculptor of Autun*, New York, 1961, 49, for the history of the piece.

38. Conversation with Creda Glenn, Raymond Pitcairn's sister-in-law, October 7, 1981.

39. Letter dated January 12, 1922, in the 1922 letter book.

40. Letter to Dikran Kelekian, dated December 1, 1926, in Raymond Pitcairn's files of correspondence with art dealers.

41. The groundbreaking for Glencairn was in 1928, though plans were begun the previous year. The dedication took place on December 29, 1939.

42. Lucien Demotte, *Catalogue of an Exhibition of Stained Glass from the XIth to the XVIIIth Centuries*, exhibition and sale catalogue, New York, 1929. Raymond Pitcairn purchased several pieces from this exhibition.

43. An excellent summary of the history of collecting Romanesque sculpture, which elucidates the interest in medieval art in the United States, is given in Walter Cahn's introduction to *Romanesque Sculpture in American Collections*, I, New England Museums, New York, 1979, 1–16 (co-authored with Linda Seidel).

44. See note 27 *supra*.

45. Jean Lafond's "The Traffic in Old Stained Glass from Abroad during the 18th and 19th Centuries in England," *Journal of the British Society of Master Glass Painters*, XIV/1, 1964, 58–67, provides an excellent summary of the dealings of Hampp, and the attitudes of English collectors.

46. A history of Sir William Burrell's stained-glass collecting is given in William Wells, *Stained and Painted Glass: Burrell Collection, Figure and Ornamental Subjects*, Glasgow, 1965, 4–7.

47. Maurice Drake, *The Grosvenor Thomas Collection of Ancient Stained Glass*, exhibition and sale catalogue, 2 vols., New York, 1913.

48. A letter dated December 26, 1918, a copy of which is in Raymond Pitcairn's correspondence files.

49. A letter dated June 6, 1922. The files of Raymond Pitcairn's correspondence with art dealers contain a copy.

1. Capital with The Martyrdom of Saint Andrew

France, Quercy

First quarter of the 12th century

Limestone

Height, 59.1 cm. (23 1/4 in.); width, 61.6 cm. (24 1/4 in.); depth, 62.2 cm. (24 1/2 in.)

09.SP.3

According to Lucien Demotte, the Parisian art dealer from whom the capital was purchased in 1926, this remarkable work was found "in front of a house in Issoire" (Auvergne). Its style, however, points to Quercy. It is close to one of the capitals of the chapter house in Marcilhac (Lot) and may well be by the hand of the same sculptor (Vidal, 1959, 177 ff.). Yet, its large dimensions indicate that it must have crowned an engaged pier in a church rather than having served in a lesser dependency. The strong and rhythmic articulation of the forms recalls the manuscript illumination of Aquitaine. This connection is most clearly revealed in the characteristic definition of the garment folds by means of precisely incised parallel lines. The capital is in good condition with only minor surface abrasions.

The subject is the crucifixion of Saint Andrew. The saint is bound by means of crossed ropes to an X-shaped cross (or *crux decussata*). According to the story of his martyrdom contained in the apocryphal accounts of the lives of the apostles, he agonized on the cross for three days but continued to preach. On the fourth day, the proconsul Egeas, in response to popular protest, ordered that he be untied, but Andrew pleaded with the Lord to let him endure martyrdom and the men (*carnifices*) charged with the task of liberating him became paralyzed (*Pat. gr.*, II, 1243–44). This moment in the story is illustrated by the two men in striding poses whose arms seem almost frozen against the sides of the cross. The miracle is also made manifest by the hand of God superimposed on the cross, which appears on a disk above the head of the saint, in the position normally occupied by a Corinthian rosette. The crowned and seated figure wielding a scepter, on the narrow, right side of the capital, is the proconsul Egeas. The bowing haloed woman at the left, with veiled hands extended, is

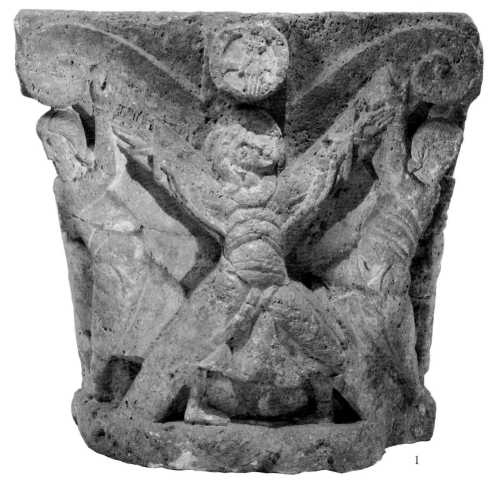

1

49

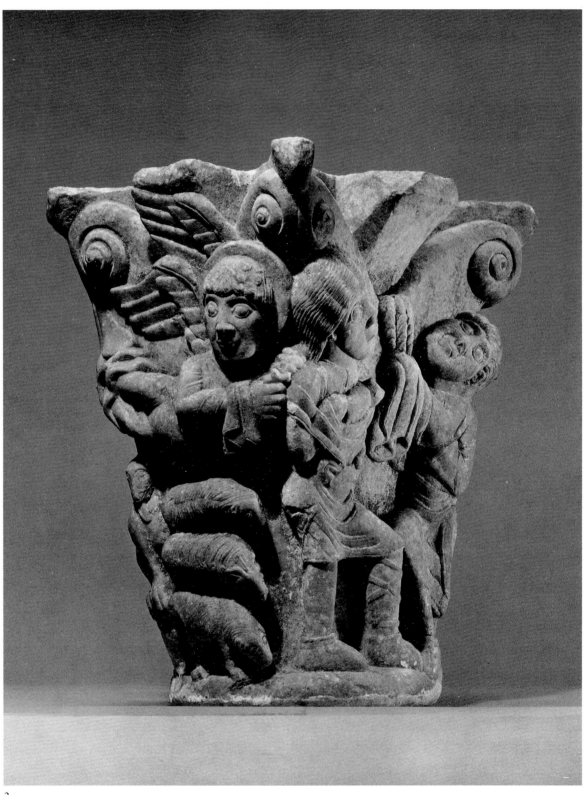

2

most probably the proconsul's wife, Maximilla, who, having been healed by the apostle, became a convert to his faith.

Émile Mâle (1951, 412–21) has proposed that representations of the martyrdom of Saint Andrew with an X-shaped cross did not antedate the fourteenth century. Indeed, in Romanesque times the cross was customarily of the vertical type and thus was similar to Christ's, as on a capital in Besse-en-Chandesse (Auvergne); more frequently, it was planted in horizontal fashion. However, the *crux decussata*, contrary to Mâle's opinion, was not entirely unknown in the twelfth century. It figures in the illustration of the martyrdom of the saint found in the Troper of Autun (Paris, Bibl. de l'Arsenal, ms. 1169, fol. 14v.), a manuscript executed between 996 and 1024, and on a twelfth-century baptismal font at Cottam in East Riding, England.

Purchased from Lucien Demotte, Paris, 1926.

Bibliography: Cahn, 1977, 70–71, no. 4.

2. Capital with The Sacrifice of Cain and Abel

France (Aquitaine), region of Agen (?)
About 1125
Marble
Height, 44.5 cm. (17 1/2 in.); width, 35.5 cm. (14 in.); depth, 28 cm. (11 in.)
09.SP.70

The story of the sacrificial offerings made by Cain and Abel (Genesis 4:2–5) covers three sides of this capital. A semicircular indentation, carefully cut into the base of one of the sides, may have been for installation purposes. At the heart of the composition, Abel presents a lamb and Cain a sheaf of wheat. Abel's flock of sheep is depicted behind him on the left side of the block, along with an angel who touches his shoulder as a mark of divine approbation. A crouching lion and a serpent appear on the opposite face of the capital behind the figure of Cain, whose head the reptile stings. The style of the carving is rooted in the sculpture of the cloister of Moissac, dated 1100, and in the oldest group of capitals from the cloister of the church of La Daurade in Toulouse, which displays a parallel manifestation of the same art in the characteristic treatment of facial features and in the crisply delineated draperies. The more expansive treatment of the story of Cain and Abel at Moissac also features an angel who acknowledges the offering of Abel, while Cain lays his sacrifice on an altar in the presence of a winged and claw-footed demon. The effect of the carving in the Pitcairn capital is nonetheless distinctive. The composition is more crowded than in the antecedents at Moissac and in Toulouse, and the figures are more voluminous and animated. The slender proportions of the capital and the rendering of the

volute in a manner resembling a snail shell point to a more westerly area of Aquitaine, specifically the territory between Agen and Bordeaux, as its probable place of origin. A capital with two wrestling figures, found in Clermont-Dessous, northwest of Agen, albeit somewhat cruder, exhibits a comparable configuration and style (Musée des Beaux-Arts, Agen, Inv. no. 284; Pressouyre, 1978, 238, fig. 3).

Bibliography: Gómez-Moreno, 1968, no. 24; Cahn and Seidel, 1979, 130.

3. Relief with a Bishop

France, Saint-Vincent-lès-Digne (Basses-Alpes)
First half of the 12th century
Marble
Height, 85 cm. (33 7/16 in.); width, 46.4 cm. (18 5/16 in.); depth, 14 cm. (5 1/2 in.)
09.SP.296

This marble relief shows a bearded figure in a strictly frontal pose, clad in episcopal vestments. The unidentified personage wields a crosier and raises his right hand in a gesture of blessing. Before 1886, when the work was acquired by a private collector in Sisteron, it was enshrined with two other reliefs in the walls of the chapel of Saint-Vincent, overlooking the city of Digne (Basses-Alpes). This chapel, mentioned in

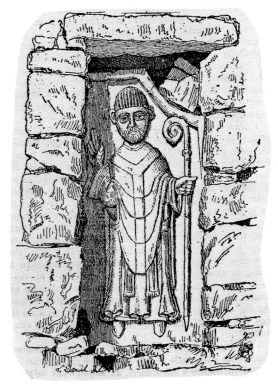

10. Engraving, after a drawing, of the *Relief with a Bishop* from Saint-Vincent-lès-Digne (Basses-Alpes), *Bulletin de la Société Nationale des Antiquaires de France*, 1882, 182. The present location of the drawing is unknown

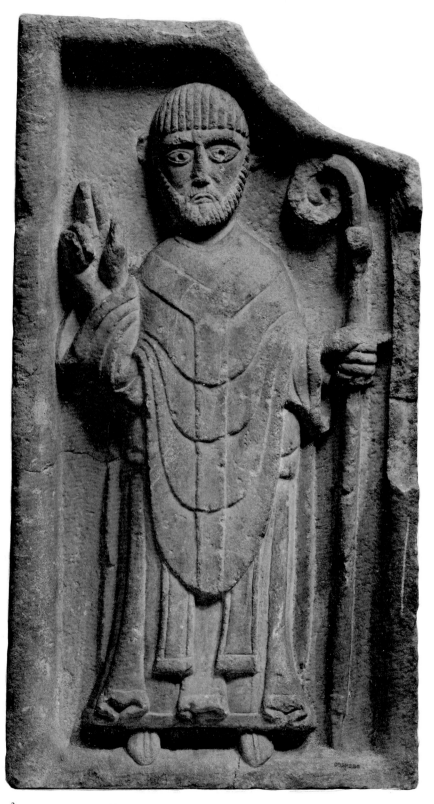

3

the bulls of Popes Alexander III (1180) and Lucius III (1184), was a possession of the Chapter of Notre-Dame-du-Bourg, the old cathedral of Digne. Along with the Pitcairn carving, there was a tympanum with a representation of the Lamb of God flanked by angels (now in the Fondation Maeght in Saint-Paul-de-Vence), and another rectangular relief of a second bishop. The latter was smaller than the present work (44 x 37 cm.) and apparently quite eroded; its present whereabouts are unknown. Nineteenth-century scholars believed that the larger Pitcairn relief represented Saint Vincent and the smaller, lost carving, Saint Domninus, the apostle of the region and the reputed first bishop of Digne. The two reliefs were mounted initially "in the corner to the right of the façade," and later moved to a dry wall constructed in front of the chapel. A drawing of the Pitcairn relief published by Flouest in 1882 seems to show it in this location (fig. 10). A puzzling aspect of the relief is the rounded excision of the upper right corner, which must have been made in order to accommodate another element of a larger composition or a particular feature of the architecture. The sober and somewhat rustic style of the carving has been compared with a fragmentary relief from Saint-André-de-Rosans, now in the museum in Gap (Thirion, 1972, 38–39), and it is echoed in other sculpture from the same region, such as the relief, possibly an altar frontal, from the church of Saint-Pierre in Reillanne (Sénanque, 1977, 43, no. 38). There is no sign here of the grand pictorial rhetoric in the Roman imperial manner for which Provençal Romanesque sculpture is famous. The head and the body are rounded and regularly bounded volumes, and the details in the smoothly finished surface are rendered with a cool and uneventful precision.

Ex collections: Marcel Eysséric, Sisteron (until about 1886); bought by a dealer, Aix-en-Provence, 1934; private collection, Cannes.

Bibliography: Cruvellier, 1881, 200–211; Flouest, 1882, 118–86; Rohault de Fleury, 1883–89, VIII, 96, fig. 697; Anon., 1886, 438–47; Thirion, 1972, 38–39; Sénanque, 1977, no. 38; Thirion, 1980, 431–32.

4. Double Capital

France, Lombez (Gers)
Second quarter of the 12th century
Limestone
Height, 42.5 cm. (16 3/4 in.); width, 62.5 cm. (24 5/8 in.); depth, 40.5 cm. (15 5/16 in.)
09.SP.236

Each of the long faces of this capital depicts a male figure at the center, standing astride the space between the astragals. The figure is youthful, beardless, and wears a simple belted tunic. His arms are hori-

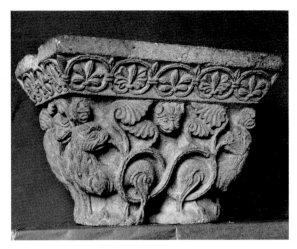

11. Double capital from Lombez. 12th century. Limestone. Victoria and Albert Museum, London, A.59-1935

zontally extended, and he is flanked by a pair of lions. The figure and the animals are carved in high relief, with the lions' hindquarters touching at the centers of the narrow ends of the block. Here, between the beasts, there are two large fan-shaped acanthus leaves, one inscribed upon the other. In each of the upper corners of the capital is a small, four-petaled rosette. The abacus, decorated with a palmette frieze in low relief, is carved from the same block of light-gray limestone as the rest of the capital. The long sides of the abacus have four palmettes and the ends two palmettes each, and an elliptical circlet of vine encloses each palmette. The circlets are joined to one another by ligatures of horizontal vines. At the center of each palmette, and at all four corners of the abacus, is a vertical bud.

The capital has sustained some damage. The face of the central figure on one of the long sides has suffered a break and only the left eye remains. Two of the small rosettes are badly broken and it is apparent that the two astragals originally were joined beneath the open space at the center of the block. This narrow bridge of stone has been broken away.

The youthful figure with upraised arms, confronted by a pair of lions, recalls the iconography of Daniel in the Lions' Den, but the lions in such scenes are usually depicted as docile creatures who do not harm the prophet. Here, while the central figure remains passive, the lions bare their teeth. It would seem that the hero's arms, which pass behind the bodies of the lions, are imprisoned in their jaws, though the sculptor probably intended to show him grasping their manes. The gesture of extended arms has connotations of superhuman strength (Schapiro, 1973, 17ff.). Furthermore, it would be unusual for the identical scene to appear twice, on opposite sides

of the same carving. It is, thus, likely that this is a decorative or heraldic image and not a biblical illustration.

In 1958, Paul Mesplé (177–84) identified a double capital in the Musée des Augustins in Toulouse as a remnant from the cloister of the destroyed monastery of Lombez, a Benedictine foundation of Carolingian date that was later transformed into a house of Augustinian canons, a dependency of the cathedral Chapter of Saint-Étienne in Toulouse. Mesplé also claimed for Lombez two double capitals in the Victoria and Albert Museum in London and concluded his discussion with the hope that more sculpture from this site eventually would be discovered. The Pitcairn capital clearly belongs with Mesplé's Lombez group. The measurements and the material are the same, as is the abacus with palmette frieze carved from one block, and the astragals that originally were joined. One of the London pieces is a decorative capital with a similar pair of lions on each of the long faces, although the animals are addorsed (fig. 11). Not only are the eyes on the London and the Pitcairn capitals outlined with an evenly weighted band, the lions' manes given the same flame-like treatment, and their rib cages articulated with a series of simple striations, but the Toulouse capital, which represents the martyrdom of an unidentified saint, also displays the same

figure and drapery style (Mesplé, 1961, no. 256). The style and iconography of a second London capital, representing the Adoration of the Magi, are closely related to a capital with the same scene, from Saint-Étienne in Toulouse (Mesplé, 1958, fig. 7). The connection is probably explained by the institutional link between Lombez and Saint-Étienne, noted earlier.

With the three carvings identified by Mesplé, the Pitcairn capital brings the number of Lombez capitals to four. Five additional capitals can be added to the group. Two are in the National Gallery of Canada in Ottawa (Inv. nos. 16950, 16954) and another is in the Musées Royaux d'Art et d'Histoire in Brussels (Inv. Sc. 2; Lafontaine-Dosogne, 1977, pl. 35). These three pieces are consistent in measurements, design, and material with the Lombez series of London, Toulouse, and Bryn Athyn, though some elements of their decoration are stylistically more developed. Two last capitals attributable to Lombez are installed in the west wall of the Saint-Guilhem cloister at The Cloisters (34.21.10, 34.21.11). These two double capitals are similar to the Ottawa and Brussels carvings in the foliate decoration of the principal faces, but the abaci differ somewhat. Instead of variations on the palmette, the New York capitals show a running vine scroll in this zone.

P. B.

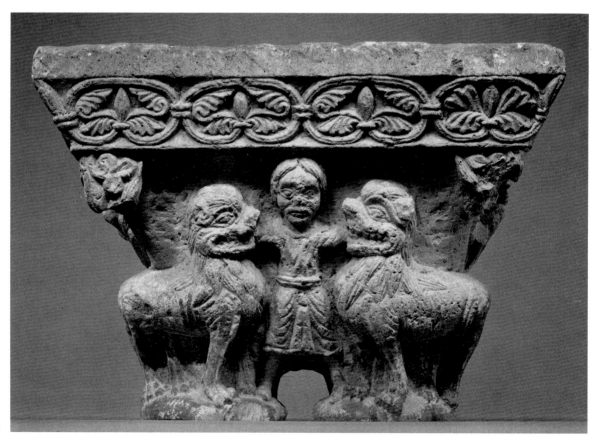

4

5. Architectural Elements

France (Roussillon), Abbey of Saint-Michel-de-Cuxa
Second quarter of the 12th century
Pink and gray Villefranche marble

(A) **Capital**

Height, 40 cm. (15 3/4 in.); width, 40.1 cm.
(15 13/16 in.); depth, 40.6 cm. (16 in.)
03.SP.129

Column

Height, 89.3 cm. (35 1/8 in.); diameter, 24.8 cm.
(9 3/4 in.)
03.SP.130

Base

Height, 20.3 cm. (8 in.); width, 36.5 cm.
(14 3/8 in.); depth, 36.5 cm. (14 3/8 in.)
03.SP.131

(B) **Capital**

Height, 38.2 cm. (15 in.); width, 36.8 cm.
(14 1/2 in.); depth, 35.6 cm. (14 in.)
Philadelphia Museum of Art, 34.1931.2

The monastery of Saint-Michel-de Cuxa provides the
focal point for studies of Romanesque sculpture in
Roussillon, since its workshop was evidently the larg-
est in the region. Founded in 879 by monks from
Escalada and initially dedicated to Saint Germanus,
the abbey rose to prominence during the latter half
of the following century, when it was increasingly
known by the name of its other patron saint, the
Archangel Michael. Its ascent was due, in part, to
the influence of two strong abbots, Guarinus in the
late tenth century and Oliba of Ripoll in the eleventh.
Under the latter, important construction took place.
While some stone carving was done at Cuxa during
Oliba's time—as evidenced by the famous "letter"
(more a sermon) written by the monk Garcia to the
abbot, which included a discussion of the ciborium
of the church (Durliat, 1959, 16)—the most pro-
ductive period for sculpture at Cuxa was the twelfth
century. By the 1130s, work was underway on the
large cloister of the monastery, which was constructed
at the behest of Abbot Gregory, who died in 1146
(Durliat, 1959, 92; Ponsich, 1976, 82). Its estimated
sixty-four capitals were most likely in place by 1151,
when the Augustinian priory of Serrabone, whose
sculpture is closely related to Cuxa, was consecrated;
at this time, the elaborate tribune of the church of
Serrabone, carved by Cuxa-trained artisans, at least
had begun (Durliat, 1969, 15). The sculptural activity
of the masons at Serrabone is only one instance of
the effect of Cuxa's workshop on programs elsewhere.
From this period until the end of the century, its
particular type of capital appeared as architectural
decoration throughout the region: in Espira-de-l'Agly,
Elne, and Villefranche-de-Conflent, among other
places.

5(A)

55

Engravings and a plan made before 1850 demonstrate that, until that date, the cloister of Cuxa had survived nearly intact, despite its secularization during the French Revolution and the subsequent sale of the monument to a buyer in Prades nearby (Durliat, 1959, 23–25). Before 1906, the American sculptor George Grey Barnard acquired a large group of capitals and other fragments of sculpture from the monument. Some thirty-six capitals, along with other architectural elements, were eventually purchased from Barnard by The Metropolitan Museum of Art in 1925 and became the nucleus of the new Cloisters constructed in Fort Tryon Park. A second lot of Cuxa capitals was assembled on the site of the ancient cloister in another partial reconstruction of the ensemble. A number of additional capitals are scattered in collections in France and America, but, since the Cuxa provenance cannot always be established with certainty, attributions in some cases must remain conjectural. Of the four "Cuxa" capitals purchased by Raymond Pitcairn, it is the two discussed here that can be assigned to the cloister with the greatest probability.

The first capital (A) shows four standing eagles at the corners, their talons clutching the striated astragal. Neatly contained volutes curl out over their heads, forming a kind of niche around each bird. This is a typical configuration of many Cuxa capitals, though the animals may be of different species. As was generally the case at Cuxa, the decorative elements of the Pitcairn capital tightly adhere to the structure of the block. Directly at the center of each face, a miniature capital and column, ornate with striations, is pressed between the symmetrically outspread wings of the eagles. Star-like rosettes mark the center of the curving abacus; elsewhere at Cuxa the rosette might take the form of human masks or pinecones. The surface is almost completely covered by the carving in a kind of *horror vacui* aesthetic that was widespread among the Roussillon capitals.

There are at least two eagle capitals in the present reconstruction at Cuxa that are of the same type as the Pitcairn carving. One is almost identical, with the addition of a striated abacus (Durliat, 1959, fig. 23). Perhaps the Pitcairn capital was intended to have similar decoration, since, in several details, it appears to be unfinished. The two extant eagles' heads are only summarily defined, with lightly incised eyes, and

5(A)

one bird has no feathers on its body. This is not exceptional in the Cuxa capital series. The Cloisters installation contains several examples of unfinished work, such as the small capital with a completely uncarved abacus (25.120.614). Marcel Durliat (1973, 74) and Milton D. Lowenstein (1953, 8) believe that the decorative sculpture of Roussillon was carved at the quarry and shipped to the site. If so, then it is possible that in such a process of mass production some of the capitals were left unfinished, to be completed later *in situ.*

On contiguous faces of the second capital (B) are a pair of striding lions whose bodies are joined to a single head. The animals stand on a striated astragal. Simians' heads occupy the corners over the lions' rumps, and the places that ordinarily would be filled by the rosettes are here taken by human heads (two of them broken) with lead-filled pupils. The bell of the capital is striated. Some arguments have been made against the Cuxa attribution. Walter Cahn (1978, 78) has noted the "assertive plasticity," more generally characteristic of the carving at Serrabone, and has compared the capital with a carving of similar design in the outer south gallery of that church. In

addition, the Pitcairn capital is smaller than the typical Cuxa block, though at least one of the pieces in The Cloisters ensemble (25.120.614) has the same dimensions, as does a group of Cuxa capitals found in Olette (Durliat, 1959, 37–38). Nonetheless, the weight of the evidence favors Cuxa. As in the capital with eagles (A), the volutes converge to form a kind of protective niche for the animals at the corners. The use of lions, monkeys, and human heads was widespread at Cuxa, though rarely are all three combined. Cahn has described the globular treatment of the lions' heads as particular to Cuxa, comparing the Philadelphia capital to one of the capitals now reinstalled at Cuxa (Durliat, 1959, 35, fig. 26). The heads of the Pitcairn lions and the grotesque masks of this capital share such details as drilled pupils, widely grinning maws, sharply cut horizontal bands across the bridges of the noses, and beading; similar beading occurs on many other Cuxa capitals.

F. H.

(A) Purchased from Lucien Demotte, Paris, 1923.
(B) Purchased from George Grey Barnard, New York, 1921.
Bibliography: Cahn, 1978, no. 3 (capital B).

5(B)

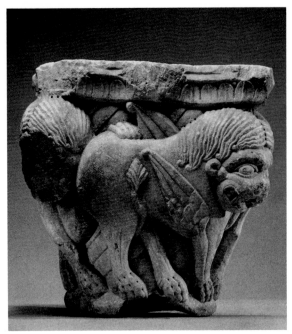

6(A)

6. Two Capitals

France (Roussillon)

Second quarter of the 12th century

Pink marble

(A) Height, 37.4 cm. (14 3/8 in.); width, 50.2 cm. (19 3/4 in.); depth, 33 cm. (13 in.)
09.SP.168

(B) Height, 39 cm. (15 3/8 in.); width, 36.5 cm. (14 3/4 in.); depth, 21 cm. (8 1/4 in.)
09.SP.170

These two capitals are among more than ninety that are said to have come from the twelfth-century cloister of Saint-Michel-de-Cuxa (cf. no. 5). However, from a plan of the abbey made in 1779, Durliat (1959, 28) and others have been able to determine that the cloister held no more than sixty-four capitals. The disparity between these figures is great enough to indicate that the attribution of a specific carving to Cuxa should be carefully examined. Durliat has explained the inconsistency by surmising that capitals would have been found not only in the cloister but elsewhere in the abbey, as well. He points to a colonnaded structure beside the cloister on the plan, which would allow for another twenty capitals. Durliat also assumes that other capitals would have decorated a tribune, similar to that found at Serrabone, as well as various interior spaces within the monument, which would not appear on the plan. While these suggestions seem reasonable, sufficient differences in style and dimensions within this vast material raise the question as to whether all the capitals in the group have a common origin.

One of the problems in delimiting the Cuxa material is the fact that the local workshop had a profound impact on sculpture throughout the region. The squarish type of capital, carved of local pink and gray stone and decorated with a particular range of foliate and animal motifs found at Cuxa, thus occurs in several other monuments in Roussillon. The same compositions recur frequently, and it is evident that there must have been much contact among workshops, perhaps, in part, based on the use of copy books. The two Pitcairn capitals probably are best understood as a part of this process of diffusion.

The second capital (B) is in a fragmentary state, with only one complete face remaining. It shows two winged lions (griffins?) rearing on their hind legs. The single heads of beasts at the corners serve two bodies. The same design thus was repeated on all four faces of the block. The motif of paired rearing leonine creatures is found in numerous versions throughout Roussillon; better-preserved examples elsewhere show the lions biting their own wings. This is undoubtedly how the Pitcairn capital should be reconstructed. Bearded masks, one shown in three-quarter view, the other frontal, mark the place of the rosette on the abacus. There is drilling in the lions' eyes, ears, and paws. The capital is chipped in many places, with the animals' snouts, wings, and paws especially damaged.

In spite of its fragmentary state, enough remains of the capital to distinguish it from the majority of Cuxa capitals in the reconstructions at Saint-Michel-de-Cuxa and in New York. A similar capital with rearing lions, found in Ardèche, was associated by Durliat (1959, 41, fig. 36) with a group of five that are more closely related to Serrabone than to Cuxa. It is broken in the same way as the Pitcairn capital, a type of fracture that led Durliat to assume that at Cuxa the capital originally was engaged in a wall or pier. This capital and others in the group are smaller (38 x 38 cm.) than the body of Cuxa capitals, and thus are quite close to the measurements of the Pitcairn carving, whose theme and carving technique also connect it with this other group of capitals. The absence of volutes, the use of the drill, and the depiction of the heads in the abaci in three-quarter view are characteristics often found at Serrabone, both in the tribune and in the south gallery (Durliat, 1959, figs. 45, 47). By contrast, in the Cuxa reconstruction at The Cloisters, all but a few of the figural capitals possess volutes, the drill is used very sparingly, and the heads—where found—invariably are shown frontally.

Of the entire Cuxa series in the Pitcairn collection, the first capital (A) is the most difficult to reconcile with the type prevailing in the Cuxa reconstructions. It is in the same fragmentary condition as the second capital (B), with two complete contiguous sides remaining. Each shows a striding winged lion. The bell of the capital is striated, and the curving, vigorously undercut abacus is decorated with a frieze of simple rounded leaves. The drill was used in the

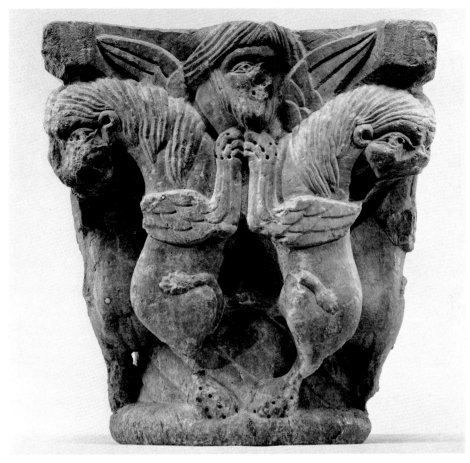

6 (B)

rendering of eyes, ears, manes, and paws. The animals are somewhat damaged, one head being broken. The strongly disengaged abacus with a leafy decoration appears on several capitals now at Cuxa, notably in the carving with the blessing Christ flanked by angels (Durliat, 1959, 39, fig. 34), which Durliat believes to have come from the tribune, but the closest regional parallel is again found at Serrabone, where a capital in the tribune shows lions similarly arranged, with drilling on the surface of the block and an abacus of the same type (albeit with a proportionately larger leaf decoration). However, the lions at Serrabone have ballooning chests and different physiognomies. The Pitcairn capital may also be compared with another capital in the collection, this one from Saint-Pons-de-Thomières (cf. no. 7). Those lions' heads have a heavy, voluminous quality not unlike the masks on this piece, and both capitals display a similar use of the drill. The connections between the first Saint-Pons workshop and the sculpture of Roussillon are generally acknowledged.

F. H.

Purchased from George Grey Barnard, New York, 1921.

Bibliography: Porter, 1923, no. 557a (capital A).

see colorplate 1

7. Capital

France, Abbey of Saint-Pons-de-Thomières (Hérault)
Second quarter or middle of the 12th century
Gray marble
Height, 39 cm. (15 3/8 in.); width, 39 cm. (15 3/8 in.);
 depth, 39 cm. (15 3/8 in.)
09.SP.165

In the early thirteenth century, the cloister of the Abbey of Saint-Pons-de-Thomières in Languedoc (Hérault) housed an eclectic ensemble of sculpted decoration. At least four different styles characterize the more than thirty extant capitals from the monument now dispersed among collections in France and the United States (Rhode Island, 1969, 85–92). They were made at different intervals in the twelfth and early thirteenth centuries, by separate workshops that brought with them styles current elsewhere in Languedoc, in Provence, and in Catalonia. The Pitcairn capital was carved by the earliest of the Saint-Pons ateliers, working in a mode that was prevalent in Roussillon. It is one of a group of nine capitals that was probably reused in the reconstruction of the cloister carried out in 1171 by Roger Trencavel, who had destroyed it in the previous year while battling the

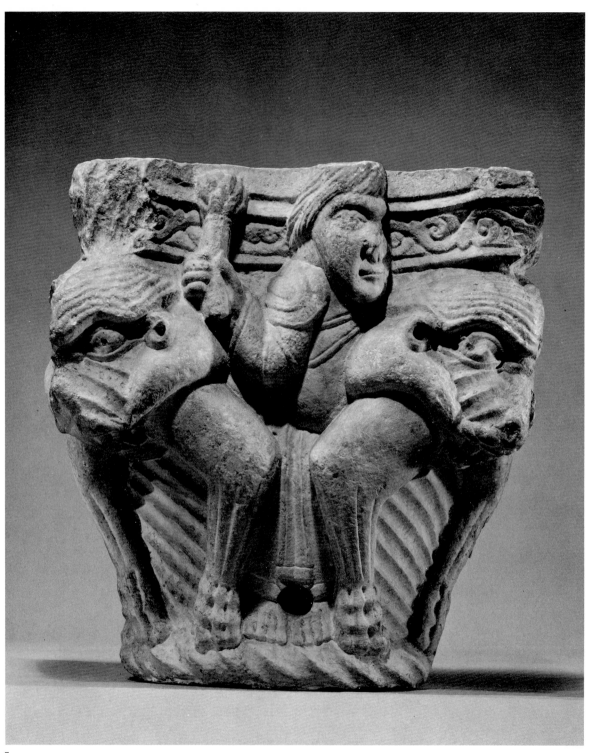

7

monastery's protector, the Count of Toulouse (Bousquet, 1973, 80).

The presence of Catalan sculptors at Saint-Pons was not merely fortuitous. Their work is the visual embodiment of the strong political connections that existed between the abbey and the regions to the south, almost from the time of its founding in 936 by Raymond Pons, Count of Toulouse, and his wife, Garsinde of Narbonne. Frotard, under whose abbacy the monastery reached its apogee, was a papal legate to Spain in the 1070s (Bousquet, 1973, 78), responsible for the disputed acquisition of daughter houses in Spain and Catalonia (Bousquet, 1973, 78–80; Mundó, 1971, 118–20). One of the abbey's monks, Ramiro, left the community in 1134 to become for a brief time King of Aragon. When he returned to monastic life, it was to a dependency of Saint-Pons in Aragon, San Pedro el Viejo in Huesca. By the early thirteenth century, however, these ties were considerably weakened by the general decline of Saint-Pons. The abbey, itself, particularly suffered during the Wars of Religion of the 1560s, and although it was rebuilt in 1668 by Percin de Montgaillard, who recorded the layout of the cloister (Sahuc, 1908, 52; Bousquet, 1973, 88), Saint-Pons never fully recovered. By 1785, the cloister was an overgrown ruin.

There has been some disagreement on the dates of the Roussillon workshop's activity at Saint-Pons-de-Thomières. Joseph Sahuc, in his early monograph (1908, 53), and, more recently, Jacques Bousquet (1973, 95) situate this campaign in the late eleventh century, when, they believe, Frotard brought sculptors back with him from the south. This was also the opinion of Durliat in his publications of the 1950s, based on the stylistic similarities in drapery and decorative motifs between the early sculpture of Saint-Pons and the tympanum of Santa María in Besalú, which the same scholar dated in the 1070s. However, Durliat (1972, 230) has recently revised his dating of Besalú to the middle or third quarter of the twelfth century and has adjusted the date of Saint-Pons accordingly. Earlier, Linda Seidel dated the capitals of the early Saint-Pons workshop in the second quarter of the twelfth century on the basis of their affinity with such monuments as the cloister of Saint-Michel-de-Cuxa (datable in the 1140s) and Serrabone (1151). She believes that the work was undertaken with the help of gifts provided by the Monk-King Ramiro (Rhode Island, 1969, 89).

The Pitcairn capital shows grotesque animals' heads at each of the four corners, with sinewy legs extending downward from their jaws. Their faces are lined with striations along the noses and brows. The eyes and ears were worked with the drill, the former at both the corners and the pupils, which are filled with lead. A man in a tunic stands pressed between the heads on each capital face, with his hand raised and holding a kind of club. Like the grotesque heads, his pupils were drilled and are lead filled. His head is off-center within the concavity of the abacus. His tunic resembles monastic garb, though he has no tonsure, and the drapery falls in heavy pleats to his bare feet. The bell of the capital is striated and the abacus decorated with a meandering rinceau pattern. The abacus has sustained a break and the capital is worn over three of its faces, reducing somewhat the clarity of the details. A hole (for mounting?) appears on one side, above the feet of the central figure.

The capital argues in favor of the Roussillon connections made by Seidel. The grotesque heads at the corners are among a repertory of ornamental motifs found in the sculpture of Roussillon. In a distant way, the composition seems to hint at a mythological subject (the Labors of Hercules?). The Pitcairn carving has the squarish proportions and striated bell of many Roussillon capitals. Yet, in spite of these similarities, the Saint-Pons group has special traits that set it apart and give it its own peculiar expressive power. The decorative drilling of the ears, mouths, and eyes—with lead filling for the pupils—and the armor-like effect of the draperies are typical characteristics. The Pitcairn capital has no volutes, nor have most of the others in the early Saint-Pons series; these almost invariably are present at Cuxa. Somewhat awkward, stocky figures crowd the surfaces with their "compressed, menaced forms" (Rhode Island, 1969, 89). The Saint-Pons capitals are, in this respect, quite different from the norm that prevailed at Saint-Michel-de-Cuxa, where crisp, aggressive forms were subordinated to the ornamental logic of the block.

F. H.

Purchased from Durlacher Brothers, New York, 1923.

Ex collection: Mme. Huë (née Azam), Château de Cabanes, Corniou (Hérault).

Bibliography: Sahuc, 1908, 54, pl. C,1; Bousquet, 1973, 77–95.

8. Three Apocalyptic Elders

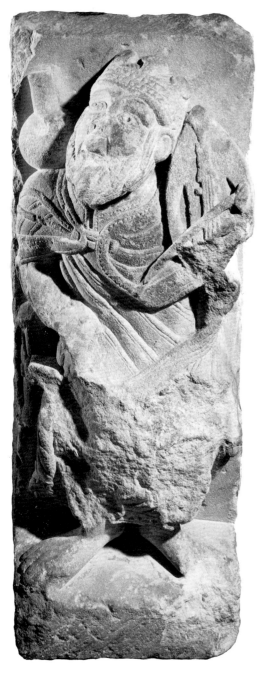

8 (A)

Southwestern France, or Northern Spain
Second quarter of the 12th century
Limestone

(A) Height, 51.4 cm. (22 ¼ in.); width, 24.8 cm.
(9 ¾ in.); depth, 22.6 cm. (8 ⅞ in.)
Philadelphia Museum of Art, 34.1931.30b

(B) Height, 53 cm. (20 ⅞ in.); width, 24.2 cm.
(9 ½ in.); depth, 29.3 cm. (11 ½ in.)
Philadelphia Museum of Art, 34.1931.30c

(C) Height, 56 cm. (22 ¹⁄₁₆ in.); width, 24 cm.
(9 ⁷⁄₁₆ in.); depth, 17.2 cm. (6 ¾ in.)
09.SP.262

These sculptures once formed part of an Adoration of the twenty-four apocalyptic elders (Revelation 4:4 ff.), which appeared around a portal of a church, as at Notre-Dame in Saintes; around the south transept doorway of Saint-Pierre in Aulnay; and at other sites in western France and in Spain. The figures are crowned and hold vials and musical instruments. Their active postures, with heads turned to one side, indicate that they were shown engaged in dialogue with an adjoining figure, like the elders of the portal in Saintes. One of the royal musicians in Philadelphia (A) is seated on a faldstool and plays a viol-like instrument. His cape is drawn across his body and his flask rests on his right shoulder. His bowing arm and a section of the body from the knees to the hem of his garment are broken. The second figure (B) rests his instrument on his knee and holds a long-necked vessel in the other hand. His beard, knees, and both attributes are damaged. Only the upper part of the body of the third figure (C), from Bryn Athyn, is preserved.

A certain coarse vigor, closer to the art of Aquitaine than to Saintonge, characterizes the carving. Bodies are of stocky proportions but are strongly articulated, and the crisscross of the broad parallel stripes that define the garments heightens the effect of unresolved tension. Such characteristics of style inform two other apocalyptic portals in southwestern France, though in different ways: those of Sainte-Foy in Morlaas (unfortunately much restored) and Sainte-Marie in Oloron. The Pitcairn files record the purchase of "a small head of a king from the porch of Morlaas" from the French dealer Henri Daguerre in 1922, but it cannot be positively determined whether the three elders came from this site.

Bibliography: Cahn, 1978, no. 4.

8 (B) 8 (C)

9. Capital with Daniel in the Lions' Den

Northern Spain

First quarter of the 12th century

Limestone

Height, 39.3 cm. (15 $\frac{1}{2}$ in.); width, 45 cm. (17 $\frac{3}{4}$ in.); depth, 48.2 cm. (19 in.)

09.SP.22

The standing figure who appears at the center of one of the four sides of this capital in a frontal pose, holding a book, must be Daniel. The two adjoining sides each show a pair of diminutive and deferential lions. On the fourth side, an angel gestures in blessing with one hand while extending the other toward the Prophet Habakkuk (missing the head and upper torso), whom he must have grasped by the hair (Daniel 14:35), in the prescribed fashion. Corinthian volutes flattened into unsubstantial markings on the surface of the block establish the upper boundary of the scenic ground. On two sides, clustered swirls of leaves sprout.

Daniel's salvation was a very popular subject in the Romanesque sculpture of northern Spain. The inclination was toward the version of the story contained in the noncanonical addenda of the Book of Daniel, which note Habakkuk's mission of mercy, rather than toward the account in the body of the text (Daniel 6:16 ff.), which was preferred in Early Christian art (on this point see Schapiro, 1973, 42–43). While this version of the story (Daniel 14:39) speaks of the presence of seven lions in the den, in the Pitcairn carving — as on a capital in the cloister of La Daurade in Toulouse (Mesplé, 1961, no. 104) and one in the church in Moirax (Lot-et-Garonne)— there are only four beasts. Though this handsome capital is unfortunately somewhat depreciated by breaks and surface erosion, the style of the carving suggests northern Spain as its provenance. In general terms, it is comparable to the sculpture of the Castillo at Loarre, in Huesca (Porter, 1923, I, pl. 53a), and of San Juan de la Peña (Simon, 1975, 50–54).

Bibliography: Cahn, 1977, 77, no. 18.

9

10. Capital with Inverted Quadrupeds

Northern Spain

First half of the 12th century

Limestone

Height, 43.7 cm. (17 1/4 in.); width, 43.7 cm.
 (17 1/4 in.); depth, 43.7 cm. (17 1/4 in.)

09.SP.164

This large capital, of unknown provenance, has a bulky, chalice-like bell joined at the base to a short and disproportionately slender neck and astragal. The upper part of the block exhibits the volute structure and the abacus of the Corinthian order. Pairs of inverted feline quadrupeds, placed back to back, fill each of the capital's four faces. The carving has a boldly tectonic, yet buoyantly springy quality. The capital is in good condition with only slight surface abrasion and three minor breaks along the lower edge. The motif of paired lions twisting back to bite their tails, or extremities, occurs in Romanesque sculpture on both sides of the Pyrenees (Mesplé, 1961, nos. 217, 219–220, 241–243). A capital of somewhat similar design, though with the beasts right-side up—as is most often the case—is found along the cornice of the Fuentidueña apse in The Cloisters (Gómez-Moreno, 1961, 278, fig. 14).

10

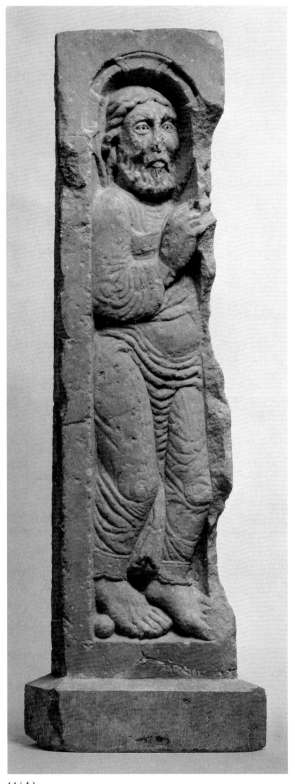

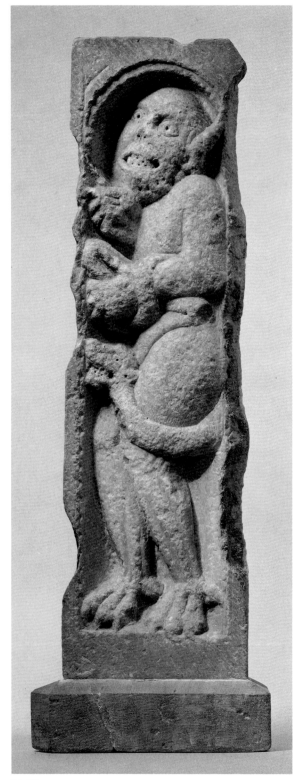

11(A) 11(B)

66

11. The Temptation of Christ

France, Collegiate Church of Saint-Gaudens
(Haute-Garonne)

Middle or third quarter of the 12th century

Marble

(A) Height, 102.2 cm. (40 1/4 in.); width, 29.8 cm.
(11 3/4 in.); depth, 15.7 cm. (6 3/8 in.)
09.SP.25A

(B) Height, 102.7 cm. (40 7/16 in.); width, 29.8 cm.
(11 3/4 in.); depth, 17.2 cm. (6 3/4 in.)
09.SP.25B

These two upright slabs show (A) a standing figure
of Christ, whose arm is half upraised in a speaking
gesture, and (B) a grimacing demon, with a tail ter-
minating in a serpent's head, proffering a stone with
his left hand and holding an unidentifiable object in
his right. The figures are housed in niche-like spaces.
The two reliefs, triangular in section, initially formed
a single block, with two figures facing each other on
two contiguous sides of a larger and somewhat irregular
right triangle. The subject is one of the temptations
of Christ that occurred in the desert wilderness, as
related in the Gospel of Saint Luke (4:1–4): "And
Jesus being full of the Holy Ghost returned from [the]
Jordan, and was led by the Spirit into the wilderness,
Being forty days tempted of the devil. And in those
days he did eat nothing: and when they were ended,
he afterward hungered. And the devil said unto him,
If thou be the Son of God, command this stone that
it be made bread. And Jesus answered him, saying,
It is written, That man shall not live by bread alone,
but by every word of God."

The work comes from the cloister of the colle-
giate church of Saint-Gaudens, southwest of Toulouse
(Haute-Garonne)—which was demolished early in
the nineteenth century (Durliat and Rivère, 1979,
19–32)—as indicated by a recently published draw-
ing, made about 1822, by the Toulouse antiquarian
Alexandre DuMège (Durliat, 1974, 35, fig. 10). The
drawing shows the two figures facing each other on
a single slab—though a line drawn between them
might suggest that DuMège intended a hypothetical
reconstruction, rather than a record of the work's
appearance at that time. DuMège initially saw the
carving on the occasion of a visit to Saint-Gaudens
in 1807. It was then mounted on one of the piers
in the cloister, presumably in the manner of the reliefs
of the cloister of Moissac (DuMège, 1834–36, 109).
A local antiquarian, J.-P.-M. Morel, later mentions
that the relief was mounted on a buttress along the
southern wall of the church of Saint-Gaudens (Dumail
and Bernat, 1976, 308, n. 6). In 1876, it was removed

to the Saint-Gaudens city hall. It disappeared there-
after. Both slabs show considerable damage. The de-
mon relief has breaks along both sides and a diagonal
crack in the back of the block. The frame of the niche
housing Christ is broken off almost completely along
the right side, and a triangular gap at the lower edge
has been filled in.

The theme of the Temptation of Christ is found
in the Romanesque sculpture of southwestern France
and of northern Spain—in the Puerta de las Platerías
at Santiago de Compostela, the tympanum of Errondo
(now in The Cloisters; 65.122.1), the porch of the
church of Beaulieu (Corrèze) (Kupfer, 1977, 21–31),
and on capitals from Vigeois (Macary, 1966, 106) and
Saulgé (Limousin) (Camus, 1976, 96). The Bryn
Athyn Temptation may be connected with a frag-
ment, recently discovered at Saint-Gaudens itself, of
a Virgin and Child, which is, possibly, also an element
from the cloister that was destroyed about 1810 (Du-
mail and Bernat, 1976, 301–8). The style of these
carvings is comparable to the sculpture of another
church in this region of the Pyrenees, Saint-Aventin.
A common source should, perhaps, be sought in Tou-
louse, as suggested by the existence of somewhat sim-
ilar art in the portal capitals of the church of Saint-
Pierre-des-Cuisines.

Purchased from Lucien Demotte, Paris, 1924.

Bibliography: DuMège, 1834–36, 109; Durliat, 1974, 35;
Dumail and Bernat, 1976, 306; Cahn, 1977, 78–79, no.
21; Durliat, 1977, 151–56; Rivère, 1978, 333, 339; Dur-
liat and Rivère, 1979, 58, 61.

12. Double Capital

France, Collegiate Church of Saint-Gaudens
(Haute-Garonne)

Middle or third quarter of the 12th century

Marble

Height, 40 cm. (15 3/4 in.); width, 45.7 cm. (18
in.); depth, 27.9 cm. (11 in.)

09.SP.240

The entire surface of this block is covered with a
somewhat coarse lattice network of a striated and
cord-like material. All four corners and the base of
the capital have suffered slight damage. Two rounded
dowel holes are visible at the top and bottom.

Four other double capitals of gray marble in
American collections can be associated with the carv-
ing: two in The Metropolitan Museum of Art (fig.
12—as pointed out by David Simon—and fig. 13),
one in the Jewett Arts Center at Wellesley College
(Cahn and Seidel, 1979, 58, no. 3), and another in
the Cincinnati Art Museum (fig. 14). All display the
same narrow, tapering volume and stringy vegetation.

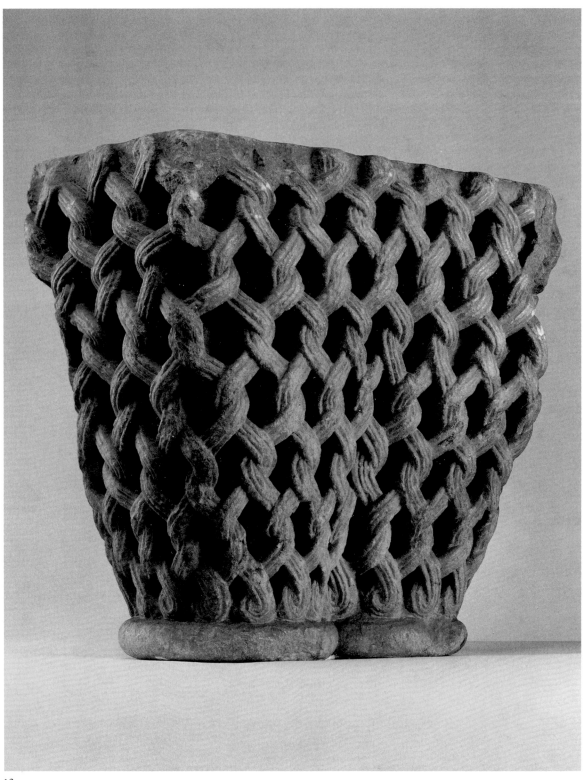

12

12. Double capital from the Collegiate Church of Saint-Gaudens (Haute-Garonne). Middle or third quarter of the 12th century. Marble. Height, 38.1 cm. (15 in.); width, 44.5 cm. (17½ in.); depth, 21.6 cm. (8½ in.). The Metropolitan Museum of Art, New York, Rogers Fund, 1949, 49.56.9

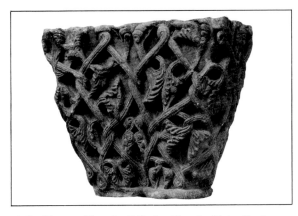

13. Double capital from the Collegiate Church of Saint-Gaudens (Haute-Garonne). Middle or third quarter of the 12th century. Marble. Height, 40 cm. (15¾ in.); width, 45.7 cm. (18 in.); depth, 26.6 cm. (10½ in.). The Metropolitan Museum of Art, New York, Rogers Fund, 1951, 51.124

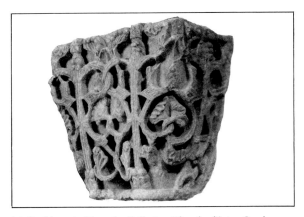

14. Double capital from the Collegiate Church of Saint-Gaudens (Haute-Garonne). Middle or third quarter of the 12th century. Marble. Height, 38 cm. (14¹⁵/₁₆ in.); width, 43.4 cm. (17¹/₁₆ in.); depth, 28.7 cm. (11⁵/₁₆ in.). Cincinnati Art Museum, 1973.602

These features, as well as the dimensions, are duplicated in a group of capitals from the cloister of Saint-Gaudens, several of which also contain the lattice-work interlace of the Pitcairn carving, combined with foliage or zoomorphic elements, which seems to have had some currency in the region of the Pyrenees. The capital attributed to Lombez, in the diocese of Auch (cf. no. 4; now at The Cloisters), also has this type of design, as do others at Saint-Bertrand-de-Comminges, not far from Saint-Gaudens, and in the cloister of Saint-Lizier (Ariège).

Purchased from Henri Daguerre, Paris, 1923.

13. Two Capitals

France, Toulouse, Church of Saint-Sernin (?)
Second quarter of the 12th century
Marble

(A) Height, 24.8 cm. (9¹³/₁₆ in.); width, 28.4 cm. (11¹/₈ in.); depth, 29 cm. (11⁷/₁₆ in.) 09.SP.6

(B) Height, 25.4 cm. (10 in.); width, 27.3 cm. (10³/₄ in.); depth, 27.3 cm. (10³/₄ in.) 09.SP.7

The first capital shows paired rampant lions, alternately confronted and addorsed, on each of the four sides of the block. The animals are violently twisted back, their snouts touching their bent hind legs. A foliate tendril, which divides into a heart-shaped formation in the middle of each side, is imprisoned under the beasts' napes and hindquarters. The extended tips of the notched abacus, deeply undercut, are broken. The very similar capital in the Musée des Augustins in Toulouse (Mesplé, 1961, no. 217) that is part of a series of comparable carvings with crouching and confronted animals is said to have come from the cloister of Saint-Sernin. The cloister was situated on the north side of the church. The dates of its construction are not known, but it must have followed the completion of the nave of the adjoining basilica, toward the end of the first quarter of the twelfth century. It was destroyed between 1804 and 1808. Twenty-three capitals from the monument were acquired by Lucas in 1805, and by DuMège, between 1818 and 1825, for the Musée des Augustins. Two more are in a French private collection in Castres. With the exception of two historiated pieces, and some with vegetal decoration, the capitals were decorated with lions, birds, or confronted monsters (Abrial-Aribert, 1976, 157–74).

The cloister capitals of Saint-Sernin have close stylistic connections with the most advanced sculpture of the basilica: the capitals of the west portals and the single block of the same configuration lodged in the right outer splay of the Porte Miégeville on the south side of the structure. The suggestion of David

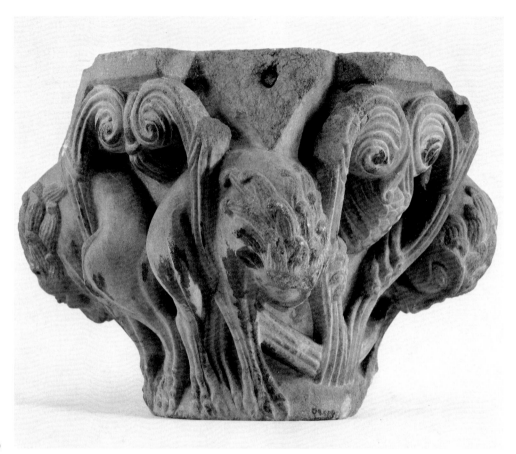

13 (A)

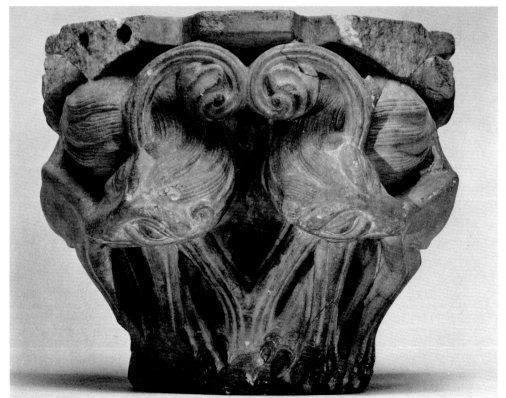

13(B)

70

Scott (1964, 271–82) that the sculpture of this "last" workshop at Saint-Sernin should be identified with the building activity of Raymond Gayrard, who died in 1118, is now generally accepted (Cabanot, 1974, 140 ff.). In addition to the Saint-Sernin cloister, further development of this style is noticeable in the capitals of the cloister of Santo Domingo de Silos.

The second capital (B) is similar to carving (A), although more archaizing in style and less refined in execution. Paired beasts in an addorsed stance are restricted to two sides of the block, while the alternating faces are wholly occupied by the symmetrical convolutions of the foliage. The view of the corner of the carving enables one to reconstruct the path of the bending tendrils, which, in an unbroken state, met over the lions' bodies and were joined to the extended tip of the abacus at the four corners. Traces of this feature also can be observed in the first-mentioned, more accomplished carving (A).

Bibliography: Gómez-Moreno, 1968, no. 26; Cahn, 1977, 71–72, no. 6 (capital A); Cahn, 1977, 72, no. 7 (capital B).

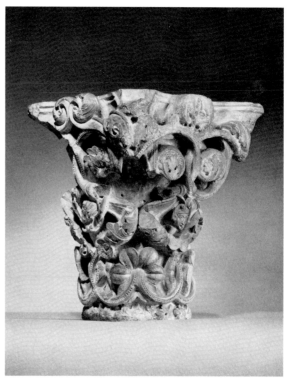

14

14. Capital

France, Abbey of Saint-Guilhem-le-Désert (Hérault)
Last quarter of the 12th century
Limestone
Height, 27.9 cm. (11 in.); width, 24.2 cm. (9 ½ in.); depth, 24.1 cm. (9 ½ in.)
09.SP.106

The monastery of Saint-Guilhem-le-Désert, known in the Early Middle Ages as Gellona, was founded in 804 by Count William (Guilhem) of Toulouse. The church, which was reconstructed in the second half of the eleventh century, was dedicated in 1076. The cloister, located on its southern side, was a two-storied structure laid out in the form of an irregular trapezoid. Damaged in the Wars of Religion of the sixteenth century, it was dismantled in the aftermath of the French Revolution, but the arrangement of both stories is recorded in plans made in 1656 by a monk of the Congregation of Saint-Maur, Dom Plouvier. While the arcades of the ground level were contemporaneous with the Romanesque church, the lighter, upper galleries seem to have been begun in the later decades of the twelfth century. Their existence is first mentioned in the cartulary of the monastery in a charter dated 1205, where they are designated *novum claustrum*. The construction apparently extended over a long period of time, and some of the armorial shields of abbots that were mounted in the spandrels of the arches are datable as late as the beginning of the fourteenth century. Pieces of this remarkable ensemble are now dispersed far and wide. A large group of capitals, columns, and other architectural elements acquired before World War I by George Grey Barnard from Pierre Yon-Vernière, a justice of the peace in nearby Aniane, form the basis of the cloister's partial reconstruction at The Cloisters (Rorimer, 1972, 17–19). Other fragments are in the Musée de la Société Archéologique in Montpellier, at Lodève, Saint-Jean-de-Fos, Saint-Guilhem, itself, as well as elsewhere. Robert Saint-Jean (in Lugand, 1975, 346–54; Saint-Jean, 1976, 45–60) has recently published a new reconstruction of the monument based on a careful study of the Plouvier plans and of the extant sculpture.

The Pitcairn capital, which Henri Revoil illustrated in his influential survey of the Romanesque architecture of southern France (1873), gives a striking demonstration of the artistry of the Saint-Guilhem sculptors. The spiraling and intertwining foliage that covers the surface of the block is deeply undercut and, in places, is worked free from the bell. The carving—of great delicacy and enlivened by a small, naked satyr; a dog biting its hind leg; and, in the midst of a crisscross of tendrils, a detached head—gives the impression of being suspended in front of the relief ground, in an effect reminiscent of goldsmith's work.

Purchased from Henri Daguerre, Paris, March 15, 1920.

Bibliography: Revoil, 1873, III, pl. LVII; Porter, 1923, IX, no. 1403; Saint-Jean, 1976, 51, no. 20.

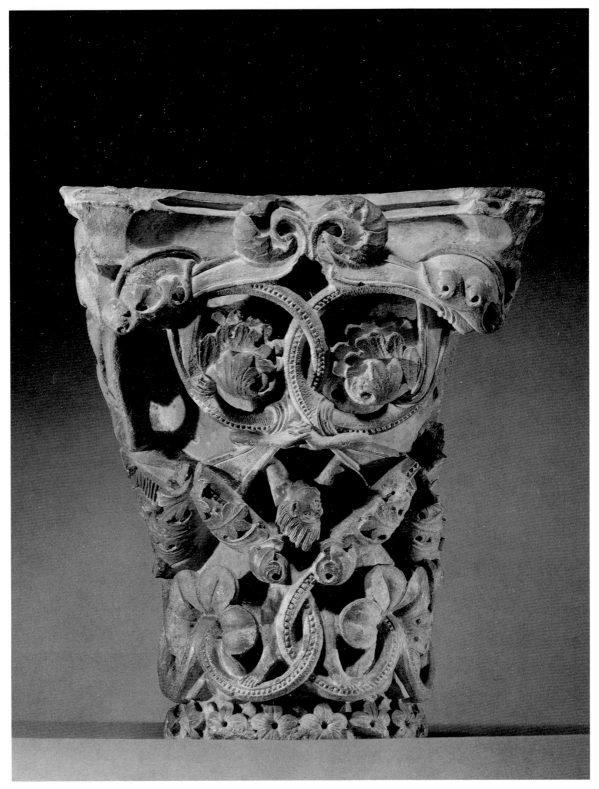

14

15. Capital

Italy (Apulia)
Late 11th or early 12th century
Marble
Height, 38.1 cm. (15 in.); width, 48.2 cm. (19 in.);
 depth, 17.2 cm. (6 3/4 in.)
09.SP.21

This wedge-shaped capital, flat along its broader sides, shows a pair of addorsed griffins squatting back to back. A row of leafy tips forms a border around the base and at the top of the block. The same pattern is repeated in the double rows of feathers on the lower parts of the creatures' wings, which meet the body along a path marked by a pearly band. There is a break at the upper left corner and a much bigger loss on the upper right side. The motif of addorsed fabulous beasts in Apulian sculpture is thought to reflect Islamic sources (Garton, 1973, 100–116). A fragmentary capital in the Pinacoteca Provinciale in Bari, said to have been found in Bari Cathedral, is comparable in design (Bari, 1975, 109, no. 123). A letter in the Pitcairn files, of May 11, 1928, announcing the dispatch to Bryn Athyn, by the dealer Joseph Brummer, of "two columns and capitals from the city of Bari," likely concerns this piece and the lion capital also in the collection (cf. no. 16).

Purchased from Joseph Brummer, Paris, 1928 (?).
Bibliography: Cahn, 1977, 77, no. 17.

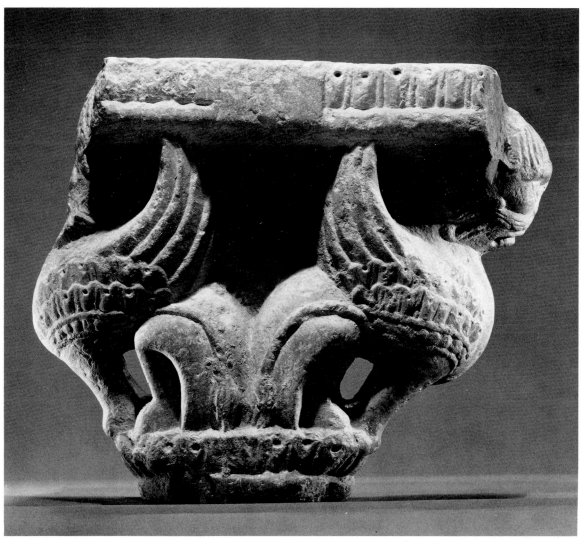

15

73

16. Capital

Italy (Apulia)
Late 11th or first half of the 12th century
Marble
Height, 27.9 cm. (11 in.); width, 40.6 cm. (16 in.);
 depth, 12.6 cm. (5 in.)
09.SP.243

Like the preceding work (cf. no. 15), the design of this capital is of the flat and elongated type common in southern Italy. It consists of two lions seated back to back. One animal is fully preserved; of the other, only the hindquarters remain. The head of the creature, still intact, is turned slightly to one side, with the tongue extending beyond the parted jaws. The mane is rendered as a series of delicately striated locks curling at the extremities. The tail passes under the body, rising against the animal's flank and terminating in a large tuft of hair. The second beast's stance repeated that of the first, in mirror image. Capitals with addorsed pairs of seated lions are found in the outer gallery of Bitonto Cathedral, in the portico of the cathedral of Sessa Aurunca, and elsewhere in the region.

Purchased from Joseph Brummer, Paris, 1928(?).

17. Fragment of a Relief

Western France
Second quarter of the 12th century
Limestone
Height, 53.9 cm. (21¼ in.); width, 26 cm. (10¼ in.); depth, 20.9 cm. (8¼ in.)
09.SP.4

This fragment, said to have come from Parthenay in western France, is the lower section of a slim and long-limbed figure poised with legs crossed on a wavy ground that denotes clouds. The sense of airborne motion is well rendered by the flutter of the irregularly pleated garment, which lies taut against the body but spills beyond it in a supple cascade of folds. A piece

16

74

of apparently unattached drapery visible at the right may belong to the upper part of the garment or to an adjoining figure. The back of the carving is flat. There is some slight surface damage to the drapery and the feet. The figure was, perhaps, Christ, from an Ascension, or one of the accompanying angels in such a theophany group. It is best imagined as an element of a façade composition of separate reliefs, as are commonly found on churches in western France. The fluid and softly modeled contours recall the Virtues on the portal of Saint-Pierre in Aulnay, which are somewhat more schematic in their effect, or the angels in the innermost archivolt of the same ensemble, whose legs are similarly crossed in a suggestion of ethereal movement (Werner, 1979, figs. 205–217).

Purchased from Henri Daguerre, Paris, 1923.

Bibliography: Gómez-Moreno, 1968, no. 23; Cahn, 1977, 70, no. 3.

17

18. Bust of an Apocalyptic Elder

Western France, Parthenay (?)
Mid-12th century
Limestone
Height, 49.5 cm. (19 1/2 in.); width, 43.2 cm. (17 in.); depth, 35.6 cm. (14 in.)
09.SP.93

The church of Notre-Dame-de-la-Couldre stood within the walled enclosure of the citadel of the lords of Parthenay, situated some sixty kilometers west of Poitiers in western France. According to a tradition attested since the seventeenth century, Saint Bernard of Clairvaux celebrated Mass there in 1135 and, on that occasion, won back to orthodoxy Count William of Poitou, who had defected to the side of the Antipope Anacletus II. Of the twelfth-century monument, only the lower section of the façade, with its richly decorated doorway flanked by niches, still stands. These niches harbor the remains of a figure on horseback (left) and of an even more battered fragment, probably from a depiction of Samson overpowering a lion (right). Two nineteenth-century authors of regional histories, Charles Arnauld (1843) and Bélisaire Ledain (1876), also describe a number of pieces of sculpture then on the site. Two capitals from the interior of the church, one of the Sacrifice of Isaac and the other showing the combat of David and Goliath, were acquired by the Louvre in 1925 (Aubert and Beaulieu, 1950, 50–51, nos. 38, 39). A monumental relief of the Adoration of the Shepherds, much restored, entered the same collection a few years earlier (*idem*, 51–53, no. 40), and another large relief showing the Entry of Christ into Jerusalem, also somewhat recut, is in the Isabella Stewart Gardner Museum in Boston (Cahn and Seidel, 1979, 77–80, no. 1b). Finally, there were four reliefs of crowned and haloed men, one of them with a vase, another with a gourd-like attribute. Only the upper parts of the bodies were preserved. These figures, who in all likelihood may be identified as the apocalyptic elders with their vials and musical instruments, also left Parthenay. Two of them, completed and restored by a sculptor named Boutron, are in the Gardner Museum (Cahn and Seidel, 1979, 77–80, no. 1a), while the others, restored in the same drastic fashion, are in the Louvre (Aubert and Beaulieu, 1950, 53–54, nos. 41–42). It is assumed that the Louvre Adoration, the Gardner Museum Entry, and the four elders (with eight additional figures?) came from the upper part of the façade of Notre-Dame-de-la-Couldre. They were placed, perhaps, within a second tier of niches in an arrangement somewhat like that still to be seen in the region, as in Civray.

The Pitcairn relief also has been associated with this ensemble, though this connection is unproven and must be regarded as somewhat problematical. The

block is smaller than the four other reliefs of the elders from Notre-Dame and almost certainly has been trimmed along the bottom. The surface is badly weathered but, luckily, does not appear to have been touched by the restorer's chisel. On first inspection, the pose and details of the form are disturbingly similar to one of the Parthenay torsos in the Louvre (Aubert and Beaulieu, 1950, no. 42), whose prerestoration state is documented, along with that of the other three elders, by the mediocre engravings in Ledain's publication and by old photographs (Bouralière, 1904, pl. opp. 46, rt.). The handsome bearded head is turned at a slight angle to the viewer's right, the right arm is bent at the elbow, and the left forearm seems to have been half raised. A stump just below the right shoulder marks the position of the attribute, a long-

necked vessel held in the right hand. This feature is lacking in the Louvre bust. One aspect of the Pitcairn relief that has no counterpart in the other reliefs is the treatment of the drapery, which falls across the chest in soft catenary curves. This is noticeably at variance with the more rigid system of convex parallel striations defining the garments of the other figures as well as the drapery over the elder's left arm. Is this work a fifth and unrecorded figure in the series from Notre-Dame-de-la-Couldre, or a slightly later carving, by the same workshop, from another project?

Purchased from Henri Daguerre, Paris, 1923.

Ex collection: Charles Joret, Paris.

Bibliography: *Art News*, March 21, 1931, 33; Pijoán, 1944, 257; Cahn and Seidel, 1979, 78.

18

19. Keystone

Western France (?)
Second half of the 12th century
Limestone
Height, 43.2 cm. (17 in.); width, 43.2 cm. (17 in.);
 depth, 25.4 cm. (10 in.)
09.SP.46

At the center of this eight-sided block of stone, with a corresponding number of rib sections, there is an open flower whose ten petals have coarsely studded spines. The flower is surrounded by a wreath composed of interconnected, heart-shaped formations with heavy striated outlines. The ends fan out in the middle of the design to form palmette-like ornaments. The keystone must have capped a vault, set over a square or octagonal bay, perhaps under a crossing tower or in a structure with vaulting of the Angevin type, which was fairly widely diffused in western France. Such Angevin Gothic vaults with eight ribs of equal weight in each bay appeared in Angers toward the end of the twelfth century—in the Hospice Saint-Jean, the transept and choir of the cathedral, and, a little later, in the church of Saint-Serge (Mussat, 1963, 223 ff.). The style of the carving would seem to be a good deal older than the date implied by the rib departures, and it is only conceivable at this time as a flagrant archaism.

Purchased from Joseph Brummer, Paris, November 1, 1926.

19

20. Architectural Frieze

France, Burgundy, Cluny

Mid-12th century

Limestone

Height, 29.2 cm. (11 1/2 in.); width, 55.9 cm. (22 in.); depth, 22.2 cm. (8 3/4 in.)

New York, The Metropolitan Museum of Art, The Cloisters Collection, 1980.263.1

This section of a cornice-like relief comprises an architectural prospect with a variety of structures aligned in a horizontal sequence: an apsidal complex, three turrets with conical roofs, a crenellated tower, a basilican edifice, and another turreted construction. These buildings are both tiled and shingled, and the details of the masonry are attentively rendered. This frieze crowns a continuous file of arches with beaded decoration on their undersides. Each arch houses a large rosette set within a pearly border. On the back of the block, there is a simpler carved decoration of small, coupled rosettes, connected by drilled bands, and below, a set of horizontal moldings. There are two other blocks in the Pitcairn collection with architectural friezes of this kind (09.SP.97, 09.SP.105).

One has the same type of flattened rosettes and is almost certainly another section of the same relief. The second, somewhat longer, may well constitute yet an additional element of the same slab, though in this instance the rosettes are carved in a plastically more assertive way, and they alternate with animal and human heads. A plaster cast of this more elaborate section in the Musée des Monuments Français in Paris, which must have been made some time before the departure of the work from Europe, records Cluny as its place of origin. Finally, the Fogg Art Museum in Cambridge (1949.47.94) and the Musée Municipal des Ursulines in Mâcon possess smaller, fragmentary reliefs with representations of architecture on beaded arches—evidently yet other pieces of this carving.

It has been plausibly assumed that the relief was made to decorate the façade of a private dwelling in Cluny, where it might have been installed above a second-floor gallery. The design has a parallel in a long frieze with beaded arches housing rosettes, geometric designs, and animal roundels, now in the Musée Ochier in Cluny (Aubert, 1930, pls. 182, 1, 183, 2), which also is believed to be from a house in the town. Here, however, the upper zone of the relief is filled with vine foliage and a laboring harvester.

Comparison between the two works also brings out some other important differences. While the relief in the Musée Ochier is stylistically connected with the sculpture of the abbey church of Cluny (Cluny III), which was probably completed about 1130, the fastidiously carved and illusionistic conception of the architectural panorama of the Pitcairn slab must be somewhat later in time. In Burgundy, such a depiction of architecture, with deeply slotted windows and intercolumniations, can be found in the model held by an apostle (now in the Musée Rolin in Autun; Hamann, 1935, 310), said to have come from the refectory of the cathedral of Saint-Lazare in Autun. This relief dates from the middle years of the twelfth century, at the earliest. In the Île-de-France, the representation of architecture, as in the Cluny carving, is paralleled in the townscape of the relief (now in the Louvre; Inv. R.F. 1612) from Carrières-Saint-Denis, most recently dated in the years shortly after 1150.

Acquired from the Glencairn Foundation, Bryn Athyn, Pennsylvania, 1980.

Ex collection: Purchased by Raymond Pitcairn from Lucien Demotte, Paris, January 22, 1923; Pitcairn collection, Bryn Athyn, Pennsylvania (until 1980).

Bibliography: Gómez-Moreno, 1968, no. 29; Cahn and Seidel, 1979, 143; *Not. Acq.*, 1981, 20–21, ill.

21. Head of a King

France, Burgundy, Autun
Second quarter of the 12th century
Limestone
Height, 13 cm. (5 1/8 in.); width, 8.2 cm. (3 1/4 in.); depth, 9.2 cm. (3 5/8 in.)
09.SP.2

This beautiful fragment is a characteristic example of the art of Gislebertus, the famed sculptor of Autun. The head is a gently ovoid volume with softly modeled features, the pupils were drilled to receive lead pellets, and the expression is imbued with the understated air of sweet melancholy that typically informs this master's work. The crown, which has an arcuated form that is also seen on the capitals with the sleeping Magi and with the Adoration of the Kings in the cathedral of Saint-Lazare in Autun (Grivot and Zarnecki, 1961, nos. 11, 12), disappears into the larger mass of the stone from which the carving emerges, at the right side of the head. The surface of the sculpture is somewhat eroded, especially so in the area of the nose and along the left side. A section of the right side of the bearded chin is lost. The fragment possibly once belonged to a capital within Saint-La-

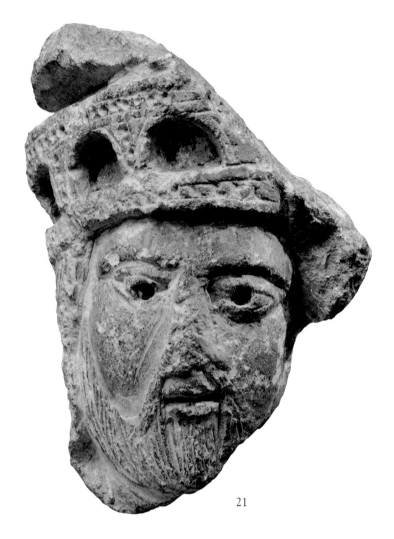

21

zare or to the series of crowned apocalyptic elders that decorated the innermost of the three archivolts of the west portal of the church. These figures were removed and the archivolt pared down in a restoration carried out on the instructions of the cathedral Chapter in 1766. Other heads with crowns, and fragments of the elders' musical instruments, are preserved in the Musée Rolin in Autun (Grivot and Zarnecki, 1961, 32, pl. S 1–6; Stratford, 1976, 59). Saint-Lazare was consecrated in 1130, and Gislebertus's sculpture is thought to have been carried out between 1125 and 1135.

Bibliography: Gómez-Moreno, 1968, no. 22; Cahn, 1977, 70, no. 2.

22. Capital with The Story of Lazarus and Dives

France, Burgundy, Abbey of Moutiers-Saint-Jean (?)
About 1150–60
Limestone
Height, 63.5 cm. (25 in.); width, 27.9 cm. (11 in.);
 depth, 36.8 cm. (14 ½ in.)
09.SP.94

This large capital, which must have crowned the en-
gaged half-column of a compound pier, is devoted to
the story of the evil rich man and the pauper Lazarus,
following the account given in the Gospel of Saint
Luke (16:19–25). On the narrow, left side, an angel
receives the soul of the dying Lazarus, while the bless-
ing hand of the Lord emerges from a band of clouds
above. On the right side, unfortunately much eroded,
the rich man's soul is being seized by demons. While
Lazarus lies alone on the bare ground, the rich man's
demise takes place within a house, with the protag-
onist reclining on a bed, surrounded by his grieving
family. In yet another antithetical juxtaposition, the
major face of the capital shows a diminutive Lazarus
in the bosom of Abraham and the rich man in hell,
belabored by a demon. *Pater Abraham* is framed by
a pair of trees, one planted in the left corner and the
other in the middle of the block. While these trees
mark the boundaries of two distinct episodes of the
story, they also designate the setting as Paradise, fol-
lowing the traditional iconography of other Abraham-

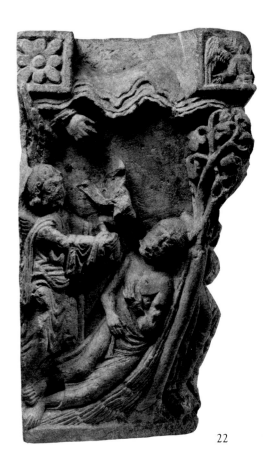

22

15. Fragment of a capital from Saint-Bénigne, Dijon. Mid-12th
century. Limestone. Musée Archéologique, Dijon

Lazarus sculptural groups. The gesture of the rich man,
who points to his mouth, literally interprets the words
that the Gospel (Luke 19: 24–25) lends to the un-
fortunate victim: "Father Abraham, have mercy on
me, and send Lazarus, that he may dip the tip of his
finger in water, and cool my tongue; for I am tor-
mented in this flame." The zone of the abacus is
elaborated in a very distinctive way. In place of the
rosette at the center is an aedicula-like opening in
which a naked figure stands, hands resting on the
upper rim of the bell. The upper left corner is occupied
by an angel who points toward the scene below, and
the crenellated turret at the right appears to be an
appendage to the rich man's house. The narrow face
of the astragal is carved with a frieze of rosettes, which
the sculptor left unfinished. The condition of the
capital is quite uneven. On all three sides, some of
the heads are either completely lost or the faces are
severely abraded. The corners of the abacus are miss-
ing, in part. A diagonal crack, filled with a dark
mastic, runs from the center to the lower left-hand
corner and continues around the entire block.

The same subject is depicted in several monu-
ments in Burgundy. In Vézelay, the story occupies two

80

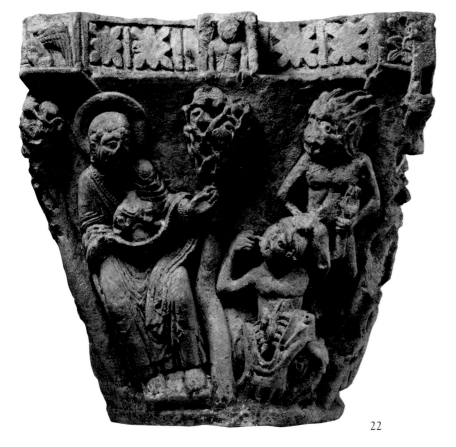
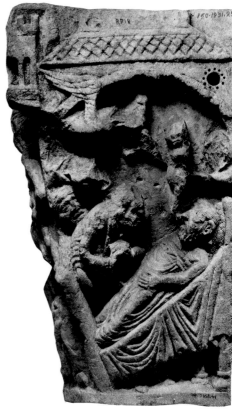

22

capitals within the nave. One is devoted to the feast of the rich man; the other presents much the same sequence of scenes as the Pitcairn capital: the soul of Lazarus is received into heaven; the rich man's death is attended by demons; and Lazarus reposes in the bosom of Abraham, seated between two palm trees (Salet and Adhémar, 1948, 184, no. 21, 190, no. 72). The story is also illustrated on the capitals of the north doorway of Saint-Lazare in Autun (Grivot and Zarnecki, 1961, 146–47) and on a pair of capitals (now in the Musée Archéologique de la Porte du Croux, Nevers; Anfray, 1951, 269) from Saint-Sauveur in Nevers. It is evident, however, that the Pitcairn capital is stylistically more advanced than this group of sculptures, and is best associated with the mid-century transition from Romanesque to Early Gothic in Burgundy. A fragmentary capital from Saint-Bénigne in Dijon with two bearded figures (fig. 15) matches the conception of form embodied in the depiction of Abraham in the Pitcairn carving. As Neil Stratford has observed, the dimensions of the Pitcairn block and the capitals of another Burgundian church, Moutiers-Saint-Jean (now destroyed), are nearly identical. The bulk of the sculpture from Mou-

tiers—presently divided between the Louvre, the Fogg Art Museum, or still at Moutiers and in its environs—also antedates the Pitcairn capital, remaining firmly anchored within an older style that is related to the sculpture of Autun. Work continued at Moutiers through the middle of the twelfth century, when the triple portal of the church, illustrated in an engraving in Dom Urbain Plancher's *Histoire générale et particulière de Bourgogne* (1739), must have been carved. The engraving is not sufficiently accurate to permit reliable comparisons and, thus far, only a small fragment of this ensemble has come to light (Paris, private collection). Yet, as the engraving shows, the large capitals below the arch that frames the central doorway have abaci with rosettes at the center and in the corners of the block, and the one on the left includes a scene within a house with a lean-to roof quite like the structure depicted on the left side of the Pitcairn capital.

Ex collection: Ambrose Monell, Tuxedo Park, N.Y. (until 1930).

Bibliography: Monell sale cat., 1930, no. 36; *Art News*, November 1, 1930, 4; *idem*, December 6, 1938, 22.

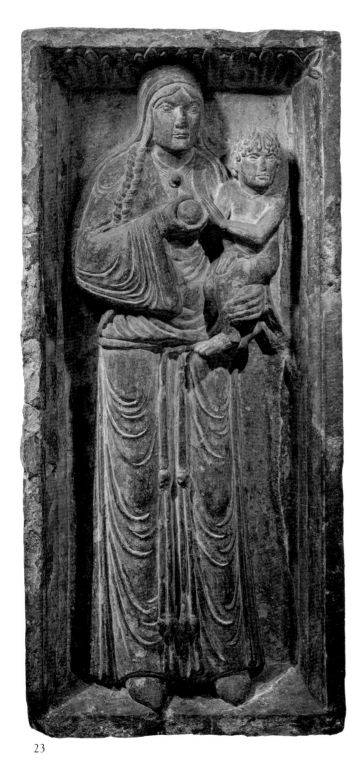

23

23. Relief with The Fast of Saint Nicholas

France, Metz, Saint-Gengoult
Second half of the 12th century
Limestone
Height, 115.5 cm. (45 ½ in.); width, 52.1 cm.
 (20 ½ in.); depth, 24.1 cm. (9 ½ in.)
09.SP.90

This relief was formerly mounted in a wall in the courtyard of a private house in Metz, located on the site of the parish church of Saint-Gengoult, which was closed in 1798 and demolished some time thereafter. The shape and composition of the quadrangular block, which shows a standing woman offering her breast to her child, are reminiscent of funerary sculpture. The ground of the relief is recessed within a heavy frame, whose inner edges are cut on a slant. Along the two vertical sides, these beveled inner edges have an articulated molding. The carving on the upper horizontal strip is of acanthus foliage and a triple-leafed plant fills the corners. There is some damage to the outer edges of the frame. The lower edge was left unworked. A large hole and a rectangular groove were cut into the right side, presumably for installation purposes.

The sluggish forms of these figures and their bulging garment folds are comparable to the large reliefs installed on the buttresses of the apse of the cathedral of Verdun, which was constructed in the eleventh century, remodeled after 1132, and newly consecrated by Pope Eugenius III in 1147 (Müller-Dietrich, 1968, 52 ff.). The style of the Pitcairn relief is also closely echoed in another Late Romanesque carving from the region, the curious pilgrim couple from Belval (now in the Musée Historique Lorrain in Nancy; Müller-Dietrich, 1968, 114–19).

The subject of the Metz relief was long thought to be the nursing Madonna (*Virgo lactans*), but, as pointed out by Kurt Bauch, several features speak against this identification. There is no nimbus. The woman's long tresses are entwined with a ribbon and her full-length robe is tied at the waist with a corded sash. The figure, indeed, appears to be a high-born, secular personage. The child, who is entirely naked, modestly covers the lower part of his body with one hand and seems to reject the proffered nourishment with the other. These details point to an episode in the story of Saint Nicholas, who, as an infant, demonstrated his precocious piety by accepting his mother's milk only once each Wednesday and Friday. This story inspired a number of representations in twelfth-century sculpture. As indicated by Virginia Wylie Egbert (1964, 64–70), it is the subject of a column statue from Saint-Maur-des-Fossés, as well as of cloister statues from Châlons-sur-Marne, Sant'Ellero in Galeata, and San Bartolomeo in Ancona (Pressouyre, 1973,

77). Bauch notes that the church of Saint-Gengoult was located only a short distance from the Hospice Saint-Nicolas, apparently founded in the time of Bishop Bertram of Metz (1170–1202), and surmises that the relief may have come from that institution.

Purchased from Lucien Demotte, Paris, 1924.

Bibliography: Lorrain, 1874, 107; Kraus, 1888, 17; *idem*, 1889, 692–95; Vöge, 1899, 94 (reprinted 1958, 139); Wolfram, 1905, 62; Keune, 1907, 150; Dehio, 1911, 269; Staatsmann, 1911, 103; Boinet, 1922, 78; Beenken, 1924, 200; Schürer, 1944, 64; Vloberg, 1954, 69; Hotz, 1965, 126; Schmoll gen. Eisenwerth, 1965, 91; Meiss, 1967, 126–27, fig. 453; Müller-Dietrich, 1968, 103; Bauch, 1970, 13–14; Pressouyre, 1973, 77.

24. Border Section, from The Life of Moses Window (?)

France, Abbey of Saint-Denis
About 1144
Pot-metal glass
Height, 48.4 cm. (19 1/16 in.); width, 20 cm. (7 7/8 in.)
03.SG.181

Bouquets of green, murrey, yellow, and light blue leaves on a red field are enclosed by a white ribbon of painted pearls, set against a blue background. The piece is in excellent condition, with very few replacements, and is the only extant example of this border in which the complete design has been preserved.

The choir of the Abbey of Saint-Denis on the outskirts of the modern city of Paris was rebuilt between 1140 and 1144, in the time of Abbot Suger. In his treatise describing the work accomplished during his administration, Suger mentioned several of the stained-glass windows of the new choir, including one devoted to the Life of Moses. The original scenes from this window that still exist in the choir are now surrounded by a copy of this border made by Alfred Gérente during the restoration of the church in 1852. That this border section came from Saint-Denis is ascertained by an engraving of the design published by Charles Cahier and Arthur Martin in 1841–44 (II, pl. D, b) before the restoration began. That it belonged originally to the Life of Moses window is less certain, since three of the choir windows now duplicate its design (CVMA, 1976, 129–30). (One of these borders even contains modern glass interspersed with the original.) The attribution of this border to the Moses window is based on the exceptional width of the section, since it would have been too wide to have been accommodated in either of the other two windows as reconstructed by Louis Grodecki (CVMA, 1976, 103–5). Nothing is known of this fragment between the time that it was removed from the abbey in 1799 during the French Revolution and

24

its purchase at an unknown date in the twentieth century by Raymond Pitcairn.

The width of this border and its vertical orientation of centrally grouped rather than continuously repeated elements are characteristic of stained-glass ornament in the mid-twelfth century. Twelfth-century windows with similarly composed borders are found in Angers, Poitiers, Chartres, and Strasbourg. The bouquet, or palmette, enclosed by a knotted ribbon or strap, either repeated or opposed as in this example, was one of the most common and widely used ornamental motifs in the twelfth century. It was neither restricted to geographical area nor to medium, and appears both in England and in France on sculpture, metalwork, and in manuscripts, as well as in stained glass. In general, the distinguishing feature of this border and ornament from Saint-Denis is its exceptional richness. Within the ribbon, pearls alternating with tiny pierced beads are incised in the paint. Where strands of ribbon intersect, they are caught with button rosettes. The undersides of the leaves have beaded veins or cross-hatching peculiar to foliate ornament at Saint-Denis from the time of Suger. These stylistic features are also found in the sculpture and the metalwork at Saint-Denis (*Saint-Denis*, 1981, nos. 2, 6, 25, 27).

Only one other border design known from Saint-Denis has both the width and the complexity of this example. The actual piece has since disappeared but its full-scale design is known from a tracing made in the course of the abbey's restoration (CVMA, 1976, ill. 198). The drawing indicates a double ribbon caught by button rosettes, and bouquets of foliage, that virtually repeat those of this border section. The details of their design are so similar, in fact, that they must have been executed by the same master, further suggesting that this master painted other windows for the choir that have since disappeared. The tracing, like the border section from which it was made, indicates a type of design that is found elsewhere in the twelfth century, as at Angers.

The origins of this richly ornamental style may stem from the Rhineland and the Meuse Valley, where the tradition of fine metalwork employing these techniques was well known even in Suger's time (Crosby, 1966, 24–27). That the master who made the Moses window and this border was familiar with such techniques is exemplified by his use of ornament. His work elucidates the cross-fertilization of style that took place at Saint-Denis among the masters called by Suger from many different regions to create his new church.

Bibliography: Cahier and Martin, 1841–44, II, Mosaïques, Bordures, pl. D, b; Westlake, 1881, I, pl. XII; Gómez-Moreno, 1968, no. 175; CVMA, 1976, 129, ill. 209; *Saint-Denis*, 1981, no. 15.

see colorplate II

25. The Flight into Egypt, from The Infancy of Christ Window (?)

France, Abbey of Saint-Denis

About 1145

Pot-metal glass

Height, 52 cm. (20 1/2 in.); width, 50 cm. (19 3/4 in.)

03.SG.114

Against a red background, the Virgin, in a long blue veil and a green gown, holds the Child Jesus, who wears a white dress and a murrey mantle. They are seated upon a white donkey led by Joseph, dressed in a yellow tunic and boots and a blue mantle and cap. Details of the setting are indicated in blue, green, and white glass.

Both the authenticity and the provenance of this panel have been questioned (CVMA, 1976, 67). Recent scientific tests have indicated, however, that the glass in the panel compares with genuine pieces from the Infancy window (*Saint-Denis*, 1981, 81). A study of the style and iconography of the panel in comparison to the Infancy window of Chartres led Michael Cothren to conclude that the panel is original (1978, 74–75), while other observations (*Saint-Denis*, 1981, 78–81) suggested that it was a fragment completed with old glass.

Evidence for the fragmentary condition of the panel prior to its restoration has been based on differences in the color of the paint on various pieces of glass; incongruities of costume, such as the long blue veil of the Virgin (it is usually shorter, and white); the unusual iconographic feature of the palm tree; and the stylistic variations in the drawing of features, particularly the eyes, which appear more characteristic of the Charlemagne panel (no. 28) than like those of the Infancy shop (*Saint-Denis*, 1981, 81).

A second problem in accepting the Flight into Egypt as original in its present form is its placement in the window as it existed before the restoration of the nineteenth century. Only three of the scenes in the window now contain twelfth-century glass; the rest date from the nineteenth-century restoration. In restoring the window, Viollet-le-Duc, architect-in-charge, followed the arrangement of alternating round and square panels in the Infancy window of Chartres, which, together with the Tree of Jesse window, resemble—and are thought to have been modeled on—the windows at Saint-Denis. Recently, Grodecki has discovered a number of original scenes from the Saint-Denis Infancy window, which were dispersed in the nineteenth century, in collections in England and in France. These finds have permitted him to reconstruct the window as clusters of scenes rather than as an alternating pattern of round and square panels, as at Chartres (CVMA, 1976, 89–92). Grodecki believes that the original Flight into Egypt is the fragment now

in the Wilton Parish Church in England. Cothren (1978, 74–75) has modified Grodecki's reconstruction into a symmetrical arrangement of clustered scenes, more usual in twelfth-century windows, placing the Pitcairn panel in the central rectangle of the uppermost cluster of scenes (cf. fig. 16).

Both Grodecki and Cothren have noted comparisons between the compositions of individual scenes at Saint-Denis and in Chartres. Grodecki has suggested that the Arrival of the Magi at Herod's Court (*Saint-Denis*, 1981, no. 11) had as its pendant the Departure of the Magi, an arrangement that was copied later in Chartres. Cothren believes that the same duplication of scenes accounts for the two versions of the Flight into Egypt at Saint-Denis. In his opinion, the Pitcairn panel is the actual Flight, while the Wilton fragment is the Entrance of the Holy Family into the City of Sotine, mentioned in Pseudo-Matthew XXII, and both shown in Chartres.

Possible extensive restoration of the Pitcairn panel was noted in the "Saint-Denis" exhibition catalogue (1981, 78). Prolonged examination of the panel has indicated that this restoration is more extensive than originally thought. It now appears that only the skirts and the feet of the Virgin and Child; the body of the donkey, the background between his legs, and the mounds of earth beneath his feet; as well as the right foot of Joseph, and the cloud above his head, are original. Yet, these fragmentary remains, in style and composition, virtually duplicate, in reverse, those of the Wilton panel. Even as a fragment, this scene could not have been anything other than a Flight into Egypt. Cothren's thesis should, therefore, be accepted in principle, but his reconstruction should be questioned. In Chartres, the Massacre of the Innocents precedes the Flight. Nothing remains of this subject at Saint-Denis except the Dream of Joseph, sections of which are still in the Infancy window. Grodecki (CVMA, 1976, ill. 100) has postulated that the fragment in Wilton is Joseph at the entrance to the Temple. If the reconstruction, as proposed (fig. 16), is correct, the Pitcairn Flight, with Joseph situated behind the neck of the donkey, as in Wilton, would have occupied the angular space at the top left corner of the window, with the Wilton Arrival at Sotine directly opposite on the right. Grodecki has already identified another fragment in Wilton as the People of Sotine at the gates of their city—as they also appear in Chartres. The top central panel at Saint-Denis, however, would have been circular, rather than rectangular as it is in Chartres. The original circular edge on the right of the Wilton panel, in fact, is still visible (CVMA, 1976, ill. 102), while the city that would have completed the circle has been reduced to a few random pieces. Since the Sotine panel has been accepted as part of the Infancy window, the Wilton Flight, because of its orientation, thus must be interpreted as the Arrival of the Holy Family,

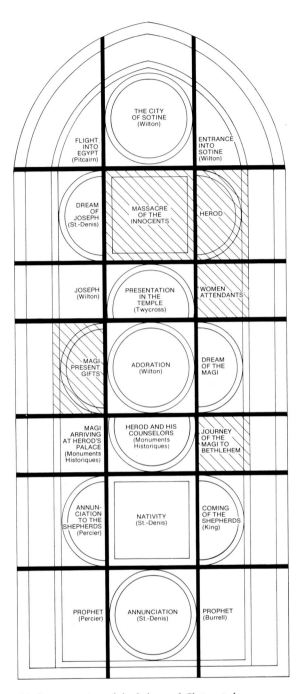

16. Reconstruction of the Infancy of Christ window, choir, Abbey of Saint-Denis

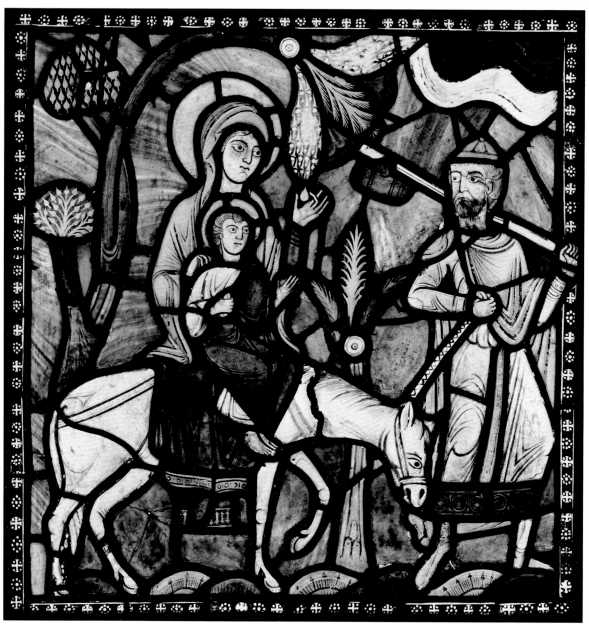

25

and the Pitcairn panel as the original Flight—albeit a fragment.

Nothing is known about the present panel prior to its purchase in 1930 from Lucien Demotte. When pressed for a provenance on the panel, Demotte claimed that the owner, whose name was never revealed, was not a dealer and had no interest in works of art. Demotte, himself, believed that the glass might have come from Saint-Denis.

Although not mentioned by Suger, the Infancy window is described in accounts of the abbey from the sixteenth century onward. The lower portion of the window was included in the drawing made by Charles Percier in 1794–95 (Saint-Denis, 1981, fig. 19). This was before the removal of the choir windows from Saint-Denis—toward the end of the Revolution, in 1799—by Alexandre Lenoir, for inclusion in his newly created Musée des Monuments Français in Paris. Unfortunately, little of the glass was installed in the museum; most of it was broken in transit. Lenoir sold a number of panels to the English dealer John Christopher Hampp in 1802 (CVMA, 1976, 66–67). The fragmentary condition of these pieces is shown in drawings made by the glass historian Charles Winston prior to 1840 (Saint-Denis, 1981, fig. 29). Other fragments probably never left the abbey but, instead, remained there in storage to be utilized later in the restoration of the church, conducted by Viollet-le-Duc, that began in 1847 (Saint-Denis, 1981, fig. 20 a,b,c). Viollet-le-Duc's glaziers, in charge of the restoration of the windows, were Henri Gérente (who died in 1849 before the work had progressed very far) and his brother, Alfred. A considerable amount of scrap glass and, evidently, some panels, as well (CVMA, 1976, 109 n. 16), were sent to Alfred Gérente's workshop in Paris to aid in the restoration. It was, perhaps, there that the architect Just Lisch made tracings of the panels (Saint-Denis, 1981, fig. 20 a,b,c), including two borders now in the Pitcairn collection (03.SG.33, 03.SG.22). Alfred Gérente rarely used the old glass except in the case of the border patterned on that of the Moses window (no. 24). The contents of his shop as well as any glass that might have remained in storage at the abbey have never been found, except for one panel, for which Lisch made a tracing, that was purchased for the Musée de Cluny in 1958. Its last private owner was a descendant of Alfred Gérente (CVMA, 1976, 109).

Cartoon drawings made by Alfred Gérente for the restoration of the windows at Saint-Denis (Saint-Denis, 1981, fig. 21) were purchased by Raymond Pitcairn from the French dealer Michel Acézat in 1925. Acézat was both a collector and an excellent restorer of old glass (the sale of his collection in 1969 included twenty boxes of old glass). Although unprovable, it is possible that Acézat restored the Flight into Egypt with glass obtained, like the drawings, from the heirs of Alfred Gérente. Acézat was quite capable of copying the Saint-Denis style and of reusing old glass, but he could not have known in 1930 that Viollet-le-Duc's reconstruction of the Infancy window was incorrect. He, therefore, completed the fragment of the Flight into Egypt according to the size and rectangular format of the Nativity in the central tier.

Demotte's reputation for "completing" medieval works of art was well known but his restorations of stained glass were often of poor quality. He was also well aware of Raymond Pitcairn's special interest in Saint-Denis, having accompanied him on a visit to the church in 1922. In 1930, Raymond Pitcairn had not acquired anything from Acézat for several years, but Demotte was still actively engaged in adding to the collection in Bryn Athyn, though cognizant of the dwindling American art market. It is tempting, therefore, to speculate that the Flight into Egypt, like the Gérente drawings, was the property of Acézat. In support of this idea, only four months after the sale of the Flight into Egypt, Demotte unsuccessfully offered Raymond Pitcairn a Cistercian panel, bought by the French government at the sale of the Acézat collection.

Purchased from Lucien Demotte, Paris, January 14, 1930.

Ex collection: Michel Acézat, Paris (?).

Bibliography: Demotte, 1932, 307–8; Cothren, 1978, 74–75; Saint-Denis, 1981, no. 13.

26

26. Border Section, from the Saint Benedict Window

France, Abbey of Saint-Denis

About 1145

Pot-metal glass

Height, 35.3 cm. (13 7/8 in.); width, 15 cm. (5 7/8 in.)

03.SG.33

Bouquets of alternating yellow and pink leaves on a blue field are surrounded by a white, leafy vine on a green background. The edge fillet is blue.

That this border belonged to the Saint Benedict window at Saint-Denis can be verified from several sources. It is included in the drawing of the window (*Saint-Denis*, 1981, fig. 19) that Percier made in 1794 when the glass was still *in situ*. A fragment of the border is still attached to a scene from the window, now in the Musée de Cluny (*Saint-Denis*, 1981, no. 17), that was purchased from the heirs of the restorer of the glass, Alfred Gérente (cf. no. 25). In addition, this border section was included in the tracings of glass from Saint-Denis made about 1849 by Just Lisch (*Saint-Denis*, 1981, fig. 20b), at the time of the restoration of the windows, when the border was either still at the abbey or transferred to the Gérente workshop. Several other sections of the border have been identified, one fragment of which is also in the Pitcairn collection (03.SG.190), purchased from Bacri Frères in Paris in 1923 (Gómez-Moreno, 1968, no. 177). Other pieces are in a private collection in Paris (CVMA, 1976, ill. 203) and in The Cloisters (unpublished). The Pitcairn accounts mention neither the source of this border section nor the time of its purchase.

The panel is in excellent condition, with only three replacements in the background. Unique among the border fragments that have been preserved from the Saint Benedict window, it has retained the blue fillet of its outer edge, though the white pearled band that once separated it from the scenes within the window has disappeared. The slight curve at the upper left-hand corner ascertains the original location of this border section in the Saint Benedict window, since it defines the beginning of the arch at the top of the stone frame in which the glass was set. The border would, in fact, have been adjacent to the scene now in the Musée de Cluny, its design continuing the segment in the upper left corner of the panel. Almost no paint losses are observable in this border. Its state of preservation is, in fact, remarkable, with a light but even patination covering its exterior surface. In the twelfth century the chapel of Saint Benedict was located in the crypt at Saint-Denis where its windows were more protected from the elements than those of the choir above, perhaps accounting for the excellent condition of this glass.

The design of the present border is simpler than those of the choir windows, yet there is no reason to doubt that the panel was installed at the dedication of the rebuilt choir, or shortly thereafter. Grodecki, in his first publication of the Saint Benedict window (1958, 161–71), noted stylistic differences that he explained by attributing the window to a different atelier from the one that had executed the glass in the other choir windows. In this border, the direction of the motifs is continuous rather than centralized, as in the border of the Moses window. Each palmette is enclosed by a vine stem from which curling leaves sprout. The interior bouquets are symmetrically arranged, with two pairs of leaves alternating in color from one cluster to the next. Motifs are connected by a looped knot in the vine. Predominantly cool colors in the border and in the scenes contrast with the brilliant red of the background of the window. The painting technique is less elegant than that of the Moses border and the leaves are somewhat stiffly drawn. While the Moses border is stylistically similar to metalwork of the twelfth century, the Saint Benedict window is closer to the painterly style of manuscript illumination. The pearls on the undersides of the leaves are not overpainted with mat as they are in the Moses border, so that the curvilinear effect of these leaves is lessened in much the same way that the schematic design of the drapery flattens the figures in the Saint Benedict window scenes (CVMA, 1976, ills. 145, 150, 151, 153, 155, 158).

Bibliography: Cahier and Martin, 1841–44, II, Mosaïques, Bordures, pl. L., 13; Gómez-Moreno, 1968, nos. 176, 177; CVMA, 1976, 112–14, 127, ill. 203; *Saint-Denis*, 1981, no. 18, figs. 19, 20b.

27. The March of the Christian Army, from the First Crusade Window

France, Abbey of Saint-Denis
About 1150
Pot-metal glass
Diameter, 50.1 cm. (19 3/4 in.)
03.SG.156

Against a blue background, soldiers wearing green, red, pink, and yellow chain mail—and mounted on green, pink, and white horses—surround a king dressed in a green robe, murrey mantle, and gold crown, who rides a white horse. Above their heads floats a green and white dragon and beneath the feet of the horses are green and yellow hillocks. The inscription, I/VIP/IAN/VSIN, is indecipherable.

Dom Bernard de Montfaucon, whose *Les Monumens de la Monarchie françoise*, published in 1729, records so many lost monuments of French art, was the first to mention a window describing the First Crusade in the choir of Saint-Denis. As early as 1721, however, the drawings from which the plates in his book were made had already been prepared, and included ten scenes from the Crusade window. Unfortunately, the Pitcairn panel is not among these drawings, but Grodecki (CVMA, 1976, 117) has estimated that, based on the size of the choir apertures and the diameter of the panel, the window originally would have contained four scenes in addition to the ten that are illustrated. One scene from the window was mentioned by Alexandre Lenoir, who was responsible for dismounting the glass at Saint-Denis and who illustrated the scene in his book (1818, 30, pl. XXIII). Unfortunately, neither author mentions the chapel in which the window was installed, but Grodecki believes that it occupied either the first radiating chapel on the north side of the choir or its pendant on the south.

The earliest record of the Pitcairn panel comes from an engraving, published by Ferdinand de Lasteyrie (1857, II, pl. III), of the two windows containing original glass that were reinstalled in the choir in 1833 following the closing of Lenoir's museum. The scene is shown in the lower right-hand corner of the engraving (*Saint-Denis,* 1981, fig. 27). Lenoir, apparently, did not use the panel in his museum nor did Viollet-le-Duc reinstall it in his restoration of the choir in 1847. It is now known, however, from a drawing by Alfred Gérente, newly discovered in the Pitcairn collection (fig. 17), that the panel was probably sold from the Gérente atelier rather than having been retired to storage at Saint-Denis, as the only surviving panel of a lost window. The more recent history of the panel begins in 1923 when it appeared in the sale of the collection of Léon-Joseph-Florentin Bonnat, who had been a prosperous academic por-

17. Alfred Gérente. *The March of the Christian Army.* Cartoon drawing of 12th-century stained glass from the First Crusade window, choir, Abbey of Saint-Denis. About 1855. Brown and black ink on paper. Height, 67 cm. (26 3/8 in.); width, 65.4 cm. (25 3/4 in.). Glencairn Museum, Bryn Athyn, Pennsylvania, 07.DR.273

traitist of considerable reputation in Paris since the 1870s, and was named director of the École des Beaux-Arts early in the twentieth century. Since Bonnat was over eighty years old at the time of his death in 1922 (he was born in 1833), he could have been the first private owner of the panel. Though Raymond Pitcairn was offered other glass from the collection soon after the sale, he was told that the "Horsemen"—which he must have recognized from his own copy of de Lasteyrie—was lost. In 1934, Lucien Demotte informed Raymond Pitcairn that the Paris dealer Dikran Kelekian had bought the "Horsemen," but it was not until 1937 that the Crusade panel finally came to Bryn Athyn. It is one of the few pieces in the collection whose history can be traced in such detail— and it was also one of the last pieces of stained glass ever purchased by Raymond Pitcairn.

Though the figure of the king, his horse, and the lower edge of the panel including the inscription are considerably restored—probably by François Debret, since the insertions appear in the plate published by de Lasteyrie, showing Debret's installation—the panel still retains its original composition. The size of the roundel is smaller than others from the choir at Saint-Denis, which has led Grodecki to propose that the window originally contained a double column of scenes rather than a single row, like the Life of Moses window. Grodecki has based his reconstruction of the Crusade window on the engravings of Montfaucon— which show two truncated roundels that would have

90

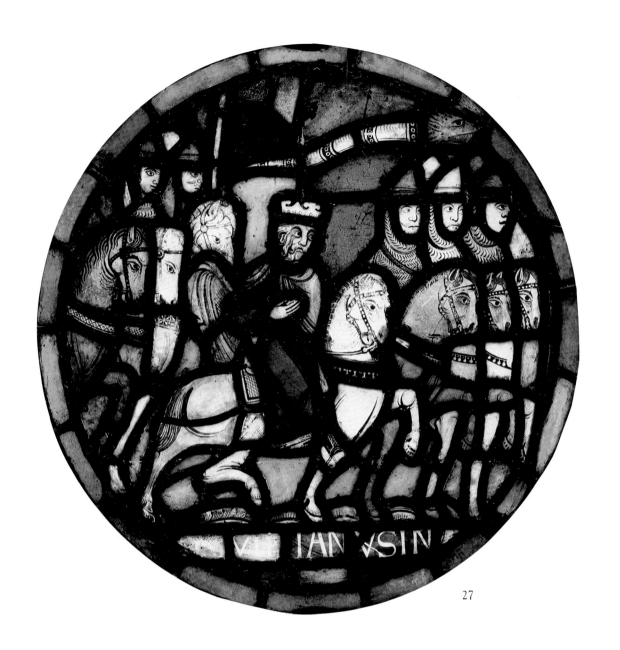

IANVSIN

27

been placed, side by side, in the arch at the top of the aperture—and on the sketches of Percier, which, he believes, reproduce this arrangement.

The scale of the Pitcairn roundel, the crowding of the figures, and the symmetrical composition are all characteristic of the scenes from the Crusade window drawn from Montfaucon. Other similarities can be noted in the costumes of the knights and the trappings of the horses, as well as in the hillocks in the foreground. Although there is little doubt that the roundel once belonged to the Crusade window, its subject cannot be defined with certainty because of the loss of the inscription and because of the other restored parts. Since most of the Montfaucon scenes refer to later incidents in the history of the Crusade, it is probable that this scene illustrates an early event in the story. Grodecki has suggested two possibilities: the march of the Lotharingian crusaders under the leadership of Godfrey of Bouillon, or the march of the Christian Army across Asia Minor. Neither of these incidents, however, explains the presence in the panel of the heavily restored king, and the dragon in the sky above the army (CVMA, 1976, ill. 177). According to the eyewitness account of the First Crusade, written in 1112 by Ekkehard of Aura (Krey, 1921, 47), a legend invented at the time when the armies were being assembled reported that Charlemagne had risen from the dead to lead the march. Since the Carolingian church at Saint-Denis had been dedicated in the emperor's presence and, in Abbot Suger's time, still contained relics of the Passion supposedly brought from the Holy Land by Charlemagne himself, it is highly unlikely that Suger would not have had this legend included in the window. If this is the incident that is depicted in the panel, the central king would have been Charlemagne himself, since, historically, no other king took part in the Crusade. The place of the dragon in the panel, however, suggests another aspect of the Charlemagne legend that states that the emperor placed the golden banner of Saint Peter, which he had received at his coronation from the Pope, on the Holy Sepulcher in Jerusalem (Erdmann, 1977, 41–42, 195). The dragon, therefore, might have supplanted the royal banner in the original glass.

When and why the First Crusade window was installed in the choir at Saint-Denis provides additional evidence for this interpretation of the subject of the roundel. Saint-Denis was not only the burial place of the French monarchy but also the keeper of the royal crowns and the sacred flag carried into battle by all French kings. As the royal abbey, Saint-Denis was accorded special revenue privileges by the crown. By including this historical window and its pendant, the Pilgrimage of Charlemagne, in the iconographic program of the choir, Suger had hoped to foster the close ties between the abbey and the monarchy. Of all the windows, these two were the most directly linked to this relationship, serving as historic reminders of the role of the French kings as protectors of the abbey. In 1147, just three years after the choir was consecrated, Louis VII accepted the sacred battle standard from Suger's own hand to carry in a Second Crusade to free the Holy Land. It is obvious that the Crusade window was propaganda for this endeavor and that the window was installed shortly after the king's departure.

There is little doubt that this panel was part of the twelfth-century glazing of the choir, or that it is a later work of the Infancy master's shop, whose short figure type with large globular eyes is exemplified by the warriors. Another distinctive quality of this shop that can also be seen in this panel is its use of color. A scene of riders on horseback, all dressed in the same type of armor, could be monotonous, but the master who designed this panel constructed each horse in the group, and its rider, from different colors of glass. The scene is, therefore, animated by small spots of color, a technique that is repeated in the foreground of the panel. The groundline is composed of small hillocks painted with foliage patterns, as was the case in the Flight into Egypt (no. 25). The change in scale is a new element in the Crusade panel. Whereas, in the Infancy window, each scene had only a few figures, in the roundels depicting the Crusade many figures are included. This latter condition was undoubtedly dictated by the subject matter, but the way in which the scenes were composed is an indication of the artistry of the master. In the Pitcairn roundel the warriors are clustered in tight groups in which a single action is repeated. Isolated between two similar groupings of soldiers is the single figure of the king—or, rather, Charlemagne—who thus assumes importance in the scene. The resulting balance achieved is a compositional device characteristic of this workshop.

Purchased from Dikran Kelekian, Paris, May 20, 1937.

Ex collection: Léon Bonnat, Paris (until 1922).

Bibliography: CVMA, 1976, 115–21; Saint-Denis, 1981, no. 20.

28. A Triple Coronation, from The Pilgrimage of Charlemagne Window

France, Abbey of Saint-Denis
About 1150
Pot-metal glass
Diameter, 52.3 cm. (20 5/8 in.)
03.SG.111

Against a blue background, three groups of three crowned figures are seated upon white thrones with red cushions. The central and lateral groups are dressed in green, yellow, white, and murrey robes.

In his history of the French monarchy, published in 1729, Montfaucon included, in addition to scenes from the First Crusade, two other scenes that he said came from a Life of Charlemagne window in the choir of Saint-Denis. The drawings made for these engravings are the earliest record of the existence of this window. Percier's sketch of 1794–95 (*Saint-Denis*, 1981, fig. 19), difficult to interpret because of its hasty execution, records two windows in the choir that Grodecki (CVMA, 1976, 115) believes are these two historical windows; he has deduced that they filled one of the two end chapels of the ambulatory. The Triple Coronation panel in the Pitcairn collection was first published by de Lasteyrie in 1857 (II, pl. III), and again by Charles-Jules Labarte in 1864 (I, 318). Like the First Crusade panel, it is shown with other twelfth-century glass that was leaded into the two windows of the chapel of the Virgin by Debret in 1833. Though not included by Lenoir in his museum, the panel was removed by him in 1799 and was probably returned to Saint-Denis when the museum closed in 1816. The panel was not reemployed in the restoration of 1847 by Viollet-le-Duc because his reorganization of the glass was based on the writings of Abbot Suger, in which these windows are not mentioned. Since a drawing of the piece by Alfred Gérente (fig. 18) was recently discovered in the Pitcairn collection, the panel probably found its way from the Gérente atelier in Paris to the art market. Its first owner may have been Léon Bonnat, in whose possession it remained until 1923, when the Parisian art dealer Augustin Lambert bought most of the collection and, the same year, resold it to Raymond Pitcairn.

The roundel is in an excellent state of preservation except for two of the groups of heads, whose restoration may indicate the whereabouts of the panel

18. Alfred Gérente. *A Triple Coronation.* Cartoon drawing of 12th-century stained glass from the Pilgrimage of Charlemagne window, choir, Abbey of Saint-Denis. About 1855. Brown and black ink on paper. Height, 66.2 cm. (26 1/16 in.); width, 67 cm. (26 3/8 in.). Glencairn Museum, Bryn Athyn, Pennsylvania, 07.DR.272

between the time that it was removed by Viollet-le-Duc and its acquisition by Bonnat. A virtual duplicate of the roundel in reverse is in the Museo Civico in Turin, Italy (CVMA, 1976, ill. 180). It was purchased in Florence in 1888. Except for the group of heads on the right, the panel is made of modern glass. The central group of heads in the Turin panel, however, is quite different from that of the Pitcairn roundel, which Grodecki believes to be an old restoration. These heads must have been restored before the panel was installed by Debret, since they are shown in the de Lasteyrie plate. The central group of heads at Turin, on the contrary, is clearly in the style of the modern windows at Saint-Denis that were made by Alfred Gérente. It seems logical to suppose, as Grodecki does, that the Pitcairn panels were taken by Gérente to his shop in Paris, as the Pitcairn drawing proves, where the Turin panel was made and the original heads from the right side of the Pitcairn roundel were inserted.

Since only the one panel of glass from the Charlemagne window and the two engravings in Montfaucon remain, the iconography of the scenes is dif-

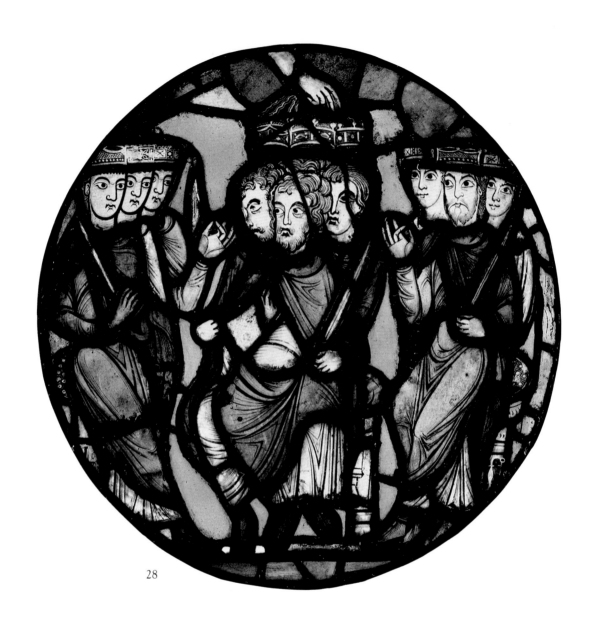

28

ficult to interpret. According to their inscriptions, the Montfaucon illustrations depict the arrival of Constantine's ambassadors at Charlemagne's court in Paris and the meeting of Charlemagne and Constantine in Constantinople. The five centuries that separate these two historical emperors indicate that the subject of this window was apocryphal, but that it had special significance for the Abbey of Saint-Denis in the twelfth century.

In the ninth century, Charles the Bald, grandson of Charlemagne and lay abbot of Saint-Denis, had given the abbey relics of the Passion that had supposedly been procured by Charlemagne. In order to authenticate these relics, by 1124 the monks of Saint-Denis had fabricated a legend of the emperor's pilgrimage to the Holy Land that was preserved at the abbey under the title of the *Descriptio*. The Montfaucon images come from this legendary account of Constantine requesting that Charlemagne come to Constantinople to free the Holy Land and Charlemagne's subsequent receipt of the relics as a gift from Constantine (the relics were first taken to Aachen and then transferred to Saint-Denis). Suger had obviously read the *Descriptio* and had realized its importance both as a means of strengthening the bonds between the abbey and the monarchy and as a way of enhancing the abbey's prestige. Like the Crusade window, the Charlemagne window was excellent propaganda for the reputation of Saint-Denis.

The Triple Coronation does not occur in the *Descriptio*, nor does it appear in the accounts of the Roland legend in the so-called Pseudo Turpin of the eleventh and twelfth centuries that are included in the thirteenth-century Charlemagne window in Chartres (Delaporte, 1926, I, 315–19). Though certain similarities to the Chartres window have been noted, the remains from Saint-Denis are too fragmentary and too different from Chartres to conclude that one window copied the iconography of the other (CVMA, 1976, 118–19). Several suggestions have been made regarding the meaning of the Triple Coronation. François de Guilhermy (Paris, Bibl. Nat., nouv. acq. fr. 6121–22, I, 88v.) believed it to be the coronation of Saint Denis and his two companions, but none of the figures has a nimbus. Erwin Panofsky, in conversation with Grodecki, suggested that it might be the Accord of 842, which was reached by Charlemagne's grandsons long after his death. Grodecki, himself (1976, 121), has suggested that the scene continues the legendary account of the *Descriptio* in representing the court held at Constantinople by Constantine, his son, Leo—who was also an emperor—and Charlemagne. The division of the empire had been planned by Charlemagne during his lifetime in the Act of Thionville of 806; it was re-

corded by his biographer, Einhard, and recognized by his nobles and the Pope. By this means the emperor had hoped to maintain the "charitable" relationship among his three sons. This event should also be considered as the possible inspiration for the scene.

The panel contains nine figures divided into three groups. The lateral figures wear crowns, while the central group is being crowned by the hand of God. In each case, three figures sit upon a single throne. The two lateral groups (the original right-hand group is in the panel in Turin) are beardless young men while the central group, perhaps copying the lost original, is bearded. This suggested still another meaning to Grodecki.

The Pope, Zacharias (741–752), had stated that the one who possessed actual authority deserved the title of King of the Franks. Accordingly, in 751 an assembly of Frankish chieftains acclaimed the mayor of the palace, Pepin the Short, as king. Pepin was then solemnly annointed King Pepin III. However, official papal sanction was not accorded the new Carolingian line until 754, when Pope Stephen II repeated the coronation of Pepin together with his sons, Charlemagne and Carloman, at Saint-Denis. Thus, this coronation at the royal abbey founded the Carolingian dynasty, an event that had historical importance for the abbey. It is hardly likely that Suger, in his desire to augment the power of the abbey and its direct relationship to the French monarchy, would have overlooked including this event in the scenes in the Charlemagne window. This would explain the youthfulness of the lateral figures while, at the same time, expressing the unity of Pepin's realm. If this is the correct meaning of the panel—which seems most likely—it was probably one of the early scenes in the window.

The Triple Coronation panel and the two engravings of other scenes from the Charlemagne window indicate a change in scale from the Crusade window. The figures are now larger in relation to the field and there is a vertical rather than a horizontal stress to the composition. Both in figure type and in composition the Triple Coronation scene is more like the panels of the Infancy window, although the heads and the rendering of the drapery display a certain stylistic stereotyping also seen in the Crusade window. One can envision that the Infancy shop had either evolved a formula of representation or that a less-accomplished assistant had succeeded the master.

Purchased from Augustin Lambert, Paris, August 13, 1923.
Ex collection: Léon Bonnat, Paris (until February 9, 1923).
Bibliography: de Lasteyrie, 1857, II, pl. III; Labarte, 1864, I, 318; CVMA, 1976, 115–21; *Saint-Denis*, 1981, no. 21.

29

29. Border Section, from an Unknown Window

France, Abbey of Saint-Denis
About 1150
Pot-metal glass
Height, 49.2 cm. (19 ³/₈ in.); width, 12 cm.
 (4 ³/₄ in.)
03.SG.6

Against a red background, green, pink, and yellow leaves entwine white beaded circlets. The field within the circles is blue.

Although its design was not reproduced by Percier, Lisch made a tracing of this border section either at Saint-Denis during the restoration of the choir by Viollet-le-Duc or at the atelier of Alfred Gérente, restorer of the glass. That the Lisch tracing (*Saint-Denis*, 1981, fig. 20c) reproduced this exact fragment can be determined by the duplication of the mending leads, the size, and the way the design breaks at the top of the panel. There appears to be little doubt that it was once part of a window at Saint-Denis but there is no documentation to determine which window this might have been. Though there is some restoration in the upper part of the background, and the paint is rubbed in places, the piece is generally in good condition. It is probable that, like the Saint Benedict border, the piece was sent to the Gérente studio to serve as a model for new borders but was never used and, instead, found its way onto the art market, eventually to be purchased by Raymond Pitcairn from the French dealer Daguerre in 1922.

Unlike most of the borders at Saint-Denis, but like that of the Saint Benedict window, this border is not designed with opposing motifs. The pattern of leaf sprays and circlets continues in the same direction. The shapes of the leaves and the indication of their veins with fine brushstrokes recall the leaves in the border of the Infancy window (*Saint-Denis*, 1981, no. 14). Another element used in both borders is the circlet. In this border, however, the pearling of the circlet is painted rather than scratched out, as in the Infancy window. In neither case, moreover, are there pearled veins in the leaves—almost a hallmark in other windows of the choir. The painting technique, however, has been simplified in this example: the painting of the pearls was accomplished merely with dots of the brush, while the undersides of the leaves have a flat coating of mat rather than the more elaborate cross-hatching of the Infancy border.

Also unlike most of the borders at Saint-Denis, this one is very narrow. The only other example of similar dimensions is the restored fragment (in storage at Champs-sur-Marne in the Dépôt des Monuments Historiques) that Grodecki has attributed, on the basis of the Percier drawing, to either the Crusade or the Charlemagne window. Like the border of the Moses

96

window it was also copied by Debret, and can still be seen in one of the side chapels of the choir (CVMA, 1976, ills. 28, 206). Percier's drawing does not indicate whether both the Crusade and the Charlemagne windows had the same border, but if this were true it would be unique for twelfth-century windows. The narrowness of the Pitcairn border, which compares only with the one attributed to either the Crusade or the Charlemagne windows, suggests that it came originally from one of these two windows. This idea is confirmed by stylistic similarities with the ornament of the Infancy window, which was created by the same workshop as the Charlemagne and Crusade windows. Neither the two scenes that remain from these windows (nos. 27, 28) nor this border is as skillfully executed as the Infancy window.

Several years had elapsed between the dedication of the choir and the installation of these two windows. It is possible that, in the meantime, the Infancy shop had been inherited by a less-talented assistant.

Purchased from Henri Daguerre, Paris, October 20, 1922.

Bibliography: CVMA, 1976, 130; *Saint-Denis*, 1981, no. 22.

30. Impost Block with Acanthus Decoration

France, Abbey of Saint-Denis (?)
Mid-12th century
Limestone
Height, 36.8 cm. (14 1/2 in.); width, 81.2 cm. (32 in.); depth, 34.3 cm. (13 1/2 in.)
09.SP.271

This impost block is part of a series. The two in the Glencairn Museum in Bryn Athyn, Pennsylvania (09.SP.12, 09.SP.13) and the one in The Metropolitan Museum of Art (13.152.1) share the same type of decoration, carving technique, and weathering, in spite of the fact that they are of different dimensions. Three sides of the block are ornamented with an organic frieze of repeated pairs of acanthus leaves enveloping an axial acanthus flower bud.

A Saint-Denis provenance for these impost blocks cannot be documented, although the one in the Metropolitan Museum is said to have come from the abbey. Analogous types of decoration can be found on the impost blocks of the piers in the ambulatory

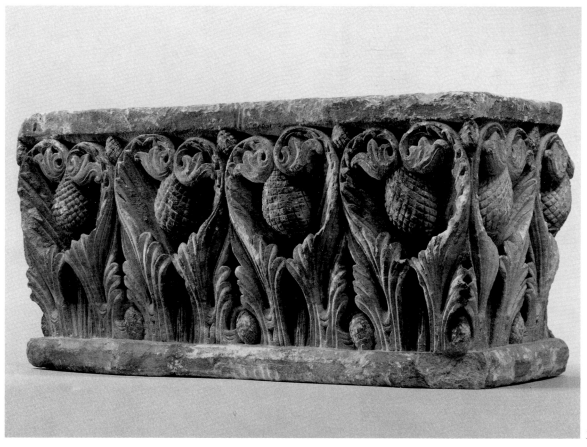

30

of the crypt built by Abbot Suger (Crosby, 1972, fig. 58). This suggests a date of some time after 1144 for the blocks. It is not unlikely that such impost blocks were prepared *en masse* in the workshop at the abbey, for eventual use, but they may never have been installed. Sumner Crosby (1953, 48) has suggested that they might have been intended for Suger's replacement of the old Carolingian nave or transept, which was not constructed until the thirteenth century. During the nineteenth century, the abbey was a central collecting point for medieval sculpture and building materials in the Île-de-France, so that it is possible that these blocks originated at some other church in the region.

<div align="right">C. T. L.</div>

Bibliography: Cahn, 1977, 74, no. 12; *Saint-Denis*, 1981, no. 8C.

31. Column Statue of a Haloed Queen

France, Provins, Church of Saint-Thibaut
About 1160–70
Limestone
Height, 165.1 cm. (65 in.); width, 30.5 cm. (12 in.); depth, 28 cm. (11 in.)
09.SP.103

This statue comes from the church of Saint-Thibaut in Provins, mentioned in 1157 as a dependency of the collegiate foundation of Saint-Quiriace located nearby. The figure is crowned and haloed. She wears a large jewel at the throat, and her hair extends downward in two symmetrical strands, which are entwined with a ribbon. The left hand is broken. In her right hand, she carries a book with the remains of a jeweled binding. The feet and possibly a support of some kind were trimmed in order to enable the statue to stand on a flat base. A lithograph published in 1822 shows the figure displayed in this fashion on a large overturned capital. The area around the mouth and chin has also been restored in a manner that undoubtedly falsifies the expression. The figure is a descendant of the column statues of the Royal Portal of Chartres, and calls to mind, as well, the statue of a queen from Corbeil (now in the Louvre), itself also somewhat altered by restoration. The stance conforms to the axial fixity of the column, but suggests concentrated

stillness rather than rigidity. The drapery, made of thin, parallel striations, enhances the effect of stasis, which, at the same time, is undermined by intimations of softness and transparency. Like the Corbeil statue, the carving, perhaps, depicts the Queen of Sheba.

The church of Saint-Thibaut was an edifice of fairly modest dimensions, composed of a nave flanked by single aisles and preceded by an entrance tower. It had a troubled history. Already in the fourteenth century, the building required urgent repairs, and three hundred years later it was again in ruinous condition. Destruction began in 1785 and continued in the period of the French Revolution. A section of the tower, with the left jamb of the porch and the springing of the arch over the entrance, is all that now remains of the monument. There were two entrances. The one below the western tower seems to have comprised an image of Saint Theobaldus (Thibaut), but was otherwise inconspicuous. The weight of the decoration was concentrated in the second portal, located at the entrance to a vestibule giving access to the first bay on the southern side of the church. According to one old description, it was "covered with figures of prophets, apostles and other saints," while another author describes it as comparable to the portal of the church of Saint-Ayoul, a still-surviving doorway, in the Chartrain manner, in Provins (Maillé, 1939, 200). Unfortunately, there is no accurate record of the appearance of this entrance. Saint Theobaldus was represented there a second time, in episcopal garb, according to an eighteenth-century source. It is generally assumed that this figure is the one now preserved in the Grange-aux-Dîmes in Provins, and that it served as the trumeau of the portal. A relief of Christ in Majesty within a mandorla, which is now set over the main doorway of Saint-Quiriace, is thought to have been part of the tympanum of this portal. The Pitcairn column statue must have been installed in one of the jambs, along with a pendant on the opposite splay and an undetermined number of other figures.

Purchased from Georges Demotte, Paris, 1923.

Ex collections: Max Michelin, Provins; Lehouson le-Duc, Paris.

Bibliography: Du Sommerard, 1822, 19; Opoix, 1823, 289; Maillé, 1939, I, 201; Aubert, 1946, 196–97; Pressouyre, 1967, 108, n. 3.; *idem*, 1970, 23–24; Sauerländer, 1972, 403.

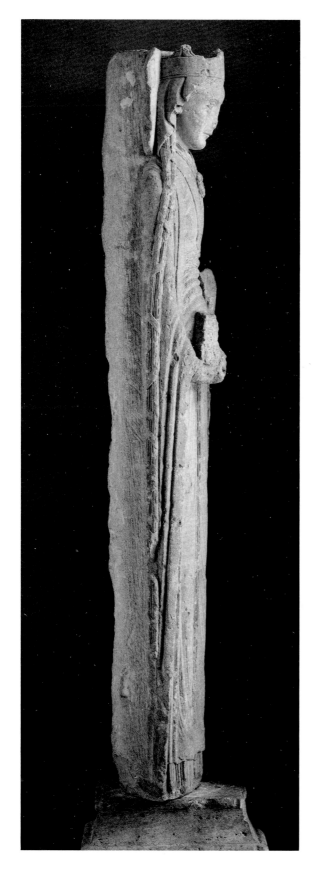 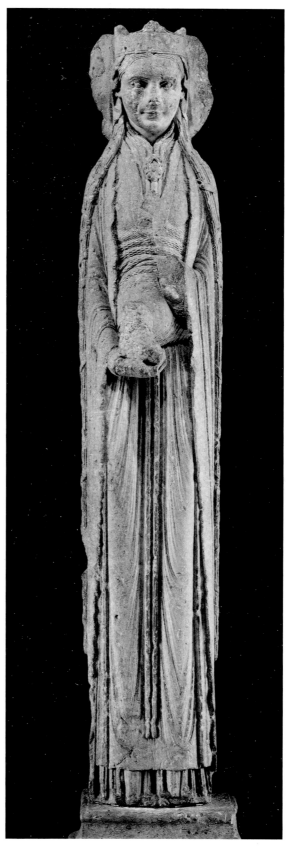

31

32. Historiated Capital with The Raising of Lazarus and Related Scenes

France, Champagne, or Île-de-France

About 1160–70

Limestone

Height, 30.3 cm. (11 5/16 in.); width, 43 cm. (16 15/16 in.); depth, 43 cm. (16 15/16 in.)

09.SP.196

Historiated capitals were often a principal part of the decoration of twelfth-century churches and cloisters. This richly carved example, of unknown provenance, has suffered from both weathering and breakage. The basically quadrangular shape of the capital has been truncated at the base. In spite of these damages, the exceptional quality of the carving remains clearly evident.

Two faces of the capital depict scenes from the miracle of Lazarus, as described in the Gospel of John (11: 17–44). On one side, Christ, accompanied by an apostle, is met by Martha, who tells him that her brother has been dead for four days; the other side, reading clockwise, shows the Raising of Lazarus. Here, Christ stands at the right in front of a tree, holding a book in his left hand while gesturing in benediction with his right. As a bearded man lifts the lid, Lazarus sits up in the sarcophagus. At the left, a woman who may be either Mary or Martha lifts her arms in an orans-like gesture.

The subjects of the other two sides of the capital are problematical. Clockwise, from the Raising of Lazarus, is a scene showing two men within a mitered arcade, the one at the left seated and turned toward the right. This figure appears to be receiving an animal—perhaps a calf—from a standing personage at the right, who gestures toward the first figure with his right arm and holds his mantle with his left. The fourth scene also takes place within a mitered arch in which a single, seated and cross-legged man, wear-

32

ing a cap and stroking his beard, faces right. None of the three figures on these last two sides is nimbed.

It is unlikely that these two enigmatic scenes are an extension of the Lazarus narrative, since they do not correspond to any existing extended cycle of his life. Rather, they must represent a story from the Old Testament, but not from the usual typological scenes associated with the Raising of Lazarus. In the absence of any connection with existing representations that contain similar visual juxtapositions of events, the source and identification of this capital possibly can be explained through contemporary commentaries on the Lazarus story. In Saint Bernard of Clairvaux's sermon on Mary, Martha, and Lazarus, the three members of the Bethany family are cited as examples of three types of religious life—*contemplatio, administratio*, and *poenitentia* (*Pat. lat.*, CLXXXIII, 423). He goes on to discuss Daniel, Noah, and Job in the same terms. Peter of Blois, Bernard's contemporary, draws an explicit parallel among the three Old Testament figures of Mary, Martha, and Lazarus, focusing on the penitential ideal of Lazarus and Job (*Pat. lat.*, CCVII, 667). There is also often a liturgical association between Job and Lazarus in the Office of the Dead (Besserman, 1979, 63). Finally, Books of Hours frequently depicted Lazarus and Job, often on the same page (cf. Leroquais, 1927, II, 236).

This close correspondence between Lazarus and Job in twelfth-century homiletic writings and liturgy may be visually extended to the Pitcairn capital. The seated figure under the arch may be Job contemplating his sorrows. Although Job is usually depicted in the presence of his wife, the Devil, or his friends, he is sometimes shown by himself, particularly in twelfth-century *Moralia in Job* manuscripts (Caen, Arch. Calvados, ms. 57–58; *Abbayes Normandes*, Rouen-Caen, 1979, 176, ill.). The scene of the man receiving an animal might also refer to Job, who, when his fortunes changed, was presented with a ewe and a gold ring by each of his brothers and friends (Job 42:11). The Pitcairn capital may represent an abbreviated version of this episode, which usually is given more elaboration, as in the Pamplona Bible (Harburg, Oettingen-Wallerstein collection, fol. 92r.), or the Ripoll Bible (Vat. Lat. 5729, fol. 163). Such a concordance of Old and New Testament themes is entirely appropriate to the twelfth century, and might have been elaborated upon in the kind of cloister ensemble in which one could easily envision this capital.

Because of the subject matter, one might be tempted to associate the capital with Burgundy, where the relics of Lazarus were revered (especially in Autun, Avallon, and Vézelay). The capital does contain general stylistic elements associated with that area—specifically, a sensitive handling of the forms, as in the roundness of the heads, the shapes of the eyes, and the cut of the hair and beards. Yet, it is more likely

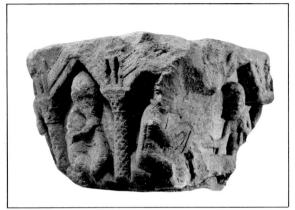

32

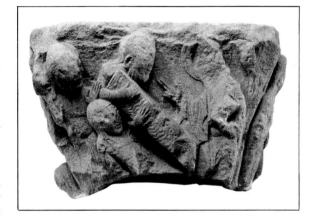

that the style indirectly reflects these Burgundian elements, and is characteristic of a fundamental stylistic transformation taking place in the Île-de-France and in Champagne during the third quarter of the twelfth century that pointed the way toward a true Gothic style. Actually, the sculpture closest to this piece is the beautifully preserved capital with confronted harpies (no. 33) that may have originated in the same sculptural ensemble. Especially noteworthy are the shapes of the ears; the design of the eyes, with their drilled pupils; and the method of carving the beards—in addition to the general proportions and the depth of the forms. In spite of its deplorable condition, the physical richness of the Lazarus capital, in general—and the almost sensuous beauty of the drapery and tender rapport between the *dramatis personae*, in particular—finds a striking parallel in the extraordinary cloister sculpture at Notre-Dame-en-Vaux in Châlons-sur-Marne. Whether—and, if so, how—this capital is related to the Châlons sculpture is difficult to determine. Nevertheless, in its original state and context, the quality of the Lazarus capital would have proven itself a worthy rival to its counterparts in Châlons.

C. T. L., M. B.

33. Capital with Confronted Harpies

France, Île-de-France
About 1160–70
Limestone
Height, 29.8 cm. (11 ³/₄ in.); width, 25.3 cm. (10 in.); depth, 25.3 cm. (10 in.)
09.SP.163

This finely carved capital, of relatively small size, shows a pair of winged quadrupeds with bearded, monk-like heads, set against a background of stylized plant swags. The design was repeated on the badly eroded opposite side of the block, so that the creatures thus were placed rump to rump, with the tips of their wings touching. The presence of clerical tonsures and cowls perhaps harbors a satirical or moralizing connotation. Other cowled creatures of this kind are found among the portal splays at Saint-Loup-de-Naud (Seine-et-Marne) and in the cloister of the cathedral of Lérida in Catalonia (Puig i Cadafalch, 1949–52, III, pl. 30), whose sculpture was clearly touched by the decorative idiom of the Île-de-France, as represented by the present carving and by the capital with the Raising of Lazarus (no. 32).

Bibliography: Gómez-Moreno, 1968, no. 28.

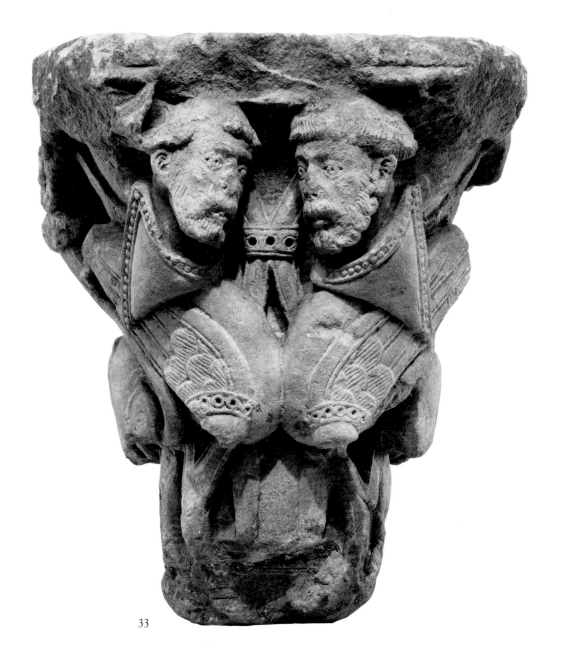

33

34. Capital with Harpy-Siren

France, Île-de-France
Third quarter of the 12th century
Limestone
Height, 31.7 cm. (12 1/2 in.); width, 26.6 cm.
 (10 1/2 in.); depth, 26.6 cm. (10 1/2 in.)
09.SP.14

This block of somewhat elongated proportions is devoid of internal articulation. The carving, unfortunately severely damaged in places, consists of three fantastic creatures arrayed around the bell. Relatively well preserved are a crowned harpy-siren, and, behind it, a quadruped with a human face (now broken), whose tail ends in a floral swag. Only traces are left of the third subject, another parading animal. The style as well as the imagery relate this fragment to the decorative sculpture of Early Gothic monuments in the Île-de-France and in Champagne, of about 1160–70. Among these are the capitals of the choir of Saint-Germain-des-Prés in Paris, dedicated in 1163; a group of capitals associated with the cloister of the Abbey of Saint-Denis (*Saint-Denis*, 1981, 47, no. 5A, B); and the capitals in the portal splays of the churches of Saint-Loup-de-Naud, and Notre-Dame-en-Vaux in Châlons-sur-Marne.

Bibliography: Cahn, 1977, 74–75, no. 13.

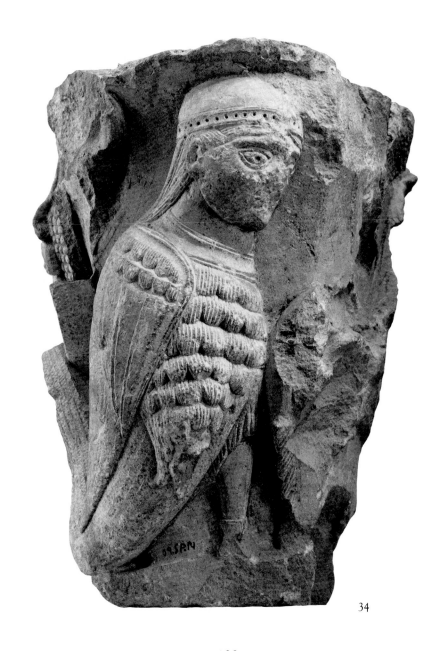

34

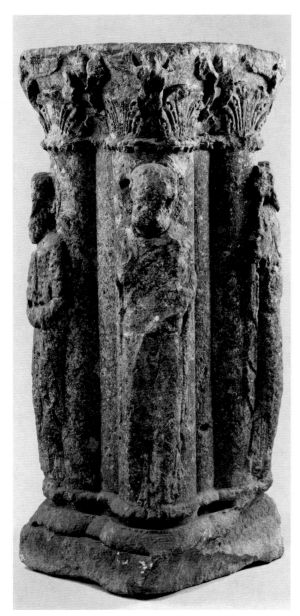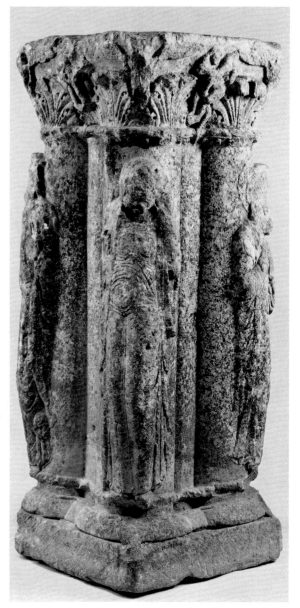

35

35. Compound Support with Allegorical Figures

France, Île-de-France, or Champagne (?)
About 1170–80
Limestone
Height, 109.2 cm. (43 in.); width, 41.8 cm. (16 1/2
 in.); depth, 17.2 cm. (6 3/4 in.)
09.SP.113

This quadrangular pillar with four engaged columnar shafts is a work of the first interest, though its weathered and eroded condition makes any description or interpretation tentative. The capital in the upper zone, carved in the same block, shows acanthus foliage, and the four diminutive figures overturning vases, in the middle of each of the four sides, are the Rivers of Paradise. At the four corners, above the foliage, are angels in half-length with wings symmetrically spread out. Each of the four columns bears a standing figure. The best preserved is a woman carrying what, at first, appears to be a lance. One might be tempted to think of her as a personified Virtue, but there is no indication of the customarily included defeated Vice at her feet. It is also clear that her attribute is not a weapon but an overturned pennant. This makes it probable that the figure is a personification of the Synagogue, who is occasionally shown this way, as on the approximately contemporaneous paten of the Abbey of Trzemeszno in Poland. The figure's left arm, raised toward her head, betokens sorrow. A second female figure (at the left) with braids must be the Church (Ecclesia). It is likely that she carried an upright pennant and wore a crown, though this is more conjecture than observation. The other two figures are haloed and almost certainly are men. There are no means of positively identifying the figures, but the context in which they appear leads one to hypothesize that they are depictions of Moses and Saint Paul—representatives, respectively, of the Old and the New Law. One would expect that the entire program was completed by an image of the Crucifixion, shown above or nearby.

According to the Pitcairn records, the carving is said to have come "from the cloister of Saint-Loup-de-Naud, near Provins." This is a well-known monument with a portal of the Chartrain type (Maines, 1979), and, on a *prima facie* basis, the information is not entirely implausible. However, no other records or traces of a cloister at Saint-Loup have thus far been discovered. In his catalogue of the medieval sculpture in the Louvre, Aubert expressed another opinion regarding the matter of origin (Aubert and Beaulieu, 1950, 73–74), later repeated by André Lapeyre (1960, 229). These authors associate the work with Châlons-sur-Marne. No source for this judgment is given, and one may surmise that it was based entirely—or in

large part—on the resemblance of the Pitcairn sculpture and the fragmentary, similarly shaped "Colonne des trois chevaliers," formerly in the Louvre. The latter work, since then completed and convincingly interpreted by Pressouyre (1963, 76–81), came from Notre-Dame-en-Vaux in Châlons. The outward shape of the two supports is, indeed, quite similar. One of the capitals of the cloister of Notre-Dame-en-Vaux (formerly in the Musée Municipal in Châlons-sur-Marne) also includes the motif of acanthus foliage, with angel busts at the four corners. On the other hand, the capitals of Notre-Dame-en-Vaux lack the pearly decoration of the Pitcairn astragal and are scooped out rather than straight at the level of the abacus. The Pitcairn pillar is also a good deal smaller than the Châlons supports, whose collective height (base, column, and capital) varies from 140 to 147 centimeters. The condition of the work impedes any further attempts at more precise comparisons.

Purchased from Arnold Seligmann, December 8, 1924.

Ex collection: Altounian, Mâcon.

Bibliography: Aubert and Beaulieu, 1950, 73–74, no. 85; Lapeyre, 1960, 229; Sauerländer, 1963, 122, n. 8; Pressouyre, 1964, 26, n. 3.

36. Apostles Mourning the Death of the Virgin, from The Dormition of the Virgin Window

France, Troyes, Cathedral of Saint-Pierre (?)
1170–80
Pot-metal glass
Height, 42.5 cm. (16 3/4 in.); width, 24.8 cm. (9 3/4
 in.)
03.SG.185

In a half-circle edged in red and cut by a yellow boss are four seated and nimbed apostles wearing white, green, yellow, and murrey robes and mantles. The background is blue, diapered in a rinceau pattern. In the corners are leaf sprays of yellow, blue, and white, on a green field. The painted edging on the right is composed of green, yellow, blue, and murrey palmettes. A head has been inserted in the lower part of the scene but much of the leading is old. Some of the inscription remains, GVS · REPAT VNTCELOS · S, though the lower portion of the panel is so rearranged that it is no longer readable; the first part may refer to the return of the apostles. None of the other panels from this window, however, is inscribed.

Although the immediate source of the panel is uncertain, there is no doubt that, originally, it came from Troyes. It may have been purchased from Acézat in 1929 or 1930, since Raymond Pitcairn was offered twelfth-century glass of the "school of Troyes" in both those years. In 1929, Lucien Demotte published his

105

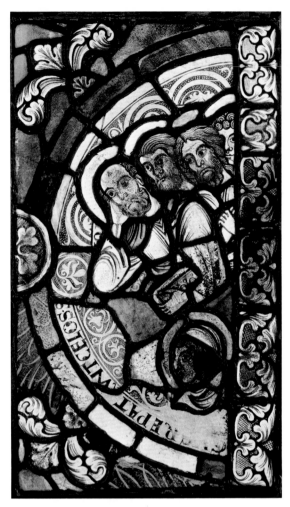

36

made by Viollet-le-Duc, head of the Monuments Historiques, in 1846, indicated severe structural problems in the masonry of the chapels that necessitated removal of all the windows (Arch. des Mon. Hist., 1853, dossier no. 74). This had been accomplished by 1849, since Eugène Millet, architect-in-charge at Troyes, reported that the restored windows were packed in cases (Arch. des Mon. Hist., 1849, dossier no. 74). The glass had been reinstalled by 1864, however, when Guilhermy returned to Troyes and commented with displeasure on the apparent radical cleaning, new additions, and restoration of the windows. That Guilhermy's statements were exaggerated was verified by Jean Lafond (1957, 29–45), who was the first to examine the windows in detail from scaffolding and to compare their present state with the nineteenth-century descriptions. Lafond's observations are critical to the study of the twelfth-century panels, since they prove that none of the extant panels from this series was installed in the cathedral choir before the restoration. This is reconfirmed by a current catalogue of the windows (Marsat, 1977, 92–104), all of which appear to be from the first quarter of the thirteenth century. Arnaud, however, published engravings of three of the twelfth-century panels that are now in the Victoria and Albert Museum in London (*The Year 1200*, 1970, I, nos. 204, 205), indicating that the series may have originated in Troyes or, at least, was in Troyes in the nineteenth century. Other evidence supports this fact. A panel from the legend of Saint Nicholas, which belongs with these scenes, was discovered in the attic of the cathedral before 1891 (Lafond, 1957, 44), but has since disappeared. The most conclusive archaeological evidence for a Troyes origin for the panels is that the three panels now in London, in addition to still another from the same series as the Pitcairn Apostle (no. 37), were photographed by a local photographer in Troyes about 1895. By 1900, however, they were on the Paris art market; they were sold in that year to J. Pierpont Morgan, and in 1919 to the Victoria and Albert Museum (Grodecki, 1973, 191–93). This suggests, therefore, that, though in storage in the cathedral, the panels were not installed in the choir when Arnaud described the glass and that, by the end of the century, they had been dispersed from Troyes.

Moreover, there is some question as to whether the eighteen panels or fragments from the five different windows that have been identified as belonging to the series were made originally for the cathedral of Troyes (Little, 1981, 119–27; Grodecki, 1973, 191–203). The Gothic cathedral of Saint-Pierre in Troyes was begun in 1208. The early-eleventh-century church that it replaced had been destroyed by fire in 1188. Based on their style in relation to other glass

exhibition catalogue of stained glass that included the Apostle from the cathedral of Troyes (no. 37), so the distinctive style of the Troyes glass was well known at the time. A number of panels attributed to this series on stylistic grounds exist in collections in Europe and America (Grodecki, 1973, 191–203), but no glass of this period remains installed in the cathedral of Troyes (Little, 1981, 119). Most of the literature on these panels has located them as inserts in the ambulatory chapels of the cathedral, prior to the restoration of its stained glass, which was begun in 1839. This association with the cathedral has been based on descriptions of the glass prior to its restoration. The glass painter Anne François Arnaud published a detailed account of the Troyes windows in 1837 (Arnaud, 175–81); this was followed by the notes that Guilhermy made in 1843, before the actual dismounting of the glass (Paris, Bibl. Nat., nouv. acq. fr. 6111, fols. 6117–19). The restoration evidently began soon after, for an inspection of the building

and manuscripts, it is generally conceded that the Troyes panels were made about 1170–80, approximately a decade before the fire. Some of the panels have been widened by the addition of borders, dating from about 1240, that have been attached to the sides of the scenes, indicating a possible reuse of the glass (CVMA, 1976, ill. 124). The total width of these panels with the additions, however, is only twenty-two inches. Therefore, they are much too narrow to have been adjusted to fit the large apertures of the chapels of the Gothic building, even if they had survived the fire. The only logical explanation is that the twelfth-century glass was made for another church in Troyes, modified in the thirteenth century, and then at some later time brought to the cathedral but never used. Windows from at least two other churches in Troyes, disaffected at the time of the Revolution, are now installed in the cathedral (Lafond, 1957, 62).

A number of panels still exist from the Dormition of the Virgin window. In addition to the Pitcairn scene that shows the apostles mourning the death of the Virgin, the panel depicting the summoning of the apostles to attend the Virgin's funeral has recently been purchased by the city of Troyes for the cathedral treasury. A group of censing angels is now in The Metropolitan Museum of Art (1977. 346.1) and there are two more single angels—one attached to the Troyes treasury panel and the other in the collection of Wellesley College (1949–19a; Caviness, 1978, no. 1). Fragments that include the head of the dead Virgin, drapery, and the damascened background are also in the Metropolitan. The extent of these remains would indicate that the window was originally composed of at least six scenes, since it would also have included the Funeral, the Assumption, and the Coronation of the Virgin. The format of the existing panels is unusual for the twelfth century in that they are all arranged in apposed half-circles. Both Louis Grodecki and Charles Little have suggested that this was not the original plan of the window but, rather, the result of a rearrangement. Little has also noted the similar iconography of the Dormition window in Saint-Quentin, suggesting that the Troyes glass was its model. The Saint-Quentin window, with its central squares joined by arcs, is, however, an arrangement more typical of the thirteenth than of the twelfth century. The most unusual feature of all the remaining scenes from the Troyes window is that, in each case, the main event is missing. In the Summoning of the Apostles scene, the angel who calls them together and leads them is not included. The Assumption of the Virgin, which should be surrounded by the censing angels, is absent. The Pitcairn mourning apostles face the perimeter of the frame, while the dead Virgin is not present—nor is there any place in the panel for

her recumbent figure. If, however, these half-circular panels flanked a full circle in each horizontal register of the window, the arrangement, as in Poitiers, would be a standard one for the twelfth century. This would also allow for the completion of the scenes by placing the main event (at which the apostles in the Pitcairn panel direct their melancholy gaze) in the central compartment of the window. Unless the unknown building for which these Troyes panels were originally made was much earlier than its glass, this arrangement of circles and half-circles with a surrounding border would constitute a window more in keeping with the bay size of mid-twelfth-century buildings.

Grodecki (1973, 199–203) has compared the style of these Troyes panels with manuscripts illuminated in Champagne in the last quarter of the twelfth century. This comparison is particularly appropriate for the master who created the mourning apostles, whom Grodecki (1963, 137–39) has suggested was trained as a manuscript painter. The technique of this panel is different from that usually found in stained glass. At least three successive coats of mat were used to model the faces, in addition to the trace lines that outline the features. This building of form with successive coats of paint is a technique employed in manuscript illumination. The brushwork and the use of the stylus for highlighting is miniature-like in its fineness and detail. Though it does not predominate in this particular scene, the Troyes panels are distinguished by the presence of a clear, lemon yellow glass that may also have been influenced by the use of gold in illuminated manuscripts. The panels that remain from the Dormition window are the most exquisitely ornamental and delicately painted of the series. There is no question that all of the glass from Troyes was the product of a single workshop, but the hand of the Dormition painter can be isolated by a slight stiffness of pose, a summary treatment of drapery, and a precision of line. Most of the ornament in this panel is original though, perhaps, rearranged in the thirteenth century. The painted frame on the right edge of the panel is characteristic of Troyes glass, as are the crisply delineated leaves in the corners. The boss in the center of the arc that frames the scene probably joined this panel to the central circle that contained the dead Virgin with Christ receiving her soul, fragments of which are in the Metropolitan. It is probable that another group of apostles similar to this one completed the scene at the left-hand edge of the window.

Purchased from Michel Acézat, Paris, 1929/30 (?).

Bibliography: Gómez-Moreno, 1968, no. 181; Roserot de Melin, 1970, pl. 6, fig. 2; Grodecki, 1973, 197; Little, 1981, 122–24.

see colorplate III

107

37. Standing Apostle, from The Public Life of Christ Window

France, Troyes, Cathedral of Saint-Pierre (?)
1170–80
Pot-metal glass
Height, 30.5 cm. (12 in.); width, 7 cm. (2 ³/₄ in.)
03.SG.224

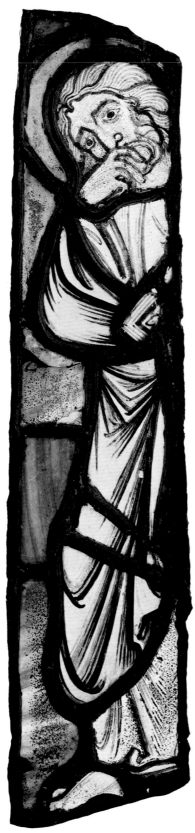

37

Against a red background, the standing bearded apostle is dressed in a white robe and a blue mantle. His nimbus is green and he holds a yellow book. Only one piece of glass, the red background above the apostle's knee, has been replaced.

This piece has been identified (Gómez-Moreno, 1968, no. 180) as part of a window illustrating Christ's miracles and his public life as a teacher. Other parts of the window are known, including a complete scene of the Multiplication of the Loaves and the Fishes, now in the Victoria and Albert Museum in London (C. 105–1919; Grodecki, 1977, ill. 125), and a fragment of the Healing of the Paralytic, currently lent by Robin B. Martin to the Metropolitan Museum (L49.22; Gómez-Moreno, 1968, no. 179). The fragment was first exhibited in New York by Lucien Demotte in 1929, as part of his collection of stained glass (Demotte, 1929, no. 3), and was purchased in the same year by Raymond Pitcairn. Supposedly, it was formerly in the Garnier collection in Paris.

Its association with the cathedral of Troyes is based on descriptions of the choir windows published in 1837 by Arnaud (175–81), who also included three engravings of other panels from the same series. Though Arnaud's descriptions, corroborated by the notes of Guilhermy (1843–45, Paris, Bibl. Nat., nouv. acq. fr. 6111, fols. 6117–19) are fully detailed, they appear to describe the thirteenth-century windows that were installed when the Gothic choir was constructed, beginning in 1208 (Lafond, 1957, 29–45), rather than these twelfth-century panels. That these panels were in Troyes in Arnaud's time can be verified by his engravings, as well as by the local photographer's photographs of some of these pieces, including the Multiplication of the Loaves scene, which were made in Troyes about 1895. In comparing Arnaud's descriptions with windows still *in situ* in Troyes, Lafond noted that a number of subjects from the twelfth-century series had been repeated in the thirteenth-century windows. These included incidents from the Public Life of Christ, the Temptation of Christ, and the Life of the Virgin. This would lend further validity to the idea that the twelfth-century glass was in Troyes when the cathedral choir was glazed in the thirteenth century, and that these panels served as the iconographic models for the choir windows.

Grodecki (1973, 191–203) has suggested that the twelfth-century panels came from an extensive series of lost windows. On the basis of remains in collections in Europe and America, he has identified four different windows, including the three mentioned previously and a Life of Saint Nicholas. Little (1981, 119–27) has added a typological Passion window based on a Crucifixion, the present whereabouts of which is unknown, and certain lost scenes described by Arnaud, to the series. Though Lafond did not recognize any twelfth-century scenes in the thirteenth-century choir windows in Troyes, he also noted lost panels described by Arnaud. Among them were the three typological scenes identified by Little, who has attributed them to the twelfth century on the basis of their damascened background, as described by Arnaud. This type of background decoration is typical of windows from the latter part of the twelfth century and characteristic of the panels from Troyes (no. 36). The Public Life of Christ window also utilized a painted background that, unfortunately, has been cropped from the Pitcairn Apostle. By the beginning of the thirteenth century, the decorated background had gone out of fashion, which is the most compelling reason for attributing these lost panels to the twelfth-century series. Three other lost panels from a Creation cycle were also noted by Arnaud in the first chapel on the right of the ambulatory, which, perhaps, should also be attributed to this series. It would appear, therefore, that the nineteenth-century restoration that took place soon after the publication of Arnaud's book carefully eliminated any remaining twelfth-century debris, and created new panels to complete the losses in the thirteenth-century windows.

It is not impossible, however, that the twelfth-century panels were once installed in Troyes, but were removed in the eighteenth century when more light was demanded and new altars were added to the choir chapels (Marsat, 1977, 92). Even in Arnaud's time the lateral chapels on the north side, adjacent to the choir, were filled with white glass. Arnaud noted old borders in the second chapel, which have since been moved to the first chapel on the north side of the choir, that Lafond (1957, 29–30) has identified as twelfth century. If these panels were ever reused in the cathedral, it is probable that they were inserted in these windows only to be removed in the eighteenth century and "rediscovered" in the twentieth.

With so few scenes remaining from the Public Life of Christ window, it is impossible to reconstruct its iconography or to determine how many panels it originally contained. Based on the one surviving panel in the Victoria and Albert Museum, it was composed of horizontal rectangles. Rectangular frames were em-ployed in two other windows from this series, a Life of Saint Nicholas and the Temptations of Christ. The consistent use of the rectangular frame is unusual in twelfth-century windows; an alternation of circular and rectangular frames, as in Chartres and Le Mans, was more common. Little (1981, 119–21) has proved, however, that this was the case in Troyes, since he discovered a second scene belonging to the Third Temptation of Christ that directly followed the first scene, both of which were originally rectangular. Thus, these panels from Troyes are a unique surviving example of the use of an unusual theme in twelfth-century glass, the Public Life of Christ. Because of the fragmentary state of the Pitcairn Apostle, it is impossible to determine the subject of the scene to which it belonged. The arched top of the fragment and the striding pose of the figure suggest that he is stepping through a doorway; the red background, which occurs frequently in medieval glass, indicates an interior. Unfortunately, the apostle cannot be identified, since several figures in the other panels from this window are the same bearded type.

Based also on the fragment from this window in The Metropolitan Museum of Art, the figures are larger than those of the Dormition window (no. 36), and the style is more classical and less animated. Grodecki (1977, 140–47) has compared the work of this painter, who was probably the master of the shop, to the sculpture of the Champagne region, as exemplified by the cloister of Châlons-sur-Marne of contemporary date. He has called this classicizing style— which originated in the Meuse Valley and, by the year 1200, had spread throughout northern France— Proto-Gothic. This style is not without parallels in the manuscript illumination of northeastern France. Grodecki has noted in particular the technique of modeling employed in the apostle. The drapery folds are delineated by splayed strokes of the brush rather than by flat tones of mat. Each strand of hair is similarly defined. This linear technique, however, overlays several layers of tonal modeling that give volume and solidity to the form. The technical virtuosity of this figure typifies the work of this Troyes atelier. As far as can be determined, it was unique to the region, faintly distinguishable in a later window in Orbais but in none of the other artistic centers of eastern France.

Purchased from Lucien Demotte, Paris, May 3, 1929.

Ex collection: Garnier, Paris.

Bibliography: Demotte sale cat., 1929, no. 3; Gómez-Moreno, 1968, no. 180; Grodecki, 1973, 197–99; Grodecki, 1977, 294.

38(A)

38. Two Border Sections, from the Choir Windows

France, Reims, Abbey of Saint-Remi
About 1190–1200
Pot-metal glass
(A) Height, 62.8 cm. (24 3/4 in.); width, 16.8 cm.
 (6 5/8 in.)
 03.SG.145
(B) Height, 71.7 cm. (28 1/4 in.); width, 13.9 cm.
 (5 7/16 in.)
 03.SG.216

(A) Red and white edge fillets on either side enclose a white ribbon caught by green painted bosses. Murrey leaves with green buds are contained within the ribbon, while yellow curled leaves extend beyond it on the deep blue background. The condition of the border is excellent, except for the replacement of parts of the ribbon and the white edge fillets.

(B) Arches of white glass enclose palmettes of murrey and green, with a gold leaf curling over each hoop. A white stem with green tufts of foliage connects the palmettes, which are set on a blue field. The background is red.

The aesthetic importance of these borders was first recognized in 1928 by the American glass painter Lawrence Saint, a consultant to Raymond Pitcairn, who selected the borders for possible purchase from Acézat. Not only was their provenance unknown at that time, but there is still no record of how Acézat obtained the borders. The attribution of border (A) to the church of Saint-Remi in Reims is based on a colored engraving of the border published in 1841–44 by Cahier and Martin (II, pl. E, 6), while the piece was still in the church. Border (B) has been identified from other fragments of the glass that were recovered after the bombardment of the abbey in 1914. These remains are now leaded into one of the chapel windows in the south transept.

The abbey church of Saint-Remi has undergone several major restorations and rearrangements of its windows in the last two centuries (Simon, 1959, 14–25), the most drastic of which took place between 1850 and 1875. Many of the choir windows were moved from one location to another, old windows were completed by additions of new glass, and windows that lacked stained glass were newly glazed. During this restoration, figures from the clerestory that did not originally belong there (Tourneur, 1856, 88–90; idem, 1862, 87–97) were moved to the tribune and inserted in the ornamental windows, one of which initially contained border (A). It was probably in the course of this restoration that a section from another ornamental window in the tribune (26.218.1; now at The Cloisters) was removed. Even before this time, however, the tribune windows had undergone drastic

110

modifications. In the middle of the eighteenth century the sill levels of the three central bays had been lowered four feet and the resulting empty spaces were filled with white glass (Prache, 1981, 147–48). The stained glass in the radiating chapels, removed at the same time, subsequently disappeared. The most serious damage to the windows occurred in 1914, when Saint-Remi was bombarded before the glass could be removed (Simon, 1959, 14–25). Following this first disaster, only the figural glass was dismounted; the ornamental windows remained in place as shattered fragments throughout the war. After the war, what was left of the glass was removed and stored until the long restoration of the building could be completed. Since all the glass in the hemicycle of the clerestory had been destroyed in the first bombing with the exception of the fragments of border (B) and two heads of figures, it was decided to make new glass for this part of the church. Undoubtedly, some of the panels were lost in the interim, since restoration of the windows did not begin until 1943.

The choir of the abbey church of Saint-Remi was begun in 1170 and was completed by 1185 (Prache, 1978, 59–74). While the windows of the clerestory were completely filled with a double register of figures, the windows of the tribune below contained mostly ornamental glass flanking a large Crucifixion in the central bay. Other figures may have occupied the openings adjacent to the Crucifixion, but Jacques Simon (1959, 18–20), who was in charge of the most recent restoration of the glass, has estimated that twenty-six of the gallery windows contained ornament. A number of these windows had been completely reglazed in the nineteenth century. More were lost between 1914 and 1918. At the present time, only two remain intact and five more have retained parts of their original glass. Engravings of five of the designs with their borders were published by Cahier and Martin. They are composed of repeated medallions of painted ornament combining colored glass with grisaille. The borders, as seen in the Pitcairn example (A), are narrow in comparison to others of the late twelfth century. Since the entire window for which they formed an edging was ornament, these borders acted as the termination of a field of decoration rather than as separate decorative elements enclosing a figural representation. Ornamental windows were not uncommon in twelfth-century stained glass. Suger had had the lateral bays of the choir at Saint-Denis glazed with similar windows, but these Griffin windows contained a much greater amount of white glass than the more richly colored examples at Saint-Remi. Both the cathedrals of Reims and of Soissons have later windows that are similar to those at Saint-Remi, indicating a preference for the type in northeastern France.

The design of border (A) is a vertically oriented

38 (B)

repeated or running pattern. The color scheme is unvaried from one motif to the next. As shown in the engravings in Cahier and Martin, this repetition of color seems to have been a characteristic of the borders in these windows, except that a horizontal orientation occurs just as frequently as the vertical. Border (B) is an example of the horizontal type. It, too, is fairly narrow in comparison to others of the period, but in the glazing of the clerestory at Saint-Remi the emphasis was upon the figure rather than on ornament. Like border (A), the color scheme of (B) is consistent from one motif to the next. The painted detail of the foliate ornament of which both of these examples are composed, and the stylized character of the leaves, relate them to other examples of the twelfth century.

Purchased from Michel Acézat, Paris, April 2, 1928.

Bibliography: Cahier and Martin, 1841–44, II, Grisailles, pl. E, 6; *The Year 1200*, 1970, I, no. 206; Grodecki, 1977, no. 78.

39. Foliate Capital

France, Reims, Abbey of Saint-Remi
Second quarter of the 12th century
Limestone
Height, 29.2 cm. (11 1/2 in.); width, 26 cm. (10 1/4 in.); depth, 22.8 cm. (9 in.)
09.SP.10

The circumference of the basket is lined with a weave of thick and leafy shoots arranged in alternating upright and turndown heart-shaped formations. Where the finely chiseled branches meet, they are joined by wide, flat bands covered with a hatched pattern. The broad, flame-like leaves have scalloped edges, and spines marked by pearly bands.

A 1923 invoice to Raymond Pitcairn from the dealer Lucien Demotte refers to a capital from Saint-Remi in Reims that undoubtedly is the present example. Elements of the early twelfth-century chapter house were reemployed in subsequent structures of the

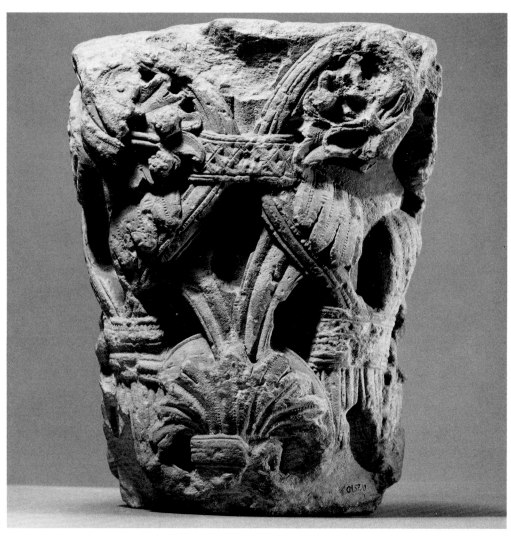

39

Gothic period, as well as in the seventeenth and eighteenth centuries. In 1952, a series of Romanesque capitals was discovered imbedded in the arcades of the south wall of the rebuilt chapter house of Saint-Remi (Bouxin, 1976, *passim*; Prache, et al., 1981, 167, pls. 74–78) that is directly related to the Pitcairn capital in terms of dimensions, formal design elements, and carving technique. However, current excavations of the cloister have failed to uncover further examples of the rich sculptural decoration such as was found in the chapter house. The present capital must have been removed in the course of the construction of the seventeenth- and eighteenth-century walls.

<div style="text-align: right">C. T. L.</div>

Purchased from Lucien Demotte, Paris, 1923.
Bibliography: Cahn, 1977, p. 73, fig. 10.

40. Enthroned Virgin

France, Île-de-France
Third quarter of the 12th century
Polychromed wood
Height, 109.2 cm. (43 in.)
Philadelphia Museum of Art, 150.1931.21

This statue was carved from a section of a tree trunk whose shape determined its rather elongated proportions and tubular silhouette. It is hollowed out in the back and the remaining wood is of inconsiderable thickness. The Child and a section along the left side of the image, embracing Mary's arm and shoulder, are missing, together with both hands, which must have been carved separately and held in place by dowels. In the area of the seat on the right side of the statue, the flatness of the wood and the presence of nail holes suggest that parts of the throne also have been lost. The carving has suffered wormhole damage, especially around the Virgin's lap. Much of its surface is covered with a purplish color of murky effect, though remains of an older polychromy are visible in places.

The Virgin is seated in a pose of hieratic frontality. She wears a crown, placed atop a veil that is drawn over the shoulder in the manner of a cowl. The pliant, softly pleated garments and, more generally, the statue's appealing mixture of gravity and grace indicate that the sculptor was acquainted with the Early Gothic sculpture of the Île-de-France. The work was said by the dealer Lucien Demotte to have come "from the church of Brentel at Le Mans." Though no such toponym is recorded, the place-names Brestel, Bresteau, and Brette occur a number of times in the region of Maine, so that a mistranscription must be suspected. On the basis of style,

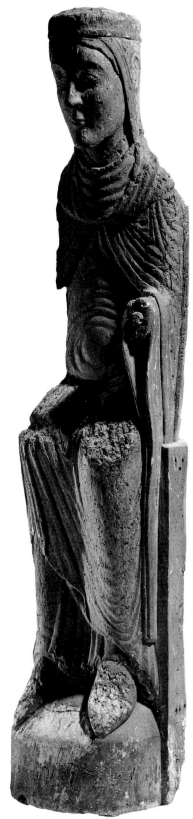

40

Ilene H. Forsyth (1972, fig. 186) associates the carving with a statue of the Virgin in the Walters Art Gallery in Baltimore (27.255). According to information that has recently come to light, this statue is believed to be from Précigné, from where it was later taken to nearby Sillé-le-Guillaume, some twenty-eight kilometers northwest of Le Mans. This makes more plausible the given provenance of the Pitcairn Virgin, at least so far as a connection with the region of Le Mans is concerned.

Purchased from Lucien Demotte, Paris.

Ex collection: Adrien Moreau-Néret, Paris.

Bibliography: *Art News*, March 1, 1930, 6; Réau, 1930, 8–9; Demotte, 1932, 307–8; Glass, 1970, 57; I. H. Forsyth, 1972, 201–2, no. 107; Cahn, 1978, 77, no. 1; Lemeunier, 1981, 1–3.

41. Fragment of a Corpus of the Crucified Christ

Northern France (?)
Last quarter of the 12th century
Polychromed wood
Height, 88.9 cm. (35 in.); width, 19 cm. (7 1/2 in.)
Philadelphia Museum of Art, 47.1931.4

Christ is crowned and wears a clinging loincloth (*perizonium*) tied at the waist in a prominent knot. His slightly inclined head is turned to one side, as is the lower part of his body. The arms, lateral sections of the torso, and the bent legs from a point below the knee are lost. The back is hollowed out. The torsion of the body, the supple drapery, and the character of the head—surprisingly well preserved and, perhaps, somewhat worked over—point to a comparatively advanced date. A fragmentary wood sculpture of the Virgin and Child in the Fogg Art Museum (I. H. Forsyth, 1972, 197–98, no. 102) presents some comparable traits of facial and garment structure, but the present work has, for the moment, no clear parallels among the surviving scattered monumental wood carvings of the crucified Christ from twelfth-century France. Stylistically and chronologically, this carving falls halfway between an older group of figures that is tentatively assigned to Burgundy—such as the Christ from a Deposition, now in the Louvre (Inv. R.F. 1082); a work in the Musée de Cluny (Inv. no. 723); and a corpus, said to have come from Clamecy, recently acquired by The Cleveland Museum of Art (80.1)—and the later sculptures, dated about 1200, from a Crucifixion group in Sens Cathedral (Sauerländer, 1972, 419).

Purchased from Joseph Brummer, Paris, 1927.

Bibliography: *Pa. Mus. Bull.*, XXXI, March 1936, 3; Cahn, 1978, 77–78, no. 2; Verdier, 1981, 70–72.

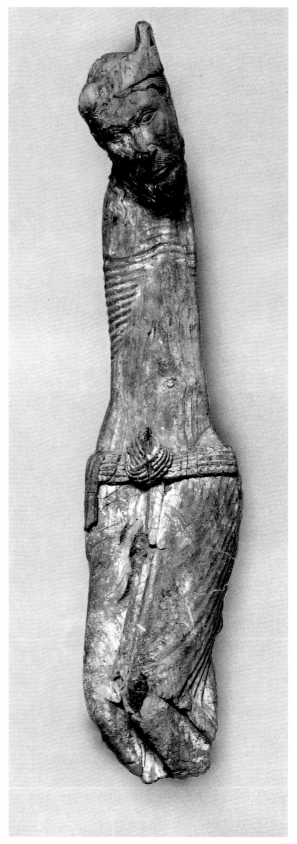

41

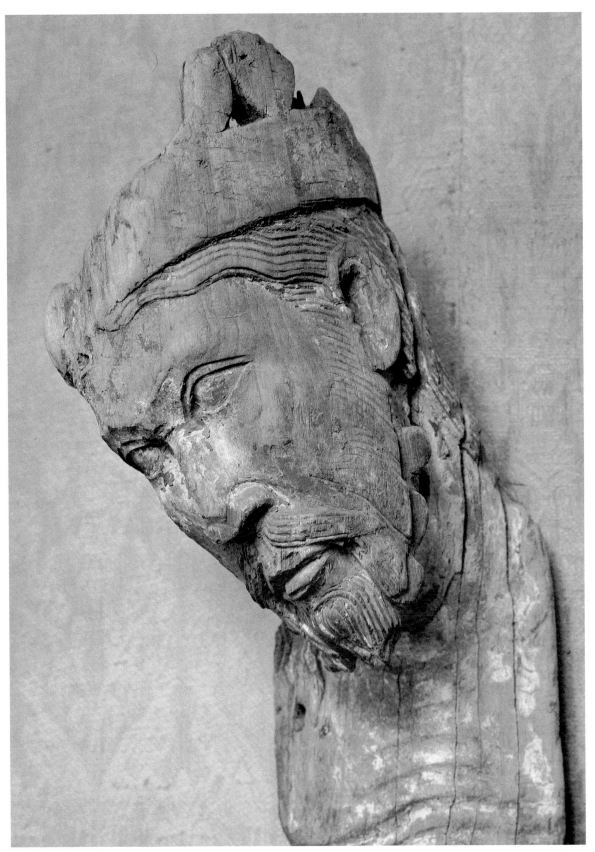

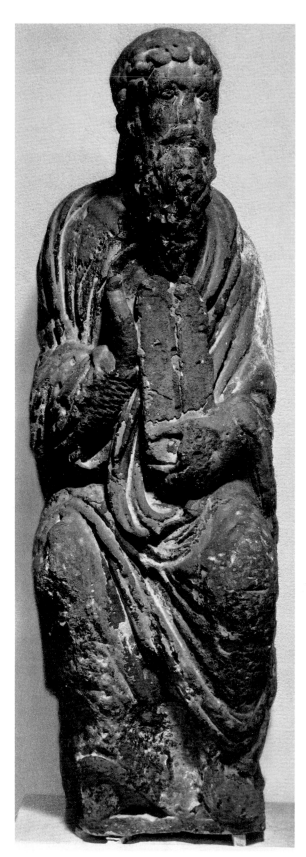

42. Moses

Northern France
About 1180–90
Limestone
Height, 125 cm. (49 $^3/_{16}$ in.); width, 42 cm. (16 $^9/_{16}$ in.); depth, 30.5 cm. (12 in.)
New York, The Metropolitan Museum of Art, Gift of Raymond Pitcairn, 1965, 65.268

Moses is seated on a simple, box-like bench, whose open ends are visible along the right side of the statue. He displays the tablets of the law and with his right hand gestures in speech or in blessing. The surface of the carving, which shows traces of a murky film of paint (?) or residue, is battered and weakened. In addition to the part of a cusped halo that can be seen at the back of the figure's head, there is also an iron ring and, on the left side, a large hole presumably made to facilitate handling and mounting. The statue's function, date, and the localization of its origins are as yet unresolved, though the work is said to have come from Chartres. It has been linked with another seated prophet in The Metropolitan Museum

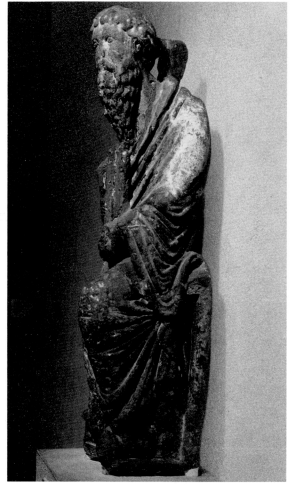

42

of Art (22.60.17), which has the same dimensions and given origin. The style of the drapery of this latter figure is more tense and dynamic in its organization and is only marginally similar to that of the Moses. José Manuel Pita Andrade (1950–51, 389 ff.) has attributed the Cloisters statue to a follower of Master Mateo, who carved the Pórtico de la Gloria of the cathedral of Santiago de Compostela (1188). Pita Andrade associated the work with the choir screen of the cathedral, dismantled in the seventeenth century, fragments of which are now incorporated in the Puerta Santa on the eastern flank of the basilica. The style of the carving also has been compared with the sculpture of San Vicente in Avila, which is thought to be somewhat older than Mateo's work at Compostela (Los Angeles and Chicago, 1970, 105). These connections do not seem to be sufficiently precise to establish with certainty a Spanish origin, and the relationship to Master Mateo is more a question of common models and prototypes than a direct stylistic affinity. While the condition of the statue complicates the determination of its date and attribution, its general features permit at least some broad observations concerning these issues. Life-size seated figures are a common occurrence on church façades in the Poitou, where they are positioned on corbels enframing windows or in arcades, as at Notre-Dame-la-Grande in Poitiers. In the Île-de-France the same phenomenon also occurs, but less frequently, as at Bertaucourt and in Châteaudun (Lapeyre, 1960, figs. 5, 10, 36, 38). The Moses conceivably might have been part of a façade, in a similar context.

The statue cannot have originated before the 1170s. The bulky yet pliant drapery that cloaks the figure belongs more to the classicizing phase of *détente* inaugurated at Sens Cathedral (after 1184), and continued at Notre-Dame-de-Paris (about 1200). The elongated proportions of the head and the handling of the beard point to the same ambient. Some elements of the formal language of the Moses might be compared to the Job relief carved on the buttress of the central portal of the west façade of Notre-Dame. However, the construction of Moses' ample drapery still reveals a tension in the way the folds radiate around his right arm and left knee that echoes the stylistic tendencies of the 1170s in Mantes and in the Porte des Valois at Saint-Denis; it also recalls the type of drapery of the Virgin and Child (of about 1180) placed on the trumeau of the central doorway of the cathedral of Notre-Dame in Noyon (Senlis, 1977, no. 41).

W. C., C. T. L.

Purchased from Joseph Brummer, Paris (?).

Bibliography: *Art News*, March 21, 1931, 33; *The Arts*, 1931, 477; Pita Andrade, 1950–51, 389 ff.; Los Angeles and Chicago, 1970, 104–5, 256, no. 47.

43. Synagogue, from a Typological Redemption Window

France, provenance uncertain
About 1190–1200
Pot-metal glass
Height, 57.5 cm. (22 5/8 in.); width, 40 cm. (15 3/4 in.)
03.SG.25

The figure of Synagogue, with bound eyes and dressed in a yellow gown and a green cloak and shoes, bends under the weight of her broken lance. The background of the medallion is blue, encircled with a band of red. A white vine defines the edge of the medallion and the quarter-circles that once surrounded the two adjacent scenes in the window. A cluster of yellow berries, and green and blue leaves, sprout from the vine, against a red background. The border, separated from the background by a blue edge fillet, is composed of similar ornament that contains alternating yellow and murrey leaves and green bosses. Small palmettes on blue glass comprise the painted edgings of the major scenes. The piece is in almost perfect condition and has even preserved the back painting that was applied to the glass to reinforce the modeling of the front surface.

This panel was purchased in 1929 from Lucien Demotte, after it had been exhibited in New York (Demotte, 1929, no. 6). Demotte claimed that the piece came from "the collection of M. Marchand, a restorer of the abbey church of Saint-Remi in Reims from which the panel was removed, after the war of 1870." This does not agree with the historical fact concerning the restoration of the glass at Saint-Remi, since the abbey church was untouched by the Franco-Prussian War and the restoration then in progress was necessitated by neglect. Furthermore, though the names of several of the restorers who worked on this campaign are known (Prache, 1981, 148), there is no mention of a Marchand. It is possible that tradition confused the name with that of Maréchal, a glass painter from Metz, who was responsible for the reglazing of the west façade of Saint-Remi that took place during the major restoration of 1850–75.

If the Synagogue panel originally came from Saint-Remi, its scale indicates that it must have been contained in one of the lower windows of the church and its subject suggests that, as part of a Passion window, it would have been accorded the central bay of the axial chapel of the choir. There is, however, no proof of this, because the stained glass of the chapels had been removed in the eighteenth century before any written descriptions of the windows existed (Prache, 1978, 72–73). It is not known whether this glass was destroyed or whether it was stored away in

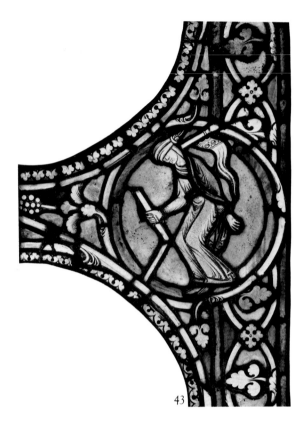

43

19. Border section from an unknown window, possibly from Reims. 13th century. Pot-metal glass. Height, 64.2 cm. (25¼ in.); width, 25.3 cm. (10 in.). The Metropolitan Museum of Art, New York, The Cloisters Collection, 1978.408.1

the church. Accounts that predate the nineteenth-century restoration (Simon, 1959, 15) indicate that fragments of the glazing were found on the flooring of the galleries, and that some were salvaged by a local sculptor, but whether these were scraps that had fallen out of the gallery windows or pieces that had been discarded from the chapels is impossible to determine. The most conclusive evidence against a Saint-Remi origin for the Pitcairn panel is its size. The shape of the piece indicates that it was made to fill half of an opening. Since the panel is less than sixteen inches wide, the window for which it was made was quite small. The chapel windows at Saint-Remi, on the contrary, are large, measuring well over a meter in width.

In a forthcoming article, Madeline Caviness (1982, in press) considers the possibility of another provenance for the Synagogue panel. Her studies-in-progress on the glazing programs at Saint-Remi, the cathedral of Soissons, and the church of Saint-Yved in Braine investigate the lost windows from Braine that were removed in 1815 when the church was cited for demolition and later were partially reused in the choir of the cathedral of Soissons (cf. no. 46). Soissons, which had been used during the Revolution as an ammunitions depot, had subsequently exploded in 1815, thus destroying many of the original windows. The extent to which the Braine windows were reemployed in Soissons has been debated. Édouard Fleury (1879, 119–25) believed that the north clerestory windows of the choir, as well as several of the chapel windows, contained glass transported from Braine. Caviness has discovered additional panels from Braine in other locations. She tentatively suggests that the Synagogue panel also may have come from Braine, but further study on this question will be necessary before conclusions can be reached.

Whatever may have been its provenance, the iconography of the Pitcairn panel relates it to other windows in northeastern France, and to a type that was known in Champagne from the middle of the twelfth century on. In several articles, Grodecki (1977, 120, no. 41, with bibl.) explained the origins of the typological Crucifixion in stained glass as stemming from metalwork and manuscripts produced in the Meuse Valley. In such windows, a centrally placed Crucifixion was surrounded by Old Testament types, in a prefiguration of Christ's death on the cross. This occurs in Châlons-sur-Marne (dating from about 1160) and in Orbais (from about 1190). Within this context, the figure of Synagogue, representing the Old Law, is vanquished by the Church (Ecclesia), symbolizing the New Law, through Christ's redemp-

118

tion of mankind by his sacrifice on the cross. In all probability, as a pendant to Synagogue, a panel of Ecclesia occupied a similar space on the opposite side of the window. The Crucifixion probably filled the central compartment directly above these two figures, with Old Testament scenes occupying the remaining spaces, as in Orbais (Grodecki, 1977, fig. 111).

Several stylistic traits relate this panel to stained glass in Champagne. Caviness (1977, 80–81) has suggested that the panel is a possible source of the French origins of the master who made the Petronilla window at the cathedral of Canterbury, and has further compared the Pitcairn panel with the Crucifixion window of Orbais. The drapery that hugs the limbs of the figure, spilling softly into multiple folds that turn back in ripples at the hemline, is repeated in Orbais. Comparisons can also be made with the early glass from Troyes—particularly the use of light yellow as a dominant color within the scenes—and with the later glass of the choir chapels in Troyes, such as the Saint Peter window, where decorative elements like the red edgings of medallions and painted fillets also appear. The ornament of the border and background of the Synagogue panel, while somewhat dry like that of Orbais, has a distinctive character that is different from these other examples. Synagogue is closest to two pieces of an unknown border (fig. 19) now in The Cloisters collection, and may well be the work of the same atelier. These borders, in turn, have been compared to ornament at Saint-Remi, in Canterbury, and in Chartres (the border of the Saint Eustace window); Grodecki (1965, 171–94) claims that the master of the latter window came from northeastern France. It seems fairly conclusive, therefore, that the Synagogue panel originated in Champagne, toward the southern part of the province—perhaps because of its similarities with the windows of Orbais and Troyes. Its connections with Braine should not be ruled out, particularly when its drapery style is compared with the somewhat more developed style of the Coronation portal of Saint-Yved, of 1205–15 (Sauerländer, 1972, pl. 74). The dating of the panel can be approximated only on stylistic grounds. It is probably closest to Orbais, contemporary with the Crucifixion window there that has been dated in the last decade of the twelfth century.

Purchased from Lucien Demotte, Paris, May 14, 1929.

Ex collection: M. Marchand, Reims (?).

Bibliography: Demotte sale cat., 1929, no. 6; Gómez-Moreno, 1968, no. 190; Caviness, 1977, 180–81, pl. 157.

see colorplate IV

44. Donor Figure, from an Unknown Window

France, provenance uncertain
About 1190–1200
Pot-metal glass
Height, 24 cm. (9 3/8 in.); width, 22.8 cm. (9 in.)
03.SG.11

A kneeling figure in a murrey robe, olive green mantle and stockings, and yellow shoes holds the yellowish-white model of a window. The foreground is white and the background blue. A red edge fillet surrounds the panel. Most of the leading in this piece is old. There is a heavy patination on the back of the glass. The murrey glass, the flesh tones, and the white glass are heavily corroded on the front as well, and there is evidence of the repainting of the outlines in these areas. The inscription PETRVS was added at a later date. Several cracks were mended with surface leads since the piece was first exhibited by Lucien Demotte.

Like the previous example, among others, this panel was published in Demotte's catalogue (1929, no. 4) of an exhibition of his stained glass that was held in New York in 1929, and this piece, too, was purchased by Raymond Pitcairn after the exhibition closed. The provenance was also given as the Abbey of Saint-Remi in Reims, from which the piece supposedly had been removed in 1870 by Marchand. Nothing further is known of the history of the panel.

If this small roundel originally came from the abbey church of Saint-Remi—of which there is no proof—it would have been placed in one of the lower windows of the choir. These windows had already been removed from the church before the Revolution. In keeping with the Maurist reform of the Benedictine Order and the resulting desire for more light in churches, Dom Pierre Chastelain, a monk at the abbey, wrote in 1757 (Reims, Bibl., ms. 1828, 21) that almost all of the windows had been glazed with white glass some years before. Unfortunately, interest in the windows at that time was so slight that Chastelain did not bother to describe them. Apparently, however, some of the borders remained in place until the bombardment of 1914 (Simon, 1959, 23). What happened to the figural parts of these windows is unknown but, based on accounts of the restoration of 1850–75, it is possible that some panels were stored or abandoned in the gallery of the choir (Simon, 1959, 23). Since no stylistic or iconographic comparisons can be made between existing glass at Saint-Remi and the Pitcairn panel, it is impossible to attribute the piece to Reims.

Caviness's forthcoming article (1982, in press) on the Gothic church of Saint-Yved in Braine places

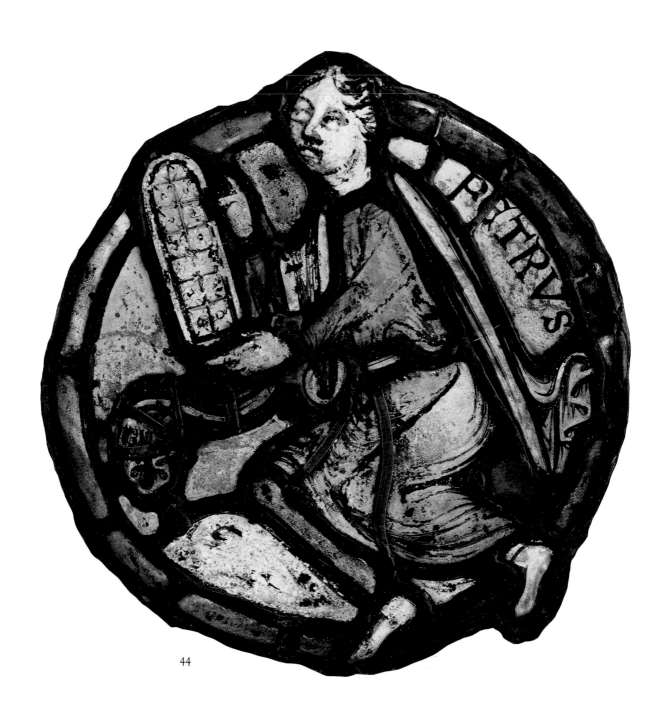

44

this panel among possible lost glass from this abbey. The traditional date for the beginning of the reconstruction of the church in Braine is based on a gift from Robert of Dreux in 1180. On his departure for the Holy Land, Robert gave the monks of Prémontré a large sum of money for the rebuilding (Herbelin, Paris, Bibl. Ste.-Gen., no. 855). Since the consecration of the church took place in 1216, however, Stanislas Prioux (1859, 12–15) suggested that a somewhat earlier date for the start of the building was more feasible. Caviness would support a date as early as 1175. If construction began in the choir, the eastern windows would have been ready for glazing by the last decade of the twelfth century, a date that would make the inclusion of the Pitcairn Donor stylistically possible. Further research will be necessary, however, before a definite provenance for the Donor panel can be established.

Though rare, donors of French stained-glass windows are not unknown. The earliest example is the Crucifixion window in Poitiers, from about 1165, in which Henry II and his queen, Eleanor of Aquitaine, offer their window to the cathedral (Grodecki, 1977, ill. 56). Of this donor type of window, the best known in northeastern France are those of the axial chapel in the collegiate church in Saint-Quentin, located thirty miles north of Soissons. Generally dated about 1220 (Little, 1981, 124), these windows are painted in the elegant style that, in the first decade of the thirteenth century, succeeded the more robust clerestory figures at Saint-Remi (Grodecki, 1965, 171–91). These donor figures, though of a later date, indicate that the type was known in the region, perhaps even as early as the 1180s, the time of the glazing of the central clerestory window in Braine (Fleury, 1879, 120–32).

The Pitcairn Donor Figure, because of its costume and the absence of a tonsure, appears to be a layman rather than a cleric. There is no suggestion of royal or military station in the clothing, which might help to define the figure's identity. The only resemblance to other examples is the red edging that surrounds the medallion, which is also found in the Synagogue panel (no. 43). In both cases, parts of the figure extend beyond this edging, suggesting that it is not the actual frame of the scene. In the case of Synagogue, the panel is complete and it is the encircling vine that delimits the composition. A similar frame may have been used in the Donor panel, which would establish a stylistic relationship between the two pieces.

Though the Donor panel is badly corroded in comparison to the condition of Synagogue, it is possible to discern certain stylistic traits in common. Both are very simple compositions in which a circular space is filled with a single figure. Yet, in both cases, it is the animated gestures of the figures that dominate the space, and the "windblown" drapery—the rippled edges of which are folded back—that acts as a space filler. Despite the corrosion and the defacement by overpainting and mending leads, the tiny molded folds of the skirt of the Donor and the sharp accent of his left knee repeat the fold patterns and anatomy of the Synagogue figure. The form of the cheek, intercepted by the line of the mouth and by the firm chin, is a feature common to both heads. Very probably, these two panels had a common provenance, but its determination will require further investigation.

Purchased from Lucien Demotte, Paris, May 14, 1929.

Ex collection: M. Marchand, Reims (?).

Bibliography: Demotte sale cat., 1929, no. 4.

45. Two Angels, from The Infancy of Christ Window

France, Clermont-Ferrand, Cathedral of Notre-Dame
1190–1200

Pot-metal glass

Height, 22 cm. (8 5/8 in.); width, 36.8 cm. (14 1/2 in.)

03.SG.10

Two angels with white wings are dressed in white robes and murrey mantles and are placed against a blue sky. There is a yellow star in the center of the scene. The head and the mantle of the angel on the right have been replaced.

This panel was purchased from Lucien Demotte in 1929 following its exhibition in New York. In the exhibition catalogue (Demotte, 1929, no. 2) the provenance is wrongly given as Angers, but the Gaudin collection, which is stated as its source, is undoubtedly correct. Félix Gaudin, originally from Clermont-Ferrand, was commissioned to undertake the restoration of the choir windows of the cathedral of Notre-Dame in Clermont between 1913 and 1922. The windows were removed from the church and the work was done in Paris, where Gaudin had established an atelier. Gaudin's restoration was particularly heavy-handed.

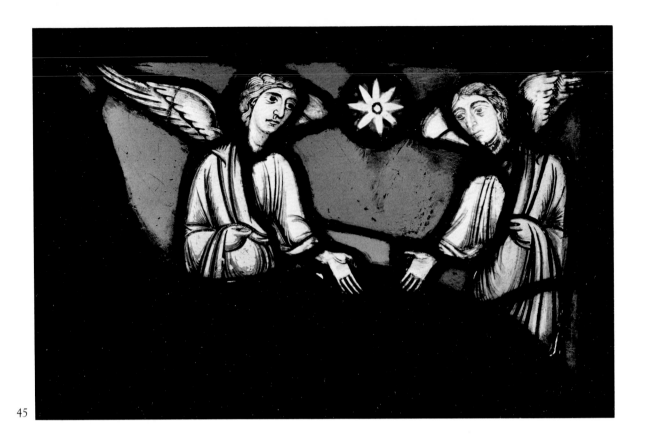

45

Eighty-one completely new panels were made to fill the gaps in the glazing program. An examination of the Pitcairn fragment reveals no reason why it should have been extracted from its original place in the Nativity panel in Clermont (Grodecki, 1977, fig. 168). The original head of the angel on the right (fig. 20) is now in the Metropolitan Museum, a recent gift of Mrs. Ernest Brummer. Gaudin was a capable imitator of the style of the twelfth-century panels in Clermont, but his restorations lack definition and strength when compared with the original head on the left of the Pitcairn piece. Iridescence on the back of the Pitcairn panel, moreover, indicates that the glass may have been cleaned with acid, a method often employed by restorers in the early years of this century.

In addition to cleaning and repairing the twelfth-century panels, Gaudin reorganized the scenes according to the traditional sequence of events. The previous restoration of 1837 had transferred the panels to the chapel of Saint Anne, but in no logical order (Paris, Arch. de la Dir. de l'Arch., 1910, dossiers for Clermont-Ferrand, report of the architect Victor Marie Charles Ruprich-Robert). This restoration was the result of a storm that severely damaged windows on the north side of the cathedral but does not seem to have harmed the Infancy cycle, the panels of which, at that time, had been used as stopgaps in several of the windows on the south side of the choir. The twelfth-century panels are now on the south side, inserted in the central window of the first radiating chapel of the choir, but their original location remains unknown.

The present cathedral of Clermont-Ferrand is traditionally thought to have been begun in 1248 (du Ranquet, 1913, 9–14). Robert Branner (1965, 141–42) has suggested 1262 as a more plausible date, with the completion of the choir in 1286. In either case, the twelfth-century glass must have been reused in the present Gothic choir. Most authors have considered that the glass came originally from the previous cathedral that was destroyed to make way for the Gothic structure (du Ranquet, 1932, 193–96), or from another church in Clermont (Grodecki, 1977, 190). According to documents, however, the previous cathedral was consecrated in 946 (Craplet, 1977,

31–35). This mid-tenth-century building would hardly have contained windows large enough to accommodate the twelfth-century glass. May Vieillard-Troïékouroff (1960, 199–247) has proposed, based on stylistic examination of the substructure of the former building and its resemblance to the choir of Notre-Dame-du-Port, a twelfth-century church in Clermont, that the former cathedral should be dated about 1095. A choir of this date could have contained those windows whose remnants are now reglazed in the chapel of Saint Anne.

The Infancy cycle is composed of scenes framed in circles and rectangles. Catherine Brisac (1978, 38–49), who has studied the glass most recently, believes that, originally, the window was composed, like the one in Chartres, in alternating square and circular panels, three scenes to a register. The iconography evidently followed the standard sequence of events, beginning with the Annunciation and concluding with the Baptism, both panels of which are still extant, although only ten scenes from the cycle remain. In contrast to Chartres, however, the iconography of the Clermont Infancy window was strongly influenced by Byzantine models. In the Pitcairn fragment from the Nativity, for example, the curving line at the lower edge of the piece represents the opening to the cave in which the birth of Christ takes place (Grodecki, 1977, fig. 168). The Nativity in a cave rather than a manger was standard Byzantine iconography in the twelfth century. Other Byzantine features of the Nativity scene are the presence of the angelic hosts and their gestures of pointing to the cave; the posture of Joseph, with his chin cupped in his hand; and the placement of the mattress, upon which the Virgin reclines, on the ground. Grodecki (1961, 292–94) has suggested that Byzantine influences might have spread to southeastern France from southern Italy, transmitted by manuscripts emanating from Cluniac priories. The earliest window—now at Champ-près-Froges—that is iconographically related to the Clermont glass was made originally for the Cluniac priory church in Domène.

Yet, the stylistic source of the glass appears to be Clermont, itself. Brisac (1974, 303–15) has convincingly demonstrated that a sacramentary (Clermont-Ferrand, Bibl. Mun., ms. 63) made in Clermont at the end of the twelfth century, probably for the cathedral, is clearly related stylistically to the glass, the individualized style of which can be defined even within the limited range of the Pitcairn fragment. Facial features, particularly the brows and the pupils of the eyes, are accented in black trace paint, a characteristic of the miniatures in manuscript 63 that Gaudin failed to imitate. The loosely waved hair of

20. Fragment of a head from the Cathedral of Notre-Dame, Clermont-Ferrand. 1190–1200. Pot-metal glass. Height, 5.9 cm. (2 5/16 in.); width, 4 cm. (1 9/16 in.). The Metropolitan Museum of Art, New York, Gift of Ella Brummer, in memory of her late husband, Ernest Brummer, 1977.346.5

the angel on the left and the double range of feathers in his wing are also apparent in the Christ in Majesty miniature of the manuscript (fol. 55). The most distinctive stylistic trait that unites the two Clermont examples is, however, the drapery. The sleeves of the angels terminate in soft spiraling folds, as does the sleeve of Christ in the miniature. When drapery is pulled across the limbs of the figures in the glass, as over the legs of the Virgin in the Nativity or the shoulder of the angel, it is rendered in a quite arbitrary fashion by hard, dart-like strokes. This convention is also found in the folds that cover the legs of Christ in the miniature. Shading techniques are distinctive in both examples. A translucent, watery mat is applied, sometimes in two layers of brushstrokes. The palmette ornament that defines the edge of the cave and the border of the Nativity is characteristic of all the glass in Clermont and that of other glass-painting centers of southeastern France. Ornament of this type can be recognized as well in ivories from the Ottonian period, and later in the Rhineland, also strongly influenced by Byzantine tradition. Byzantine influence was widespread in western Europe by the twelfth century but its impact was strongest in such southeastern French locales as Clermont-Ferrand.

Purchased from Lucien Demotte, Paris, May 14, 1929.

Ex collection: Félix Gaudin, Paris.

Bibliography: Demotte sale cat., 1929, no. 2; Grodecki, 1961, 289–98; Gómez-Moreno, 1968, no. 178; Grodecki, 1977, 190–94, cat. no. 53.

46

46. Seated King, from a Clerestory Window

France, Braine, Abbey of Saint-Yved
About 1190–1200
Pot-metal glass
Height, 168 cm. (66 1/8 in.); width, 70.2 cm.
(27 5/8 in.)
03.SG.243A–C

The king, seated upon a yellow and white throne with a blue footrest, holds a white scepter with a yellow fleur-de-lis and wears a gold crown. His murrey robe has a green neckband, and green sleeves banded in yellow and lined in red. His stockings are green and his white mantle is trimmed in blue. The background is red. The king has been composed of two different figures, which accounts for his elongated appearance and for the green sleeves in the middle panel of the glass. Much of this middle panel is replacement glass, as is the upper left side of the face—its most noticeable area of restoration.

This panel was purchased in 1922 from Bacri Frères. Its location prior to that time is unknown. Traditionally, it was thought to have come from the church of Saint-Remi in Reims. Recently, however, Caviness (1982, in press) identified it, together with several other figures in American collections, as part of the lost glass from the clerestory of the church of Saint-Yved in Braine. Little is known about the original glazing program there. Construction is believed to have begun in 1180, upon receipt of Robert of Dreux's gift. At the dedication in 1216 the building was presumably complete, with all its windows in place (Lefèvre-Pontalis, "Braine," 1912, 428–29).

Both Prioux's and Caviness's suggestions of a slightly earlier date for the start of construction are based on the homogeneity of the building. Because of the style of the windows, Caviness arrived at her date of 1175. Agnes, Countess of Braine and wife of Robert of Dreux, before her death had provided windows for the new church that supposedly were paid for by her mother, Isabelle, Queen of England. A description exists of the central clerestory window in the apse that showed Agnes and her husband, Robert, as donors, kneeling at the feet of the Virgin and Child (Fleury, 1879, 119–20). Apparently, this window was surrounded by Old and New Testament figures in the windows of the other clerestory bays. The abbey was pillaged by the Spaniards in 1650 and again in 1793 at the time of the Revolution. In 1815, it was declared a ruin and its demolition was ordered by royal decree. At that time, all of the glass—some 250 panels—was removed, and later all but the two easternmost bays of the nave were destroyed. The restoration that began in 1829 repaired and thus saved the choir and the transept of the abbey, but the windows were never replaced. Instead, some of the glass from Braine was

used to fill windows in the cathedral of Soissons during its restoration, which began in 1830.

The glass now in the second turning bay of the apse clerestory in Soissons is acknowledged to have come from Braine (Grodecki, 1953, 48–52). The enormous opening contains four superimposed seated figures surrounded by a wide border of roundels illustrating the signs of the zodiac and the labors of the months. The identity of these four figures is important to the reconstruction of the iconographic program of the Braine clerestory. Each of their names—Cainan, Aminadab, Salathiel, and Iechonias—is inscribed on bands above their heads and also included among the ancestors of Christ as recorded in the Gospels of Matthew and Luke. It would appear, therefore, that the clerestory in Braine, as in Canterbury, was devoted to a genealogy of Christ. The windows of the Braine clerestory, however, are much shorter than those of Soissons, so that it is doubtful that they could have contained more than two of these figures in each light. The original arrangement, therefore, may have followed that of Canterbury (Caviness, 1977, 101–15).

Because of the scale and the type of the Pitcairn King, it also must have belonged to the clerestory in Braine, even though the replacement of the background around the head has resulted in the loss of an identifying inscription. His crown and scepter, however, appear to be original, so that he must have been one of the several royal ancestors of Christ that included David and Solomon. The lowest figure of the group (now in the Soissons clerestory) also wears a crown and carries a scepter.

It is almost impossible to determine the original setting of the Pitcairn King. Like the ancestors now in Soissons, he is seated on a square throne with a footrest. The thrones in Soissons have high, square backs that show above the shoulders of the figures. The panels there terminate in pointed arches with lobes of foliage added to fill the corners. A bust-length figure of Jacob, also in the Pitcairn collection (03.SG.230) and possibly related to this series, is completed with similar foliate lobes. The colonnettes and the elaborately draped canopy above the king's head appear to have been added by the restorer. Both the head and shoulders and the lower portions of the king's figure have retained most of their original glass, enabling the style of the panel to be defined.

The pose is rigidly frontal, with only a slight turn of the left leg. The eyes are heavily outlined, without a break between the upper and lower lids, and the arch of the upper lid is repeated by the curving brow. The mouth turns downward at the corners, its expression accentuated by the protruding arc of the lower lip. The cleft chin is accented by the circular form below the mouth. The stylized character of this head is quite different from the clerestory figures in Reims, with their expressively furrowed brows, directed gazes,

and curling beards. The slender feet of the king are spread apart and turned outward, as are those of the ancestors in Soissons, but, unlike the feet of the clerestory figures in Saint-Remi, they are not firmly placed upon the footrest of the throne. There were, however, basic similarities of conception and figural type in the programs of Reims and Braine. In the two churches, double rows of figures were superimposed in each light, surrounding a central image of the Virgin. Painted bands of a contrasting color enrich the costumes of both groups. The glazing of the clerestory of Saint-Remi probably preceded that of Braine by a few years and undoubtedly was its model. Though the Braine figures are somewhat less elegantly conceived than those of Saint-Remi, they exhibit a new concept of monumentality that was formulated in Champagne at the end of the twelfth century and that would introduce the Gothic style in stained glass.

Purchased from Bacri Frères, Paris, December 15, 1922.
Bibliography: Caviness, 1982, in press.

see colorplate V

47. Two Roundels from a Rose Window

France, Braine, Abbey of Saint-Yved
About 1205–15
Pot-metal glass
(A) **Ver (Spring)**
 Diameter, 42.8 cm. (16 7/8 in.)
 03.SG.178
(B) **Grammar**
 Diameter, 42.6 cm. (16 3/4 in.)
 03.SG.179

(A) A standing male figure dressed in a green tunic, yellow cloak, and white hose holds a white bird's nest containing three yellow fledglings. In his other hand he grasps a white palm. The panel is inscribed VER (Spring).

(B) Grammar, holding a white switch and seated upon a white bench, is dressed in a greenish-blue cap, white collar, green overdress, and yellow underskirt with a red belt. Her pupil wears a white blouse, murrey skirt, and yellow stockings. He holds a white book. The inscription, which should appear above the boy's head, is lost.

Both medallions have deep blue backgrounds and are framed by modern borders composed of yellow, green, and red fillets; the back surfaces of the glass are heavily pitted and the fronts corroded. The paint is worn in places, especially in the head of the boy in the Grammar roundel.

125

47 (A)

47(B)

The panels were purchased in Paris in 1927 from Arnold Seligmann, who claimed that they had come from the collection of Julien Chappée of Le Mans. In 1924, however, they appeared in the sale of art from the collection of Raoul Heilbronner, a French dealer of German extraction, which had been sequestered by the French government from 1914 until then. The history of these pieces from 1830 until 1914 is unknown.

According to the recent research of Madeline Caviness (1982, in press) the two roundels formed part of the glazing of the north rose of the Premonstratensian Abbey of Saint-Yved in Braine, whose Gothic church, she believes, was begun about 1175. (The Premonstratensian order was relatively new, having been founded in 1119. Braine, itself, was the second daughter abbey of Prémontré.) While existing descriptions of most of the windows of Saint-Yved are vague, records of the subjects of the roses of the north and south transepts are quite precise and correspond to the compartments of the windows, as defined by their ironwork that is still in place. The tracery of each of these roses is the same; it consists of a central rosette with twelve lobes and twelve colonnettes that extend as spokes to the perimeter of the circular frame. Within each compartment framed by the colonnettes are three roundels: one on the smaller inside division and two on the rim defined by the lobes of the stone tracery. All of these circular panels are the same size. Each rose in Braine, therefore, was composed of thirty-six circular compartments plus the central rosette that could be filled with figural glass. The north rose contained a Christ in Glory in the center, surrounded by the twelve apostles in the inner ring and the twenty-four elders in the outer compartments. The subject of the central compartment of the south rose is not mentioned by Fleury, but the inner circle contained a calendar composed of the signs of the zodiac and the outer ring was filled with the labors of the months and the Virtues and Vices (Fleury, 1879, 119). Yet, Fleury's description does not conform to the remains from this rose now in the second bay of the north clerestory window of the choir of Soissons Cathedral. It also does not conform to the Pitcairn panels that, supposedly, were once installed in the north rose in Braine. Both Édouard Fleury and Eugène Lefèvre-Pontalis ("Braine," 1912, 434), however, depended upon secondhand accounts for their descriptions of the glass in Braine, since all had been dismounted by 1820. Of the 260 panels that were removed, only forty were reused in Soissons. The rest had disappeared, until Caviness's current research led to a number of discoveries in various collections, including Bryn Athyn. (A list of Caviness's Braine identifications is given in her forthcoming article.) Of the panels from Braine that are now in the clerestory in Soissons, set as a border in the window surrounding the ancestors of Christ (no. 46), twenty-eight are roundels presumably from the rose windows. Most of these are of zodiac signs or labors of the months but some are angels holding instruments of the Passion, and seven are representations of the liberal arts. Since the liberal arts would have no place in an apocalyptic rose, or in a Last Judgment rose—mentioned by Fleury as the subject of the lost west rose of Braine—they must have come from the south rose.

Had Braine followed the disposition of the slightly earlier rose of about 1205 in Laon, the liberal arts would have filled the north rather than the south rose. In medieval buildings, however, there seems to have been little conformity in the placement of this encyclopedic or cosmological type of rose window: the one in Notre-Dame in Paris (of about 1230) is on the west façade; that in Lausanne, only slightly later in date, is above the south transept; and in Chartres the lancet window (of about 1220) containing these signs is in the ambulatory of the choir. The most complete sculptural representation of cosmological scenes is on the socles of the west portals of Amiens (of about 1220). It is possible, however, that the encyclopedic rose in Braine, following Laon by less than a decade, could have been the first of the fully developed stained-glass windows of this type.

The iconography of the south rose of Braine, based on the two panels in the Pitcairn collection, must be reviewed in the light of early descriptions of the glass. Twenty-four panels are now in Soissons, including the twelve signs of the zodiac that Fleury placed in the inner ring of the rose, some of which are heavily restored; two are in Bryn Athyn; and one, known from a photograph (Heilbronner, 1924, no. 96), is now lost. (The Pisces that Ellen J. Beer notes as severely restored [CVMA, 1956, comp. pl. 15] is, in fact, virtually modern. The original of this panel was in the Heilbronner sale, but its present whereabouts are unknown.) Only four of the initial twelve labors of the months remain in Soissons but there is no trace of the Virtues and the Vices mentioned by Fleury. It would seem, therefore, that his source confused the seven liberal arts with this series. Since Music is included among the liberal arts in Soissons, as she was in Laon, there would have been eight in the series originally; seven are still in Soissons and the eighth, Grammar, is now in the Pitcairn collection. This would have left four remaining compartments in the south rose of Braine to be filled with subjects not identified in the early descriptions. One of these was the Ver panel now in Bryn Athyn. Another, Hyems, is inserted at the top of the window in Soissons. Since Spring (Ver) and Winter (Hyems) still exist, it is obvious that the four seasons, together with the liberal arts—and not the Virtues and Vices—completed the cosmological south rose of Braine. The

seasons were combined with the labors and the zodiac in Lausanne. The liberal arts alone were the subject of the north rose of Laon, which strongly influenced their representation in Braine, but the combination of all these elements seems to have been unique to the encyclopedic rose of Braine.

Ver is quite unlike the usual representations of Spring in medieval calendars as a standing figure holding flowering branches. Occasionally, however, a figure with a bird's nest does appear in the calendar for April and May (Webster, 1938, pls. 35, 89). Sometimes the symbolism is combined in these calendars and a figure is shown holding flowering branches as well as a nest. The cosmology was extensively developed in northeastern France by the tenth century, particularly in the mosaic pavements in Reims, and it is probable that the personification of Spring holding a bird's nest evolved as a result of the iconography of these pavements (Altet, 1980, 79–108). The iconography of the Grammar roundel is more typical, deriving directly from the north rose of Laon where she is also shown in profile view, seated on a cushioned chair with a broad footrest, holding her switch upright as she points with her other hand to her pupil seated at her feet. The boy is bent over the book held upon his knees. The only variation between the Pitcairn scene and that in Laon is that there are two pupils in the Laon north rose but only one in Braine. In the latter example, the area that would have been occupied by the second figure was taken up by the inscription (now lost). None of the liberal arts in Laon has an inscription, but all of those from Braine prominently display the names of the figures, usually in horizontal bands like that in the Ver panel.

The transept roses in Braine, together with the rose over the north transept in Laon, heralded a new classicizing style that prevailed in northeastern France for nearly a quarter of a century. It was much more sculptural than the style of the surface modeling and the decorative patterning of the folds of drapery seen in twelfth-century glass. Though both of the Pitcairn panels are more heavily weathered than the Braine panels that remained in Soissons, manifestations of this style can be seen in the solidity of the figures, the manner in which the roundness of forms is modeled by the drapery, and the recessive foreshortening of the features—especially the eyes, which follow the swell of the cheeks and brows. A clear distinction in size is made between the adult figure of Grammar and her youthful pupil, as is also the case in Laon. His face has the soft, rounded forms of childhood, while hers has the lean, angular planes of age. The pose of Grammar—her feet are crossed at the ankles—and the V-shaped form of her skirt also echo the Laon window. The Pitcairn panels display the beginnings of damp-fold drapery, particularly in the cloak of Ver, which is bunched elegantly over his shoulder and

sweeps, in an exquisite variety of pleated folds, across his arm.

Purchased from Arnold Seligmann, Paris, April 15, 1927.

Ex collections: Raoul Heilbronner, Paris (until 1914); Julien Chappée, Le Mans.

Bibliography: Heilbronner sale cat., 1924, no. 96; Gómez-Moreno, 1968, nos. 186–187.

48. The Annunciation, from an Infancy of Christ Window

France, Braine, Abbey of Saint-Yved (?)
1210–15
Pot-metal glass
Diameter, 50.8 cm. (20 in.) [without edge fillet]
03.SG.236

The angel, in a white robe and a murrey mantle, has green wings and a red nimbus. The Virgin, also nimbed in red, is dressed in red and green, with a murrey cloak, white veil, and blue shoes. She stands before a yellow and red brick wall at the right. The foreground is made of green, red, murrey, and white glass. Between the two figures is a yellow pot of red flowers above which is the white dove. The background is blue.

Most of the restoration in this panel is on the right-hand side of the piece, in the architecture and in the lower parts of the Virgin's robe. The red and white edge fillets have also been replaced.

The panel was acquired from Acézat in 1928. It had previously been in the Heilbronner collection, which was sold in Paris in 1924 after having been held by the French government since 1914. The whereabouts of the piece before then are unknown.

There is no actual evidence linking this panel with Braine other than its style. No early descriptions of the abbey church even mention its lower windows, much less their subjects. Yet, because of the subject and scale of this panel, most probably it would have been included in an Infancy of Christ window. The medieval dedications of the altars and chapels in Braine are known: The second chapel on the north side of the choir was consecrated to the Virgin and contained three windows, each more than a meter in width. Any one of these windows could have more than adequately contained an Infancy cycle with panels of the diameter of this Annunciation. Moreover, since the founding of the abbey, the Virgin had shared with Saint Yved the patronage of the church. It is more than likely, therefore, that windows depicting her life would have been included in the glazing program.

The iconography of this Annunciation has its closest parallel in the window of the same subject in

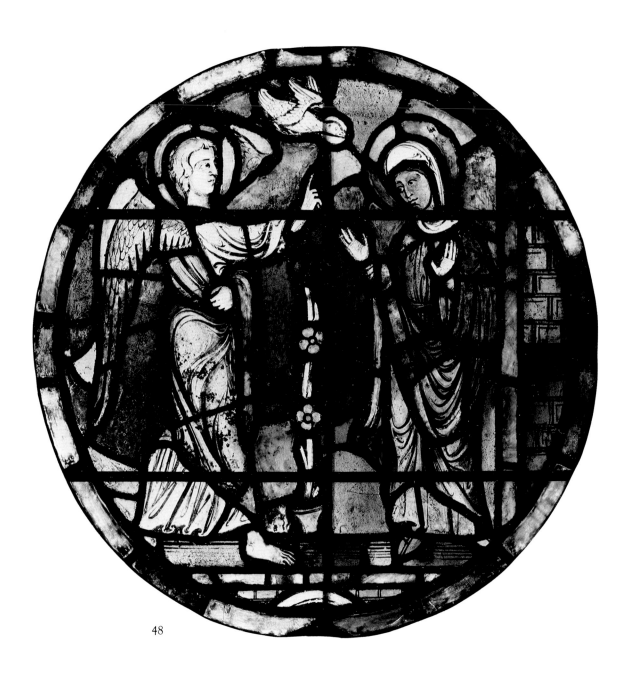

48

Laon, which may be only slightly earlier in date (CVMA, 1978, pl. 12). As in Laon, the angel strides toward the Virgin from the left, his arm raised in a pointing gesture of salutation. At Laon, however, the angel carries a flowering scepter in his other hand and his head is turned in three-quarter view. In both cases the Virgin stands on the right, facing front, and inclines her head toward the left. In the Pitcairn Annunciation her hands are raised, palms outward, in an attitude of acceptance; in Laon she clasps a book to her breast. In both panels the dove of the Holy Spirit descends toward the Virgin's inclined head; in Laon the dove issues from a cloud, and a clump of trees on the right grows from the tufted ground upon which the figures stand. The Pitcairn Annunciation contains a vase with a tall spray of roses that separates the two figures, but the architecture on the right has been replaced so that it is impossible to know whether the Laon motif was repeated.

In general, the Pitcairn Annunciation follows the formula developed in Western Europe during the twelfth century. The striding pose of the angel and his gesture is common in Ottonian art and even in art of earlier periods (Schiller, 1971, 33–62). Though the angel frequently holds a wand, he is just as often shown without it, particularly in interpretations in western France (Hayward, 1981, 131–32). The frontal pose of the standing Virgin and her raised hands are also in the western French tradition. Less common in French art is the presence of the dove, but it occurs frequently in German manuscripts and metalwork of the eleventh and twelfth centuries. What is most unusual, however, is the vase of roses and its prominence in both scenes. The tree, as a symbol of redemption, was not unknown in Italian and German Annunciation scenes of a much earlier date, but in both the Braine and Laon panels it has been replaced by the Marian rose, the symbol of the joys of the Virgin, that, together with the lily, would become a standard inclusion in later Annunciation iconography. The combination of German and French elements in the Pitcairn Annunciation and its counterpart in Laon are reminders of the crosscurrents of influence in Champagne in the twelfth and thirteenth centuries, reflected not only iconographically but also stylistically.

The damp-fold drapery style common to the sculpture of Soissons, Laon, and Braine is also characteristic of the glass from these three centers. In all probability, the style developed in the Meuse Valley, epitomized in the art of Nicholas of Verdun (Wixom, 1970, 93–99). From there it spread westward and was modified in the sculpture of Champagne. Just as the iconography of the Laon windows influenced that of the Pitcairn Annunciation, so the sculpture of Laon must be taken into account as a stylistic source for both the sculpture of Braine (Sauerländer, 1972,

21. *Angel*, from The Coronation of the Virgin tympanum, central portal of the west façade, Abbey of Saint-Yved, Braine. 1205–15. Limestone. Musée Municipal, Soissons

427–29) and its Annunciation panel. The contour-like folds that model the angel's leg or hang loosely over his extended arm could hardly have been conceived without the model of the archivolt figure from the northwest door in Laon (Sauerländer, 1972, ill. 50). The Laon sculpture of about 1195–1205 was, in turn, the source of the central portal in Braine (fig. 21) that was carved from 1205 to 1215, probably by the same atelier. The angel of the Coronation portal in Braine, less sharply carved and more subtle, is the counterpart in stone to the angel in the glass Annunciation panel. Though the Pitcairn angel's skirt, with its swinging folds, has been replaced, similarities in proportions, poses, features, design of the drapery, and, more specifically, in the soft curling locks of hair, leave little doubt that the painter of the Annunciation had studied closely and at firsthand the sculpture of the Braine façade. Nor is the comparison limited to the angels. The Virgin of the Coronation, though seated, repeats—in the tilt of her head and the cascading sagging folds of her mantle—features of the Virgin of the Annunciation. Cross-media references are often unconvincing for stylistic comparisons but,

49 (A) 49 (B)

in this case, there can be little doubt that the Cor-
onation portal and the Pitcairn Annunciation are
both examples of the mature style of Saint-Yved in
Braine. The intermediate step between Laon and
Braine in stained glass is apparent in the ambulatory
windows in Soissons, which must have been installed
shortly before the consecration of the cathedral in
1212. Both Philippe Verdier (1958, 4–22) and Louis
Grodecki (1960, 163–78) have identified remains of
this dispersed glass in collections here and abroad.
The angel who announces their approaching
martyrdoms to Saints Crispin and Crispinian, a panel
in the Corcoran Gallery of Art in Washington iden-
tified by Verdier (1958, fig. 1) with Soissons, is closely
related in style and type to the angel of the Pitcairn
Annunciation. The Soissons angel is more elegantly
drawn and more animated, but a new serenity of
mood, notable in the Braine sculpture, has also af-
fected the Braine glass. The glazing program in Braine
must have been in progress over several decades, with
probable breaks in the campaign during which re-
current waves of new influences from neighboring
monuments had their effects upon the style of the
glass. Of all the fragments that can be attributed to
this program, the Annunciation comes closest to in-
corporating the indigenous style that was adapted,
from among many outside influences, at the abbey
itself.

Purchased from Michel Acézat, Paris, April 2, 1928.
Ex collection: Raoul Heilbronner, Paris (until 1914).
Bibliography: Heilbronner sale cat., 1924, no. 92.

49. The Dead Rising from Their Tombs, from a Rose Window

France, Braine, Abbey of Saint-Yved(?)
1215–20
Pot-metal glass
(A) Diameter, 34.6 cm. (13 5/8 in.)
 03.SG.204
(B) Diameter, 34.3 cm. (13 1/2 in.)
 03.SG.205
(C) Diameter, 34.6 cm. (13 5/8 in.)
 03.SG.206
(D) Diameter, 34.6 cm. (13 5/8 in.)
 03.SG.207

(A) A nude male figure in profile, with a white
shroud, raises a green sarcophagus lid. The back-
ground is blue. The panel is in the shape of an
octafoil.

(B) A nude male figure in three-quarter view, with
a murrey shroud, raises the lid of a white sarcophagus,
against a blue octafoil background.

(C) A nude male figure with head turned upward,
wearing a white shroud, raises the lid of a green sar-
cophagus. The background is blue, the panel octafoil
shaped.

(D) A nude male figure, peering over his shoulder,
is draped in a white shroud; he raises the lid of a green
sarcophagus. An octafoil shape frames the blue back-
ground.

132

49 (C)

49 (D)

The substantial amount of restoration in the backgrounds of all of these pieces, and the considerable variation in the colors and textures of the blue glass—specifically, at the edges of the panels—make the octafoil shapes suspect. Those pieces of blue background in the interiors of the roundels, however, appear to be original. Moreover, a random lifting of the edge leads at several points on the exterior of the panels did not reveal any grozing of the glass, which would have been the case had the setting been medieval. The octafoil frames are, therefore, the result of a later restoration and adaption to a new setting. The figural parts of the panels are generally in good condition. Panel (A), except for a replacement of the lower part of the sarcophagus lid, is in an excellent state of preservation. In panel (B), one piece of drapery and the lower part of the lid are replaced. The figure in panel (C) is intact, except for the head, which has been reversed in restoration. Panel (D) is the least well preserved, but has retained the most of its original blue background. The head is a nineteenth-century restoration, as is the raised left arm.

These four pieces were acquired early in 1923 from Bacri Frères, from whom Raymond Pitcairn had purchased the King (no. 46) the year before. Nothing is known of their whereabouts prior to that time. Though no firm provenance for these panels yet can be established, they can be related on stylistic grounds to the stained glass of northeastern France that was produced in a variety of centers during the first quarter of the thirteenth century. Grodecki—who kindly provided his notes for the inventory of the Pitcairn col-

lection, made in 1967—was the first to suggest that these panels might be linked with the ateliers of Saint-Yved in Braine. When the windows from Braine were removed in 1820, much of the glass was subsequently reused to patch the damaged windows of the cathedral of Soissons. At first, the glass was installed there in complete disorder and with little regard for continuity or meaning. Guilhermy's notes of 1842 (Paris, Bibl. Nat., nouv. acq. fr. 6109, fols. 254–57) record the general disorder. By the 1860s, however, Édouard Didron had begun a restoration of the glass in Soissons, most of which was removed at that time (Caviness and Raguin, 1981, 193–94). The bulk of the actual work on the glass did not take place until thirty years later, under Didron's son, who was in charge of the restoration aided by Félix Gaudin and by Jean Leprévost, whose hand Grodecki sees in the restored head of panel (D). It is possible, therefore, that these four panels were among those from Braine that were "rejected" in the general reorganization and restoration of the Soissons windows that took place in the 1890s. Confirmation of provenance must await the research-in-progress by Caviness. If, however, these panels can be attributed to Braine, they are most likely to have been placed in the west rose at the time of—or shortly after—the consecration of 1216.

The west façade and all but the two easternmost bays of the nave of Saint-Yved were demolished following the sale of the abbey lands by royal decree in 1815. Demolition of the eastern parts of the church did not take place until 1832 (Lefèvre-Pontalis, "Braine," 1912, 428–29). According to Prioux (1859,

21), historian of the abbey, who claimed to have had in his possession a drawing of the façade made in 1820, the west rose of Saint-Yved was "in all points similar to that above the principal portal of the cathedral of Laon." If this description is correct, the west rose of Braine was designed with a central rosette surrounded by twelve lozenge-shaped compartments with a similar number of lunettes on the periphery. Though little original glass remains in Laon, that rose also must have contained a Last Judgment subject, as records of Braine show its west rose to have done. Large circular medallions fill each of the lozenge compartments of Laon, some of which contain old glass, while two smaller roundels are placed in each of the peripheral spaces, all of which are modern. This does not indicate, however, whether the original disposition of the window or its adaption at Saint-Yved included a single rather than double scenes in these outer compartments.

The iconography of Early Gothic Last Judgment rose windows varies considerably and is frequently combined with apocalyptic subjects. Often depicted are the twenty-four elders, as in Laon, but in Braine these figures already had been employed in the apocalyptic rose of the north transept. The most graphic of the Last Judgment roses are the earliest—those of Chartres (from about 1205–10) and of Mantes (about 1210), which include Christ as Judge, intercessors and witnesses, the Raising of the Dead, the Weighing and Division of Souls, the Damned and the Elect, Heaven and Hell, and angels with the instruments of the Passion. With only five surviving angels displaying instruments of the Passion in the clerestory window in Soissons—and these four figures of the resurrected dead remaining from the west rose of Braine—it is impossible at this state of our knowledge to reconstruct the iconography of the Braine west rose. One clue, however, among the sculptural fragments from the Abbey of Saint-Yved must be considered. Recently installed on the interior west wall of the church are sections of a Last Judgment that Willibald Sauerländer (1972, 479, pl. 73) has dated 1205–15, and has compared to contemporary work in Laon. He does not consider these fragments to be part of the portal sculpture of the west façade and has suggested that they might be remains of a choir screen. When compared with the stained-glass panels, it is interesting to note in the sculpture the graphic depiction of the Damned, the movement of the figures, and the intensity of their gestures. It is possible that, like the roses of Chartres and of Mantes and the Saint-Yved sculpture, the iconography of the west rose of Braine included similar pictorial themes.

The style of the four Pitcairn figures may also be compared with glass in Laon and in Soissons—

particularly with the Jesse Tree (no. 52) and Genesis windows in the Soissons clerestory that Grodecki (CVMA, 1978, 171) has dated as late as 1215–20. In these large-scale figures, the distinctive features, such as the sharp profiles with protruding rounded chins, as seen in Adam in the Original Sin panel of the Soissons Genesis, may be compared with the Pitcairn panel (A). Other traits in common among the Braine windows and those in Laon and Soissons are shared by the figures themselves: each of the noses is traced with a continuous line that begins at the narrow bridge and extends around the tip, the arched brows thicken at midpoint, and the eyelids are drawn as two separate lines with exaggerated pouches extending from the inner corners. The sinuous drapery that loops about the figures is also repeated in the Soissons glass, as are the curiously interrupted indentations of the fold lines (nos. 51 A, B). This is a different style from that of the choir glass in Braine, yet a style that became dominant in northeastern France in the second decade of the thirteenth century. If these four figures are the remains of the west rose of Braine, then they are examples of this Laon-Soissons style after it had crystallized into a formula. They can hardly be dated much before 1220 and, therefore, must have been among the last windows to have been installed in the glazing program at Saint-Yved.

Purchased from Bacri Frères, Paris, January 27, 1923.

50. The Offering of Grapes to a King, from an Unknown Window

France, Champagne (?)
About 1215–30
Pot-metal glass
Height, 55.5 cm. (21 7/8 in.); width, 40.4 cm. (15 15/16 in.)
03.SG.118

The scene is set in a double arcade of red arches with white pediments, blue spandrels, green capitals, and red colonnettes, against a blue background. The foreground consists of green and red strips, with corner ornament of blue-painted trefoils and red and white fillets. The central kneeling figure wearing a white mantle over a red robe presents a basket of grapes to a king, who wears a gold crown, green robe, and murrey mantle. On the left is a standing figure in a murrey cloak and green robe.

Most noticeable among the restored areas in this panel is the head of the standing figure on the left, which has been repaired with glass not original to the piece. In addition, much of the foreground and the

50

lower right side of the king have been replaced with modern glass.

The provenance of this panel is unknown. A tentative attribution to Soissons (Gómez-Moreno, 1968, no. 189) is unconfirmed, yet certain stylistic traits do link this panel to northeastern France.

The subject of the panel is equally puzzling, but if one disregards the tonsured head on the left, which has been confirmed by examination to be a replacement, the possibility that the scene belonged to a monastic legend is eliminated. Since none of the figures is nimbed, the story may derive from the Old Testament. Of primary significance in the interpretation of its iconography are the kneeling figure with the bowl of grapes and the enthroned king. Such an incident occurs in the story of the Egyptian Joseph (Genesis 40:1–21) during his imprisonment at the hands of Potiphar, whose wife had falsely accused Joseph of seduction. While in prison Joseph became a warden and had in his charge the butler and the baker of the Pharaoh. Each of these men had a dream that Joseph interpreted. The butler dreamed that a vine that he held in his hand grew into three branches that budded and brought forth clusters of grapes, which he plucked and squeezed into the Pharaoh's cup. Joseph told the man that the three branches signified three days, and that upon the third day he would be freed to resume his post as chief butler to the ruler, but that the baker, on the third day, would be hanged. It happened as Joseph had predicted, and the butler was restored to his former place in the palace of the Pharaoh. It is this scene that the Pitcairn panel probably depicts. The grape clusters in the bowl held by the kneeling butler are undoubtedly a reference to his dream and to Joseph's interpretation of it. The scene might also illustrate a later incident in the story when the butler, who had forgotten his promise to ask for Joseph's release, remembered his transgression and brought Joseph to the Pharaoh. If this is the case, then the third figure in the panel may be Joseph.

The Old Testament account of the Joseph story, associated as it was with both the death and resurrection of Christ, was one of the most frequently portrayed of biblical histories. Because of the narrative possibilities that stained glass afforded, and the number of scenes that could be included in a window, the story of Joseph was often incorporated in thirteenth-century glazing programs. In Bourges, the history is compacted into sixteen scenes; in Chartres, there are twenty-eight; but the fullest treatment of the account is in Poitiers, where two complete windows are devoted to Joseph.

The Joseph story does not seem to have been depicted in northeastern France, although it did appear in Burgundy, at Auxerre. The glazing program of the ambulatory of Soissons seems to have concentrated upon local saints or those especially venerated in the diocese, while that of Laon was devoted to the life of Christ; Saint Stephen, protomartyr; and the miracles of the Virgin. Nothing remains of the ambulatory glazing in Reims, either at Saint-Remi or at the cathedral, nor do records indicate the subjects of these windows. At the collegiate church of Saint-Quentin only windows devoted to the lives of Christ and the Virgin still exist. In Braine, however, there is at least a hint of what the glazing program was like. Prioux (1859, 23), repeating earlier accounts, reported that "a double row of beautiful windows ranged about the nave and the choir. This church was lighted by superb stained glass ornamented with subjects taken from the Old and the New Testament."

Often, the windows of a chapel contain legends related to the saint or holy personage to whom the altar is dedicated, or they recount the life of the chapel's patron. The chapel windows in Braine present a special problem. The founder of Braine, Saint Norbert, was not canonized until the fifteenth century. The chapel dedicated to him was the first on the north side of the abbey church, but the pictorial account of Norbert's life did not develop until the fifteenth century, probably coincidentally with his canonization. Though Saint Yved was the patron saint of the abbey, as well as Bishop of Rouen in the ninth century, he, too, is not represented in the art of the thirteenth century. The chasse containing his relics, apparently transferred from the chapel of the château of Braine soon after the consecration of the church, stood on the high altar before the Holy Sepulcher. The first chapel on the south side of the choir was the burial chapel of the counts of Braine who were related to the counts of Dreux and were the founders of the church. The chapel of the Virgin was the innermost on the north side of the choir, while that dedicated to Saint Sebastian was its pendant on the south. It is not surprising, therefore, that the iconographic program of the Braine windows was probably more generalized, rather than specifically related to the abbey. Within such a generalized program, the story of the Egyptian Joseph would have had a logical place.

The scene represented in the Pitcairn panel is not repeated in any of the other windows that recounts the Joseph story. The incident of the interpretation of the dream is omitted entirely in Bourges (Cahier and Martin, 1841–44, II, pl. X), probably for lack of space. It is alluded to in Chartres (Delaporte, 1926, II, pl. CLXIII) in the prison scene, where the butler displays for Joseph a cluster of grapes in one hand and a bowl in the other. In the second window in Poitiers the story is told in four scenes (Grodecki, 1951, 152) that include the interpretation of the dreams, the

restoration of the butler to his post, the hanging of the baker, and the presentation of Joseph to the Pharaoh. In Poitiers, the Pharaoh is seated at a table and the butler is serving him wine, but the cup is not shown in the presentation scene. Since there is little or no conformity in the iconography of the Joseph story in windows of the thirteenth century, the lack of a prototype for the Pitcairn panel does not exclude its possible inclusion in such a cycle.

The style of this panel, however, relates it to glass produced in northeastern France during the first third of the thirteenth century. The facial types of the two original heads already have been seen in the panels from the rose windows of Braine (nos. 47, 49). A similar delineation of the features, including the presence of pouches below the eyes; the use of thin lines to define the bridges and the pinched nostrils of the noses; the rounded protruding chins shown in profile; and the softly curling locks of hair, all appear in the other examples from Braine. The drapery falls in segmental folds like the drapery of the Resurrected Dead from Braine (no. 49 A–D), but the drawing is more summary in this panel. The scene is set under a double arcade, as was the lost Legend of Saint Blasius from Soissons, panels of which Grodecki has identified in Paris (Grodecki, 1960, 173–78) and which may be dated as late as 1220. The shape of the Pitcairn scene indicates that it was originally part of a cluster-medallion window, of a more complex shape than either the type used in Soissons or Laon. All of these characteristics point to a later date for this window and a possible origin in one of the lower bays in Braine.

As mentioned previously (cf. nos. 44, 46–47), though construction at Saint-Yved in Braine was under way by 1180, Caviness (1982, in press) and Prioux (1859, 12–15) support an earlier date for the beginning of the rebuilding (Caviness proposes 1175). According to Prioux, who quotes the sixteenth-century chronicler Matthieu Herbelin (Paris, Bibl. Ste.-Gen., no. 855), the consecration of 1216 was precipitated by the advanced age of Agnes, Countess of Braine, the benefactor of the abbey, who wished to see the monument finished before her death. Though the structure was probably complete in all its parts by this date, certain embellishments were still to be added. Agnes's son Robert II continued to make donations to the fabric, until his death in 1218. There is every reason to believe, therefore, that some of the windows, including a Joseph cycle, may have been completed in the decades following the consecration—the last examples of the style that had dominated the Aisne region for a quarter century.

Bibliography: Gómez-Moreno, 1968, no. 189.

51. Two Scenes from The Legend of the Three Knights, from The Life of Saint Nicholas Window

(A) **Three Knights Condemned to Death by a Consul**

(B) **Saint Nicholas Pleads for the Three Knights**

France, Soissons, Cathedral of Saint-Gervais-et-Saint-Protais
1210–15
Pot-metal glass
Height, each, 54.6 cm. (21 1/2 in.); width, each, 39.3 cm. (15 1/2 in.)
New York, The Metropolitan Museum of Art, The Cloisters Collection, 1980.263.2,3

(A) The consul, seated upon a low red throne with a white cushion and a blue footstool, is dressed in a green surcoat, a yellow tunic, and a pink mantle. His cap is red and his shoes are light blue. He gestures threateningly at the knights who stand to the right. The knight in front is bareheaded and dressed in white chain mail with a green tunic and shoes and red stockings. His companion on the right wears a helmet of blue chain mail, a yellow tunic, and a pink surcoat. The hand pointing to the consul belongs to the third knight, whose head is barely visible between the other two. The setting is a double arcade of white arches with green capitals and red brickwork in the spandrels, against a blue background. The inscription reads: [N]ICO LAVS·PRESES MILITES (Nicholas takes the soldiers).

(B) The setting of the second scene is the same as the first, except that the arches are red and the brickwork is white. Here, the consul is seated upon a green throne with a red cushion and his costume includes a white cap and mantle worn over a murrey robe. Saint Nicholas is robed as a bishop in a white miter and alb, a green dalmatic with gold orphrey, and a pink chasuble. His halo is red. He is being restrained by one of the consul's servants on the right, dressed in a green tunic and shoes with a red cloak and stockings.

Except for the insertion of the piece of pink drapery—reused from another part of the window—at the shoulder of the knight in panel (A) and the replaced head of the servant in panel (B), these pieces are in excellent condition. Both panels have been cut down slightly: (A) on the left side and (B) on the right.

Unfortunately, there is no information in the Pitcairn correspondence regarding these exceptional panels. They were probably bought before 1930, since they were installed in a window of Raymond Pitcairn's house in Bryn Athyn, which was being glazed at that

51 (A)

51 (B)

time. Most of the large purchases of stained glass prior to that date can be traced, except for foreign purchases made before 1922. It is possible that these two pieces were among the latter group. The two panels were acquired by The Cloisters museum in 1980 from the Glencairn Foundation.

The attribution of these two pieces to the cathedral of Soissons is based upon style. No window depicting the legend of Saint Nicholas is known nor are there records of one having been in the church. Considering the tragic history of the Soissons glass, however, a lost window would be possible. Carl F. Barnes, Jr. (1967, 263) has estimated that in the course of the centuries over ninety percent of the original program has disappeared. Only five windows remain in the clerestory hemicycle and one of these comes from Braine (no. 46). The lateral clerestory bays may have contained ornamental glass; it is recorded as having existed on the north side of the cathedral (Fleury, 1879, 123), and is known from the engravings of Cahier and Martin (1841–44, II, pl. F, 1, 2, 4, 8), which resemble the "grisaille" windows in the gallery of Saint-Remi in Reims. Fragments of legendary cycles exist in the radiating chapels of Soissons but there are more pieces in collections in Europe and America than remain in the church (Grodecki, 1953, 169–76; idem, 1960, 163–78; Verdier, 1958, 4–22). The central chapel of the Virgin has been entirely reglazed with glass from the nave (Barnes, 1971, 458–59). There is no record at all of the glazing of the single bays of the eight side chapels of the choir, though remains of windows that correspond to the saints to whom these chapels are dedicated strongly suggest that these, too, contained stained glass. Furthermore, there are a surprising number of donations of stained-glass windows, given by laymen as well as clerics, recorded in the Obituaries of the cathedral (Dormay, 1663–64, I, 194). Many of the windows now in the cathedral choir are not in their original locations.

Though the beginning of the construction of the cathedral is unrecorded, the canons took possession of the new choir on May 13, 1212. (The inscription that recorded this event was published by Lefèvre-Pontalis [1912, 319].) Presumably, this part of the structure was complete then, since the wood for the stalls and the roof timbers had been provided by the Countess of Braine. Most probably, some of the windows were already in place, as well; according to Barnes (1967, 265), the radiating chapels were glazed and in use by 1208–9. In 1567, the Huguenots took over the cathedral but it is uncertain what damage they may have done to the glass. Fleury (1879, 104) stated that, beginning in 1789, the three central chapels were glazed in white glass, but this may have been a temporary measure, since the descriptions of the windows in the chapel of the Virgin are of a later date. The Revolution does not seem to have done much damage to the windows, but in 1815 two powder

138

magazines located near the south flank of the cathedral exploded, shattering all the windows on that side of the building, including the west rose. It was during the general reorganization of the glass following this disaster that windows from Braine were used to patch what remained of the cathedral glass. In the war of 1870, Soissons was shelled by the Germans for thirty-seven days, yet restoration was not begun until 1882, when the clerestory windows were removed and stored in the south tower, where they were kept for four years. A thorough and radical restoration of the glass was begun by the younger Didron in 1890. It was probably during this restoration that many of the original panels were discarded in favor of new glass. During World War I, a lancet from one of the radiating chapels disappeared and considerable damage was done to other windows.

Early descriptions of the glass in Soissons are generalized and tend to concentrate on particular windows (Fleury, 1879, 122–25; de La Prairie, 1858, 144, 168), rather than describing the glazing as a whole. Too much had already been lost before such cataloguers as Guilhermy visited the cathedral in the middle of the nineteenth century to provide a detailed account of the windows. Remains of a number of windows devoted to saints venerated in the diocese of Soissons already have been identified by Verdier and Grodecki, but there are also panels from windows that evidently depicted legends of saints of more universal popularity, such as Eligius, Giles, and Blasius (Doyen, 1953, 24; Grodecki, 1960, 173–76). None of these saints had altars in the cathedral, so far as is known. It thus would have been unusual that a cathedral with so many windows in its choir did not include one dedicated to the life of Saint Nicholas, among the most universally admired saints in the Christian calendar. Saint Nicholas was not unrecognized in Champagne by the early thirteenth century. There was a window in Troyes devoted to him (*The Year 1200*, 1970, I, no. 205) and Abbé Tourneur (1856, 88–90) noted his image in the clerestory of Saint-Remi in Reims in 1855. The resemblance of the two Pitcairn panels to the many other undocumented pieces that have been attributed to Soissons, therefore, must be considered.

The two scenes depicted in these panels are from the early life of Saint Nicholas and are rarely included in windows devoted to the legend of the saint. Considering the size of the windows at Soissons—more than six meters in height—in comparison to that of the Pitcairn panels, an extensive cycle could have been accommodated in any one of the choir apertures. The scenes are recorded in *The Golden Legend* and concern a corrupt Roman consul who, during an uprising against the emperor, condemned three innocent knights to death for treason, as shown in panel (A). In panel (B), Saint Nicholas, who has heard of the consul's action, forces his way past the guards, into the palace of the consul, upbraids the wicked man, and demands the freedom of the three knights. He pleads their cause so successfully that the three soldiers are released. The inscription in the first panel, which appears to be original, does not fit the scene and may have come from a third scene in the series that showed the release of the knights in the care of the saint.

The rectangular shapes of these panels and their arcaded settings are unusual in glass of the first quarter of the thirteenth century, when clusters of medallions were the more usual design for windows. This type of composition seems to have been employed in another window in Soissons, panels from which have been identified by Grodecki (1960, 174–76) in the Musée Marmottan in Paris. These panels belonged to a window describing the life of Saint Blasius and, like those of Saint Nicholas, are not mentioned in any of the early descriptions of the cathedral glass. Both, however, can be related to Soissons on the basis of style.

The figure of the consul in panel (A) of the Cloisters pair is so close in facial features and costume to the panel with the Roman governor Rictiovarus now in the Corcoran Gallery of Art in Washington, that it must be the work of the same atelier (Verdier, 1958, fig. 3). Verdier has identified the Corcoran panel as part of the legend of Saints Crispin and Crispinian, one of the few windows described in early accounts of Soissons. In both windows, figures wear the same long, loose-sleeved garments that fall in small, pleated V-shaped folds, and both have shawl-like mantles that loop about the hips and hang over the shoulders. A counterpart to Saint Nicholas is the head of Saint Nicasius, also from Soissons, in the Isabella Stewart Gardner Museum in Boston, while the heads and costumes of the young knight and the consul in panel (B) correspond to other figures in the Boston window. The small-fold drapery style of Soissons has been compared with the *Muldenfaltenstil* that originated in the Meuse Valley at the end of the twelfth century. It appeared first in stained glass in Laon. In seeking the origins of the style, the closest comparisons to be made probably are with manuscript illuminations. Florens Deuchler (1967, 161–62) has convincingly compared this style with that of the Ingeborg Psalter of about 1180. The Soissons choir chapel windows are a late expression of this style, for they were probably not all installed until after the consecration of 1212.

Acquired from the Glencairn Foundation, Bryn Athyn, Pennsylvania, 1980.

Ex collection: Raymond Pitcairn, Bryn Athyn, Pennsylvania (03.SG.231, 03.SG.232).

Bibliography: *Not. Acq.*, 1981, 25–26, colorplates.

see colorplates VI, VII

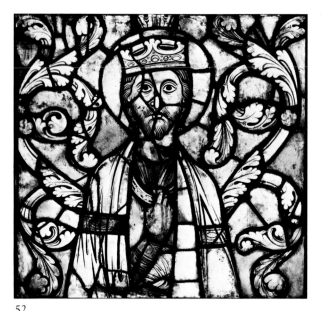

52

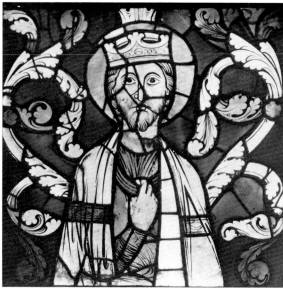

22. *King*, from The Tree of Jesse window, Cathedral of Saint-Gervais-et-Saint-Protais, Soissons. Photograph by Moreau, Paris. Between 1890 and 1910

52. King, from The Tree of Jesse Window

France, Soissons, Cathedral of Saint-Gervais-et-Saint-Protais

1210–15

Pot-metal glass

Height, 77.5 cm. (30 1/2 in.); width, 80 cm. (31 1/2 in.)

03.SG.229

The king is shown in half-length against a blue background with foliate rinceaux of pink, green, red, and white. He has a red nimbus and a gold crown, and wears a murrey-pink robe with a light blue neck strap under a yellow mantle with red bands of decoration across the upper arms and a lining of white fur. The flesh tone is brownish pink. At the top, behind the king's nimbus, is the white trunk of the tree. Some of the background and foliation, as well as the lower right section of the mantle, have been replaced; otherwise, the condition of this piece is excellent.

Of all the glass in the Pitcairn collection, this panel is the best known and most often cited. It was purchased in 1921 by Raymond Pitcairn at the sale of the collection of Henry C. Lawrence in New York. Lawrence had bought the panel in 1916 from the New York office of the French dealer Daguerre. The Pitcairn King was still in France between 1890 and 1910, when it was photographed by Moreau in Paris (fig. 22), but it was probably already on the art market at that time.

The clerestory windows of the chevet of Soissons had been dismounted in 1882 and were then stored for four years in the south tower of the cathedral (Barnes, 1967, 263). The Tree of Jesse window seems to have been reinstalled in 1890, since Édouard Didron was in charge of the restoration, and signed and dated the border at the base of the window, and he died in 1891 (Grodecki, 1953, 173). Didron's arrangement of the Jesse Tree was quite different from its initial disposition, yet he made use of the original parts that remained. It is probable, therefore, that the Pitcairn King—as well as the entire figure of the Virgin (Grodecki, 1953, fig. 1), which was purchased in 1905 by the Kunstgewerbemuseum in Berlin, only to be destroyed in an explosion in a bunker in 1945— "left" the south tower of Soissons before 1886. Between that time and its purchase by Lawrence in 1916 the King's whereabouts are unrecorded.

Prior to the restoration of 1890, however, the Tree of Jesse window suffered less than most of the other windows in Soissons. Though the Huguenots took over the building in 1567, desecrating the altars and relics and, perhaps, inflicting damage on the lower windows, those of the clerestory were hardly touched (Dormay, 1663–64, I, 470–71; Barnes, 1967, 244). The glass survived the Revolution because the cathedral was used to store grain and fodder. Some damage undoubtedly resulted, but this was minor in comparison to the explosion of 1815, which was responsible for the loss of all the windows on the south side of the building (cf. no. 51). In the restoration of

1817–20, a large figure of Christ was placed in the center of the Jesse window (Grodecki, 1960, 171). Some minor losses were sustained in the shelling during the war of 1870, when there was little protection for the upper windows. It was the result of this damage, as well as general neglect, that prompted the restoration that began in 1880. The Jesse Tree was only partially removed when war began again in 1914, but, fortunately for the chevet windows, the bombardment was concentrated on the western part of the cathedral and the choir clerestory glazing was dismounted with only minor damage. The Jesse Tree, without further reorganization, was once again replaced in 1926.

From the time of its installation in the newly constructed chevet in the cathedral of Soissons, the Tree of Jesse window has occupied the place of honor in the axial bay of the choir clerestory. It was a gift of Philip Augustus (1165–1223), King of France, who donated thirty pounds for the window at some time before his death. Though Grodecki (1960, 171) dates the window about 1220, there is little reason to believe that it was not installed by 1212 when the canons formally took over the use of the choir, particularly since Barnes (1967, 265) has shown that the radiating chapels were glazed and in use by 1208–9. The king's window would undoubtedly have been given preference over that of Eleanor of Vermandois, whose donation was made before 1215, the year of her death. The date of 1212 seems firm for the completion of the chevet, since the cathedral had already received wood for the roof and the stalls. The latter could hardly have been in place before the scaffolds had been cleared away.

Before its reorganization in 1890, the original Tree of Jesse window in Soissons must have been closer to the more traditional type, as at Chartres (Delaporte, 1926, Plates I, pl. I). Its border, though mutilated—as Grodecki (1953, 172) has noted—still retains its initial design, as reproduced in Cahier and Martin (1841–44, II, pl. X). It is composed of open palmettes of leaves that turn inward, ending in a trefoil tip, interspersed with bouquets of foliage. The border is somewhat wider than those of the other clerestory windows in Soissons and similar in design to a later variant in Saint-Quentin (Grodecki, 1953, 175). The window is designed on an ironwork grid with three vertical columns of figures. The lowest row, which would have originally contained the reclining Jesse, is now all ornament—added in 1790—as is the central compartment above. This disposition creates a stepped arrangement in the window, with the central column one panel above those at the sides—a composition unknown in medieval windows. Reading from the top downward, Christ's head is pressed against the pointed arch of the window; the doves, gifts of the Spirit, which should have occupied

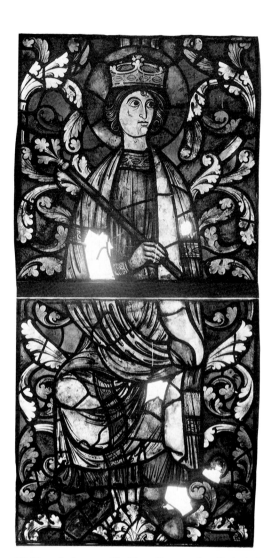

23. *King*, the lowest in The Tree of Jesse window, Cathedral of Saint-Gervais-et-Saint-Protais, Soissons. 1210–15. Pot-metal glass

this space, are gone. Instead of the flanking angels standing on the same level as Christ, their heads are on a level with his knees. These three figures are largely original. The next level, again with the central figure raised one panel, consists of the Virgin in the center flanked by Sibyls. The present modern figure of the Virgin in pose and color is completely unlike her lost counterpart (formerly in Berlin), which confirms the theory that the lost parts of the window had disappeared before Didron began his restoration. The Sibyls are largely restoration except for some portions of the one at the right. (The inclusion of Sibyls in a Tree of Jesse window is unusual, though occasionally they are found in northern French windows devoted to the Jesse theme [Cothren, 1980, 52–59].) Grodecki has questioned their inclusion by noting that the scrolls that they hold—inscribed SIBILL—are modern. The S of the figure on the right, however, is original. The next rank contains a completely modern king whose only resemblance to the Pitcairn figure is that his hand rests upon his chest. It is to the upper panel of this window that the Pitcairn King once belonged, but the present royal ancestor of Christ in the window bears no resemblance to the original. The Prophet Micheas to his left is old, while Ezekiel, on the right, is modern. The king below is partly original, except for his head, while Daniel, on the left, is in almost perfect condition, and Hosea has few replacements. The lowest king, perhaps, is the best-preserved and the most animated figure in the window. Isaiah and Jeremiah, the prophets on either side of him, are also in good condition. If the Soissons Jesse Tree can be dated as early as 1212, then it marks a departure from the twelfth-century type as seen in Chartres and at Saint-Denis. In addition to the absence of the flowering trees of the twelfth century, the prophets and Sibyls stand in architectural niches rather than in the half-medallions seen in the earlier type of window. This architectural enclosure would be repeated less than a decade later at Saint-Germain-lès-Corbeil outside of Paris, and would become the prevailing type in the thirteenth century.

In the boldness of its large scale, small-fold drapery, and delicate facial characteristics, the style of the Pitcairn King parallels the lower windows in Soissons (no. 51). Traditionally, this figure was known as the King from Bourges. Arthur Kingsley Porter (1915–17, 264–73) was the first to question this attribution, but his suggestion of Poitiers as the origin was based upon the little that was published on stained glass at that time. Since then the detailed studies of Grodecki have defined local styles, particularly those of Champagne, and the relationship of the Pitcairn King to the style of Soissons. Other characteristics,

perhaps more noticeable in the complete figure of the King (fig. 23)—such as the compartmentalized drapery and the expressive facial features—are very close to the panels from the west rose in Braine (no. 49). It is possible that this style traveled from Soissons to Braine, for, in Barnes's opinion, the stonemasons who built the south transept of Soissons left there for Braine, in order to begin the new construction of Saint-Yved (Barnes, 1967, 111–13).

It has been suggested that the style of stained glass formulated in the east windows of Laon perhaps as early as 1205 (Deuchler, 1967, 149–60)—which derived from the Ingeborg Psalter—was continued in Soissons. Grodecki (1965, 171–93) has even proposed a traveling atelier working first in Laon, then in Soissons and Chartres, and later in Saint-Quentin. He has named this atelier after the single window that was produced in Chartres—the atelier of the Master of Saint Eustace. Barnes (1967, 243–47) has demonstrated that the chapel windows of Soissons were glazed and in use at the time that those in Laon were in production. The Saint Eustace window in Chartres, of 1205–10, must also be considered as contemporary. Konrad Hoffman (*The Year 1200*, I, 1970, XXXIII–XLIII) took a broader view, claiming that all these windows belong to a general tendency in the art of this period toward a renewal of interest in the classical past. The styles of Saint-Remi in Reims and of Braine, not sufficiently defined at present, also should be considered within this general movement. In each of these centers of stained glass, during the first decade of the thirteenth century, there are basic similarities of style, but there are also local differences that make the work in each monument unique. The heavily modeled, harder style of the Laon ateliers differs greatly from those who painted the softer, more linear features of the Pitcairn King or the Saint Nicholas panels (no. 51). The masters of Soissons—for there were probably several shops at work there—are special. Though they had undoubtedly seen the glass produced in other areas in northern Champagne and had been trained in the same tradition, their personal styles are distinct and are found only in Soissons, where glazing was in progress from as early as 1205 until well into the 1220s—a period that would have spanned the productive lifetime of a mature master glass painter.

Purchased, Lawrence sale, New York, January 28, 1921.

Ex collections: Henri Daguerre, New York (until 1916); Henry C. Lawrence, New York (until 1921).

Bibliography: Porter, 1915–17, 264–73; Lawrence sale cat., 1921, no. 372, ill.; Grodecki, 1953, 169–75.

see frontispiece

53. Two Border Sections, from the Choir Windows

France, Soissons, Cathedral of Saint-Gervais-et-Saint-Protais

Pot-metal glass

(A) About 1220–25

Height, 57.5 cm. (22 5/8 in.); width, 26.7 cm. (10 1/2 in.)

03.SG.136

(B) About 1200

Height, each, 58.4 cm. (23 in.); width, each, 20.3 cm. (8 in.)

03.SG.244,245

(A) Vertical clusters of blue leaves with white centers and green leaves with yellow centers alternate on a red background. The edge fillets, which are blue, red, and white, contain replacements, but otherwise the panel is in excellent condition. Careless releading in the nineteenth century mixed the order of the pieces of foliage. The original design of the border, as shown in Cahier and Martin (1841–44, II, pl. M–1), paired the central yellow leaf with blue outer leaves, and each white central sprig with green ones.

(B) White painted palmettes containing white, blue, and greenish-blue foliage on fields of red are joined by yellow bosses and are centered upon painted quatrefoils of murrey. The background is blue. The border has now been divided into two pieces for its present installation, as part of the border of a window by Lawrence Saint, in the Pitcairn home. The lateral murrey foliate sprigs that once joined the yellow bosses have been lost and the blue background has been replaced with old glass. As shown in its original form in Cahier and Martin (1841–44, II, pl. M–5), the opulence of this border, with its yellow-pearled edge fillets, can only be imagined today.

Both these borders were acquired with a group of other borders from the restorer of stained glass and dealer Acézat in 1928. A note in the correspondence files for that year from Lawrence Saint, who was then copying the Methuselah from Canterbury, suggests that one of these borders (probably no. 53 B, since it is described as the straight, blue, restored border) might be suitable for the figure.

If it were not for the careful records in the engravings made by Cahier and Martin between 1841 and 1844, neither of these borders could be attributed to Soissons. Few scholars of the nineteenth century, with the exception of Nathaniel H. J. Westlake in England, paid much attention to ornament. Cahier and Martin published their great monograph on

53(A)

53 (B)

Bourges after the serious damage caused by the explosion of 1815 had already been inflicted upon Soissons. (The explosion of 1815 demolished most of the glass on the southwestern flank of the church and the German shelling of World War I was aimed at the north side.) Yet, their work preceded the general reorganization of the glass in 1880, proving beyond a doubt that many of the cathedral windows, including the color-grisaille of the clerestory, have since been lost. Their record also was made before the near annihilation of the cathedral during the First World War. The initial occupation of Soissons in 1914 (Barnes, 1967, 248–54) took place before any of the glass was removed. By 1915, the figural windows had been dismounted during the actual shelling of the cathedral but the ornamental glass remained. Throughout the war, shattered fragments hung in the openings. The choir was not reglazed or its original windows remounted until 1925 (Caviness and Raguin, 1981, 194). There is no medieval stained glass in any of the windows on the north side of the cathedral today, except for the medallions of the north rose that had been removed before the war. It is conceivable, therefore, that the two borders in the Pitcairn collection are remains of windows once on the north side of the choir.

These borders are not, apparently, parts of the grisaille windows, nor are they of the same date. The simplicity of design in panel (A)—its coarseness of style and pedantic repetition of motif indicate a date late in the first quarter of the thirteenth century—and its width suggest that it may be the remains of a clerestory border, further proof that the glazing program of Soissons must have extended over a considerable period. Panel (B), if examined in its original state, as shown in Cahier and Martin, appears to be much earlier in date. Its forms are carefully traced and modeled, with fine detail added in the bosses and the quatrefoils. It also has beaded edgings on both sides. While panel (A) is uncompromisingly vertical in its orientation, a tendency of the second and third decades of the thirteenth century, panel (B) has a centralized organization focused in the quatrefoil. What is left of the original borders of the ambulatory windows of Soissons has beaded edgings, but none is as elaborate as this example. Furthermore, the borders from Soissons are either vertically or horizontally composed. Only in panel (B) is the design centralized. With its pearled bands and edge fillets, moreover, this border would have been nearly twelve inches wide. In these respects, as well as in its painting style, border (B) is reminiscent of twelfth-century glass rather than of the tendencies current in the second decade of the thirteenth century when Soissons was being glazed.

Prioux and Fleury, who quotes him (Fleury, 1879, 121), believed that a significant part of the glazing

144

of Saint-Yved in Braine was reused in Soissons in 1830. Both suggested that some of the Soissons chapel glass had come from Braine. Caviness's proposed date for the beginning of the building campaign at Saint-Yved (1982, in press) is twenty years earlier than the 1195 suggested by Jean Bony (1957, 35) and even earlier than the traditional date of 1180. If this can be substantiated, it may prove that the windows in Braine received their glass somewhat before the end of the twelfth century, which, perhaps, explains the early character of the design of Pitcairn panel (B).

Purchased from Michel Acézat, Paris, April 2, 1928.

Bibliography: Cahier and Martin, 1841–44, II, Mosaïques, Bordures, pls. M, 1, 5.

54. Lobe with Foliate Ornament, from a Rosette

France, Soissons, Cathedral of Saint-Gervais-et-Saint-Protais (?)
About 1210–15
Pot-metal glass
Height, 31.8 cm. (12 $^1/_2$ in.); width, 37.5 cm. (14 $^3/_4$ in.)
03.SG.71

On a blue background with red edging, a symmetrical medallion of foliage is arranged about a light blue quatrefoil center. The foliage is composed of murrey leaves and projecting white tendrils between gold leaves. There is some restoration in the lower part of the lobe.

This piece was acquired from Bacri Frères in 1923. Nothing further is known of its history. The panel was mentioned in an article by Grodecki (1973, 199) as possibly relating to the series of twelfth-century stained-glass panels formerly in the cathedral of Troyes (cf. nos. 36, 37) or, at least, as having a Troyes origin. Grodecki was hesitant to suggest this provenance, however, since, in his opinion, the lobe came from a rosette of the type in the nave of Chartres. This "doublet and rose" window type, while prevalent throughout thirteenth-century France, was not employed in the last quarter of the twelfth century, the period assigned to the other pieces from Troyes. Furthermore, Grodecki noted, the ambulatory windows of Troyes do not contain rosettes. The only rosettes in the cathedral windows are, in fact, those of the clerestory, which cannot be dated before the middle of the thirteenth century.

The style of the Pitcairn panel, however, is not related to the twelfth-century ornament of Troyes (as seen in no. 36) or to representations of decorative foliage produced in other areas of France before the end of the twelfth century. Its closest counterparts are

to be found in the distinctive types of leaf forms employed in the glazing programs in the Aisne River Valley, which encompasses Laon, Soissons, Braine, and Saint-Quentin, all carried out during the first third of the thirteenth century.

As Grodecki suggested, the concave curve of the lower edge of the panel probably indicates that, together with several other pieces of the same design, it surrounded a circular form. Such circular forms with peripheral lobes commonly are found not only in the rosettes above a double lancet-window complex but also in the central medallion of a rose window. To cite only a few examples in the Aisne region, there are three in Laon and two in Braine. The third example in Braine, the west rose, was destroyed in the 1830s. Though there are no rose windows of the period in Soissons, there are ten rosettes in the side bays of the clerestory of the choir. Any one of these numerous windows could have contained the Pitcairn lobe.

The search for the possible origins of the Pitcairn piece can be narrowed, however, on the basis of the size and style of the panel, in comparison to other known examples. None of the roses in Laon repeats the design of the Pitcairn piece, though all of them have preserved some vestiges of their original ornament; also, there are no rosettes in Laon. The glass in Saint-Quentin is too late to be considered and its rosettes are pointed rather than rounded. Both Braine and Soissons, because of their types of windows and because of the extensive losses of glass, must be considered as potential sources of the present panel. Though almost all of the ornamental glass and most of the figural glass in Braine have been lost, significant pieces have been preserved. In Soissons, leaded into the spandrels of the arches that surmount the four ancestors of Christ—now in the second, north, turning bay of the clerestory—are a series of decorative lobes, all of the same design. There are two above each figure and two more in the same position above a bust-length figure of Jacob (fig. 24; now in the Pitcairn collection, 03.SG.230). Like the lobe under discussion, this last pair is set on blue backgrounds with red edgings. The panels also have the projecting white tendril leaves that curl backward at the tips to form trefoils. Other characteristics in common in all three pieces are the stiffly erect leaves that sprout between the tendrils. Since Braine had no rosette windows, the obvious source for this ornament would have been the lobes that surrounded the central medallions of the north and south roses—twelve lobes in each rose. Both roses in Braine are architecturally identical, yet it would have been highly unusual in the Middle Ages if their ornament were of the same design. It would be tempting to suggest that this single lobe is the only surviving piece from one of the transept roses in Braine. It is, however, too large, more

54

24. *Bust of Jacob*, probably from the Abbey of Saint-Yved, Braine. 1190–1200. Pot-metal glass. Glencairn Museum, Bryn Athyn, Pennsylvania, 03.SG.230

than an inch greater than the diameter of the Jacob lobes—even including their outer white fillets. It could, of course, have been included in the west rose of Braine but no measured drawings exist for this window.

The most obvious location for this lobe is, therefore, in one of the rosettes of the lateral windows of the clerestory of Soissons. Two of the bays on the south side still retain colored glass with ornament in the lobes. The style of the Pitcairn piece, though close to that of Braine, is more attenuated. The tendril appears in the border of the Jesse Tree window from Soissons (cf. no. 52), as does the stiff leaf. This form, though more elegant in the present lobe, is noticeable in border (A) (no. 53A), also from Soissons. Its elegance of style suggests that this lobe was installed fairly early in the glazing of the choir, perhaps in time for the dedication in 1212. As stated previously, there were a number of donations for windows in Soissons. Among them were the two rosettes for the straight bays of the choir given by Canon Cugnieres (Fleury, 1879, 125, quoted from the Obituary). Without proper measurements it cannot be proved that the Pitcairn lobe originally was installed in the choir of Soissons but its style strongly suggests the connection. For the final answer, it will be necessary to await Caviness's future publications on the relationship of Braine and Soissons to Saint-Remi in Reims.

Purchased from Bacri Frères, Paris, January 27, 1923.
Bibliography: Grodecki, 1973, 199.

55. Border with Bird, from an Unknown Window

France, Champagne (?)
About 1215–25
Pot-metal glass
Height, 59.4 cm. (23 3/8 in.); width, 22.9 cm. (9 in.)
03.SG.147

Two heart-shaped palmettes, outlined by a white vine stem, enclose bouquets of green and blue leaves that spring from yellow and white trefoil buds. The vine continues in a circular form that contains a light blue bird in flight. The field of the pattern is red and the background blue. On the left edge is a red fillet and on the right, a fillet with yellow pearls. A repeat of the palmette, in reverse, is visible at the top of the piece. The border curves slightly to the right. There is a fair amount of replacement glass in the foliage and in the background, but the design appears to be intact. The border has been carelessly releaded with a very heavy came.

This piece was probably among the group of borders selected by Lawrence Saint at Acézat's shop in Paris and purchased by Raymond Pitcairn in 1928. It is of unknown origin.

Figural motifs rarely appear in borders. The single exception in the twelfth century is the border of the Infancy window above the west portal of Chartres (Aubert, 1958, ill. 15), which also includes palmettes interspersed with roundels containing fantastic beasts or birds. In the thirteenth century, these inclusions are more frequent. Figural medallions intrude upon the border in several instances in Chartres (Delaporte, 1926, Plates II, pls. CXLVIII, CLXII, CLXXV), twice in Angers (Hayward and Grodecki, 1966, 34, 37), and twice in Lyons (Cahier and Martin, 1841–44, I, pl. VII, 2, 4). These are distinct from the overlapping of the borders with scenes, which occurs frequently in the twelfth and thirteenth centuries. In each case, these thirteenth-century examples are designed as parts of the border, but in every instance they also have iconographic or heraldic significance for the window. The bird in the Pitcairn border, on the contrary—like the fantastic animals in Chartres—is purely decorative, and might be considered a repair were it not for the fact that the glass is old, the patination on the back consistent, and the design apparently uninterrupted. A fragment formerly in the Bashford Dean collection, and now in The Metropolitan Museum of Art (30.73.141), contains a similar bird of the same size and light blue color. Though isolated from its background and slightly different in pose because of its partly furled wings, the style of the

plumage and the proportions of this bird are almost identical to the one in the Pitcairn piece.

The slight curve of this border, with its inner edging of pearls, indicates that the piece occupied the arched portion of the aperture at the top of a window. Were it not that the bird faces in the wrong direction, the border might have come from a Tree of Jesse window in which the bird symbolized one of the doves of the Holy Spirit that habitually surrounds the figure of Christ at the top of the light. The doves appear in the border of the Jesse Tree window at Saint-Germain-lès-Corbeil. It is, of course, possible that, in releading, the bird was transposed from the opposite side of the border.

In its design, the foliage that comprises this border bears certain relationships to the leaf forms found in the glass of northeastern France. The central budding leaf of the palmette that turns forward at the tip was a form employed in Soissons (cf. no. 53 B) that may have been imported from Braine. The technique of using parallel brushstrokes to indicate veins in the spreading fronds is evident in the borders of the gallery windows of the tribune at Saint-Remi in Reims (no. 38). Other features, such as the scalloped edges of the fronds and the trefoil that joins the two palmettes, also figure in the vocabulary of ornament in Champagne. Given these comparisons, it is probable that this border originated in an unknown church located in the northeastern part of France toward the end of the first quarter of the thirteenth century. Whether it once belonged to a Tree of Jesse window, or is just a rare example of the inclusion of a figural motif in an otherwise ornamental border, remains uncertain.

Purchased from Michel Acézat, Paris, April 2, 1928(?).

55

56. Four Scenes from The Legend of the Seven Sleepers of Ephesus Window

France, Rouen, Cathedral of Notre-Dame

About 1210

Pot-metal glass

(A) **The Seven Brothers Kneel and Pray in the Cave**
Height, 63.5 cm. (25 in.); width, 59 cm.
(23 1/4 in.)
03.SG.52

(B) **Malchus Is Seized While Attempting to Buy Bread**
Height, 63.5 cm. (25 in.); width, 59.7 cm.
(23 1/2 in.)
03.SG.49

(C) **Malchus Is Brought before the Bishop of Ephesus**
Height, 62.6 cm. (24 5/8 in.); width, 59 cm.
(23 1/4 in.)
03.SG.51

(D) **Theodosius Goes on Horseback to Visit the Cave**
Height, 62.2 cm. (24 1/2 in.); width, 70.8 cm.
(27 7/8 in.)
New York, The Metropolitan Museum of Art,
The Cloisters Collection, 1980.263.4

(A) All seven of the brothers have red nimbi. Those figures in full view are dressed (from left to right) in a green robe with a murrey mantle, a red robe with a light blue mantle, and a blue robe with a white mantle; the others are seen only partially, as heads and nimbi. Before the kneeling figures are green and yellow hillocks, and a clump of red, green, and yellow trees is at the right. The background is blue, and part of a "fish-scale" ornamental field of blue painted quarries, red edgings, and white crossings, can be seen above the demarcation of the cave. Edge fillets of red and white, with pearled bands, are at the sides. The panel has been extensively restored, and includes insertions of the ornament that was probably the original decorative field of the window. The lower parts of the figures are probably an early restoration of about 1245, made before the windows were reused.

(B) Malchus, in a white robe, murrey mantle, green stockings, and red halo, hands the baker ancient gold coins. The baker, wearing a murrey tunic and green stockings, clutches some of the white loaves resting on a green table with yellow legs. On the left, a citizen of Ephesus, dressed in a red cap, a yellow mantle over a green and red robe, and yellow boots, seizes Malchus. A second citizen in a light blue mantle, white robe, and green boots, assists in the arrest. The panel

is in excellent condition, except for the insertion of the dark green skirt of the first citizen. The pearled edge fillets and the ornament below the scene are the result of a later adaptation of the panel to a new setting.

(C) Malchus, dressed as in the previous scene, is held by a citizen displaying gold coins and wearing a yellow tunic, red stockings, and a green cloak and shoes. Malchus stands in judgment before the magistrate who is seated behind the arm of the bishop's throne, which is made of white glass with a green frame. He is dressed in a red cap, yellow blouse, murrey mantle, and blue robe, with green boots. The Bishop of Ephesus, also sitting in judgment, is in his episcopal costume—a white miter, yellow crosier, pink cope, and white alb. The background is blue with red and white edge fillets, pearled bands, and blue and red quarries below. The scene is in almost perfect condition, except for one small piece of repainted old glass. The pearled edgings and quarries were added when the panel was adapted to a different shape. The inscription reads: hIC · ANTE · PRE SVL EM · D VCITV[R] (Here he is led before the proconsul).

(D) Three figures on horseback approach a city gate. In the center, the Emperor Theodosius, crowned in gold, wears a murrey-pink surcoat over a white robe, and yellow boots. He rides a brownish-pink horse. The rider in front of him in blue and yellow is mounted on a white horse. The figure behind, in green and yellow, has a light blue horse. The gate is red, green, and white; the background is blue; and the edge fillets are red and white. This panel has retained the borders added during its reemployment elsewhere in the cathedral; they are composed of yellow and white castles and fleur-de-lis on a blue ground. There are some replacements in the piece, notably in the belly and neck of the emperor's horse and in parts of the city gate.

The first three panels of the series were purchased by Raymond Pitcairn at the sale of the Lawrence collection in New York in 1921. Lawrence had acquired them from Bacri Frères in Paris in 1918. The Lawrence sale catalogue stated that the panels were "removed many years ago from a cathedral in France." The fourth panel, only recently recognized by Françoise Perrot, then assistant to Jean Lafond (1975, 407, n. 7), as part of the Seven Sleepers series, was purchased by Raymond Pitcairn from Lambert in Paris in 1923. No previous ownership is known for the panel. It was acquired by The Cloisters in 1980 from the Glencairn Foundation.

Though earlier scholars have suggested that the entire Romanesque cathedral of Rouen was destroyed

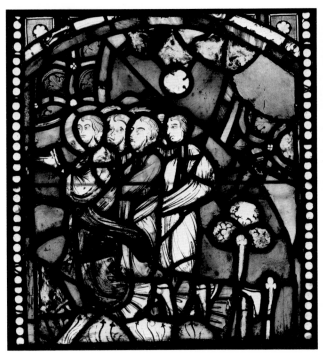

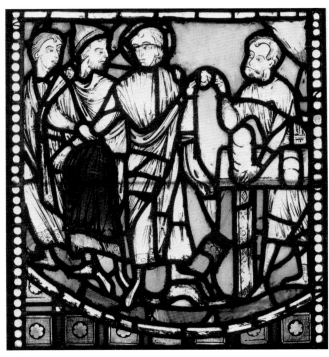

56 (A) 56 (B)

by fire in 1200 (Aubert, 1927, 15), it was, in fact, then in the process of reconstruction. A new Gothic façade had been built about 1170, and about 1185 Bishop Gauthier demolished the Romanesque nave while retaining the choir and transept for the use of the congregation. Building began at the west end in order to link the new façade to the existing choir. Four bays of the new nave had been completed up to the triforium level when the fire occurred. Though the choir and transept were destroyed, the void that stretched between them and the nave was probably the reason that the new construction survived intact. King John of England provided handsomely for the rebuilding, but it was the French King Philip Augustus who, entering his newly won province in 1204, saw the nave nearly finished. The high altar was consecrated in 1207 but this was undoubtedly a temporary structure, erected at the east end of the completed nave. The aisle windows of this new nave, which included the window depicting the legend of the Seven Sleepers of Ephesus, are usually dated about 1210. Several ateliers can be recognized in the glass that remains in these windows. The windows must have been installed in the aisle of the nave as the construction progressed eastward from bay to bay. The date of 1210 is probably a terminus rather than a beginning for most of them.

Following in 1270, however (Perrot, 1972, 11), the decision was made to construct chapels between the nave buttresses, thus destroying the walls that

held the windows. The new chapel windows conformed to the current Rayonnant Style of architecture and were designed as narrow multiple lancets, four to each bay, where there had been only two windows before. Lafond (1975, 408, n. 10) confirmed, on the basis of the lancets that still exist in the first bay on the north side, that the nave had two windows in each bay. A text of the early fourteenth century states, however, that the people thought so highly of the "belles verrières" of the thirteenth century that they decided to reuse them in the new chapel windows. The thirteenth-century windows were designed, like those of Chartres, as medallions composed of clusters of scenes on mosaic or foliate grounds with broad borders of ornament. When cut into narrow strips to fit the new windows, many of them had their curved edges either sheared off or built out into rectangles. The Pitcairn panels are examples of the latter means of alteration. Narrow borders of the late thirteenth century, bearing the arms of France and Castile, were added at the sides, perhaps in recognition of King Louis IX's three separate visits to the cathedral after its completion. The Cloisters panel (D) is the only one of the group that still retains its late border.

In 1832, at least four of the nave chapels contained remains of the original glazing. The late Jean Lafond had, in his personal archive, a sketch plan of the cathedral with notes on the windows made by the art historian E. H. Langlois, who mentioned the Rouen glass in two publications in 1823 and 1832

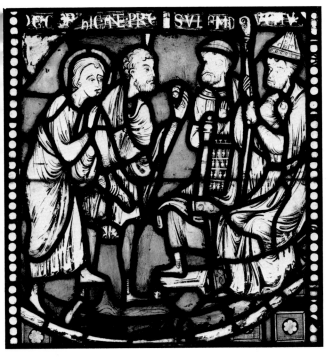

56 (C)

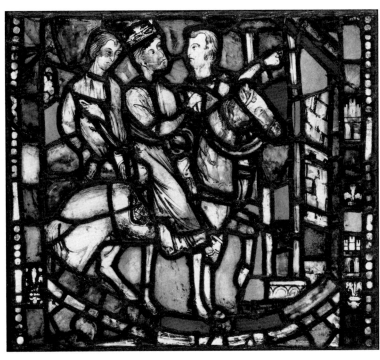

56 (D)

(Lafond, 1975, 400–408, n. 8). The sketch is of particular importance to the Seven Sleepers panels since it records an inscription, HIC: hIC ANTE PRESVL[EM], which is still in place in panel (C), even to the additional HIC inserted in the 1270 rearrangement of the glass. The Langlois sketch notes thirteenth-century glass on the south side of the nave, in the fifth chapel (of Saint Columba) and the sixth (of Saint Peter), where the inscriptions were found. Unfortunately, about 1870, the nave windows were modernized and the thirteenth-century glass was removed from the south chapels to a storage room in the tower of Saint Romaine on the north side of the façade (Perrot, 1972, 13). Remains of the "belles verrières" are still to be found on the north side of the nave in the third and fourth chapels (of Saint John of the Nave and Saint Severus, respectively). Between 1465 and 1469, the lower portions of these windows, however, were reglazed with new glass by Guillaume Barbe. Nothing is known of the fate of the thirteenth-century glass. In 1911, Lafond was permitted to inventory the stained glass in storage in the tower, for the Monuments Historiques. He noted fifteen panels from the thirteenth-century windows in addition to eleven unrecognizable fragments from the same series and twenty-nine borders. None of the Seven Sleepers scenes from the Pitcairn collection was among them. These panels evidently had found their way onto the art market between 1870—when they were removed from the nave to storage—and 1911, when the stored glass was inventoried. At the present time, twelve scenes remain from the window. The best preserved are the four from the Pitcairn collection and one additional panel, now in the Worcester Art Museum (1921.60; Caviness, 1977, no. 5), which was acquired in the Lawrence sale. The other seven pieces are fragments in storage at the depot of the Monuments Historiques at the Château de Champs-sur-Marne (Lafond, 1975, figs. 1, 2, 4, 5, 11).

The legend of the Seven Sleepers of Ephesus was first recorded in the West by Saint Gregory of Tours in the sixth century (*Anal. Boll.*, 1893, 371–87). Excavations conducted in 1926 by the Austrian Institute of Archaeology uncovered the remains of a basilica, dating from the fifth century, above the cavern of the Seven Sleepers (Lafond, 1975, 405). The invention of the relics of the martyrs may date from the second century. A crypt in the village of Vieux-Marché in Brittany, dedicated to the Seven Sleepers, is the only example in France of their veneration. The legend was apparently popular in the Middle Ages, particularly among the Normans. It was translated into English by Aelfric, monk of Eynsham (Lafond, 1975, 406), and existed in an Anglo-Norman poem *Li Set Dormanz*, written by a certain Chardry (ed. Koch, Heilbronn, 1879; *The Year 1200*, I, 1970, 202). Except for the window in Rouen, however, there are no other French depictions of the legend, nor are there any cycles in other countries that predate this glass. There are also no records of any confra-

ternity or chaplaincy in Rouen consecrated to the veneration of the Sleepers. The presence of the Seven Sleepers in the cathedral, painted more than half a century before the legend was made popular by inclusion in *The Golden Legend,* must have been the result of local popular tradition.

The story concerns the seven Christian brothers who were warned against pursuing their faith by the Emperor Decius. The brothers sought refuge in a cave near the town of Ephesus and, awaiting their impending persecution, knelt in prayer (panel A). Daily, one of the brothers, Malchus, would go out for food. The refuge was discovered by the emperor's soldiers, who sealed the cave. Instead of dying, the brothers were put to sleep through divine intervention. Two centuries later, construction on the site uncovered the cave. The brothers awoke and again Malchus went out to buy food. At the bakery, he presented a gold coin in payment (panel B) that was immediately recognized as ancient, whereupon he was seized as a thief and taken before the magistrate and the Bishop of Ephesus (panel C). He was found innocent and the miraculous story of the brothers spread, even arousing the interest of the new emperor, Theodosius, who, with his servants, went on horseback to see the miracle for himself (panel D).

Though there are no iconographic equivalents for the Seven Sleepers panels, their style is easily compared to other examples in Rouen. Several ateliers worked on the nave windows, and, perhaps, at different times. Yet, the work of one atelier—which, apparently, was responsible for more than one window—stands out. The head of this atelier has been called the Master of Saint John the Baptist after his principal window, several scenes of which survive in the chapel of Saint John of the Nave. Grodecki (Notes, 1967), upon examining the Seven Sleepers panels, did not hesitate to attribute them to this master. The Saint John the Baptist master's style is distinctive, particularly his use of color. The backgrounds of his compositions are uniformly cut from a deep yet limpid blue. The colors of his figures, on the contrary, are generally light or bright. He uses a murrey that is almost pink, a very pale green, often white—or very light blue—with a bright yellow, and small touches of red, so that his figures stand out as clearly read silhouettes against the background. He is also known for unusual colors, such as the light brown striated with pink that is seen in the emperor's horse. His figures are very animated and by their emphatic gestures they engage one another's attention. He employs several facial types that reappear in the various scenes of his windows. The bearded brother in panel (B) is also seen among the people who go to hear Saint John preach (now in the chapel of Saint John of the Nave in Rouen; Ritter, 1926, pl. IV, c7). The magistrate in panel (B), with his

protruding jaw and square forehead, has a counterpart in the Worcester panel (Lafond, 1975, fig. 8) in the group on the right, and also in the scene of Saint John preaching, in Rouen (Lafond, 1975, fig. 9). A figure resembling Malchus, the youthful type, is also found in the scene of the Baptist's imprisonment (Ritter, 1926, pl. II, b8). The drapery flows over the forms and molds them; it floats in the air and spreads upon the chairs on which the figures are seated. It is exquisitely designed, with infinite variety in the patterns made by the folds. What is the source for this style? It owes nothing to western France. It is far more solid than what is known of the Champagne style. It is not found in Chartres, though similarities have been suggested (Grodecki, *Vitraux,* 1953, 143). Perhaps its origins lie in the historical connections of Normandy with England and the Channel School. At this juncture, the idea cannot be proven, but it is worth exploring. The closest associations of this style with glass in France are with the capital—Paris, itself—where, some twenty years later, there are echoes of the style in the west rose of the cathedral. If Paris is its origin, there is no proof; not a shred of glass exists there from the period between the last decade of the twelfth century and the date of the west rose of Notre-Dame (1225–30). Where this remarkable master received his training still remains a mystery.

(A) (B) (C) Purchased, Lawrence sale, New York, January 28, 1921; (D) Purchased from Augustin Lambert, Paris, August 13, 1923; Acquired from the Glencairn Foundation, Bryn Athyn, Pennsylvania, 1980 (03.SG.161).

Ex collections: (A) (B) (C) Bacri Frères, Paris (until 1918); Henry C. Lawrence, New York (until 1921); (D) Raymond Pitcairn, Bryn Athyn, Pennsylvania (until 1980).

Bibliography: Lawrence sale cat., 1921, 36–38, ill.; Gómez-Moreno, 1968, nos. 183–185; *The Year 1200,* I, 1970, no. 207; Hayward, 1970, n.p.; Lafond, 1975, 399–416; *Not. Acq.,* 1981, 24–25, colorplate (panel D).

see colorplate VIII

57. Saint Peter Preaching, from a Lost Window

France, Rouen, Cathedral of Notre-Dame
About 1210
Pot-metal glass
Height, 73.7 cm. (29 in.); width, 68 cm. (26 3/4 in.)
03.SG.242

Saint Peter, dressed in a green robe and murrey mantle, and holding his white keys, turns away from a kneeling group of converts. The man on the left wears an olive green robe with a red cloak and the figure

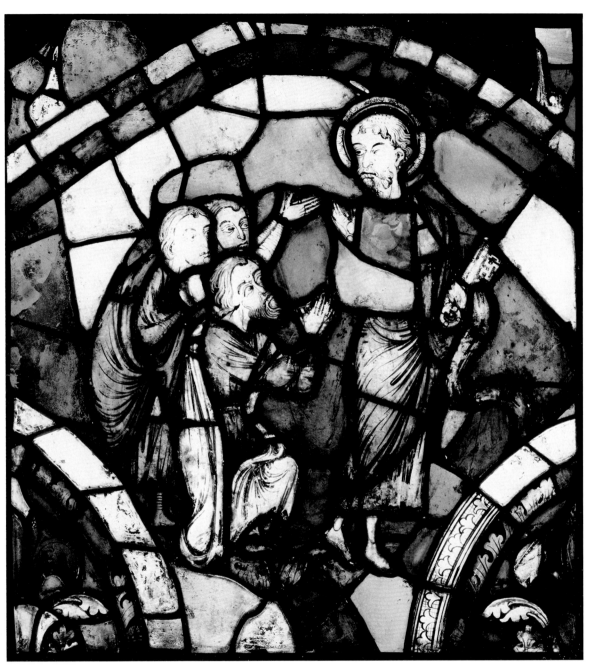

in front a murrey robe and white mantle. A third head, and raised arms covered with white sleeves, appear behind the other figures. The deep blue background, visible between the figures, still contains original glass. Quadrants of foliate ornament in yellow and white on red grounds, edged in green palmettes and white fillets, make up the lower corners of the panel. Above the scene is a red pointed arch edged in light blue with blue filling at the corners. The panel is in fair, fragmentary condition. The figures and the background between them are intact, except for two replacements in the upper torso of Saint Peter, and, though the lower quadrants of ornament may be original, the upper portion of the panel, including the red arch, is also a replacement.

The Pitcairn files do not mention this panel, nor is there any record of its purchase or source. It has been installed at Glencairn, but this does not indicate that it was acquired after 1928, when construction on the house began. Since the panel was reframed for installation and all dealers' marks removed, there is no means of tracing its origin. Its attribution to Rouen is based on style, among other evidence.

Were it not for the inventory made in 1911 by Lafond (1975, 399–407) of glass in storage in the cathedral of Rouen, there would have been no record of a Saint Peter window at Notre-Dame. Among the twenty-six panels of stained glass remaining from the thirteenth-century glazing of the nave of the cathedral, Lafond noted two, in fragmentary condition, that came originally from a Life of Simon Peter—the first of Christ's apostles. One isolated panel, still in place in the chapel of Saint Severus, was described by Georges Ritter (1926, 41, pl. VII, g 1) as depicting a group of apostles, but its style and the ornament that surrounds it—apparently original—are completely different from the Saint Peter panel.

Shortly after Lafond completed his inventory (Lafond, 1975, 401), the glass, which had been stored with little care or order, was packed in cases. However, upon his return to Rouen, Lafond learned that some of the thirteenth-century panels had been used by the cathedral glazier to repair various windows in Notre-Dame, so that the cases had not remained intact. They were next opened in 1931—when the glass was to be shown in an exhibition in Rouen (Guey and Lafond, 1931, nos. 308–314)—and some cases were found to be empty, containing only stones to give the impression of weight. Among the missing panels were the two scenes from the Life of Saint Peter. Without proof at present—though examination of the Lafond notes would undoubtedly provide the answer—the Pitcairn Saint Peter panel should be considered, provisionally, as one of the lost pieces from Rouen. The Saint Peter panels disappeared from the cathedral between 1911 and 1931—the same period during which Raymond Pitcairn acquired most of the stained glass in his collection.

With the slight evidence that this isolated panel offers, its subject is difficult to define precisely. Peter holds the keys, a symbolic representation of the passage from the Gospel of Saint Matthew (16:18–19) in which Christ names Peter as his successor, bestowing upon him the keys to the kingdom of heaven. The keys usually do not appear in the hands of the apostle until after the Ascension or the Pentecost. The window from which this panel came, therefore, probably illustrated the period in Peter's life when he performed his miracles of healing and his preaching, which culminated in his imprisonment and crucifixion in Rome. The scene does not seem to represent one of the miracles attributed to the saint that usually is depicted in windows devoted to his life, but is more likely an incident of his preaching, since the group on the left kneels and raises its hands in prayer.

The style of the panel, however, can be related to the work of an atelier that was responsible for one of the nave windows in Rouen—of which a number of panels still exist. This is the window devoted to the legend of Saint Severus, Bishop of Ravenna, who was evidently confused with the local Bishop of Avranches of the same name, since scenes from the lives of both saints appeared in the same window. Much of the ornamental fill is still preserved, so there is no doubt that the sixteen scenes all come from one window; they still occupy the lancets in the chapel of Saint Severus on the south side of the nave, to which they were adapted at the end of the thirteenth century. The atelier that painted this window, including the Pitcairn Saint Peter panel, is not the one that was responsible for the legend of the Seven Sleepers (no. 56), though their figure styles are similar in some respects. The Saint Peter panel is a fragment, and all but a portion of its setting has disappeared. Yet, it is still possible to distinguish, for analysis, elements of its design that compare with the more complete scenes in the Saint Severus window. In the Seven Sleepers window—whose painter is known as the Master of Saint John the Baptist—ornament played a minor role. The settings were reduced to essentials and it was the action of the figures that explained the story. Almost never did this master employ space fillers. The mosaic backgrounds of his scenes—still preserved in two of the panels in Paris (Lafond, 1975, figs. 1, 5)—were of a stock variety: a trellis intersecting painted circles, of the type seen both in Chartres and in Bourges. Simple fillets enclosed the scenes.

The Saint Severus master, on the contrary, filled his scenes with incidental material and painted detail (Perrot, 1972, pl. I). In the Saint Peter panel, tiny plants decorate the foreground, while the scenes of

Saint Severus are overloaded with architectural details and delicately patterned furnishings. The ornament in the lower corners of the Saint Peter panel is composed of slender fronds edged in painted fillets. Very similar ornamental bosses with painted edge fillets fill the corners of the Saint Severus scenes. Small-fold drapery, which is gathered over the arms of the figures and floats in the air, was also characteristic of the Saint John the Baptist master, but in the case of the Saint Severus master it is a purely decorative device rather than a means of defining form. The facial types, as shown in the Saint Peter panel, are less individualized than those of the Saint John the Baptist master: noses are long and narrow, but end in a pronounced hook; brows are drawn as simple arches, rather than in the expressive curves of the Baptist master; hair and beards fall in a variety of stylized waves and curls, disguising the bone structure of the heads rather than defining it. The style of the Saint Severus master, as illustrated by the Saint Peter panel, is decorative rather than structural, its emphasis on filling the space of the panel rather than concentrating on mass in relation to void. The similarities in the work of the two masters indicate common influences, but it was the Master of Saint John the Baptist who was the leading exponent of the style of Rouen.

58. Border Section, from an Unknown Window

Northern France, Amiens(?)
1230–45
Pot-metal glass
Height, 56.8 cm. (22 3/8 in.); width, 21.6 cm.
(8 1/2 in.)
03.SG.172

On a red background with blue and white edge fillets, a white leafy vine forms alternating oval- and lozenge-shaped compartments. Within the ovals are green and pink leaves on a blue field, while within the lozenges a red leaf supports a pink cup from which sprout crossed blue leaves. Alternating green and yellow trefoil leaves join the vine. The condition of the border is excellent, except for some replacement glass in the lower left corner.

The piece was acquired from Joseph Brummer in Paris in 1921. Nothing further is known of its history.

This border probably comes from northern France, but it is unlike the borders of the first quarter of the thirteenth century. Most borders of that period continue the undulating, curvilinear forms of the ribbons or vines of twelfth-century borders, though they are usually narrower than the earlier borders, and the

58

elaborate "stick work" effects, created with the stylus, are greatly reduced or omitted entirely. Hatching—for additional decorative effects—is also not employed. When a strap is substituted for a ribbon in early-thirteenth-century borders, it is distinct from the leaves in the design.

The confusion—or combination—of a strap with leaf tendrils, as in this example, is very unusual. Furthermore, though the orientation of the border is vertical, or in one direction, the leaves of the vine tendril grow downward. The tiny bowls from which the crossed leaves sprout, as far as is known, are unique to this border.

The only example that even approaches some of the particularities of this border is found in northern France, at Amiens, leaded into the window in the second straight bay on the north side of the choir. Attached to several scenes in this bay, which appear to come from the same window, are fragments of their border. Its background is red with blue edge fillets and, like the Pitcairn example, it is comparatively narrow. Two slender blue fronds in this border sprout from a small leaf bud and divide, continuing in white vine tendrils that curve inward and turn over at the tip, paralleling in type those in the Pitcairn example. Within the compartment thus formed, a single stalk, with pairs of leaves that jut out sharply, grows downward. One element, the stalk, is opposed in direction to the overall verticality of this border.

Together with the scenes to which it is joined, the border in Amiens is not in its original location. The shapes of these scenes and their mosaic backgrounds indicate that they were once part of a cluster medallion window that, as an economy measure, was cut up and reused. Jean-Jacques Gruber, who has made the latest inventory of the glass (CVMA, 1978, 218–19), believes that these panels are the remains of the original glazing of the nave of Amiens, which took place in the latter part of the 1230s. This corresponds to the decade assigned, on the basis of style, to the Pitcairn border. Construction of the nave began in 1220 and was completed by 1223 or 1236 (Durand, 1901–3, I, 15–54; Branner, 1965, 138–40). In the course of the fourteenth century, as in Rouen (no. 57), chapels were added between the lateral buttresses, thus destroying the window walls of the nave. The original windows comprised a double lancet with a rosette above, while the succeeding chapel bays contained six lights each, too narrow to accommodate the old glass. The nave windows were probably all discarded by the eighteenth century—or even long before (Durand, 1901–3, II, 543–47).

This border is unpublished, as is most of the glass from Amiens (cf. no. 69).

Purchased from Joseph Brummer, Paris, March 11, 1921.

59. Three Scenes from The Life of Saint John the Baptist

France, Breuil-le-Vert (Oise), Church of Saint-Martin
About 1235
Pot-metal glass

(A) **The Baptism of Christ**
Diameter, 46.5 cm. (18 5/16 in.)
03.SG.110

(B) **Salome Dances at the Feast of Herod**
Diameter, 47.5 cm. (18 11/16 in.)
03.SG.109

(C) **Salome Receives the Head of the Baptist from an Executioner**
Diameter, 46 cm. (18 1/8 in.)
03.SG.209

(A) At the left of this symmetrical composition, a bearded and yellow-nimbed figure of Saint John the Baptist, dressed in a light green robe and a murrey hair shirt, reaches up to receive a jar of chrism, or sacred oil, from a descending white dove. At the center, a nude figure of Christ is partially concealed by a mound of white, yellow, and murrey water, representing the river Jordan. At the right, a white-nimbed angel with yellow wings, dressed in a green robe and white mantle, holds Christ's murrey tunic. The scene is set on a blue ground, framed by a red fillet. Although the essential components of this panel are authentic, some portions have been seriously affected by later restoration. Most of the clothing of the angel, the lower part of the fur mantle of the Baptist, and parts of the water in which Christ stands are clumsily painted modern replacements. Whereas the upper torso of Christ is original to this panel, its curiously clean appearance is the result of the attempt of an overzealous restorer to remove a crust of patina from the exterior surface with acid. The effect of this pernicious cleaning method is also visible in panel (C).

(B) Herodias, in a murrey mantle, white wimple, and yellow crown, engages Herod, dressed in a light green robe, murrey mantle, and yellow crown, in an animated conversation. They are seated behind an emerald green table, draped with a white cloth and set with food. A figure in a white robe and blue mantle stands behind Herod, and a servant holding a jug and a cup, and dressed in a yellow tunic and light green hose, enters from the left. At the base of the composition, Salome, wearing a yellow dress, performs an acrobatic dance while holding a sword over her head. As in the previous panel, the background is

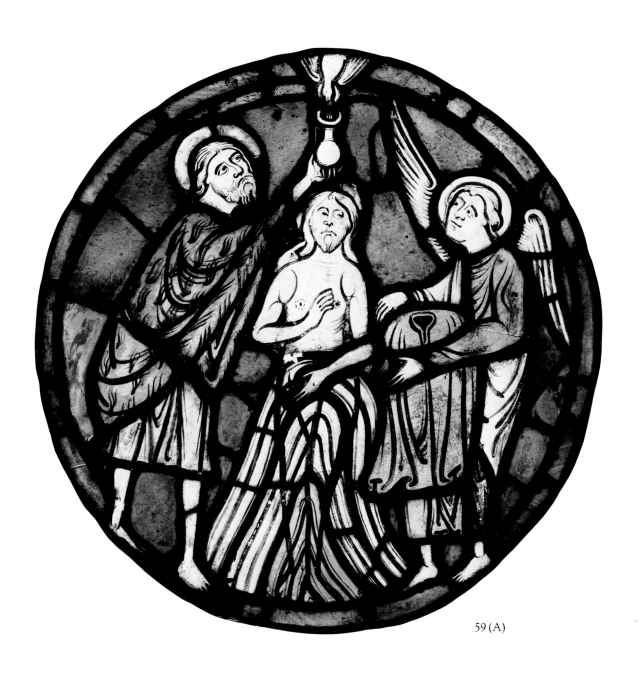

59 (A)

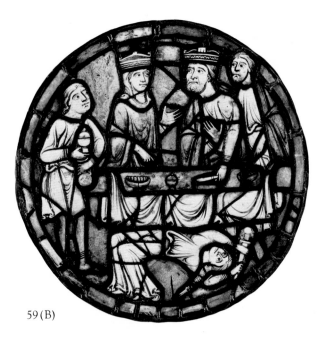

59 (B)

blue and the edge fillet is red. Unlike the previous panel, this piece is in virtually perfect condition. Two small and insignificant bits of drapery on the attendant figures, a piece from the top of the table, and two pieces of the edge fillet are modern.

(C) Salome, dressed in a white robe, stands at the left, on emerald green turf. She accepts the head of the Baptist, in a footed dish, from an executioner in a yellow tunic and light green hose, who stands on a white hillock at the center of the composition, wielding a bloodied sword. At the right, the headless figure of the Baptist, wearing a light green robe and murrey mantle, leans from a fortified tower built with yellow, green, murrey, and white glass. The background is blue and the scene is edged with a red fillet. As was the case in panel (A), portions of the piece—the heads of the two standing figures and the tile roof of the tower—have been treated with acid. Elements of the tower, four segments of blue ground, and four pieces of the red fillet are modern replacements.

Raymond Pitcairn purchased these three panels from the Parisian dealer Lambert in 1923. Lambert had obtained them (along with a panel from Saint-Denis, now also in the Pitcairn collection; cf. no. 28) at the Hôtel Drouot on February 9, 1923, when part of the Bonnat collection was put up for auction. Bonnat had channeled much of his wealth into gathering a comprehensive, didactic art collection (Weisberg, 1980, 271–73), but it is not known when and from whom Bonnat acquired these panels. An article published in 1850 (Ledicte-Duflos, 94–95), however, identifies their provenance as the church of Saint-Martin in Breuil-le-Vert, and indicates that they already had become part of the collection of an "amateur" in Clermont-sur-Oise, who apparently had

saved them from destruction. They were still installed in the church in 1838 (Graves, 1838, 61).

Very little is known about the history of Breuil-le-Vert and the church of Saint-Martin that would help to interpret these remains from its glazing other than that the choir and transept were rebuilt during the thirteenth century (Mabile, 1969–71, 148–50). The church was founded at the end of the eleventh century by Count Hugh of Clermont, who placed it under the jurisdiction of the Abbey of Saint-Germer-de-Fly. In the twelfth century, the secular domain of Breuil-le-Vert passed with the dowry of a daughter of the Count of Clermont to the house of Candavène, in whose possession it remained during the thirteenth century (Graves, 1838, 60–61; de Lépinois, 1874, 313–17). These ties with local nobility provide a context for the kind of patronage that might explain the appearance of glass of this quality in what is otherwise an extremely modest church.

The life of John the Baptist was an especially popular subject for architectural decoration in the thirteenth century, appearing in windows in Bourges, Amiens, Saint-Julien-du-Sault, Angers, Clermont-Ferrand, Lyons, Coutances, and Rouen, and figuring in the sculpted portals of the cathedrals of Sens, Auxerre, and Rouen. It is not certain whether or not these three panels from Breuil-le-Vert represent a complete cycle. The tall, narrow lancets of the church suggest that the panels could be fragments of a more extensive narrative window. Nevertheless, the three episodes depicted—the Baptism of Christ, the Feast of Herod, and the Martyrdom of the Baptist—are among the most popular in illustrated lives of this saint, and could stand alone as an abbreviated cycle. On the left portal of the west façade of Sens, for example, these same three scenes are extracted from the cycle and prominently displayed on the lintel, while the remainder of the story is relegated to the less conspicuous archivolts (Sauerländer, 1972, pl. 58).

Featured in all four Gospel accounts, the Baptism of Christ is clearly the most important event in John's life, establishing his role as the final prophet who heralded the messiah at the very moment that he was identified by God through the descent of the dove, and who inaugurated Christ's ministry through this symbolic ritual. The Passion of the Baptist, more narrative than symbolic, is related in only two of the Gospels (Matthew 14:3–12; Mark 6:17–29). The story begins with a description of the seductive dance that Salome performed for Herod at a banquet given to celebrate his birthday. Herod was so pleased by his stepdaughter's performance that he promised Salome any reward that she desired. Counseled by her mother, Herodias, who sought revenge against the Baptist for pointing to the inappropriateness of her union with Herod, Salome demanded John's head on a platter. The Martyrdom of the Baptist is represented in Breuil-

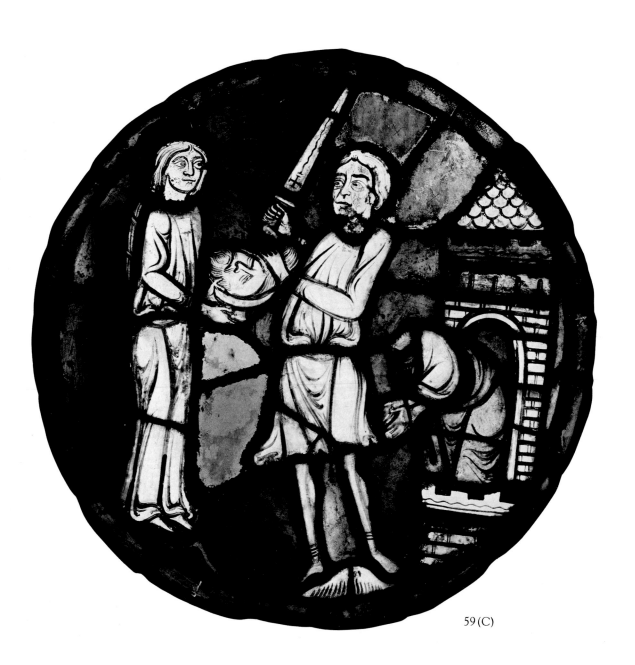

59 (C)

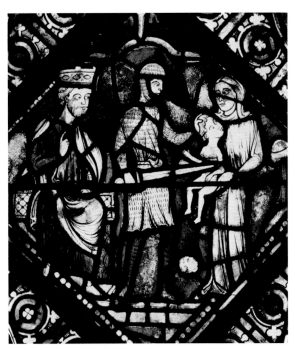

25. *The Massacre of the Innocents,* from the Infancy of Christ window, Chapel of the Virgin, Cathedral of Saint-Pierre, Beauvais. About 1225. Pot-metal glass

le-Vert in a scene that conflates the decapitation with the presentation of the prize to Salome.

The most unusual iconographic feature of these three panels occurs in the Baptism of Christ. Actually, in most respects this is a conventional depiction. Only the presence of the upright flagon of chrism in the hand of the Baptist, and its relationship to the descending dove, is relatively unusual. In most contemporary compositions, the Baptist simply raises his hand over the head of Christ, as if in blessing. This traditional gesture is standard in Parisian manuscripts (Branner, 1977, fig. 120) and also can be seen in the choir clerestory of Chartres (Delaporte, 1926, pl. CCXXIII) and in a transept chapel window in Rouen (Ritter, 1926, pl. XXX). Moreover, since the ninth century, in most instances where the ampulla is present, either John or the dove annoints Christ with its contents (Schiller, 1971–72, pls. 366, 372, 373) or John simply holds it to the side (Ritter, 1926, pl. XXX).

Apart from a group of specialized images in which a dove arrives with two ampullae in his beak (Deshman, 1971), the closest parallels to the disposition of the upright flask at Breuil-le-Vert can be found in depictions of the Baptism of Clovis in cycles of the life of Saint Remigius (Remi). According to a tendentious, ninth-century account of this regal baptism written by Hincmar, a dove miraculously appeared to Saint Remigius, carrying in its beak the ampulla of chrism that was to be used in the baptism of Clovis, the first Christian king of the Franks. That ampulla

and its chrism were still being used to annoint the French kings in the thirteenth century, according to the archbishops of Reims. The earliest known illustration of the Baptism of Clovis is a tenth-century ivory relief (Goldschmidt, 1914–18, I, no. 57, pl. XXIII). The same iconography appears in the thirteenth century in the Saint Remigius window in Chartres (Delaporte, 1926, pl. LXXVII) and in an illustrated life of Saint Denis (Paris, Bibl. Nat., nouv. acq. fr. 1098, 50v.).

Is there any significance to this correspondence between a scene from the life of a bishop saint and the depiction of the Baptism of Christ? If so, why would it occur in the window of a parish church during the second quarter of the thirteenth century? Is it possible that the Breuil-le-Vert artist made a casual error, introducing a stray iconographic detail in an inappropriate context? Or was he simply being faithful to a distinctively northern French iconographic type? Though less emphatic in its presentation, the Baptism of Christ in the Ingeborg Psalter (Deuchler, 1967, pl. XV) does include a tiny dove clutching an ampulla in its beak.

In Reims, where the possession of the miraculous ampulla of Saint Remigius was a crucial element in the struggle to maintain the prestigious and powerful privilege of annointing the kings of France, baptism, annointment, and kingship were carefully and closely related (Hinkle, 1965, 23–40; Deshman, 1971). Since Breuil-le-Vert, as part of the diocese of Beauvais, was under the ultimate jurisdiction of the archdiocese of Reims, the inclusion of this motif as a variant with special regional significance would not have seemed at all unusual. In addition, there may have been an especially compelling reason for such a representation, about 1235. In the first quarter of the thirteenth century, the primacy of Reims as the coronation church had solidified, but, by the 1230s, its relationship with the young King Louis IX and Queen Blanche was strained. Major controversies between the church and the king about jurisdiction— first in Beauvais (Pontal, 1956) and then in Reims, itself (Campbell, 1960, 548–49)—crippled the archdiocese with a series of interdicts and excommunications. The struggle in Beauvais (1232–38) was especially bitter and represents the immediate political context in which the Breuil-le-Vert Baptist panels were made, since the cathedral is only twenty-eight kilometers northwest of this parish. Is it not possible that the primacy of the Church was asserted in Breuil-le-Vert, through a conflation of the Baptism of Christ and the miraculous acquisition of the ampulla containing the very chrism that had been used in 1226 to annoint Louis, thereby legitimizing his own kingship? In panel (A), John, like the church at Reims, accepts the sacramental oil, acting as an intermediary who initiates an earthly mission with a symbol of its dependence on an otherworldly sanction.

Admittedly, a more comprehensive study of these panels must be undertaken before a definitive answer can be offered for the questions raised by this iconographic peculiarity and its regional ramifications. Still, the possibility certainly exists that, far from being innocent, the iconography may have been related to a complicated political and ecclesiastical struggle in the province of Reims, specifically in the diocese of Beauvais, during the 1230s.

On the basis of its style, the Breuil-le-Vert Baptist series may be associated with a group of windows executed for churches in the Beauvaisis during the second quarter of the thirteenth century (Cothren, 1980, 71–87), reinforcing the potential importance of regional peculiarities revealed in the iconography of the Baptism of Christ. The place of these three panels within this local style can be evaluated by comparing them with its most prominent product, the Infancy of Christ window in the chapel of the Virgin in the cathedral of Beauvais. There are striking similarities in facial types, specifically—for instance— the heavy eyebrows with upturned, spiky projections above the bridges of the noses of the executioner, the baptizing Saint John, and Herod, all of whom can be likened to the mother whose baby is being massacred in the Beauvais Infancy window (fig. 25). In the faces of Herod at Beauvais and Breuil-le-Vert, mouths are indicated by the same downward curving lines. Lower lips are defined by an identical motif; beards spiral at the chin. Jaws are delineated by bold lines, lending a sense of weight to the heads, which crane forward on long necks. Hair curls in neatly overlapped bundles. There is an unusual drapery motif—a pendulous loop falling over the upper arm. Figures are relatively stocky, with large heads, but with tapering, slender ankles ending in small, pudgy feet.

More general similarities are equally revealing. Like the compositions of the Beauvais Infancy window, those from Breuil-le-Vert are rectilinear in conception, with little attempt to mold the arrangement of figures and environment to the shape of the frame. Angularity of design extends to the rigid postures of individual figures. Rather than adhering to the graceful curve that characterizes Salome's dancing pose in most contemporary depictions of this theme (Sauerländer, 1972, pl. 182), the Breuil-le-Vert artist placed her in a neatly contorted pose that can be inscribed inside a rectangle. Like the Massacre of the Innocents at Beauvais, each of the episodes in the life of the Baptist is expressively neutral. A stiffly posed Salome receives the head of the Baptist without passion, and her lack of emotional involvement is shared by all of the Beauvais participants.

Another distinctive feature of the Beauvaisis group found in the roundels from Breuil-le-Vert is the use of an extensive palette in varying combinations to counteract the dominance of red and blue, both of which are reserved primarily for ground and frame.

For example, there are two shades of green—very pale olive and emerald. Flesh tones alternate between pink and a yellowish white. Furthermore, the limpid lemon yellow used in the Breuil-le-Vert glass is a favorite color in the Beauvaisis group.

For an understanding of the Beauvaisis style and its development, however, the differences between the Breuil-le-Vert and Beauvais glass are almost as important as the similarities. The windows were not produced by the same artists, or at the same time. Perhaps the distinction can be most easily understood through a single, close comparison of the drapery of the standing mother from the Beauvais Massacre of the Innocents (fig. 25) and Salome (from Breuil-le-Vert) receiving the head of John the Baptist. The latter figure is, in almost every respect, more supple and more fluidly painted. In comparison, the articulation of the stiffer Beauvais figure is more schematized, defined by a less flowing and spontaneous, more precise and dry, line.

With the inclusion of Breuil-le-Vert into the Beauvaisis group, three distinct phases in its stylistic development can be charted. Breuil-le-Vert, itself, represents the first phase, of about 1235. By the middle of the 1240s, when the Beauvais chapel of the Virgin was glazed, the softness of the figures had been hardened somewhat into a precise and studied formula. By the third phase, in the late 1240s, when a series of small churches—such as Agnières (Somme) or Belle-Église (Oise)—were glazed, meticulousness, to a large extent, had been transformed into academic convention, and linear articulation had become brittle (Caviness, 1978, no. 7). In other words, a progressive hardening of style, the tendency that Grodecki (1978) has cited as the unifying feature of the formal development of stained glass during the second quarter of the thirteenth century, can be observed in this carefully localized group of closely related windows.

Thus, in addition to their intrinsic interest as well-preserved products of a glass painter whose consummate skill is revealed in the creation of chromatic harmonies and fluidly articulated figures, these panels from Breuil-le-Vert provide important information for the understanding of a little-known regional style of glass painting in the 1230s and 1240s. For both reasons, their survival is a fortunate circumstance for the student of Gothic art.

M. W. C.

Purchased from Augustin Lambert, Paris, August 13, 1923.
Ex collection: Léon Bonnat, Paris (until February 9, 1923).
Bibliography: Ledicte-Duflos, 1850, 94–95; Cothren, 1980, 86, pl. 49.

see colorplate IX

60. Seated and Blessing Christ, from an Unknown Window

France, Beauce, Chartres(?)

About 1215–20

Pot-metal glass

Height, 46.6 cm. (18 3/8 in.); width, 32 cm. (12 5/8 in.)

03.SG.22

Christ, seated upon a yellow throne with red and green inserts, raises his right hand in blessing. His nimbus of pale yellow is crossed in red and he wears a murrey robe and a white mantle. The background of the panel is dark blue. The red and white edge fillets are made from old, reused glass. Except for the murrey pieces above Christ's left hand and the adjoining blue of the background, the glass is in excellent condition.

The panel was purchased from Lucien Demotte in Paris in 1928. Previously, it is said to have been in the collection of Octave Homberg and was sold in Paris in 1908. No further provenance provides any clue as to the origin of the piece.

The inventory of Raymond Pitcairn's stained-glass collection (now in the Glencairn Museum), compiled in 1967 by Henry Lea Willet and Philippe Verdier, suggests that this seated Christ once might have been part of a Coronation of the Virgin scene; the Virgin would have been seated to the left of Christ, with angel attendants flanking the pair. That the Virgin and angels are now missing emphasizes the present incomplete state of the Pitcairn panel. Though it is impossible to determine with certainty the original subject of this fragment, evidence suggests the Coronation as the most likely prospect. Iconographic types showing Christ enthroned are well defined in medieval art. Christ in Majesty, or the *Maestas Domini*, almost always is depicted as a frontally posed figure seated either upon a low throne or an ark, holding a book or sphere in his left hand and blessing with his right (cf. no. 66). When included in the Coronation scene, Christ is invariably seated, his body—or just his head—turned toward the left. This is the pose assumed in the Dormition windows in Angers (Hayward and Grodecki, 1966, 20), Chartres (Delaporte, 1926, pl. XXIV), and Saint-Quentin (Grodecki, 1965, pl. 115). The Coronation is depicted in similar fashion in the sculpture on innumerable twelfth- and thirteenth-century portals, including those of Senlis, Mantes, Braine, and on the north transept of Chartres (Sauerländer, 1972, pls. 42, 47, 74, 78). Christ is often shown holding a book in his left hand in these scenes, but because of the repair in this portion of the Pitcairn panel it is impossible to determine whether or not the book was once included. The angular line of the leading surrounding the repair, however, strongly suggests this

possibility, while the filling in the blue background in the upper right-hand corner also underscores the likelihood that this area of the panel once might have contained the figure of an attendant angel. Often, but not always, Christ is shown wearing a crown in Coronation scenes. The crown is absent in Braine and Saint-Quentin, so the fact that there is no crown in the Pitcairn panel does not negate the probability that this panel, too, once belonged to a Coronation scene; except for the fact that the background glass to the left of Christ's knees is apparently original—which indicates that the throne has always been a single-seated chair—there is little evidence to suggest that this panel was not initially part of a Coronation. Though the thrones in Coronation scenes are almost always long benches upon which both figures are seated, the north portal of Chartres furnishes an important departure from standard Coronation iconography; in Chartres, both Mary and Christ are seated upon separate thrones. Since the Pitcairn Christ has been stylistically related to the stained glass of Chartres (Grodecki, Notes, 1967), the separate throne offers supporting evidence for this provenance.

There is little chance, however, that the Pitcairn Christ originated in the glass of the cathedral of Chartres, itself. The Dormition window containing the Coronation is complete, as is the Life of the Virgin that fills one of the openings of the second bay on the south side of the choir. This window, moreover, only includes scenes from the early life of Mary. The style of the Pitcairn Christ is distinctive. The well-proportioned figure is enveloped in soft, clinging drapery whose trace lines are particularly descriptive, varying in thickness to indicate the depth of the folds. The trace paint was applied quite thickly to the glass and frequently bubbled in the firing. The head of Christ is ovate, lengthened by the beard that, with the hair, is defined by parallel waving or serpentine strokes of the brush. Mat tones were used sparingly to accentuate the roundness of forms. The eyes, accented by the pupils, are large and pointed at the outer edges; the upper lids follow the lines of the eyes and then curve upward at the outer edges toward the arched brows. The nose, slightly hooked, is drawn separately from the brows, and the lips are full. The figures in Chartres that are closest to this one are those that Grodecki (Aubert, 1958, 129) has recognized as being by the major atelier of the nave of Chartres. Delaporte (1926, 5–18) was the first to propose the Master of Saint Lubin as the head of this atelier, attributing to him also the Life of Saint Nicholas and the Noah windows—to which Gloria Gilmore-House (1974) convincingly added the Miracles of the Virgin window at the southeast corner of the nave. Grodecki has suggested that this was a local atelier whose style was founded in the traditions of western French glass painting established in Le

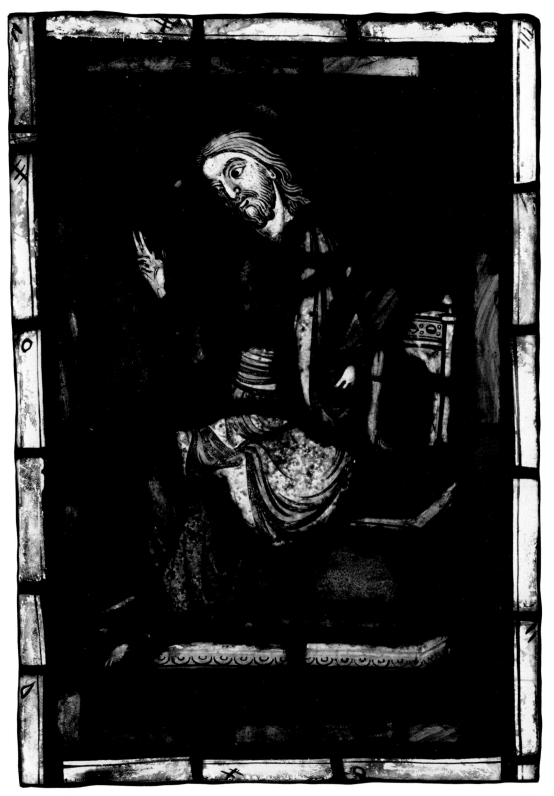

60

Mans, Angers, and Poitiers in the twelfth century. The traits of this atelier, such as the rounded heads, softly flowing hair covering small knob-like ears, clinging drapery, and classical proportions, are comparable in style to the Pitcairn Christ. The dating of the nave windows of Chartres (1205–15) also parallels that assigned to the Pitcairn piece.

If, as Grodecki proposes, the Saint Lubin atelier originated locally, there is every reason to believe that it continued to work in northwestern France. Though the ateliers responsible for painting the windows in the choir of Chartres derived their styles from the shops working in the nave, there is no indication that the choir and nave ateliers were the same. There is evidence of a break between the building of the nave and the choir of Chartres (Grodecki, *Bull. Mon.*, 1958, 91–119; van der Meulen, 1965, 29–126), and there most likely was a similar hiatus between the glazing of the nave and the choir, during which the glaziers either departed from Chartres or found work elsewhere in the area. Given the few windows that survive today, from among the vast numbers of monuments that must have been completely glazed in the thirteenth century, these isolated examples without provenance or from lost buildings undoubtedly withstood the ravages of time either through chance or the protection afforded them as a result of their removal to private collections. Fragments of glass from numerous churches demolished during and following the Revolution thus have been preserved (cf. no. 46). The Pitcairn Blessing Christ is such an example. Its style suggests that it originally glazed a window in the vicinity of Chartres, but that it was made by the atelier that also created the Story of Saint Lubin and other windows in the nave of Chartres Cathedral.

Purchased from Lucien Demotte, Paris, May 2, 1928.

Ex collection: Octave Homberg, Paris (until 1908).

61. Angels Carrying a Decapitated Martyr, from an Unknown Window

France, Beauce(?)
About 1225–30
Pot-metal glass
Diameter, 53.8 cm. (21⅛ in.)
03.SG.180

Two angels carry the white-robed, decapitated body of a martyr. The angel on the left, dressed in a green robe and murrey mantle, has white wings and a red nimbus; the one on the right wears a murrey robe and a dark green mantle, and has a red nimbus and yellow wings. The background is blue and the foreground white. A yellow tree grows on the right-hand side of the panel. Red fillets, and white-pearled fillets on the outer edge, partly original, surround the panel. A

considerable amount of the background has been replaced but the figures are in large part unrestored.

The panel was purchased from Acézat in 1928. Previously, it had been in the Heilbronner collection, which was sold in Paris in 1924 after having been sequestered by the government, as noted earlier, during World War I. Prior to 1914, however, there is no record of this panel, nor is there any specific monument to which it can be related.

The iconography is fairly straightforward. Judging from the skirt of the robe that extends over the feet of the decapitated body held by the angels, the figure must have been a female martyr. Among the most well-known martyrs of the Middle Ages to have suffered a fate similar to that depicted in this panel was Saint Catherine of Alexandria. Saint Catherine was martyred in Alexandria and, after being subjected to a series of tortures that included the infamous spiked wheel—which would become her attribute—she was beheaded. Her body, however, was miraculously transported by angels to Mount Sinai, where she was buried, supposedly on the site of the monastery that now bears her name, and where, too, her relics were invented. As a result of the Crusades, the cult of Saint Catherine became popular in the West. For some reason, she was especially venerated in the western part of France. A monastery dedicated to her was founded near Rouen in the twelfth century (Lafond, 1975, 407). The cathedral of Angers was given one of her relics by Bishop Raoul de Beaumont, in the latter part of the twelfth century, and a stained-glass window depicting her legend still exists there (Hayward and Grodecki, 1966, 17–20). Wall-paintings of the legend of Saint Catherine are found at Pritz, near Laval in the old county of Maine, as well as in Montmorillon (Pré, 1947, 143, fig. 118; Deschamps and Thibout, 1963, 71–72), both dating from the twelfth century. One of the most extensive cycles of the Saint Catherine legend, containing sixteen scenes, is in a choir window in Chartres, probably painted about 1225 (Delaporte, 1926, 254–60). There appears to be little conformity in depictions of the ending of the Saint Catherine legend, moreover. In Angers, the angels place her headless body in her tomb; in Chartres, her executioner raises his sword, but, in Regensburg (Eisen, 1940, pl. 36), she has already been beheaded; in the Sankte Maria Lyskirchen in Cologne, she is shown transported by angels, her head having been restored (Goldkuhle, 1954, 99–105). As Louis Réau has observed (1955–59, III, 271), however, it is not unusual for two angels to translate the body—and another the head—of the saint.

Given the popularity of Saint Catherine in the west of France, it is not surprising to find relationships of style between the Pitcairn panel and western French stained glass. This panel bears the closest resemblance to the glass in the west rose of Chartres,

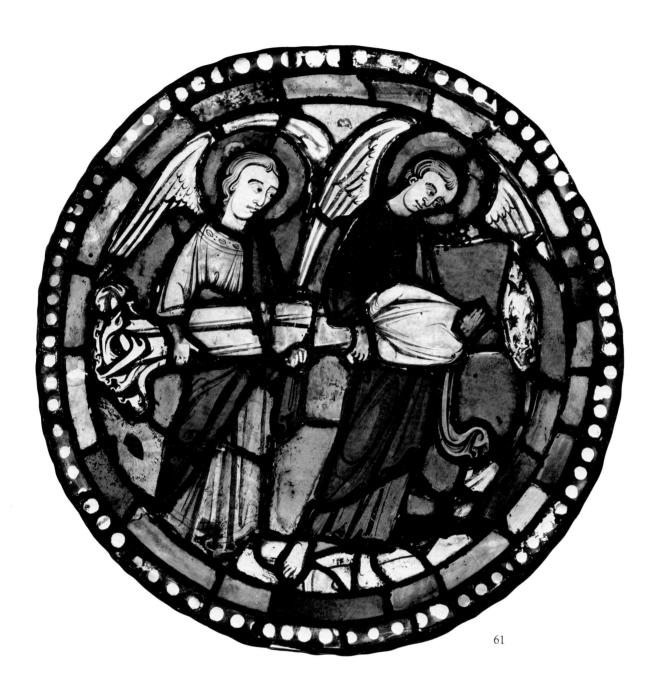

61

but the former is later in date. The glazing of the Chartres rose scarcely could have been undertaken before 1210 at the earliest and probably occurred five years after the lower side bays of the nave had been finished. Paul Popesco (1970, 143) has suggested that the atelier responsible for the Dormition of the Virgin window in the south aisle of the nave also designed and made the west rose. This theory seems valid as far as the figure style is concerned but the compositions of the individual panels are entirely different. The scenes that comprise the Dormition window are densely packed with figures, more compressed than in any other window in the cathedral. Figures are shown as complete images, rather than just as heads piled one above the other, behind those figures in front—the normal way of indicating crowds in thirteenth-century glass. The poses of these crowded figures are varied to the point of confusion. This need for compression hardly can be justified by the subject, since the same theme had been treated in a much simpler manner in Angers and, because of similarities in ornament, must have been known to the designer of this window. The compositions of the medallions of the west rose, on the contrary, are very simple, employing few figures or even single images in the scenes. This dramatic change, of course, can be attributed to differences in scale and to the necessity of legibility when the glass was at a greater distance from the spectator. A more logical explanation for this change, however, would seem to be that the Dormition master had learned from his contemporaries, the other glass painters in Chartres, the value of simplicity, and had adapted his own style accordingly in his next project, the west rose. In the figure style of the west rose, there is none of the fussiness of detail or confusion of form noted in the Dormition window. The features are rendered by bold strokes of the brush, and the drapery in broad folds that sweep in curvilinear swirls about the limbs or that float as panels in the air. This noticeable simplification indicates the maturity of style of this master. It is this stage of his style that is most closely related to the Pitcairn Saint Catherine panel.

Few of the ateliers in Chartres have been traced beyond the confines of the cathedral. Popesco's suggestion (1970, 143) that the Dormition master was also responsible for the Good Samaritan window has not been widely accepted (Aubert, 1958, 129). The most successful attempts to trace the movements of these ateliers are two studies by Grodecki on the Master of Saint Eustace (1965, 171–93) and the Master of Saint Chéron (1978, 43–64). For the most part, the ateliers of the nave are not recognizable in the glass of the choir, some ten years later in date. The Pitcairn panel is, perhaps, a rare example by an atelier whose work began in Chartres with the Dormition window in the nave and culminated in the

Last Judgment scenes of the west rose. Though a maturation in style is evident from one Chartrain work to another, there are definite differences between them and the style of the Pitcairn panel. Most apparent are further simplifications in drapery, poses, and features. The floating panels of drapery terminating in serpentine folds and the frilled edges of the garments are still noticeable in the Saint Catherine roundel, but the folds have become broader and straighter. The angels of the Pitcairn panel are not the elegant, pirouetting figures of the Last Judgment. Instead, they are almost rectilinear in shape, their arms held close against their bodies and their feet planted firmly upon the ground. In the features, particularly, there are still traces of the heavy rounded jaws continuing upward to the ears, the brows that curve downward and thicken at the outer edges, the rounded tips of the noses, the straight mouths, and the high foreheads with their pronounced forelocks. The master of the Pitcairn Saint Catherine was certainly not the master of the Chartres Last Judgment, but stylistic evidence suggests that he was trained by the Chartrain master. The Saint Catherine painter must have left Chartres, while a young man, to work elsewhere, for the windows of the choir of Chartres seem not to have influenced his work. It is doubtful that he ever saw the Saint Catherine window at the cathedral painted by the Saint Chéron master, for it bears no resemblance whatsoever to his own panel, either in style or in iconography.

Purchased from Michel Acézat, Paris, April 9, 1928.
Ex collection: Raoul Heilbronner, Paris (until 1914).
Bibliography: Heilbronner sale cat., 1924, no. 98.

62. The Resurrected Rising from Their Graves, from the East Rose Window

France, Donnemarie-en-Montois, Church of Notre-
 Dame
About 1225
Pot-metal glass
Diameter, 51.5 cm. (20 1/4 in.)
03.SG.211

On the left side of the roundel, a man wearing a green shroud steps out of a blue and white sarcophagus lined in murrey. On the right, a woman, draped in a red shroud, places her hand on the yellow lid of a green tomb. A murrey and yellow tree grows in the center of the composition. The background is blue and the tuft of ground on the left is yellow. Parts of the background, particularly in the center of the roundel, have been replaced. The figures are, generally, in good condition, except for the upper part of the body of

166

the woman and the area—now replacement glass—where her extended left arm should have appeared.

This piece was purchased in 1922 as a single item from Donald B. Taunton, a glass painter for John Hardman and Co., Ltd., of London. The panel had been presented to the firm by the architect Augustus Welby Pugin in the 1840s. Nothing further is known of its recent history. Its origin, however, has been convincingly documented by Françoise Perrot (1970, 53–63) as the east rose of the parish church in Donnemarie-en-Montois, southwest of Provins.

Though no documents exist either for the founding or the consecration of the church in Donnemarie, Bony (1957–58, 50) has placed it within the orbit of his "Resistance to Chartres" movement, suggesting that the east wall of the Donnemarie church derived from the choir of Laon, which was reconstructed about 1210. Pierre Héliot (1966, 55–78) has related the form of the rose of Donnemarie to that of the façade of the cathedral of Toulouse, but Perrot suggests that a close connection can be made with the transept roses of Braine (Caviness, 1982, in press). Francis Salet (1932, 334–35) has concluded that the choir of Donnemarie was constructed in two campaigns beginning with the eastern wall, containing the rose, early in the 1200s, and that the entire church, comprising eight bays, was completed before the middle of the century. From these various opinions, it is possible to conclude that the eastern part of the building could have been finished and ready for glazing by the end of the first quarter of the thirteenth century.

Though the architecture of the rose of Donnemarie has retained its original form, the glass has been drastically rearranged (Perrot, 1970, 53–69). It is composed of a lobed central compartment, surrounded by eight large circles with sixteen smaller circles in the lobes on the periphery. At present, only the eight large circles contain medieval glass and these have been augmented by painted borders (fig. 26). The rose was restored about 1840, according to François Antoine Delettre (1849, 411). It was at this time that the borders were added to the old panels and the outer circles filled with ornament. Sums of money were appropriated again in 1882 and 1883 for the repair of the stained glass of the church (Paris, Arch. de la Dir. de l'Arch., Donnemarie, Fab. Accts., 1883). It was probably at this time that the central compartment of the rose was remade.

According to Perrot's analysis of the rose, it is a depiction of the Last Judgment. The eight original panels, now in the large compartments, which illustrate scenes of the resurrection of the dead, angels leading the elect, and the elect wearing crowns, initially all belonged in the smaller outer circles of the rose. The Pitcairn panel, which is also a scene of resurrection—in which the figures face left—would have been placed in the lower right-hand quadrant

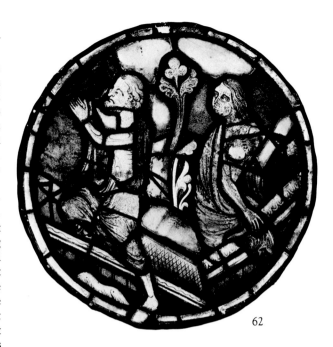

62

of the outer circle. Since four scenes of this type remain in Donnemarie, with the Pitcairn panel the fifth, one additional scene of the dead rising from their tombs must be lost. Similar scenes occupied the outer compartments of the west rose of Braine (no. 49). Perrot would place the two panels of the crowned elect and the two of the angels leading the elect in the topmost compartments because of the direction in which the figures face. Christ, the judge, would occupy the center of the rose, with Abraham holding the saved to his bosom in the large circle above and Saint Michael weighing the souls in the corresponding space below. Other compartments would have contained the damned, Hell, angels, and apostles.

Though the Last Judgment was a favored subject for rose windows in the first quarter of the thirteenth century, most roses were placed above the western door. This was the case in Chartres, Mantes, Braine, and Laon. That the Last Judgment was chosen for the

26. *The Rising Dead* (detail), from the west rose window, Notre-Dame, Donnemarie-en-Montois. About 1225. Pot-metal glass

167

eastern rose of Donnemarie probably resulted from the arrangement there of a flat chevet with a rose, which copied Laon; unlike Laon, however, Donnemarie has only one rose window. Salet suggested that a second campaign changed the plan of the building and must have been under way when the rose was being glazed, undoubtedly the reason for placing this important subject in the east end of the church. Familiar though this subject was, both in portal sculpture and in stained glass, there is little comformity either in sequence or choice of scenes illustrated. Perrot's reconstruction, which places the six resurrected figures at the bottom, does not, however, provide an adequate place for Hell, the Devil, or the damned. Hans Fischer (1969), in an unpublished paper on the iconography of the Chartres rose, proposed that the four scenes showing the fate of the damned should have been placed opposite the elect at the bottom of the Donnemarie rose and that the resurrected should have occupied the lateral compartments. This arrangement, in part, would follow that of Chartres. Though Donnemarie has fewer compartments than most Last Judgment roses, it devotes more space than any of the others to the resurrected. The Pitcairn panel, like all of the others in the series, contains two figures partially draped in shrouds. The pose of the figure on the left, who steps out of his tomb and raises his hands in prayer, is exactly duplicated by a figure in one of the other panels, except that the head of the latter is in three-quarter view and the head of the Pitcairn figure is shown in profile. The Pitcairn head in profile, in turn, is copied almost exactly in yet another panel (fig. 26), which also contains a head in three-quarter view, similar to that of the second figure in the Pitcairn roundel.

The glass in Donnemarie is difficult to study because of the surface deterioration and corrosion, which have caused considerable losses of paint. On the contrary, the Pitcairn panel—because it was probably removed in the restoration of 1840—has retained its freshness. Though the design of the Donnemarie rose is similar to those of Braine, there is little in the figures that relates them to the prevailing style in eastern France during the first quarter of the thirteenth century. The figures in Donnemarie are short and slender. Their gestures are tense and expressive and there is considerable individuality in the facial types and in the detail with which the features are drawn. Though their shrouds fall in heavy swag-like forms with small pleats, the figures totally lack the elegant calm of the Braine and Soissons examples. Whereas the anatomy of the Dead Rising from Their Tombs (no. 49)—here attributed to Braine—is generalized, the anatomical rendering of the Donnemarie figures, though stylized, is detailed. Muscles are visible in the arms of the figures, and the rib cage of the one on the left clearly indicates the bone structure beneath

the flesh. Perhaps this style should be related to the glass in Sens in the ambulatory chapel of the Virgin, though the Sens window is later, dated about 1240 (Wixom, 1967, no. IV, 21). Until the glass in Sens and in other centers of medieval glassmaking around Paris (Perrot, 1970, 63) has been studied in depth, the style of Donnemarie cannot be defined.

Purchased from Donald B. Taunton, London, July 18, 1922.
Ex collection: Augustus Welby Pugin, London (until the 1840s).
Bibliography: Perrot, 1970, 63.

see colorplate X

63. The Martyrdom of Two Saints, from an Unknown Window

France, Île-de-France, or Burgundy
About 1210–15
Pot-metal glass
Diameter, 54 cm. (21 1/4 in.)
03.SG.112

Two martyrs are being beheaded by three soldiers. The hands of the martyr on the left are roped together; the one on the right wears a cleric's robe of green with a yellow collar and belt. One executioner is in front, wielding a green sword, and dressed in a white tunic with a red collar and green hose. Directly behind him is a second soldier in green chain mail with a green sword; behind him is the blue-helmeted head of a third warrior, who carries a green shield. The background is blue with red and white-pearled edge fillets. Parts of the background and the exterior-edge fillet are new or replaced. The right arm of the martyr at the right is missing, but the lead line at his shoulder shows the raised, bent position that the arm had assumed. Either this panel once contained additional figures, or stopgaps from other scenes in the same window were used to fill the missing pieces. The bloodstained hair of a martyr, similar in color to the head on the right, was leaded into the upper part of the red edge fillet, and part of an arm clad in chain mail was inserted below the figure of the other martyr.

This panel was purchased in 1927 from Acézat of Paris, who claimed that it came from a private collection near Le Mans. The panel, in fact, had been auctioned in Paris only three years earlier as part of the Heilbronner collection. Its earlier history is unknown.

Though a certain fineness of technique distinguishes the work of the ateliers active in the cathedral of Le Mans at the end of the twelfth century, the style of this glass is still very Romanesque in character (Grodecki, 1977, 68–70) and far from the elegant "classicism" of the Pitcairn Martyrdom. The next phase in the glazing program at the cathedral of Le

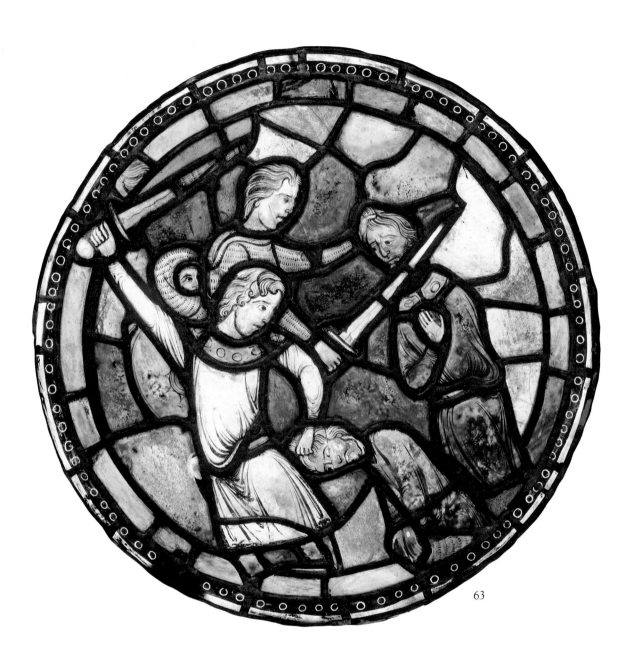

63

27. *The Good Samaritan Robbed on the Road to Jericho*, from the Good Samaritan window, Cathedral of Saint-Étienne, Sens. About 1210–15. Pot-metal glass

Mans did not take place until about 1235, when windows were added to the chapel of the Virgin during the construction of a new Gothic choir. Since there are no records of other stained glass from churches in Le Mans, it is hardly likely that this city could provide a provenance for the Martyrdom. The stylistic relationships in this panel are, in fact, quite different from those in other panels in the cathedral of Le Mans.

In her recent book on the stained glass of Canterbury Cathedral, Madeline Caviness (1977, 84–93) has convincingly demonstrated that artistic as well as historical connections existed between the English monastery and Sens. She has proposed, moreover, that the four windows that still exist in the ambulatory in Sens were glazed during the period of the exile of the monks from Canterbury (1207–13), and that these windows were greatly influenced by—or even designed after—English models. When viewed in the context of French stained glass, the windows of Sens stand in isolation. Grodecki noted comparisons between Sens and Canterbury as early as 1958 (Aubert, 139), but by dating the Sens windows about 1220 he made them an outgrowth of the English glass rather than part of a reciprocal stylistic exchange, as Caviness believes. So far, no one has demonstrated the direct stylistic impact of Sens on other monuments. The time lag between Sens and the next important glazing program in Burgundy, the choir of the cathedral of Auxerre, which probably did not get under way much before 1233 (Raguin, 1974, 35–36), was too great for Auxerre to have had any effect on the Pitcairn Martyrdom.

The Pitcairn panel is not a direct product of the atelier, or ateliers, that worked in Sens, and is even farther removed from the orbit of Braine or Soissons. Yet, the master who painted the Martyrdom must have been familiar with the style of Sens—especially if, in fact, he had served his apprenticeship at the cathedral. His style is not as powerful as that of the painter who designed and made the Good Samaritan window in Sens (fig. 27), but he has the same fondness for profile heads. He painted the hair of his figures in waved or curling locks, accenting the individual strands first with a stylus and then with a wash of mat. The master represented eyes, even in profile, as small and rounded, below brows knitted in concentration, and noses as thin and bony forms that are not as calligraphic as those of the masters of Laon and Saint-Quentin. Like those of the figures in Sens, the mouths in profile are slightly open and the jaws are sharp and angular, but it is the softly fluid drapery of the Martyrdom that most closely resembles the style of Sens. Small folds twist or bunch about the arms; fall slack and blouse above the belt; and then hang in straight pleats, with little ripples at the hems of the garments—not unlike the drapery of the doorpost figures in Sens that Sauerländer (1972, pl. 60) dates about 1200. The style of the Martyrdom, subdued in comparison to Sens, probably postdates the cathedral glass, but there are still similar details in evidence in the accessories in the Pitcairn roundel, such as the knob-like pommel of the sword and the wavy line down the center of the blade, or the delicate scalloped ornament of the shield.

As to the subject of this panel, there are several possibilities. The martyrs apparently wear monastic or clerical garb but neither of them is nimbed. Among the martyrs who were beheaded, the pair most often venerated in northeastern France was Saints Gervasius and Protasius. Because of the pieces of unrelated glass set into the borders of this roundel, however, and because of the fragmentary condition of the background, it is quite likely that there was also a third martyr in the group. In that case, the scene might represent the martyrdom of Saint Denis and his two companions, Rusticus and Eleutherius. The most famous depiction of this martyrdom is the tympanum of the north transept portal of the abbey church of Saint-Denis, carved about 1175 (Sauerländer, 1972, 410). Though extensively restored in the nineteenth century, the prerestoration state of this tympanum is known from a drawing; neither costumes nor nimbi distinguish the martyrs in this representation. Saint Denis was one of the patron saints of the French kings and was revered throughout France. A window devoted to his legend, therefore, might have been included in almost any glazing program.

The most recent source of this panel—the Heilbronner collection—should not be overlooked in considering the provenance of the piece, for the glass in

this collection was predominantly northeastern French.

Purchased from Michel Acézat, Paris, March 8, 1927.
Ex collection: Raoul Heilbronner, Paris (until 1914).
Bibliography: Heilbronner sale cat., 1924, no. 98.

64. Two Panels from an Unknown Window

France, Angers, Cathedral of Saint-Maurice
About 1215–20
Pot-metal glass

(A) **A Warrior with a Battle-Ax**
 Height, 59.1 cm. (23 1/4 in.); width, 42.2 cm.
 (16 5/8 in.)
 03.SG.119

(B) **A King Holding a Spear**
 Height, 59.3 cm. (23 3/8 in.); width, 42.2 cm.
 (16 5/8 in.)
 03.SG.32

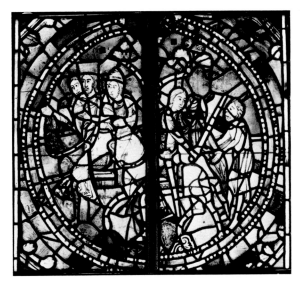

28. *Saint Martin Dividing His Coat with the Beggar*, from the nave, Cathedral of Saint-Maurice, Angers. About 1215–20. Pot-metal glass

(A) A half-length figure of a warrior wearing a red cap and mantle and a yellow blouse with a green collar, and holding a white battle-ax, faces toward the right. The background is blue with a white-pearled edge. Fragments of grisaille, with maple and ivy leaves on a crosshatched ground, fill the upper corners of the panel. Part of the background and the corner pieces are replacements.

(B) Framed like the previous panel, with similar corner pieces of grisaille, a half-length king holding a green spear with a white tip wears a gold crown and mantle and a white robe with a green skirt (replaced). On the left is a red barricade from which protrude two white arrow flèches. The background is blue and partly replaced, as are the corners.

Both of these panels were purchased from Acézat in Paris; the warrior in 1928 and the king in 1927. They had previously been sold at auction, with the rest of the Heilbronner collection, in Paris in 1924. At that time, they appeared in the sale catalogue as full figures, completed by panels of modern glass that were removed before the sale to Raymond Pitcairn. Their previous history is unknown.

The attribution of these panels to the cathedral of Angers, made on the basis of style, first appeared in the inventory of the Pitcairn collection prepared by Willet and Verdier in 1967 (now in the Glencairn Museum in Bryn Athyn) and was confirmed in the Notes of Grodecki (1967), who related these panels to glass produced by the Saint Martin atelier in the west window of the nave as well as to glass originally in the transept.

With a few notable exceptions, the glass in the windows of Angers is today a colorful patchwork of

repairs from various eras. The choir windows are particularly difficult to read for this reason and, among them, the Legend of Saint Martin has suffered the most drastically. Originally situated in the western bay of the nave, above the main portal, it was an expanse of glass nearly thirty feet in height. The window was repaired twice in the fifteenth century, was mentioned as being in bad condition in the sixteenth, and nearly half of its glass was replaced early in the seventeenth century. What was left of the window by the middle of the eighteenth century was moved to the upper half of the light when the sill level was raised to accommodate a new organ. By 1835, the remnants of the Saint Martin window occupied two small bays in the choir. The glass was consolidated and moved again, in 1845, to its present location on the south side of the apse. Of the original twenty-four scenes that comprised the Legend of Saint Martin, only twelve remain, and, of these, five contain a preponderance of medieval glass (Farcy, 1910, I, 172–81, for sources). No other window in the cathedral, with confidence, can be attributed to this atelier.

Compounding the study of the Angers glass is the chronology of the construction of the east end of the cathedral, and the conflicting evidence presented by the building itself and its surviving documents. The last window to be installed in the new Gothic nave was the Legend of Saint Martin. The installation was hardly held up by construction, however, since the west façade, including the towers, was probably about finished by 1180 (Mussat, 1963, 184–88), while the west window, on stylistic grounds, could not have been made much before 1205. Older

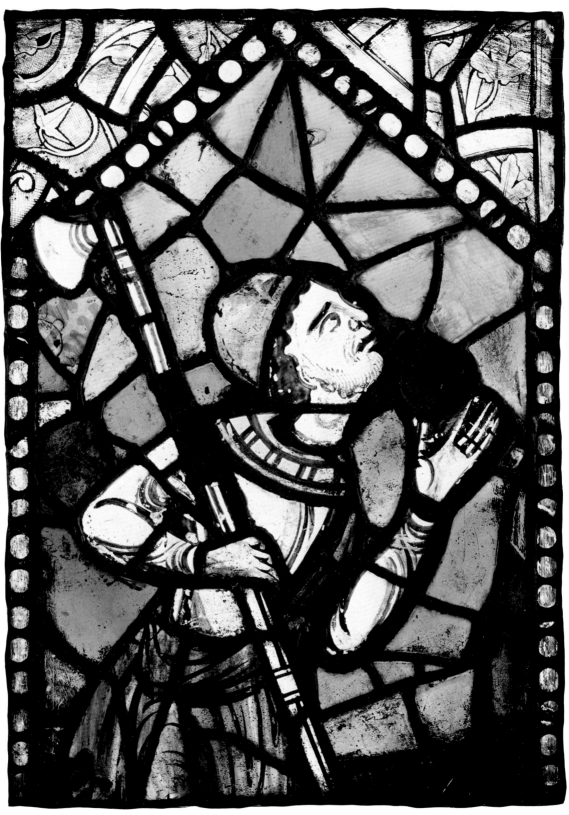

64(A)

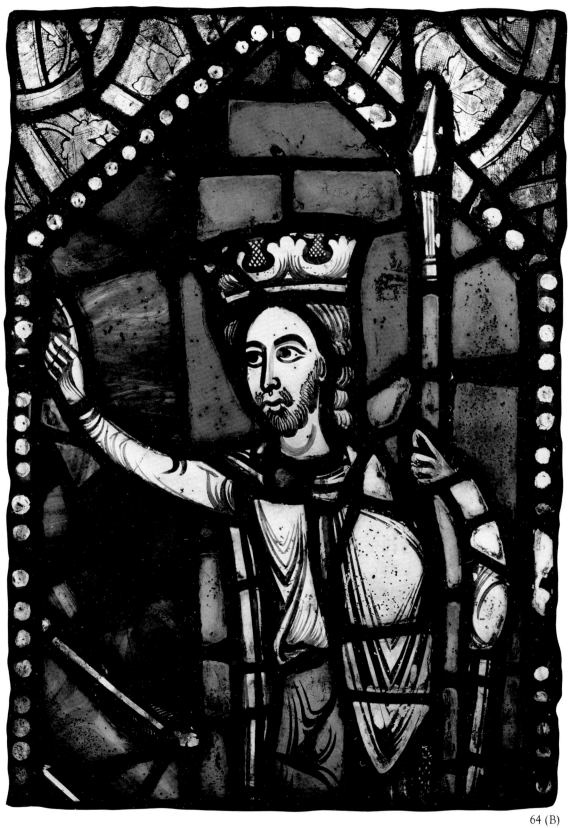

64 (B)

texts (Urseau, 1929, 15) attribute the building of the crossing and the south transept to Bishop Raoul de Beaumont (1177–97) but, in fact, Raoul probably concentrated on completing the western parts of the cathedral, including the glazing of the three last side bays of the nave, and left the construction of the east end to his nephew Guillaume. As Bishop of Angers (1203–40), Guillaume de Beaumont must have glazed the west window and then turned his attention to the transept. The crossing and south transept were built in a single campaign (1210–20), followed by the north transept and the square bay of the choir, which were finished by 1240. Little of the original glazing remains in the south transept and none in the north arm; a fire in 1451 necessitated the reglazing of the entire north transept. At the same time, the south rose was remade and two of the side windows were repaired. White glass was put in the other two bays in 1818. Either of these two bays could have contained the Pitcairn panels prior to that time. The glass that was removed was stored in the attic of the chapel on the north side of the nave. Pieces were reused from time to time (Hayward and Grodecki, 1966, 31–32), but others easily could have vanished.

These two panels are related in iconography and scale, and were probably once from the same window, if not the same scene, but part of each one is missing. There is every reason to believe that both of these figures were originally full length. The replacement areas of the background indicate that the panels were not initially lozenge shaped but the size of the figures would have permitted six panels of similar dimensions to be superimposed within the field of the window, allowing for a border at the edge. This appears to have been a standard arrangement in the nave windows of Angers. Another unvarying feature of the glazing in Angers was the vertical division of the scenes by a central support iron. This would explain the lack of continuity or the isolation of the Pitcairn figures, since each would have been separated from the other half of the scene to which it belonged.

The king in panel (B) raises his hand in a gesture of command. The two arrows on the left edge of the piece seem to protrude from the missing half of the scene; the change in the background color and an oval-shaped piece of replacement glass above the arrows might once have been the arm of a figure. The martyrdom most commonly associated with arrows is that of Saint Sebastian, whose popularity was considerable in the Middle Ages. There is, however, another saint associated with battle who has a much closer connection with the cathedral of Angers. This saint, patron of the cathedral, is Maurice, head of the fictitious "Theban Legion." The cathedral was supposedly given a vial of his blood as a relic by Saint Martin of Tours. Although an altar dedicated to Saint Maurice was located in the south transept of Angers, no window devoted to his legend exists, though the recording of the legends of those saints whose relics the cathedral possessed was a common practice in its glazing program (Hayward and Grodecki, 1966, 8). The two Pitcairn panels, therefore, may be proposed as remnants of such a window—perhaps removed in 1818, when the south transept was glazed in white glass. The king in panel (B) would be Emperor Maximianus I ordering the massacre of the legion; the arrows, perhaps, would be the arms that the Theban martyrs laid down, rather than sacrificing to the Roman gods. The soldier with the battle-ax in the other panel is undoubtedly the executioner, since decapitation with a hatchet was the martyrdom suffered by Saint Maurice, as recorded in *The Golden Legend* (for September 22).

In style, these panels are directly related to the Saint Martin window in the nave, and should have been installed as soon as the south transept was ready for glazing. Two different head types common to the Saint Martin master's style are represented in these panels. The older, bearded type of the king is paralleled by Saint Martin's companions (fig. 28) in the Division of the Cloak scene. Repeated are such features as the large, lidless eyes; heavy, curving brows; long, pointed noses, with the philtrum beneath accented by a small loop. The rolled ends of the hair of the king, his small drooping moustache and tufted beard, as well as the curved shadow on his neck, are all elements common to the heads painted by the Saint Martin master. The pose of the warrior, with his head raised in profile and his craning neck, is repeated countless times in the work of this master. Though the stylized drapery of the twelfth century, with its chevron-patterned, nested folds and its exaggerated loops, had disappeared from most of the leading French centers of sculpture and glass by the year 1200, the style continued in the work of the stained-glass ateliers of the western provinces; it lasted well into the first third of the thirteenth century in Poitiers and, as these panels testify, in Angers, as well. This glass provides important evidence not only of the style of the lost south transept windows of the cathedral, but also of the persistence of the Angevin tradition, as seen in the glazing of the nave and, subsequently, of the windows of the eastern construction. Perhaps this evidence eventually can be used in attacking the still elusive problem of the dating of the transept of Angers.

(A) Purchased from Michel Acézat, Paris April 2, 1928.

(B) Purchased from Michel Acézat, Paris, October 28, 1927.

Ex collection: Raoul Heilbronner, Paris (until 1914).

Bibliography: Heilbronner sale cat., 1924, no. 91.

65. Christ with Angels, Receiving a Soul, from an Unknown Window

France, Le Mans, Cathedral of Saint-Julien
About 1235
Pot-metal glass
Diameter, 62.3 cm. (24 1/2 in.)
03.SG.241

Christ, holding a nude soul with one arm and stretching his right hand downward in a gesture of blessing, stands in the center of the scene. He has a red nimbus crossed in white and wears a green robe and a murrey mantle. Two red-nimbed angels stand on each side of Christ, their hands raised in prayer. The one on the left has yellow wings, a murrey robe, and a white mantle, and the one on the right has white wings, a green robe, and a yellow mantle. The background is blue, with no suggestion of a groundline, and is edged in a red fillet that is partially original and in a modern pearled band. Part of the background, particularly along the lower right edge of the panel, and sections of the outer wings of both angels have been replaced.

Unfortunately, no information exists regarding the purchase of this panel. Raymond Pitcairn, himself, called it English, but the only English figural glass in the collection dates from the late fifteenth century and the records of its acquisition are documented. He had purchased a number of panels from Grosvenor Thomas of London in 1920, before records were kept in Bryn Athyn, and it is tempting to speculate that this piece was among them.

There is no question, however, that this is French glass and, based upon stylistic comparisons, that it probably originated in the cathedral of Le Mans, where it formed part of the glazing of the axial chapel of the choir. The windows of Le Mans have sustained considerable damage throughout history. In the course of the three months in 1562 during which the Huguenots occupied the town, particular attention seems to have been directed toward the glass of the axial chapel of the Virgin where, according to the report of the Chapter (Grodecki, C.A., 1961, 62–63), ten windows were destroyed. The report was probably exaggerated, since the chapel contains only eleven windows, six of which are double bays, and five of them still hold remnants of their original glazing. The windows of the chapel are set within reach of a ladder, so that considerable breakage, if not complete destruction, was probably effected. Repairs were made by moving the twelfth-century glass of the nave into the chapel of the Virgin, where it remained until the nineteenth century (Hucher, 1864, pls. 1–25). In 1858, a thorough restoration of the windows of the chapel began under the direction of Louis Steinheil,

with the glass painters Nicolas Coffetier and Antoine Lusson executing the work. Eleven lights were completely reglazed and a considerable number of new panels were made to fill the gaps in the windows containing original glass. Forty-nine of Steinheil's cartoons for this project are now in the Pitcairn collection, purchased from the Paris dealer François Haussaire in 1922. They undoubtedly came from the Coffetier collection, as did the Gérente drawings for Saint-Denis purchased earlier. The restoration evidently proceeded slowly, for it was not until 1876 that the decision was made to complete the windows of the chapel of the Virgin with new glass, and the old glass was not returned to the chapel until 1882. For most of this time, this original glass had been in the Paris ateliers of the restorers.

In this restoration, the emphasis had been on a logical rearrangement of the windows, to bring coherence to the program. Isolated panels, such as the Pitcairn roundel, easily could have been overlooked and discarded. No complete record of the original disposition of the windows at Le Mans exists, so that it is impossible to determine whether or not this panel was among them—though, in a large chapel dedicated to the Virgin that contained two lights devoted to her childhood, as well as windows with such themes as the Tree of Jesse, the Infancy of Christ, the Public Life of Christ, and a typological Passion subject, it would have seemed quite incomplete not to have included the theme of her Dormition, so popular in the thirteenth century. It is from this iconographic sequence that the Pitcairn panel probably came.

In most representations of the death of the Virgin in medieval art, the sequence of events—known in the East, since the sixth century, from the apocryphal texts (Schiller, 1980, 85)—is fairly standardized. The series usually began with the summoning of the apostles; then the death of the Virgin followed, with Christ appearing in the midst of the mourning apostles to receive in his arms the diminutive figure of his mother's soul. This was followed by the bodily Assumption of the Virgin and her Coronation. Early examples, such as the window in Angers (Hayward and Grodecki, 1966, 7–67), also included the Funeral of the Virgin, but, as emphasis on Mary's regal status and her Coronation increased, the funeral was omitted and more space was devoted to her translation to heaven. In stained glass, the culmination of this new emphasis appeared in the Dormition window in Saint-Quentin, of about 1225 (CVMA, 1978, 167; Little, 1981, fig. 7), where no less than seven panels of censing angels attend the Coronation, which is preceded by the bodily Assumption, accomplished by more angels, and where, in the panel just before, Christ, attended by two additional censing angels, holds his mother's soul (CVMA, 1978, pl. XXII). It

175

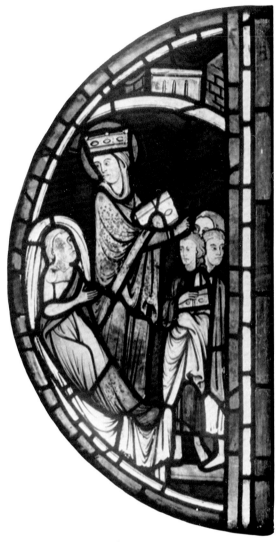

29. Panel from the Goldsmiths' window, Chapel of the Virgin, Cathedral of Saint-Julien, Le Mans. About 1235. Pot-metal glass

was not unique in the thirteenth century to place Christ, carrying the soul of his mother, in a separate scene, but it is iconographically so close to the Pitcairn panel that the Saint-Quentin scene becomes the most important example for comparison. As in the Pitcairn panel, the Christ in Saint-Quentin has a white-crossed red nimbus, and he carries the small, nude soul of his mother in his left arm, while extending his right arm downward in a gesture of blessing. In most Dormition scenes, the soul of the Virgin is shown draped, but the nude soul does appear in the Ingeborg Psalter (Deuchler, 1967, pl. 38) and the type may have originated in the Meuse. In Saint-Quentin, it is clear that the blessing gesture of Christ is directed at the figure of his dead mother, who appears in the panel below, and, since its iconography is the same, a similar arrangement of scenes was probably followed

in the window from which the Pitcairn panel came. In the Saint-Quentin version, the angels swing censers—as do their counterparts in the other seven panels—but in the Pitcairn panel they clasp their hands in prayer, a more usual gesture in Dormition scenes (Schiller, 1980, pl. 609). There is little doubt, therefore, that the Pitcairn Christ with Angels came from a Dormition window, but that its relationship to Le Mans is dependent on style.

The basic stylistic character of this panel, which is also the style of what Grodecki (C.A., 1961, 79) has called the principal atelier of the ambulatory of Le Mans, is related to traits that began to appear in a number of centers of glass painting in the 1230s. Virginia Raguin (1974, 34–36) has noted the origins of this calligraphic style in the ateliers that worked in the Île-de-France—in Gercy (such as the Saint Martin workshop), and also in Brie-Comte-Robert (on the east rose). This style, according to her analysis, was also the basis for that of the Genesis atelier, active from about 1233, at the cathedral of Auxerre. Still closer to its manifestation in Le Mans, and, perhaps, even a later production of the same atelier, are the earlier windows (such as the Saint Andrew window) in the ambulatory of Tours Cathedral, dating from the early 1240s. Indicative of this style, as it appears in Le Mans, is a new respect for the confines of the frame. In the scene of the Changers, donors of the Life of the Virgin windows (Grodecki, *Vitraux*, 1953, no. 21), a cup held by the figure on the left is cut off by the frame of the panel, whereas, in earlier examples, the cup would have extended beyond the edge fillet. In the scene of the Presentation of the Virgin in the Temple in Le Mans (Grodecki, C.A., 1961, 79), Joachim tiptoes along the lower frame rather than extending his feet beyond the fillet. Only the cross atop the dome of the temple is permitted to intrude upon the border. In the Pitcairn panel, one leg of each of the angels is cut off by the frame and their wings carefully follow the lead line of the edge fillet. In contrast to the Saint-Quentin panel, in which the figures stand upon clouds, there is no attempt to create a groundline in the Pitcairn piece; the frame, itself, is the groundline, as it is in the Presentation scene. The excitement in the figures in Saint-Quentin is absent in those from Le Mans. The angels of the Pitcairn roundel stand erect, and their robes, like the robe of Christ, hang in straight, parallel box pleats with occasional channel folds as accents. Mantles are caught upward in looped folds and sleeves are turned back to form soft cuffs. Characteristic of this style, seen also in Auxerre and in Gercy, is the position of the angels' wings; they jut sharply upward, in contrast to the half-furled wings of the Saint-Quentin angels. In the faces in Le Mans (fig. 29), the brows and the bow-shaped upper lips were accented with a loaded brush, as were the pupils of the eyes—which do not touch the almond-shaped lids. The noses are

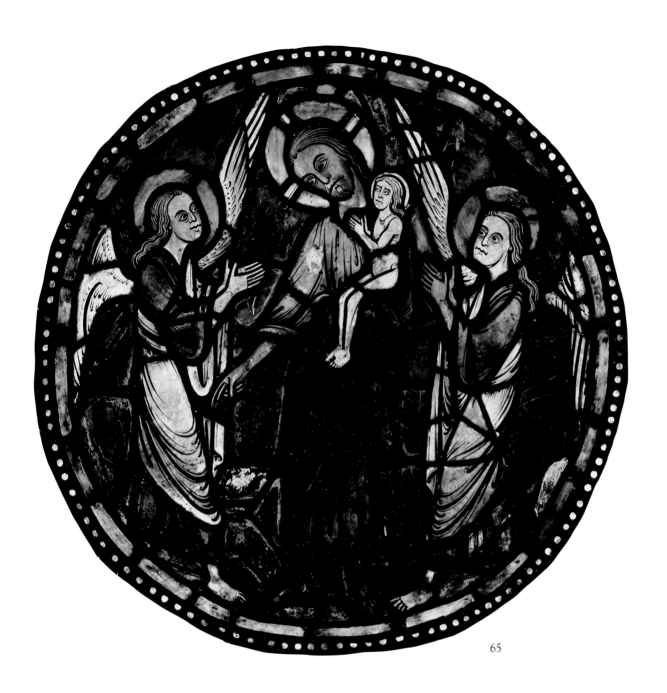

65

177

small and flattened. The hair, which clings closely to the heads and ripples at the neck, extends over the shoulders of the angels, as does that of the female figures in Le Mans. There is little doubt that the Master of the Life of the Virgin window in Le Mans also painted the Pitcairn Christ Receiving His Mother's Soul—or that panels from the original glazing of the chapel of the Virgin were lost during the nineteenth-century restoration, for photographs of two of the missing prophets from the Jesse Tree were filed under "Glass offered" in the Pitcairn archives.

Purchased from Grosvenor Thomas, London, 1920 (?).

66. Christ in Majesty, from an Unknown Window

France, Western Loire (?)
About 1235
Pot-metal glass
Diameter, 56.5 cm. (22 1/4 in.)
03.SG.46

Christ, seated within a red mandorla with a white edging of stylized painted clouds, holds a red orb in his left hand and blesses with his right. His light green nimbus is crossed, his robe is yellow, and his mantle is blue. Around the mandorla, on the blue background, are the symbols of the four Evangelists. Saint Matthew, the angel in the upper left corner, wears a red robe, carries a white book, and is surrounded by yellow and green clouds. In the opposite corner, Saint John, depicted as a red eagle, holds a green book; around him are yellow and red clouds. In the lower left corner, Saint Mark, represented as a yellow winged lion with a red halo—amid red clouds—holds a green book. Opposite him, Saint Luke appears in the form of a red ox with a yellow halo; his book is white and the surrounding clouds are green. A red band rings the scene and, in turn, is edged by a yellow fillet painted with a palmette design. The symbols of the Evangelists and the edge fillets contain considerable restoration. Most of the figure of Christ is original, except for the mantle covering his shoulders. The upper sections of the red mandorla also have been replaced.

The piece was purchased from Lucien Demotte in 1928 and later exhibited with his collection of stained glass in New York (Demotte, 1929, no. 10). It was purported to have come from the Samuel Bing collection in Paris, but nothing further is known about the panel or the area in which it originated. In an unsigned article, probably by Demotte himself, which appeared in *International Studio* (1929, 40–41), the glass was compared to the drawings of Villard de Honnecourt and dated about 1230. The reader is left with the erroneous impression that stained glass is a draw-

ing rather than a painting technique and that, since Villard was of Picard origin—though he traveled extensively—the panel is also from Picardy.

The iconography of this *Maestas Domini* is unusual in only two respects. In most similar representations, Christ is seated either upon a throne or an arc. In this panel, the arc is indicated by a double, curved section of leading. The narrow strip of red glass between the leads is, however, suspicious, and could have replaced glass of another color. If this were the case, the arc would resemble that in a contemporary example from Montreuil-sur-Loir in the Loire region (Hayward, 1981, fig. 8). The other unusual aspect of the Pitcairn roundel's iconography is the red disk in Christ's left hand. Though clearly marked as the *mappa mundi* with the triple division of the continents, most other representations of the world disk are made of light-colored glass. The red disk, however, is not unknown, since it appears beneath the feet of Christ in an early-fourteenth-century version of the Apocalypse now in The Cloisters collection (fol. 27v.; 68.174). In *Maestas* scenes, Christ more frequently is shown holding a book rather than the disk, but the globe was known in Ottonian art—the example most often cited being the famous antependium of Basel—and the type seems to have persisted in the Loire area of France into the thirteenth century (Hayward, 1981, fig. 5). Nearly all of the Evangelists' symbols, with the exception of the lion of Saint Mark, have been replaced, but, based on the one that remains, they seem to conform to standard iconography. The lion is nimbed and holds the book of his Gospel in his paws.

In style, the panel is more unusual. The palmette frame, partly original, repeats a design that is common to Chartres—specifically, to the work of the major atelier of the nave that Grodecki (Aubert, 1958, 129) has called local in origin—to Sens, and to the panel representing Synagogue (no. 43) that may have originated in northeastern France. It is the drapery style of the figure, however, that is uncommon. With its hairpin loops and pothook folds, there is no denying the relationship of this drapery to the *Muldenfaltenstil* that prevailed in the art of northern France about 1200, or that persisted in French art in more isolated places until the end of the first quarter of the thirteenth century—noticeably, in the drawings of Villard. It is known that Villard visited Chartres, since his sketchbook contained a labeled drawing of the west rose (Bucher, 1979, 101). That he was not an insignificant talent is indicated by the power of his drawings; as an artistic personality he might well have been noticed by other craftsmen working on the cathedral of Chartres. It is tempting to speculate that a young assistant glazier might have been influenced by the master's style, but a western French attribution for this panel has a firmer basis for comparison. Cer-

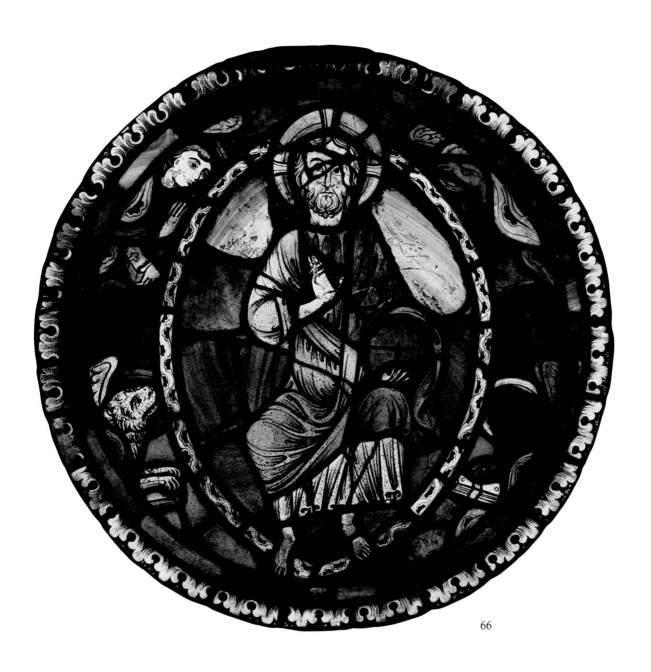

66

tain traits within the concept of the Christ figure align it especially with the art of western France at the end of the first quarter of the thirteenth century.

When compared with the stained glass of other centers in France, the glass from the western part of the country is markedly *retardataire*. Both Angers and Poitiers continued to produce windows in the thirteenth century with little noticeable change in style from the glass painted at the turn of the century. The large, blessing hand of Christ in the Pitcairn panel is drawn in a manner that was a recognized convention in the Loire area. The thumb, extremely long and considerably separated from the fingers—as well as the parallel brushstrokes indicating creases in the palm—are characteristics of a type of hand used throughout western France, even in the Loire-based atelier of Saint-Étienne in Bourges. Also common to western France are the small, flipper-like feet of the figure, the T-shaped edges of the folds of Christ's robe, and the loops of his belt. In Villard's drawings (Bucher, 1979, 91), this type of fold is convincing, but in the Pitcairn panel it is merely a stylized convention. These characteristics indicate the possibility of a western origin for the panel that is strengthened by the iconography. More examples of the Redemption window have survived in the Loire area than in any other part of France. The Loire type (Hayward, 1981, 129–38) culminated in a Christ in Majesty scene. For all of these reasons, the Pitcairn panel seems most likely to have originated in western France.

Purchased from Lucien Demotte, Paris, November 17, 1928.

Ex collection: Samuel Bing, Paris.

Bibliography: Demotte sale cat., 1929, no. 10; *International Studio*, 1929, 40–41.

67. Section of a Border, from the Redemption Window

France, Lyons, Cathedral of Saint-Jean
About 1215–20
Pot-metal glass
Height, 54 cm. (21 1/4 in.); width, 40.6 cm. (16 in.)
03.SG.127

An interlaced leafy white vine on a red background is joined by yellow quatrefoils. Entwined within the vine are bouquets of white, red, yellow, and green foliage. The interior field of the design is blue. The panel is edged with blue fillets at the left and right sides, the latter augmented by a white-pearled band. The condition of this border is excellent, with most of the replacement pieces confined to parts of the edge fillets and the upper and lower left corners of the ornament.

This panel may have been bought from Grosvenor Thomas of London in 1920, since the Pitcairn records note the purchase of a twelfth-century border in that year. Its whereabouts between that time and 1842–44, when it was removed from the cathedral of Lyons, are unknown. In 1844, the axial window of the cathedral was restored by Émile Thibaut, who had already effected a particularly harsh reorganization of the lateral bays (Brisac, 1978, nos. 26, 44–49). Very little was done to the axial window, except for the reversal of the order of the scenes and the removal of the lower border and corner pieces. The old glass was replaced by a grossly executed copy of the original design and by new corner sections. The condition of the glass just prior to this restoration is known from the engraving published by Cahier and Martin (1841–44, I, pl. VIII), showing a blank medallion in the lower edge of the window. The arrangement is similar to scenes in the lateral sections of the border that are filled with Old Testament types, prefiguring the events in the Life of Christ that appear in the main part of the window. The corner sections also were filled with white glass. The minimal repairs in the border at that time were probably made in the aftermath of the Revolution; because of the damage that had been done, in 1802 the building was declared unfit for use and was returned to the Church. Fragments of glass that were removed must have been stored in the cathedral for future reference, however, since Thibaut's restoration of 1844 copied the original design of the border, though the medallion in the center of the strip was omitted. The Pitcairn piece, in fact, must have served as the model for the present lower border of the Redemption window, which is its exact duplicate, lengthened by an additional motif to fill the existing space. The Pitcairn border is more subtle in color—the sapphire blue of its field matches the original blue in the side panels of the border—and, by still retaining its original leading, therefore, represents the border as it was designed in the thirteenth century.

The border of the Redemption window is one of the richest and most elegant of its period, since it includes not only ornament but figural subjects, as well. Though it dates from the second decade of the thirteenth century, its exceptional width, richness, and delicacy relate it to stained-glass ornament in windows from the end of the twelfth century. The proliferation of the vine motif brings to mind the ornament of the glass in the cathedral of Angers dating from about 1185, in which Byzantine iconographic tendencies, probably transmitted through English sources, are strongly felt (Hayward and Grodecki, 1966, 14–17). Byzantine iconography in Lyons was probably the result of a more direct source—the manuscripts emanating from Italy (Brisac, 1974, 303–6). The ornamental style of the Pitcairn border is most

closely related to the rich vocabulary found in the rare surviving examples of stained glass from southeastern France, dating from as early as the 1160s, such as the window now in Champ-près-Froges (Isère). While, in other areas of France, there was a tendency to reduce the size and richness of borders in the thirteenth century, these were retained and even increased in the glass of the southeast. At the cathedral of Lyons, itself, this is made manifest by comparing the border of the Saint Peter window, from about 1190 (Brisac, 1978, no. 26, pl. p. 40) with the Pitcairn piece, which is actually wider and more delicate in its design. The only aspect of the Pitcairn panel that underscores its thirteenth-century origin—as opposed to the earlier example—is the reduction of painted detail. The Pitcairn border is closest in style, however, to the window of the Three Magi (Cahier and Martin, 1841–44, I, pl. VIII, 2) on the north side of the apse in Lyons, where virtually the same foliate motifs, enclosed in palmettes, are interspersed with figural panels. Though Brisac (1978, no. 26, 44) has attributed this latter window to a different painter, and its design is not as elegant, she notes the influence of the former. In retaining this richness of ornament, the windows of southeastern France—particularly the Pitcairn example—are an exception to French tradition, and are closer to glass of the period produced in the Rhineland.

Purchased from Grosvenor Thomas, London, 1920(?).
Bibliography: *The Year 1200*, 1970, I, no. 214; Cahier and Martin, 1841–44, I, Études, pl. VIII, 4.

68. Head of a Prophet, from a Clerestory Window

France, Lyons, Cathedral of Saint-Jean
About 1235–40
Pot-metal glass
Height, 64.5 cm. (25 ³/₈ in.); width, 69.2 cm.
 (27 ¹/₄ in.)
03.SG.47

The head, turned toward the right, is made of light brownish glass with greenish-white hair, eyes, and beard. The halo is red with a white-pearled edge, and the figure wears a green robe with a murrey collar and a yellow mantle. A red trellis with blue painted inserts serves as a background, framed by white colonnettes with yellow and red capitals. Red-budded flowers on fleshy white stems occupy the space between the shoulders and the halo of the figure. This glass has been heavily restored and the back appears to have been polished. Though the original arrangement seems to have been maintained, the trellis—made of old glass—is an addition to the background. Replacements include the capital on the left and part of the

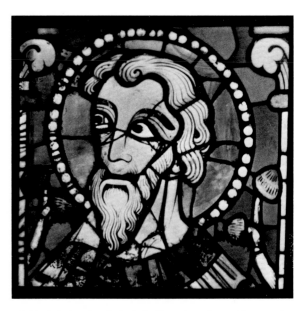

30. *Head of a Prophet*, Cathedral of Saint-Jean, Lyons. Photograph by Moreau, Paris. Between 1890 and 1910

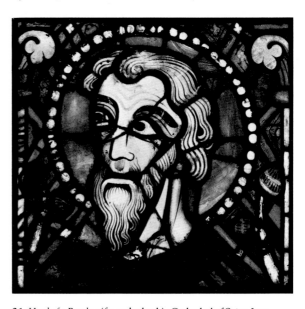

31. *Head of a Prophet* (from the back), Cathedral of Saint-Jean, Lyons. Photograph

neck and hair of the figure. There has also been some repainting.

 The panel was purchased from Seligmann Rey and Co. of New York in 1925. Supposedly, it had been acquired by Jacques Seligmann in Strasbourg. This piece has been called a forgery by virtue of a photograph that exists in the archives of the Monuments Historiques in Paris (fig. 30) that shows the identical head facing in the opposite direction, minus the trellised background. In order to explain this photograph, the Pitcairn head was photographed from the back (fig. 31) to determine whether striations in

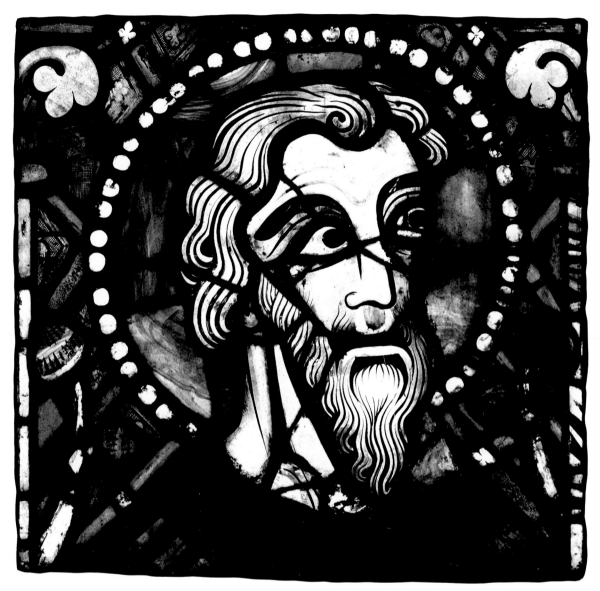

68

the glass, weathering marks, and the flecking of the paint could be matched. It is doubtful whether a forger could—or would—copy such minutiae. There is little chance that he could fabricate the weathering marks, and no chance that he could duplicate the striations in the ruby glass of the halo.

The photograph in the Monuments Historiques archives was made by a Parisian photographer named Moreau between 1890 and 1910, at the same time that the head of the Soissons King (no. 52) was photographed. The reversed view of the Pitcairn head seems to match the Moreau photo in all details, including the flecking of the paint, the particularly heavy pitting of the back surface of the collar, and, most conclusively, the striations in the red glass of the halo. It would be impossible, even today, to copy the random pattern of these striations, particularly the whorls in the piece next to the neck or in the areas above the head.

The panel has obviously been restored since the photograph was made. The background and the capital at the right were replaced, and there also may have been some repainting of the trace lines, since the paint on the bridge of the nose is beginning to lift. If the piece is genuine, as supposed, it must have belonged to the program of the choir clerestory in Lyons, whose figures it resembles, stylistically.

The clerestory windows of the choir of Lyons, which have been dated about 1235–40 (Brisac, 1978, nos. 26, 49), consist of standing figures of the twelve apostles, arranged in pairs in each double-light bay, surrounding Christ crowning the Virgin in the central bay. The Coronation is later and must have replaced the original scene, at the end of the thirteenth century. In the triple-light windows in each of the two straight bays of the choir are twelve prophets, with the four major prophets occupying the larger central light of the triad. Apostles representing the New Testament and prophets symbolizing the Old Testament, surrounding Christ and the Virgin, was not an unusual iconographic program for the glazing of a clerestory, by the second quarter of the thirteenth century. It had been used first at Saint-Remi in Reims in the twelfth century and later in Bourges. What was new in Lyons was the arrangement of the figures. Instead of placing the apostles on the south side and the prophets on the north, the usual disposition, six apostles were grouped on each side of the central figures, followed by an equal number of prophets.

These figures have been heavily restored and, in some cases, entirely remade (Bégule, 1880, 102). In 1802, following the Revolution, a local glazier and joiner named Ferrus was hired to repair the choir windows, using colored glass from the chapels as fill. By 1848, the reorganization of the windows effected by Thibaut had progressed to the clerestory. He had removed all previous restorations and by so doing

virtually remade many of the windows. A head of Jeremiah was presented by Lucien Bégule to the Monuments Historiques (Wixom, 1967, 137), after having been for many years in the collection of the glass painter Leprévost. A copy of this panel, by Thibaut, occupies a window in Lyons. The apostles have fared even worse. It is not surprising, therefore, that another head from Lyons should be found in the Pitcairn collection. There is, moreover, no reason to believe that it is the head of a prophet, for it could also be one of the apostles.

With the addition of the mosaic background, the Pitcairn head lost the general light tonality that distinguishes the clerestory figures of Lyons; these are unusual in that they are surrounded by borders of grisaille and the common blue background is made of a clear sapphire. The hair and beards are white, as are the eyes, leaded as separate pieces of glass into the heads. This technique was also employed in Chartres, Strasbourg, and in the cathedral of Reims. In Lyons, however, as seen in the Pitcairn head, the technique is more subtle: the eyes are outlined in heavy leads, in contrast to the thinner leading across the bridge of the nose. The gaze, therefore, is penetrating, but it is not as hypnotic as the expressions of the earlier examples in Chartres and in Strasbourg. The strong linear accents and broad areas of mat give these figures a three dimensionality and a solidity greater than those of the earlier, related large-scale figures.

Purchased from Seligmann Rey and Co., New York, November 18, 1925.

Ex collection: Jacques Seligmann, Paris.

69. Two Scenes from The Life of Saint Eutropia, from an Unknown Window

France, Amiens, Cathedral of Notre-Dame (?)
About 1245
Pot-metal glass

(A) **Saint Eutropia Scratches Out the Eyes of a Vandal**
Height, 60.9 cm. (24 in.); width, 51.4 cm. (20 1/4 in.)
03.SG.41

(B) **Saint Eutropia Healing the Sick**
Height, 57.2 cm. (22 1/2 in.); width, 52.1 cm. (20 1/2 in.)
03.SG.42

(A) The saint, in a green robe and murrey cloak, touches the eye of her attacker, who is dressed in a yellow tunic, red hose, and a green belt. His scabbard is red and his sword white. In the blue background is a red trefoil arch that is surmounted by yellow and blue architecture. Patterned grisaille glass serves as

filling at the top. At the right is a white building with a green door and a yellow and green turret. The glass is inscribed: S [AN]Ĉ [T]A:EV T ROP IA. The condition of this panel is good, though it is heavily patinated. The red trefoil arch is a replacement.

(B) A figure, seated on a green bench with a murrey cushion, wears a cap and a yellow robe and holds a purse. His shoes are light blue. At the left, a standing figure in a murrey gown with green sleeves holds a balance in one hand and, with the other hand, places a white jar on a red shelf. A green lamp hangs from the shelf and there are green jars in the foreground. The background is dark blue, enframed by a white trefoil arch supported by red colonnettes with green capitals, as in panel (A). The head and, perhaps, the gown of the standing figure have been replaced, but the outline is original, so that the position of the figure is authentic. The objects on the shelf also have been restored, as has the major portion of the inscription; the original part, NE: S LIC, is too fragmentary to interpret. The panel has been cropped at the top.

These two panels were purchased, together with a number of other pieces, from Bacri Frères of Paris in 1923. Nothing further is known of their history. Their attribution to Amiens, in fact, is based only on stylistic comparisons and methods of restoration.

The date for the start of construction of the choir of the cathedral of Amiens has been a matter of controversy (Branner, 1965, 138–40; Erlande-Brandenburg, 1977, 258–62) on which there is, as yet, no agreement. It must have been begun by 1238, however, when the church of Saint-Firmin-le-Confesseur, which had impeded its construction, was torn down. Since Saint-Firmin stood somewhere within the northern part of the present cathedral choir, the construction or the laying out of the south transept may have preceded even that date. According to the earliest records, the establishment of chaplaincies or the dedications of chapels seem to have taken place on the south side of the building. A chaplaincy was established in the chapel of Saint Paul in the eastern bay of the south transept in 1233 (de Rouvroy, 1934, LIII). This was undoubtedly in advance of the actual building, but the date of 1243 for the dedication of the first radiating chapel on the south side of the ambulatory to Saint Eligius appears to be firm. A few fragments of glass depicting this saint's history still occupy the central window of the chapel and conform to the style of the 1240s. The next chapel in line on the north side was dedicated to Saint Nicasius, Archbishop of Reims and brother of Saint Eutropia. Though fragments of background and border still exist in the central window of this chapel, no scenes remain—nor is there any old glass in either of the lateral lancets.

Very little thirteenth-century glass is left in any of the ambulatory windows of Amiens. The most complete record of the glass was made in 1901 by Georges Durand (II, 543–93), who carefully described each window scene by scene, but also noted the general disorder, as well as the many lancets that were without colored glazing. Unfortunately, Durand included few illustrations. Neither of the two Pitcairn panels figured in his descriptions. In the course of its history, however, the glass in Amiens has been almost completely destroyed (CVMA, 1978, 219). In the seventeenth century, storms and two separate powder explosions necessitated extensive repairs. The glass was restored in the eighteenth century only to be pillaged in the Revolution. The restoration that followed, in 1812–13, replaced many of the original panels with white glass. In 1830, a local glass painter named Touzet used pieces of the old glass to repair missing parts of the chapel windows. Fragments of this restoration are now in the north transept. A major reorganization of the windows was undertaken in 1846 by Viollet-le-Duc, with Alfred Gérente, Coffetier, and Steinheil as his glass painters. The glass was then in such bad condition that six double lancets of the ambulatory were replaced with new windows. This work involved only the three central chapels of the ambulatory; the four flanking chapels were either left untouched or had their windows moved to the central chapels. Viollet-le-Duc's methods of omitting isolated panels from his restoration programs has already been discussed in conjunction with Saint-Denis (cf. nos. 27, 28). That Alfred Gérente dispensed such panels has also been discussed in the same context. Furthermore, none of the windows now in Amiens is still in its original location, with the exception of those in the chapel of Saint Eligius. If the Saint Eutropia panels in the Pitcairn collection are from Amiens, they were probably discarded long before Durand's inventory.

It is not surprising that one of the choir chapels of Amiens should have been dedicated to Saint Nicasius. Amiens belonged to the archdiocese of Reims and Nicasius was one of its most popular saints. Since Eutropia, his sister, was martyred with him on the steps of the cathedral of Reims in the fifth century, she is usually paired with him in depictions of their martyrdoms. Among the thirteenth-century works of art in which Nicasius and Eutropia are included are the jambs and the tympanum of the Saint Calixtus portal of Reims, the tympanum of the north tower portal of Laon, and the portal of the former church of Saint-Nicaise in Reims. In stained glass, their legends were recorded in windows formerly in Soissons and in Longueval-lès-Fismes (Aisne). Since the taller rayonnant windows of the 1240s permitted expansion of iconographic themes in stained glass, it is also not surprising that the second Pitcairn scene probably

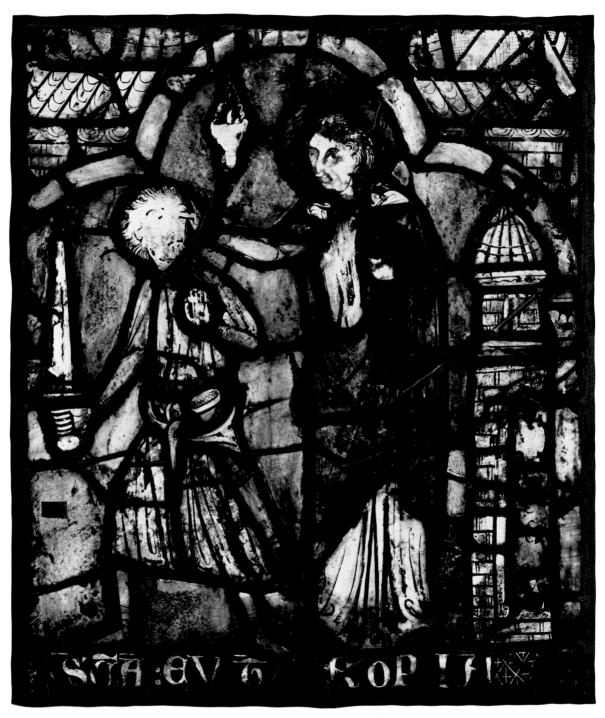

69(A)

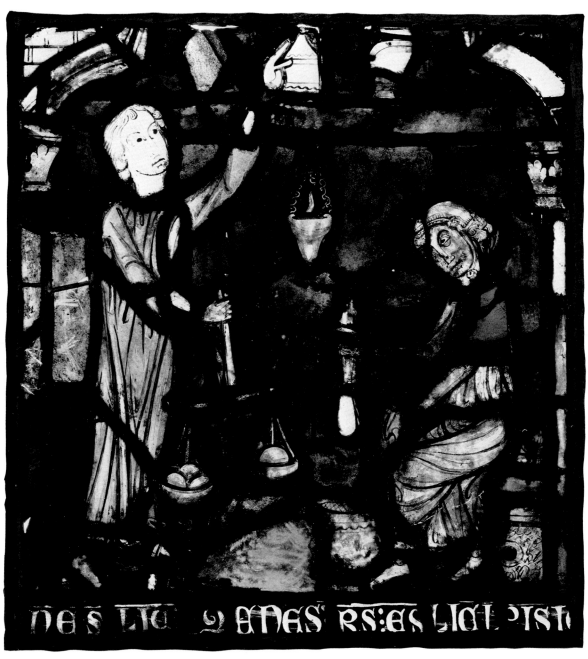

NES LTU QENES RS:ES LIQL PISTO

69 (B)

refers to the cult of Saint Eutropia rather than to her life.

The first scene concerns the actual martyrdom of the saint. In 407, the city of Reims was attacked by barbarians. The people asked their archbishop, Nicasius, whether they should resist, but he had been told by God in a dream that he was to suffer martyrdom and thus not to defer the attack. With his sister, Eutropia, at his side, the archbishop stood before the cathedral and preached to the invaders. His head was then cut off by the chief of the barbarians. Also seeking martyrdom, Eutropia attempted to scratch out the eyes of the chief—for which she, too, was decapitated. It is this scene that is graphically portrayed in panel (A), even including the cathedral of Reims at the right.

After her death, Saint Eutropia became the patron saint of ill children (Réau, 1955–59, III, 1, 457). The sick child would be placed on one pan of a balance and the cult image of the saint on the other. The child would then be miraculously cured. Though heavily restored, panel (B) probably refers to this healing. The dejected figure on the right is undoubtedly the parent of an ill child, and the fragmentary basket before him once may have been the bed of a child. The figure on the left, holding the balance, is very likely Saint Eutropia.

It is the style of these panels that connects them most closely with Amiens. The format of the scenes, a trefoil arch supported by columns, was employed first about 1225 in Chartres (Grodecki, 1978, 52–53), but this type of frame was used in at least three other windows in the choir of Amiens. Two of these windows, as restored by Touzet, are now in the north transept. The Chapter requested that Touzet reuse old glass in the restoration of these scenes, so he filled the top of the panels on each side of the arch with fragments of old grisaille—the same arrangement employed in panel (A); panel (B) has been truncated so that the top of the arch is missing. Touzet inserted the restored panels in the windows of Amiens with little concern for order. It is probable that the Eutropia panels subsequently were eliminated when the glass was moved.

The long slender figures, with their schematically rendered drapery in linear, broken folds, are also related to the glass now in Amiens; they are particularly close to what remains of the Saint Eligius panels that occupy the chapel adjacent to that of Saint Nicasius. The head type, which can be seen best in the seated figure in panel (B), is very like the heads in the Eligius panels. Characteristic of these heads are the large staring eyes, with the lower lids drawn as straight lines; the long and straight flat noses; and the straight mouths. If the gown worn by the figure holding the balance is original, it illustrates another characteristic

of the drapery also found in the Saint Eligius panels— the folds that narrow into a V toward the hem, with no relationship to the form beneath. Alfred Gérente, however, was more than capable of imitating the style of the medieval glass that he was restoring. If the gown is not original, it is certainly his work—even if the motive underlying the restoration of the panels from the choir of Amiens merely was to "tidy them up" so that they were suitable for sale.

Purchased from Bacri Frères, Paris, January 27, 1923.

70. The Crucifixion

Northern France (Oise?)
Second quarter of the 13th century (about 1240–45?)
Pot-metal glass
Height, 59.7 cm. (23 1/2 in.); width, 60.3 cm. (23 3/4 in.)
03.SG.221

The figure of the dead Christ, clothed only in a white loincloth stained with blood, hangs from a green cross that is silhouetted against a blue ground. His crossed feet rest on a red suppedaneum, and an unusually large, red and yellow cruciform nimbus surrounds his head. On the left, the Virgin, with a red nimbus and wearing a green robe and a yellow mantle, gestures with uplifted hands toward her dead Son. Saint John the Evangelist, dressed in a green robe and murrey mantle, stands at the right, supporting his head in his right hand while holding a white book in his left. His nimbus is white and is reserved on the same piece of glass on which his head is painted. Bust-length personifications, wearing white robes, appear in the quadrants above the horizontal bar of the cross, holding a red sun (to the left) and a yellow moon (to the right). A white-pearled fillet runs along the top and bottom of the panel. At the left and right sides, a white-pearled fillet is placed between a red fillet and a border composed of alternating green and blue leaves growing out of yellow buds on a red field. The entire rectangular segment at the upper right corner containing the personification of the moon, and including the top of the cross, is modern, as are the head of Christ, pieces from the lower parts of the Virgin's drapery, and a pie-shaped section of the face of Saint John. The most curious restoration is the addition of the pearled fillets on all four sides, parts of which were created from repainted ancient glass.

The weak sense of line and the sweetness of the faces in the modern portions of this panel, as well as the attempt to simulate patination with acid-eaten pits and smears of diluted paint, recall comparable restorations in another panel in the Pitcairn collection

188

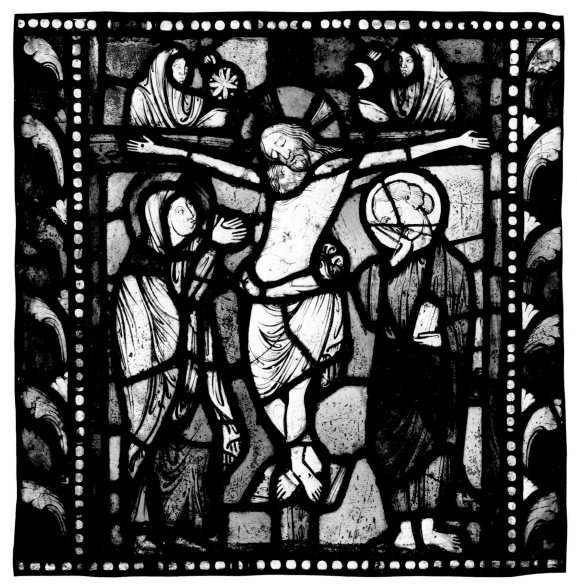

70

(no. 66). Both pieces passed through the hands of the same Parisian dealer, Lucien Demotte, and were probably "completed" and restored while they were with him. Demotte's preference for presenting his customers with tidy merchandise, rather than with articles whose timeworn appearance attested to their antiquity, is confirmed by the provision of elegantly finished wooden frames for the panels that he sold to Raymond Pitcairn. The Crucifixion was bought in 1929 after it was exhibited in New York. In the published catalogue of this exhibition (Demotte, 1929, no. 22), the piece is identified as formerly having been part of the Gsell collection—presumably that of the Parisian glass painter Albert Gsell, who was born in 1867 and was still active in 1922 (Thieme-Becker, XV, 158)—and northern France is given as its original provenance. Although it is still impossible to be more specific than Demotte in identifying the church for which it was made, a study of the style of this Crucifixion confirms his regional identification.

There is nothing unusual about the iconography of the Pitcairn Crucifixion. The sacrifice of Christ has already been accomplished, and his lifeless body sways in a gentle curve on the cross. There is no attempt to impress the viewer with the horrors of his death. John and Mary are captured in poses of grief, though the intensely personal vision of this artist infuses them—especially the Virgin—with singular eloquence, and with a pathos undermined by mannered elegance. Personifications of the sun and moon are included, as they had been since the sixth century, to underline the cosmic implications of this event (Schiller, 1971–72, II, 91–92). It is not interpreted as an ephemeral human episode drawn from a biographical narrative, but, rather, as a timeless event with universal significance.

The primary interest of this panel is stylistic, though, just as with provenance, it is difficult to come to specific conclusions about a precise stylistic milieu. In fact, it is much easier to define the general formal heritage of the artist than to pinpoint his particular place within what was a complex development growing out of that heritage. His debt to the classicizing "Style 1200," or *Muldenfaltenstil*, popular in several mediums in northeastern France during the first quarter of the thirteenth century, is revealed in the long and thin, hooked—or looped—folds of the drapery; in the finely drawn facial features; and in the long, curving lines of contours and interior articulation. All of these are characteristic features of the Passion window of the cathedral of Laon—at about 1210 the locus classicus of this far-reaching stylistic development (Deuchler, 1967, 149–60, figs. 246–249;

Grodecki, 1969). Similar features also can be seen in panels from Soissons in this exhibition (no. 51), postdating Laon by only a few years.

There are fundamental distinctions, however, between the glass of Laon and Soissons and the Pitcairn Crucifixion panel. This artist was not disturbed by discontinuities of scale. The stocky figure of John, with large head and feet, is juxtaposed with a more attentuated figure of the Virgin, with smaller head and feet. The swollen hips, and robust legs and feet of Christ contrast with his spindly, tapering arms. In certain passages, especially in the figure of the Virgin, the loop-fold drapery conventions have been liberated from their original function of indicating the form of the body underneath, and are free to create patterns existing for their own sake. A comparison of her clothing and that of the figure of Saint Nicholas from Soissons (no. 51A) will clarify the distinction. A sense of organic structure has been lost in the figure of the Pitcairn Virgin, and in its place an expressionistic distortion has been substituted, which uses the vocabulary of *Muldenfaltenstil* in new and personal syntactic combinations. Similarly, anatomical conventions have been the point of departure for a virtuoso exercise in spidery calligraphy and silhouetted patterns of halftone wash on the nude torso of Christ. In general, the figures are defined by sharply cut contours, creating strong silhouettes against the blue ground, which has been carefully reserved around them to emphasize their outlines. Overlapping has been kept to a minimum. There is little sense of space or form.

The germ of some of the mannerisms in this Crucifixion can be seen in the Soissons panels, especially in the enthroned figure in no. 51 B, but a closer stylistic comparison is provided by the Bishop Saint window from the chapel of the Virgin at the cathedral of Beauvais, dating from about 1245 (Cothren, 1980, 106–19). Here, are almost exact counterparts of the exaggerated gesture of the Pitcairn Virgin, the elongated and rubbery quality of her body, the disturbing variations in scale within a single composition, and the exploration of the potential for creating pattern with drapery, even when it distorts the organic structure and contradicts the volumetric qualities of the figure. All of these features appear in a window in Beauvais that, like the Crucifixion, traces its stylistic lineage back to the Passion master of Laon. The comparisons are not close enough to assign the Pitcairn panel to the work of this Beauvais shop, but they do provide a general context for its mannered *Muldenfaltenstil*. The Pitcairn Crucifixion clearly was painted by an artist at a parallel stage in the progressive

mannerism that developed from this classical tradition in the second quarter of the thirteenth century.

It would be logical to reconstruct the original design of the window that held this panel as a lancet of grisaille into which a full-color composition was placed—a frequent solution for the glazing of modest churches as early as the 1240s (Lillich, 1970, 26–33). Examples can be seen in Norrey-en-Auge (Calvados)(Lillich, 1970, 32–33) or in Villers-Saint-Paul (Oise), and it was even used somewhat earlier in the more lavish glazing of the transept chapels of the cathedral of Rouen (Ritter, 1926, pl. XXX) and in the Virgin Chapel of the cathedral of Auxerre (Lillich, 1970, fig. 2). The most instructive comparison for the Crucifixion, however, is with Saint-Martin-aux-Bois (CVMA, 1978, fig. 116), where a self-contained, full-color panel is set into a slender lancet of grisaille. Curiously enough, the colored border at Saint-Martin is restricted to the full-color panel and does not continue into, or originate from, the grisaille above and beneath it. A small detail in the Pitcairn Crucifixion suggests that, if, indeed, it was originally set into a grisaille window, the disposition may have been the same as that of Saint-Martin-aux-Bois. At the top of the border on each side of the panel, instead of interrupting the design with an "unfilled" yellow bud in such a way that its continuation in the subsequent panel is assumed, the artist resolved the motif with a grid of hatching in the color of the last leaf. Because of this detail, it seems unlikely that the panel initially was part of a multi-panel, narrative lancet.

Demonstrable relationships with Beauvais and Saint-Martin-aux-Bois make it reasonable to identify this panel tentatively as part of a "band window" made for a church in the Oise early in the 1240s. (The band window confined figural scenes to a narrow horizontal strip and the rest of the aperture was filled with colorless grisaille; Lillich, 1970.) Whatever uncertainties may remain about the historical context and the origin of this piece, however, nothing can cloud the powerful impression created by the work of this doggedly individual glass painter. No other artist represented in this extraordinarily rich collection had a stronger personality. None was bolder in manipulating conventional formulas toward the accomplishment of an expressionistic vision. The history of Gothic mannerism has not been written, but, when it is, this glass painter merits a special place within it.

M. W. C.

Purchased from Lucien Demotte, Paris, May 14, 1929.

Ex collection: Albert Gsell, Paris.

Bibliography: Demotte sale cat., 1929, no. 22.

71. Grisaille Panel with Fleur-de-Lis, from a Choir Window

France, Priory Church of Saint-Martin-aux-Bois (Oise)
About 1255–60
Grisaille glass with pot metal
Height, 60 cm. (23 5/8 in.); width, 36.5 cm. (14 3/8 in.)
03.SG.124

A panel of grisaille strapwork of alternating lozenge and circle shapes is interlaced around a centralized arrangement of acanthus-bud foliage on a cross-hatched field. Red and blue center bosses enclose yellow fleur-de-lis. A red fillet separates the pattern from the border, which is composed of serpentine strapwork with rosettes of grisaille glass. The piece is in excellent condition, except for the red fillet, which has been replaced in the releading.

The panel was purchased from Bacri Frères in 1923. Its pattern is reproduced exactly in the lower lights of the north angle bay of the apse in the priory church of Saint-Martin-aux-Bois, north of Paris. The dating of this church has been debated. Branner (1965, 73–74) has suggested about 1245 for the start of the building. Jean Vergnet-Ruiz and Jacques Vanuxem (1945, 137–40) had accepted the traditional date of about 1260. This dating is based on the donor panel in the central window, which shows Jean de Rouvillers offering a window. Since he was a relative of Hugues de Rouvillers, Abbot of Saint-Martin-aux-Bois (1250–76), it has been assumed that, as abbot, Hugues began the construction of the new church. More recently, however (CVMA, 1978, 208), the construction has been attributed to the years 1240–70, and the donor figure is thought to be an insert.

The apse of Saint-Martin-aux-Bois originally must have been filled completely with grisaille windows—perhaps the first example of this type of glazing in a non-Cistercian church. Within the seven enormously tall, triple-light windows, only five original patterns survive. They vary in design but are basically of the same type and are probably contemporary. Six bays in the apse contain a few original panels with the remainder of the space filled with copies; the central window is completely modern.

Following the Revolution, the abbey became a parish church, and in 1841 its windows were severely damaged by a storm. The parish, unable to raise funds for repairs, appealed for aid from the state. It was not before 1860, however, that a thorough restoration was undertaken and, by that time, irreparable losses of glass had been sustained. The windows were again

71

repaired in 1909–10 and it may have been at that time that certain panels, including the Pitcairn piece, were not replaced.

The style of the grisaille windows that fill the seven bays of the apse at Saint-Martin is not consistent with a dating in the 1270s. The Pitcairn panel, which exemplifies the type, employs a crosshatched background that does not, in itself, indicate an early date, since hatching appeared, intermittently, well into the 1280s. The design, however, is composed of centralized motifs, with rather coarse acanthus foliage surrounding the colored bosses. Even though these motifs interlace, they have not progressed very far from the centripetal patterns of the earliest grisailles at Saint-Père in Chartres, which have been dated to the mid-1240s (Lillich, 1978, 28–29). The central bosses with fleur-de-lis in the Pitcairn panel are not unlike the grisailles of bays twelve and thirteen at Saint-Père (Lillich, 1978, fig. 4). The increased sophistication of the interlace at Saint-Martin, and its grisaille border, could hardly have been conceived before 1255, which would be consistent with the latest opinions regarding the date that the choir was ready for glazing.

Purchased from Bacri Frères, Paris, January 27, 1923.

72. King, from The Tree of Jesse Window

France, Abbey of Saint-Denis
About 1240
Pot-metal glass
Height, 61.3 cm. (24 1/8 in.); width, 36.5 cm.
(14 3/8 in.)
03.SG.226

The king is seated upon the branches of the tree, whose white stem has yellow and blue foliage. He holds his attribute, a harp. He wears a gold crown, a pink mantle lined in yellow, a green robe, and light blue shoes. The interior field is blue and the background red. There is considerable replacement of the lower portion of the king's robe, including the purple glass of the mantle, and an insert of green glass on which a silver-stained pouch has been etched. The leading is, for the most part, old, so that the original outline of the figure can be determined.

This panel was selected by Lawrence Saint in Paris, and was purchased in 1922 from François Haussaire, a glass restorer from Reims. Nothing further is known of its recent history.

The figure derives from the standard type of Jesse Tree iconography of the middle of the thirteenth century, which was altered very little after its standardization in stained glass at Saint-Denis in the 1140s. Kings continued to occupy the central panels of the window, flanked by the prophets. By the middle of the thirteenth century, as windows increased in

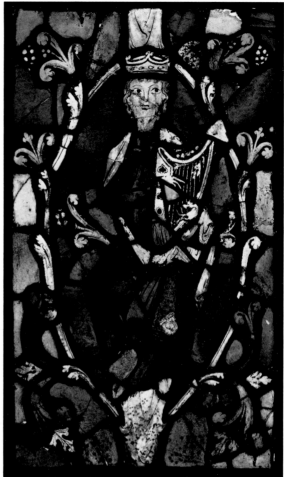

72

height, so also did the number of kings in the tree. There are fourteen of them in the genealogical tree that depicts Christ's royal ancestry at the Sainte-Chapelle. The twelfth-century kings in Chartres and at Saint-Denis grasp the branches that grow from the central trunk of the tree. In the thirteenth century, however, the branches tended to form an oval mandorla that surrounded the kings. This type occurs in Beauvais, at the Sainte-Chapelle, and in the Pitcairn panel. Instead of being shown in a rigidly bilateral pose with extended arms, the position of the arms, as seen in the Sainte-Chapelle, varies. Occasionally—and especially in the case of David—the kings were shown playing musical instruments. David holds a viol at the Sainte-Chapelle and, in Amiens, several of the figures play a variety of instruments. These new attributes for the kings necessitated a change in pose, since holding and playing instruments.did not permit the grasping of the branches of the tree. It is this stage in the development of Jesse Tree iconography that is represented by the Pitcairn panel.

The style of this panel relates it to one of the most important Parisian glazing projects of the middle of the thirteenth century—the restoration and re-

193

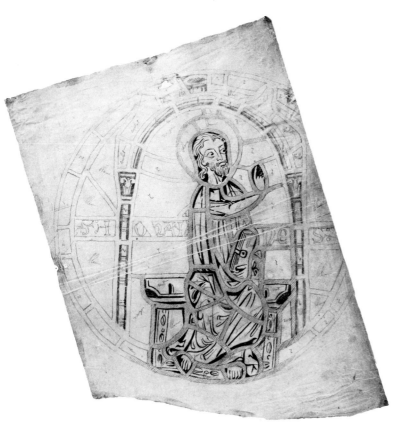

32. Just Lisch. *The Apostle Saint John*. Tracing of a roundel from the Abbey of Saint-Denis. About 1849. Archives de la Direction de l'Architecture, Paris

building of the abbey church of Saint-Denis. Abbot Suger (cf. nos. 24–29) had been unable to construct a new nave for the church before his death in 1151. By 1231, the building was threatening to collapse. After consultation with King Louis IX, Abbot Eudes de Clément began a rebuilding program that included the upper stories of the choir, the transept, and the nave—up to Suger's western narthex, which, together with his ambulatory and crypt, were retained (Crosby, 1953, 57–61). By 1241, the chevet and the north transept were finished and in use (Bruzelius, 1981). Six years later, the south transept was completed, and by 1256 the second campaign in the western part of the nave was under way. The glazing of the various sections of the church probably kept pace with the building, though it may have lagged somewhat in the western bays of the nave, since that construction was not completed until 1281. The north chapels in the nave were added in the fourteenth century (Crosby, 1953, 66) and undoubtedly were glazed at that time. The chevet and the north transept windows were probably filled with stained glass by 1241, with the glaziers using the masons' scaffolds for the installation. Unfortunately, all this thirteenth-century glass was destroyed during the Revolution, since the lead from the windows and the sheeting of the roof were used to make bullets for the army. By

the time the commission of monuments succeeded in stopping this destruction, only the glass in Suger's choir remained intact. Descriptions of the abbey before the Revolution are vague about the windows and even their subjects are unrecorded. The only record of their appearance was made in the winter of 1794–95 by Charles Percier. Unlike his drawings of Suger's windows (*Saint-Denis*, 1981, fig. 19), Percier's sketches of the thirteenth-century glass are merely rapid notations. The clerestory windows were filled with large figures and the roses were evidently composed of colored scenes, as were the rosettes above the lancet windows. This much information is definite in the sketches, suggesting that the glazing program at Saint-Denis followed the tradition of employing full-color panels, at least in its major windows.

A more precise series of documents regarding the appearance of these windows is the tracings drawn by Just Lisch, about 1849, of pieces in storage at the abbey that had been salvaged following Napoleon's initial order of 1806 to clean up Saint-Denis and to restore it to use (Crosby, 1953, 70–71). During Viollet-le-Duc's restoration of the church, which began in 1846, these fragments were evidently sent by him to the Gérentes' studio in Paris, to serve as models in the reglazing of the choir. None of these pieces, even those from the twelfth century, was ever copied or reused. Instead, they were sold by Alfred Gérente to dealers. Among the Lisch tracings are several marked "Saint-Denis," which seem to refer to the thirteenth-century windows. Only one is a figural subject (fig. 32), and it has strong stylistic connections with the Pitcairn King.

The Lisch drawing shows a roundel with a seated apostle under a canopy and is inscribed S:IOHAINES (Saint John). The slashing lines of the drapery and the summary drawing of the features are very different from the carefully articulated painting of the twelfth century. Instead, feature for feature, this style matches that of the Pitcairn King. The head of the king—with its curiously shaped eyes; narrowing plane of the nose; accentuated lower lip; softly waving hair, with tufts of the beard drawn over the earlobes; and the prominent cords of the neck—is the counterpart to that of the apostle. Other devices of this painter are even more definitive. Above the king's exceptionally long index finger that strums the harp is a dark area, like a shadow cast on the harp strings, that repeats in technique the shadow cast on the book by the hand of the apostle. Though some of the king's drapery has been replaced, in the original yellow glass that edges the mantle in his lap is an unusual rectangular fold that is repeated several times in the mantle of the apostle. These personal touches of the painter leave little doubt as to the origin of the Pitcairn King within the thirteenth-century glazing program at Saint-Denis.

The style of these two examples, moreover, suggests that both came from the lower windows in the glazing program—perhaps from the aisles of the north transept, where the Life of Christ (Percier had sketched a Crucifixion in one of the rosettes) illuminated the windows above the royal tombs. The linear drawing of these two figures, with the unresolved complexities of drapery, prefigures—but closely approaches—the fully developed Court Style of the Sainte-Chapelle. Saint-Denis was a royal abbey and its building program was supported by donations from the monarchy. The presence there of Parisian glaziers—and, moreover, glaziers who met the king's taste—was only to be expected.

Purchased from François Haussaire, Paris, June 17, 1922.

see cover

73. Fragment of Grisaille, from an Unknown Window

France, Abbey of Saint-Denis
About 1240–45
Grisaille glass with pot metal
Height, 20.6 cm. (8 1/8 in.); width, 17.2 cm.
 (6 3/4 in.)
03.SG.85

The upper lobe of a trefoil with a pattern of acanthus buds and clusters of berries on a crosshatched ground surrounds a quatrefoil of red leaves outlined in paint. In the upper corners are painted rosettes, and a strap at the bottom outlines a blue quarry—a replacement in old glass. The fragment is set in black modern glass.

This piece was purchased from Bacri Frères in 1923, with a number of other fragments of grisaille. Though of minor artistic significance in its present fragmentary condition, it is, nevertheless, of enormous historical importance, since it can be traced to the thirteenth-century glazing of the Abbey of Saint-Denis.

Among the Lisch tracings of about 1849 are several fragments of mosaic background and grisaille panels that are stylistically related to glass from the middle of the thirteenth century. Since each of these tracings is marked with the name of the abbey, they must depict remnants of the (now lost) glazing program that was part of the restoration and rebuilding of the church that began in 1231. No thirteenth-century glass survives at Saint-Denis today; it was all removed and destroyed during the Revolution. The fragments drawn by Lisch were scraps that were salvaged and stored at the abbey. Proof of this is furnished by the fact that, in 1837, François Debret had used other pieces of the same mosaic to patch the west window at Saint-Denis, during his restoration. These fragments remained in place until 1957.

33. Just Lisch. Tracing of a grisaille lobe from the Abbey of Saint-Denis. About 1849. Archives de la Direction de l'Architecture, Paris

The Pitcairn fragment can be understood only in relation to the Lisch tracing (fig. 33) that reproduces half of a trefoil of grisaille. Each lobe is surrounded by a strap interlaced around a central boss. Within the lobes are thick, curved stalks that terminate in acanthus buds and berries on a crosshatched field, as does the Pitcairn fragment. In the top lobe is a colored quatrefoil of spindly leaves, with rosettes in the corners. The arrangement is so similar to that of the Pitcairn piece, and so unusual for grisaille patterns, that the two pieces must come from the same ensemble. They are also the same size. The unusual features of the two pieces are the placement of the colored leaves off-center in the top lobes and the inclusion of the corner rosettes there but not in the lateral foils. The Pitcairn fragment is, therefore, the top lobe, minus its surrounding strap of another trefoil.

The use of the trefoil as a frame for glazing was

195

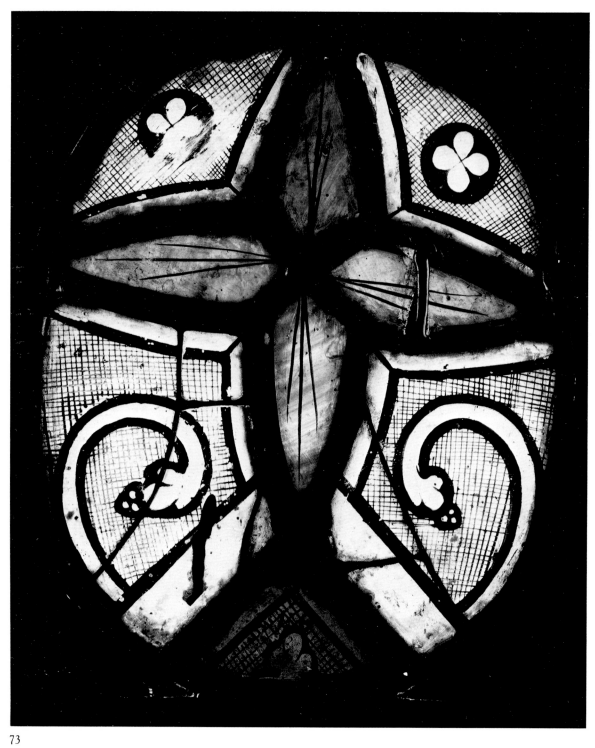

73

not common at Saint-Denis. Trefoils appear in the spandrels of both transept roses and on the periphery of the south rose. These openings are, however, much larger than those shown in the Lisch tracing. Furthermore, Percier's sketch of the north rose indicates that it was filled with colored figural glass, and it is assumed that the glazing of the south rose was similar. The only cusped arches that would accommodate glass like that indicated in the Lisch tracing are those in the lancet heads of the terminal walls of the transept, beneath the north and south roses. Furthermore, the base of the trefoil in the Lisch tracing is squared off by a lead line, clearly indicating that it was the top of a lancet rather than a tracery form. The glazing of the north transept must have been completed by 1241, when that part of the building and the chevet were put into use (Bruzelius, 1981). Construction of the north transept had progressed far enough in 1237 to permit the translation there of the relics of Saint Hippolytus. The south transept was completed some six years later.

In 1241, the idea of combining color with grisaille in a glazing program was a novel one. It would be in use by 1245 in the choir of Saint-Père in Chartres (Lillich, 1978, 28–29) and almost contemporaneously at Saint-Germain-des-Prés in Paris, but it was precisely during this period that the idea of lightening the interiors of churches by using grisaille windows came into being. It began in Chartres as early as 1235 (Lillich, 1972, 11–18). The lightening effect of a grisaille triforium to offset the saturated color of the roses and the aisle windows at Saint-Denis does not, therefore, seem out of place in 1241, particularly when a considerable amount of color was employed in the grisaille. The major reason for assuming that the earlier rather than the later transept was the original location of these grisailles, however, is their style. The stalks of the acanthus foliage are thick and their buds small and underdeveloped, and the berries are clustered. This type of foliage also is seen in the early grisaille windows in Chartres. The colored leaf spray in the Pitcairn fragment and in the Lisch tracing are outlined in paint, a practice that would be abandoned by mid-century—nor would isolated rosettes be a part of the design of grisaille windows in their developed stage. Meredith Lillich has noted that in early grisailles both sides of the strap are outlined in lead, a technique that is employed in the outer strap of the Lisch tracing as well as in a second trefoil in a tracing in the Lisch portfolio. The experimental character of these drawings, and of the Pitcairn panel, clearly marks them as early, but it also indicates that the glazing program at Saint-Denis stood in the vanguard of a new style—one that would prevail in Paris by the middle of the thirteenth century.

Purchased from Bacri Frères, Paris, October 30, 1923.

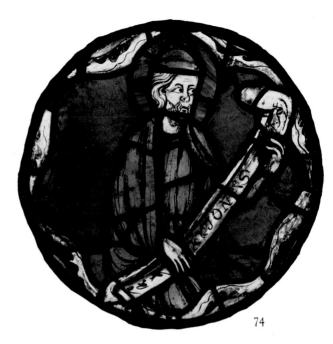

74

74. Prophet (Isaiah?)

France, Paris, The Sainte-Chapelle
Between about 1245 and 1248
Pot-metal glass
Diameter, 47 cm. (18 1/2 in.)
03.SG.210

This half-length figure of a bearded prophet is seated on a green bench, silhouetted against a blue ground, and surrounded by an undulating frame of white clouds. He wears a green cap and a green robe, which is partially concealed by a murrey mantle. A brilliant nimbus of streaky red glass encircles his head and calls attention to his expressive face. He holds a white phylactery inscribed with the name JON AS, the first three letters of which are the product of a modern restoration. Otherwise, the panel is in very good condition, marred only by modern replacements in the band of clouds and in small areas of the drapery. Even the fabric of the original glass has been spared the effects of exterior corrosion, maintaining, for the present-day viewer, the brilliance of its translucent tonalities.

Raymond Pitcairn purchased this panel from Acézat in April 1928. Acézat had acquired it at the Hôtel Drouot on May 19, 1924, at the sale of Heilbronner's collection. Although it is not known when and from whom Heilbronner obtained this panel, its provenance prior to the middle of the nineteenth century can be established with precision. Before 1848, it was installed in the Sainte-Chapelle in Paris.

We are unusually well informed about the conception, construction, and conservation of the Sainte-

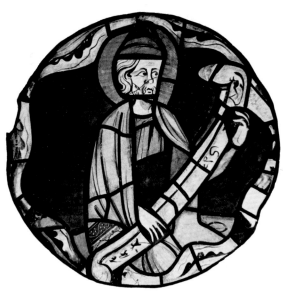

34. *Prophet*, from the Isaiah and Tree of Jesse window, The Sainte-Chapelle, Paris. Full-scale watercolor copy. Mid-19th century. Musée des Monuments Français, Paris

Chapelle, built by Louis IX to serve both as a private royal chapel and as a monumental reliquary to house important relics of Christ's Passion, which he had purchased at great cost from Baldwin II, Latin Emperor of Constantinople, in 1239 and 1241 (Grodecki, *Sainte-Chapelle*, 1975, 5–6; Branner, 1965, 56–65). Documentary evidence indicates that construction was well on its way in 1244, and, in January 1246, Louis founded a college of canons to serve in the new palace chapel. In 1244 and 1248, money was provided for the maintenance of the windows, an indication that they were completed in time for the solemn consecration of the chapel on April 26, 1248, soon before Louis left on crusade.

The Pitcairn Prophet is not the only panel of glass from the Sainte-Chapelle that has been alienated from its original context. In 1803, when the chapel was transformed into a legal archive, the windows were emptied up to a level of about two-and-a-half meters. Although most of the close-to-175 panels that were removed at that time are now lost, some found their way onto the art market and can be seen today in collections in London, Rouen, Florida, and Philadelphia—and installed in the English parish churches in Twycross and in Wilton (CVMA, 1959, 73, 337–49; Grodecki and Caviness, 1968). The Pitcairn Prophet, however, remained in the Sainte-Chapelle until the major restoration of the chapel in the middle of the nineteenth century.

Planning for the projected restoration, conceived to return the beleaguered Sainte-Chapelle to its "original" medieval appearance, began as early as 1837, and, by 1839, preliminary work, supervised by the architects Jacques-Félix Duban, Jean-Baptiste-

Antoine Lassus, and Viollet-le-Duc, was already under way. In 1846–47, a competition was held to choose the glazier who would be entrusted with the imposing task of restoring the original glass and replacing what had been lost with a modern pastiche (CVMA, 1959, 86–88). Henri Gérente, a Parisian glass painter who was also occupied with the restoration of the ambulatory windows at the Abbey of Saint-Denis (CVMA, 1976, 52–53), was awarded the commission and began work in the hemicycle in 1848. Gérente died in 1849, and his responsibilities at the Sainte-Chapelle fell to the runner-up in the competition, Antoine Lusson from Le Mans. The project was completed by 1855.

Fortunately, for the twentieth-century art historian, this carefully planned restoration included the tracing of each of the panels in the chapel as they were taken from the windows. From these tracings, full-scale watercolors were executed. The precious documents exist today in twenty bound volumes kept in the library of the Musée des Monuments Français in Paris. At the suggestion of Françoise Perrot, they were consulted to determine if any of the recorded panels that had not been returned to the chapel in the course of restoration had found their way to an American collection. The Pitcairn Prophet (fig. 34) appears in the sixth volume of the watercolors, among the panels from the Isaiah and Jesse Tree window (located in the second bay, south of the axis, in the hemicycle; bay J in CVMA, 1959). A marginal inscription indicates that the panel was originally one of three medallions, containing prophets, in the tracery lights (CVMA, 1959, pl. 43; panel C). The medallion currently installed in this position at the Sainte-Chapelle reproduces the pose of the Pitcairn figure but places him against a red ground. It was presumably copied from the panel itself, or from the tracing, as a replacement for the original figure. The question that remains is why, during a restoration that was guided by a desire to return this precious national monument to a faithful approximation of its original appearance, a panel in such extraordinary condition would have been discarded and replaced with a copy. No definitive answer can be given, but the confluence of several circumstances suggests a possible explanation.

In his comprehensive study of the windows of the Sainte-Chapelle, written in 1959 (CVMA, 1959, 86–88), Grodecki has explained how the nineteenth-century restorers eliminated certain panels that had been added during prior restorations, from the late thirteenth to the eighteenth centuries, as well as others that were badly damaged. Apparently, some panels were also set aside because they seemed iconographically inappropriate. Since the windows were restored one at a time, with each individual bay being completed before a subsequent window was removed, previously incorrectly installed, though intact, com-

ponents were often set aside if restoration of the window to which they originally belonged already had been completed. Even though all of these "superfluous" panels were supposed to be preserved either at the Sainte-Chapelle or at the Musée de Cluny, only twenty-two of the more than eighty panels that were removed remain in Paris. Remarkably enough, none of the missing panels had come to light by 1959, and Grodecki surmised that they had been sacrificed by the restorers for the lead and the old glass.

Since Grodecki's study, however, two of the missing panels have been discovered—the prophet under discussion here and a panel from the Judges window now in the depot of the Monuments Historiques at the Château de Champs-sur-Marne (Perrot, 1973, 57–58). Both are in excellent condition, comparatively free from restoration. Copies of both were made by the restorers for insertion in their original positions. Clearly, someone intimately involved in the restoration used the authority of his position for personal gain. The glass painter, of course, was ideally situated to accomplish an exchange, since it was he who executed the modern copy to be substituted for the marketable original. This is not an unfamiliar story. A comparable situation explains the alienation of the Clermont-Ferrand angels from their original home (cf. no 45).

In the instance of the Sainte-Chapelle, the most likely culprit is Henri Gérente. He was only in charge of the restoration for a year, but work had already begun in the hemicycle, and the two panels in question were taken from adjacent bays at the first turning of the apse on the north side. It is interesting in this context to note that pieces installed at the Abbey of Saint-Denis when Gérente began his work there "disappeared" in the course of restoration (cf. nos. 27, 28). In this project, Gérente was replaced by his brother, Alfred, who became a glass painter only at the death of Henri, and who, presumably, inherited his brother's studio (CVMA, 1976, 52–53). There may have been panels from Saint-Denis and the Sainte-Chapelle in the atelier, which Alfred later sold, or some already may have been sold by Henri. Alfred's hand has been identified in a copy of one of the Saint-Denis panels now in the Museo Civico in Turin (CVMA, 1976, pl. 180), so that it would seem that both brothers may have supplemented their incomes as restorers by speculating in the art market. A thorough study of all existing documentation will be necessary before this chapter in the history of nineteenth-century France can be written. Still, a careful assessment of the provenance of the glass in the Pitcairn collection has once again brought us closer to an understanding of how so many medieval treasures left their original contexts and were acquired by collectors over the course of the last two centuries.

The Pitcairn Prophet, simple enough as an isolated piece, was initially part of an iconographic composition of staggering complexity (CVMA, 1959, 78–84; Grodecki, *Sainte-Chapelle*, 1975, 49–52). Stated most simply, the glazing program of the Sainte-Chapelle combines the redemption of man in the context of Old Testament prophecy (in the hemicycle), with moralized Old Testament narratives (in the straight bays). Within this broad design there is a twofold emphasis on the relics of Christ's Passion and on the theme of sacred kingship. Both themes are obviously appropriate in a structure meant to be at the same time a royal chapel and a repository of Christ's regal relic, the crown of thorns. The Pitcairn panel is one of a series of prophets that filled the three tracery medallions in five of the seven hemicycle windows (CVMA, 1959, 75; K, J, G, F, E), supplementing the theme of Old Testament typology and prophecy of the paired lancets beneath them.

Of the prophets now installed in these medallions, only one carries a scroll with his name inscribed (GEREMIAS, in window G). The extensive restoration of so many of the other panels, however, may have obliterated other, similar inscriptions. In any event, the authenticity of a portion of the inscription held by the Pitcairn Prophet confirms that he was once labeled. Since the Latin form of many prophets' names ends with "as," it would have been virtually impossible to establish the original identity of the figure, were it not that the space available for the first letters of the name narrowed the field of candidates considerably. Jonas, the choice of the modern restorer, is conceivable, but Isaias seems more likely. The Pitcairn figure was initially placed directly over the Jesse Tree in a double-lancet window that pairs this genealogical composition with a portrayal of the prophecy of Isaiah. The iconographer may have attempted to underscore the association of the Jesse Tree (based on Isaiah 11:1–2) with this prophet, thereby unifying the iconography of the window as a whole. Of the twenty-six original figures of standing prophets in the Jesse Tree lancet, only two are identified—and one of them is Isaiah.

Even without the evidence of the nineteenth-century watercolor, it would have been possible to assign the Pitcairn Prophet to the orbit of Parisian artists who glazed the Sainte-Chapelle, solely on the basis of style. Although the glazing of the chapel is characterized by an overall sense of formal unity, Grodecki has been able to divide the windows among three ateliers (CVMA, 1959, 92–93; Grodecki, *Sainte-Chapelle*, 1975, 54–55). This panel bears the unmistakable imprint of the artists working in what Grodecki has called the "principal" workshop—Parisian artists whose style parallels that of the roughly contemporary glazing of the Lady Chapel of the Abbey of Saint-Germain-des-Prés. This style was quickly associated with Saint Louis's patronage and, as a re-

sult, spread rapidly throughout France, charged with royal prestige (Aubert, 1958, 144–56; Raguin, 1977). Windows in this Court Style were made during the 1240s and 1250s for churches in Auxerre, Saint-Julien-du-Sault, Soissons, Beauvais, and Tours.

As apparent in the Pitcairn Prophet, the Court Style is characterized by rapidly applied and economically conceived interior articulation. Facial features and drapery folds are reduced to a calligraphic system of boldness and clarity. Although the spontaneity of this style might be misinterpreted as sloppiness or awkwardness by observers familiar with the detailed and meticulous styles of the first quarter of the thirteenth century (cf. nos. 51, 56), it is actually the expression of glass painters more concerned with clearly and elegantly defined contours than with the intricacies of interior articulation. The result was immediate legibility. To this day, the figures of prophets are clearly discernible in the highest reaches of the chapel.

The large piece of undulating blue glass that has been used for the ground of the left part of the Pitcairn Prophet is one of its most striking features. Variations both in the intensity of pigment within this piece and in the refraction of transmitted light through it are the direct result of its having been cut from a disk of glass that varied in thickness—caused by the medieval process of hand blowing glass. Irregular glass such as this seems to have been prized by the artists of the Sainte-Chapelle. They leaded comparable pieces into panels throughout the chapel, creating the effect of jewels studding its translucent walls and helping to bathe the interior with the ineffable, otherworldly brilliance that has made it famous. In this and in every other respect, this panel is a small masterpiece of the mature Court Style at the middle of the thirteenth century.

M. W. C.

Purchased from Michel Acézat, Paris, April 2, 1928.
Ex collection: Raoul Heilbronner, Paris (until 1914).
Bibliography: Heilbronner sale cat., 1924, no. 92.

see colorplate XI

75. An Elder of the Apocalypse, from an Unknown Window

France
About 1240–45
Pot-metal glass
Diameter, 43.1 cm. (17 in.)
03.SG.208

The red-nimbed figure, dressed in a yellow mantle over a light green robe with a white collar and a red belt, holds a white jar in his left hand and a white lyre in his right. The background is blue. This panel is in excellent condition, except for the mending leads that cross and distort the face of the figure as well as his left leg, which is a replacement.

Purchased from Acézat in 1928, the panel was in the Heilbronner collection until its sale in Paris in 1924. The previous provenance or origin is unknown.

Because of its attributes—a musical instrument and a perfume flacon—the figure is recognized as one of the twenty-four elders of the Apocalypse; its scale and the fact that it is a single figure indicate that the roundel probably once belonged in a rose window.

As Émile Mâle has pointed out (1978, 378–97), together with the Last Judgment and the Coronation of the Virgin, the Apocalypse became one of the most important iconographic themes in the art of the twelfth and thirteenth centuries. Because of its implications of the Second Coming of Christ, the Apocalypse was usually reserved for monumental settings, such as portals or rose windows. Occasionally, the Apocalypse was depicted in lancet windows, such as those in the choirs of Bourges and Auxerre, but in these cases the theme was treated as a narrative rather than developed hieratically, as on portals and in roses. The tympanum, or the center of the rose, would contain the *Maestas Domini*, surrounded by the symbols of the Evangelists. Frequently, the four creatures were eliminated in Apocalypse roses and Christ was shown alone in the center or, as in the south rose of Chartres, he was encircled by angels in a ring of medallions. Of key importance to the theme, however, was the presence of the twenty-four elders, who usually occupied the outer voussoirs of the portals—as in Amiens and in Bourges—or the outer compartments of the roses—as in Chartres. While, in rose windows, the Last Judgment was usually conceived as a narrative—as in the west rose of Chartres, in Mantes, or in Donnemarie-en-Montois (no. 62)—the Apocalypse, until the fifteenth century, was designed as a hierarchy with Christ enthroned in the center surrounded by the celestial court—as at the Sainte-Chapelle (CVMA, 1959, 310–28). Though the narrative Apocalypse of the Sainte-Chapelle replaced an earlier window that was contemporary with the building, which was constructed in the 1240s, there is evidence that the former theme was copied; since Grodecki has discovered what he regards as one of the original elders employed as filling in a tracery light (CVMA, 1959, 274), there is also reason to believe that the first rose window followed the earlier hieratic types of roses.

The Pitcairn Elder, seated on a backless throne, is a youthful, beardless figure, who holds his two attributes. He has a nimbus but does not wear a crown. There appears to have been very little conformity in representations of the elders in the Middle Ages (Réau, 1955–59, II, B, 690–93). They are sometimes

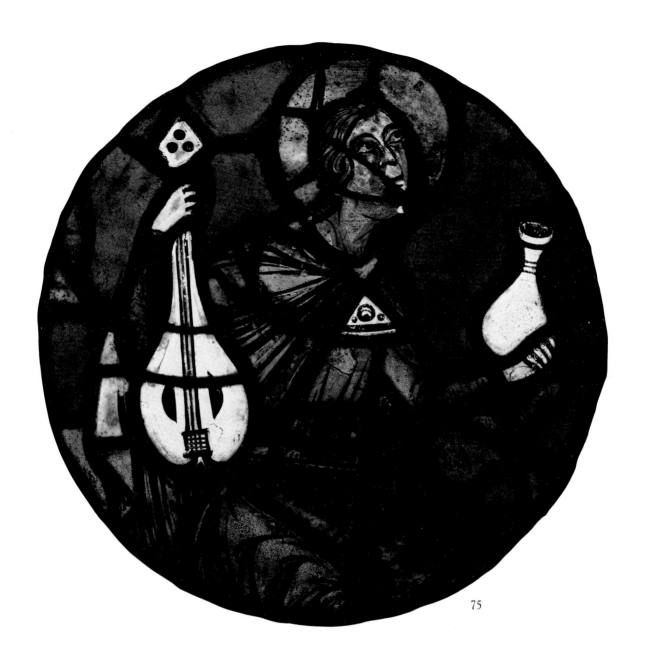

75

shown seated on high-backed thrones—as in the Sainte-Chapelle and in Chartres—and sometimes on low benches—as in Tours and, by implication, in the Pitcairn panel. On the Saint Anne portal of Notre-Dame in Paris, and on the central portal of the west façade of Chartres, they are standing. Though their inclusion in an Apocalypse subject indicates that they are old, for the most part they are beardless—as in Tours, sometimes in Chartres, and in the Pitcairn panel. Each elder in the south rose at Chartres Cathedral, and in the archivolts of Amiens, wears a crown but has no nimbus. In Tours they are sometimes without crowns. In the central portal of the west façade at Chartres they are both crowned and nimbed but, as Réau indicates (1955–59, II, 692), the elders sometimes have nimbi but no crowns.

The Pitcairn panel is thus in keeping with the variety of standard types that, in medieval art, represent the elders of the Apocalypse. The drawing of the figure is simplified, with little attention given to intricate tones of shading. Broad washes of mat suffice to outline the areas around the eyes, alongside the nose, and around the mouth. A flat tone is laid over the hair, the areas above and below the belt, and down the sides of the arms. The features are outlined with trace, while the folds in the garment are indicated by varying thicknesses of line, applied in slashing strokes with a loaded brush. There is no shading at all on the lyre or on the flacon. The folds of cloth that fall from the side of the right leg are intercepted by diagonal lines that indicate the drapery pulling across the top of the thigh. This is a summary style of painting that approaches the technique of the mid-thirteenth century. Though it is impossible to relate this figure to any known monument, it appears closest in style to Parisian art of the mid-thirteenth century. Unfortunately, there is no surviving stained glass in Paris that dates from the period between the glazing of the west rose of Notre-Dame, of 1225–30, and the completion of the windows of the Sainte-Chapelle, some twenty years later. Lafond (1946, 152–53) has estimated that some sixty churches were built and probably glazed in the city of Paris between 1150 and 1250. Though a few fragments have survived in such collections as the Musée de Cluny, they seem unrelated to any existing monument, and, like this Pitcairn panel, can provide little more than a glimpse of contemporary stylistic trends.

Purchased from Michel Acézat, Paris, April 2, 1928.
Ex collection: Raoul Heilbronner, Paris (until 1914).
Bibliography: Heilbronner sale cat., 1924, no. 92.

76. Apostle Paul

France, Paris
About 1250–70
Limestone, with polychromy and gilding
Height, 158.7 cm. (62 1/2 in.); maximum width, 54.6 cm. (21 1/2 in.)
09.SP.127

Monumental sculpture produced in Paris during the reign of Saint Louis reached its most brilliant phase with the sculptural decoration for the Sainte-Chapelle, Saint-Germain-des-Prés, and the transepts and central portal of the west façade of Notre-Dame. From this same artistic milieu comes the present life-size statue of Saint Paul, carved almost completely in the round. Holding an open book in his left hand and a sword-in-scabbard in his right, the figure stands firmly on a plinth, which originally contained an inscription with his name (now eradicated). He wears a long green tunic with a red over-mantle pulled tightly across the torso, falling in sinuous folds down his left side. The polychromy is partially original, with traces of gilding on the mantle, hair, and beard. The back of the figure is roughly chiseled, and an iron spike for mounting still remains. The noble bearing and physical strength of the figure is evident in the head, specifically, in the sharp-cut elegance of the hair and beard. This type of ample, curling hair is often characteristic of representations of Saint Peter, but a number of comparable contemporary examples of Paul exist, such as the one in Neuwiller, France,

35. *Adam* (detail), from the interior, south transept portal, Notre-Dame, Paris. About 1260. Musée de Cluny, Paris, Inv. no. 11657

in the church of Saint-Pierre-et-Saint-Paul (Sauer-länder, 1972, pl. 282).

Little is known of the history of this imposing statue prior to its acquisition in 1922. Raymond Pitcairn purchased it from René Gimpel who, in turn, had bought it from the dealer Lucien Demotte. Gimpel (1963, 132, 182) rightly stated that it was "one of the masterpieces of Gothic art."

Although its exact provenance has yet to be determined, its style evolved directly from a group of Parisian monuments of about the middle of the thirteenth century. New buildings, such as the Sainte-Chapelle (dedicated in 1248), and reconstructions, as at Saint-Denis and at Notre-Dame, called for additional sculptural programs and generated an important new style. Without doubt, this style occurred for the first time in the figure of Christ as Judge, with an attendant angel with nails, on the central tympanum of Notre-Dame. It now appears that these two figures are replacements of the earlier thirteenth-century Last Judgment portal (Erlande-Brandenburg, 1971; *idem*, 1974; Joubert, 1979). Based upon their style, they were probably executed and then integrated into the existing tympanum toward 1250. Clearly decisive in the development of Gothic sculpture, this style was continued by the first sculptor of the Sainte-Chapelle, and then in the decoration of the south transept portal of Notre-Dame, which was begun about 1258. The magnificent statue of Adam

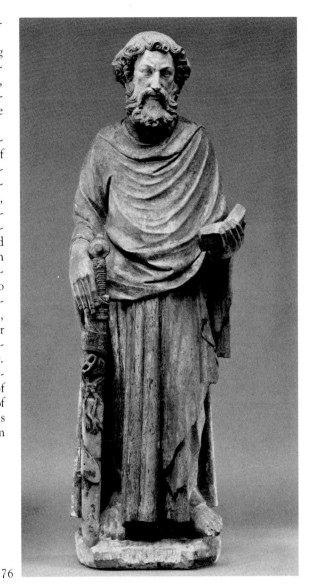

76

(Musée de Cluny) from a gable above the interior of the south transept doorway at Notre-Dame reveals some striking parallels (fig. 35) to Saint Paul. The supple treatment of the hair and the design of the eyes are nearly identical to the Pitcairn sculpture, suggesting that both works are possibly by the same hand. Therefore, Saint Paul might belong to this important atelier at Notre-Dame. Significantly, the first choir chapel adjacent to the south transept door is dedicated to Saints Peter and Paul, but whether this imposing statue of Saint Paul originally adorned this chapel must, for the moment, remain an open question.

C. T. L.

Purchased from René Gimpel, Paris, 1922.

Ex collection: Lucien Demotte, Paris.

Bibliography: Gimpel, 1963, 132, 182.

see colorplate XV and back cover

203

77

77. Section of a Border, from a Clerestory Window

France, Champagne (?)
About 1240–45
Pot-metal glass
Height, 67 cm. (26 3/8 in.); width, 29 cm. (11 7/16 in.)
03.SG.120

A white painted ribbon caught by green and yellow rosettes encloses blue four-petaled flowers with alternating red and white painted centers. The fields of the oval-shaped compartments formed by the ribbon are red and the exterior background is blue. The border is enclosed at the left by red and white fillets and at the right by a white-pearled fillet. The piece is in excellent condition except for several replacements in the red fillet.

The border was bought from Joseph Brummer in Paris in 1921 but there is no other information as to its provenance. Its large, simplified design, combined with its width, suggest that it came from a clerestory window. There is no modification of form by shading in this border—a further indication that it originated in an upper window. The only detailing in the design is done with extremely fine lines of trace paint. This absence of painted detail is characteristic of borders of the mid-thirteenth century but, in most cases, borders of this period are extremely narrow, with standardized designs (cf. nos. 80, 86). Under the influence of the Court Style, borders became little more than decorative fillets, but this tendency appeared first in the south rose of Chartres, which Grodecki (1978, 58–61) has suggested is related to the glazing of the Sainte-Chapelle. He has attributed the south rose, installed before 1230, to the Master of Saint Chéron, whose atelier, he believes, produced the principal master of the major Court Style glazing program at the Sainte-Chapelle. The narrow, stereotyped border became the rule at the royal chapel, but there is another monument, whose style also derives from the Sainte-Chapelle, where wider borders prevail. This is the choir clerestory at the cathedral of Troyes, generally dated about 1245 (Aubert, 1958, 140–43), where the influence of the Saint Chéron master also should not be overlooked. The border of the Assumption of the Virgin in the hemicycle clerestory of Troyes (Marsat, 1977, pl. 17) is only a slight variation of the border that surrounds the figure of Ezekiel in one of the lancets under the south rose of Chartres.

It is the border of the Saint Helen window in the clerestory of Troyes (Marsat, 1977, pls. 5, 6) that is more closely related to the Pitcairn piece. It, too, is wider than the usual Court Style borders and is composed of a pattern of ovals, defined by a white

ribbon painted with a narrow line of trace near the inner edge, like the Pitcairn piece; it also has red glass within the ovals and a blue background. These oval shapes are interspersed with groups of four leaves at right angles around a central flower. The detailing of these leaves is indicated only by fine strokes of trace, as is the flower in the Pitcairn piece. The resemblance between these two borders is close enough to suggest an origin in Champagne for the Pitcairn panel but its painting style is more refined than that of Troyes.

The beaded edging of the Pitcairn piece, as well as the oval ribbon and the painted rosettes, are present in borders from the nave clerestory at the cathedral of Reims (Westlake, 1881, I, pl. XLIX); this glass is usually dated about 1240 (Aubert, 1958, 140). Though similarities of type and technique between the Pitcairn panel and these two major monuments in Champagne, dating from the 1240s, suggest that this border also may have originated in northeastern France in the same period, until more detailed studies of these French monuments have been undertaken, the question of a shared provenance must remain unresolved.

Purchased from Joseph Brummer, Paris, March 11, 1921.

78. Saint Peter Enthroned as a Pope

France, Lorraine
Late 13th century
Polychromed limestone
Height, 110.5 cm. (43 1/2 in.); width, 44 cm.
 (17 5/16 in.); depth, 28.9 cm. (11 3/8 in.)
09.SP.33

The saint's right hand is raised in blessing, and in his left he holds up a pair of keys. He wears a simple conical tiara; gloves; a cope fastened in front, across the chest; and a pointed hood that hangs down his back. He is seated upon an ecclesiastical faldstool, whose crossed members are clearly depicted at the back. Dogs' heads once surmounted the four extensions of this support. The lower ends each terminate in four clawed toes. The saint's slippered feet emerge from among the lowest folds of the cope.

Relatively well preserved, the sculpture's few losses include the upper extension of the keys, the two dogs' heads on the rear of the faldstool, the two projecting fingers of the blessing hand, the tip of the tiara (the present one is a restoration), and the front corners of the base—which are broken at irregular angles. The two streamers, or lappets, suspended from the back of the tiara also were broken and the portions bridging the space behind the neck are reconstructions. The head appears to have remained intact.

Without technical study, the substantial rem-

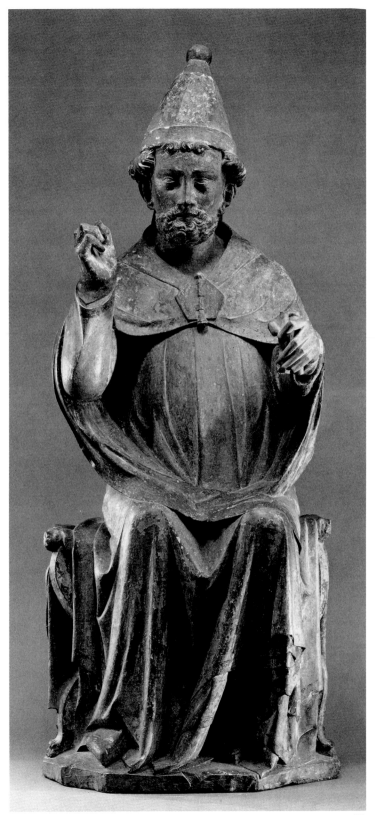

78

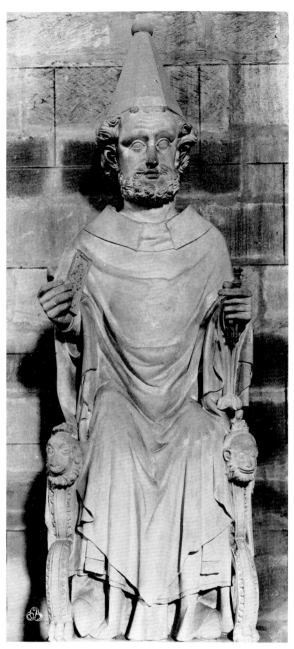

36. *Saint Peter as Pope*, Parish Church of Luxeuil-les-Bains
(Haute-Saône). Early 14th century. Limestone

nants of color cannot be verified as original. Yet, if not original, the preserved pigmentation probably testifies to the original color scheme. The exterior of the cope has substantial remains of red; the interior surfaces, as seen beneath the arms, are blue. The tunic, or dalmatic, is now tannish, possibly the ground for a white overpainting. The sleeves, with black details, are edged in ocher, perhaps to suggest embroidered gold. The flesh tones of the face, applied over a tannish ground, are offset by the gray-to-black paint of the hair and beard. The pillow visible at the sides and at the back of the faldstool has the remains of a diapered pattern in dark red. The cloth that is hung directly over the sides and back of the faldstool is decorated with an embroidered pattern of dark red, orange-red, green, and black. Chisel marks, pervasive in many areas, are especially evident at the back of the sculpture.

The plain, cone-shaped tiara appears in several other thirteenth-century sculptures—as, for example, on the heads of the popes (of about 1225–30) preserved from the north transept portal of Saint Calixtus at Reims Cathedral (Paillard-Prache, 1958, 35 repr.; Sauerländer, 1972, pl. 243). Early fourteenth-century examples include an Enthroned Peter (fig. 36) in the parish church of Luxeuil-les-Bains (Haute-Saône) and the Spanish polychromed wood sculpture of the standing Saint Peter in The Metropolitan Museum of Art (27.18.2; Rorimer, 1930). According to Verdier (1962, 92), the later fourteenth century witnessed the adoption of the triple-crown tiara, called the triregnum, which was initiated by the Avignon Popes and was later brought to Rome. The polychromed limestone sculpture in the Walters Art Gallery of an Enthroned Saint Peter, attributed to Lorraine and assigned to the last quarter of the fourteenth century, may be seen wearing the triregnum (Verdier, 1962, no. 93, pl. LXXXVIII).

The cope draped over the shoulders of the Pitcairn Saint Peter is the papal semicircular red cloak called the *Cappa Rubea*, or *Mantum* (Verdier, 1962, 93). This cope is held closed by a brooch, or morse, of two separate plates, fastened with a knobbed pin. Actual morses of this type, dating from the thirteenth and fourteenth centuries, are preserved in the Walters Art Gallery (Verdier, 1957, for a secular example; Randall, 1979, 167–68, no. 469b, for an ecclesiastical example). The Pitcairn Saint Peter also wears the pontifical gloves that designate him a Priest-King, as does the above-mentioned Walters sculpture (Verdier, 1962, 93).

The ecclesiastical faldstool has the curved cross supports characteristic of faldstools of the Gothic pe-

riod (Schmid, 1973, col. 1226). The use of curved members seems to have begun in the early thirteenth century, as in a faldstool from the Benedictine Abbey of Admont (Styria) in Austria, which retains the lions' head terminals from earlier Romanesque examples (Wixom, 1979, 95, fig. 21). Manuscript depictions of secular faldstools of the fourteenth century illustrate the adoption of dogs' heads—or, at least, heads that are less clearly leonine—as terminals (Avril, 1978, pls. 33, 35, 40).

The Pitcairn Saint Peter has a threefold importance: first, as a hieratic image; second, as an independent sculpture; and, third, as a work in characteristic High Gothic style. In the first two aspects, it recalls the famous bronze in Saint Peter's in Rome (Verdier, 1962, 92). The natural treatment of the drapery is especially evident in the pinching of the folds of the dalmatic about the lower torso and in the logical fall of the deep folds of the cope hanging from, and between, the knees. This generic type of the seated, draped figure appears in a number of voussoirs on the façades of the great cathedrals dating from the second quarter of the thirteenth century. The configuration of the drapery also is to be seen in an engraving of a lost royal "portrait" of the enthroned Dagobert, formerly in the cloister of Saint-Denis and tentatively datable in the 1260s (Sauerländer, 1972, 492, ill. 101). The general facial type, with contrasting smooth skin, almond-shaped eyes, and short, curly beard and hair, may share a related ancestry with the Reims heads of popes (Paillard-Prache, 1958, 35, repr.; Sauerländer, 1972, pl. 243). However, the Pitcairn Saint Peter cannot be dated as early as these; the particular details of the physiognomy are more closely allied with the head of Saint Eustace, a Lorraine polychromed limestone sculpture, dating from about 1290–1300, in the parish church in Vergaville (Schmoll gen. Eisenwerth, *Aachener Kunstblätter*, 1965, 59, abb. 13). Saint Peter's drapery, especially around the lower part of the figure, also may be viewed as a Lorraine adaptation of the Champagne style, as is the drapery of several parallel seated Madonnas from Lorraine—one of which is in The Cloisters collection (W. H. Forsyth, 1936, 255, 256, fig. 33; 25.120.250). A further manifestation of this drapery style is found in a work of the same subject as the Pitcairn sculpture—the previously mentioned early-fourteenth-century Enthroned Saint Peter (fig. 36) in Luxeuil-les-Bains, which is located just south of the Lorraine region.

W. D. W.

Purchased from Lucien Demotte, Paris, 1933.

79. Altar Angel

Northeastern France
Late 13th century
Oak
Height, 88.5 cm. (34 7/8 in.); width, 27.5 cm. (10 13/16 in.); depth, 18.5 cm. (7 1/4 in.)
12.SP.19

Wearing a tunic belted at the waist and a fillet binding the hair above a ring of curls encircling the head, and partially enveloped by a loose mantle draped over the shoulders, this youthful figure is related to countless representations of angels from the Gothic period, in stone, wood, metalwork, and ivory. The vertical slots behind the shoulders, which once supported wings, further confirm this identification.

Additional losses include the lowest portion of the figure and the lower arms. The feet and the base are restorations dating from after 1922, when the sculpture was photographed while in the possession of the Paris antiques dealer Simon. The lower arms, which were carved separately, contained doweled extensions that fit into holes in the upper arms and were held in place by a small peg. The original dowel and peg for the right arm are both still in place.

The common medieval practice of hollowing out wood sculpture from the back, to check the development of splits, is exemplified here, though the hollowing out came too close to the exterior surface under the right elbow, where an original repair was made with a triangular plug of wood. This repair would not have been apparent when the figure was painted. The opening at the back is closed with a separate piece of wood to which is attached a wrought-iron ring. A hole at the top of the head, now enlarged and split, was originally utilized to hold the block of wood in place, while the sculptor applied his chisel.

The sculpture exhibits little evidence of recutting. As late as 1922, it still retained substantial polychromy, but no traces of this color now remain. The surfaces that, today, appear white may be so from the original gesso ground or from a later whitewash; the dryness and slight erosion are probably the result of a drastic cleaning with corrosive chemicals. The rich polychromy with which such angel sculptures were once decorated is suggested by the remains of color and gilding in the textile patterns evident on two earlier angels, now in The Cleveland Museum of Art (Wixom, 1974, 82–85, cover, figs. 1–5).

The style of the sculpture is characterized by a certain natural elegance of stance marked by a gentle contrapposto of the body and the arms to the figure's left, while the head turns slightly in the opposite

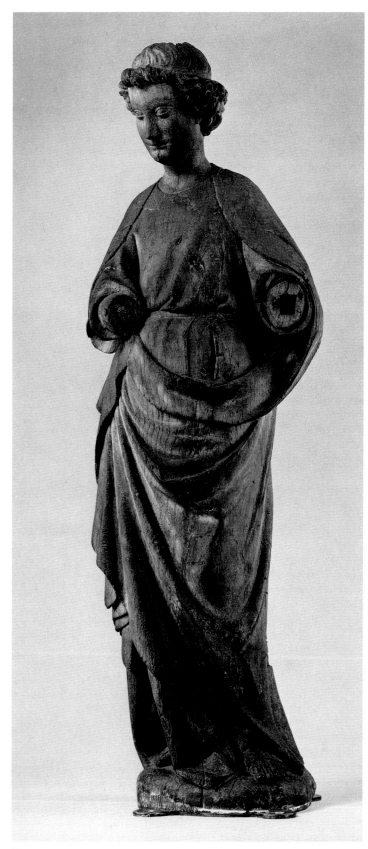

direction. The weight is borne by the hidden right leg, whereas the left leg presses forward against the drapery in the area of the knee. The smooth, curved planes of the face are sensitively modeled; the eyes are slightly puffy, and the brows highly arched; and there is the hint of a smile on the thin lips.

The Pitcairn Angel is part of a loosely related series, in various woods and ivory, dating from about 1235–45 to the end of the century (Rorimer, 1952; Randall, 1959; Wixom, 1974; Little, 1979, 61, fig. 9). It is believed that these works derived from some of the great cathedral portal sculptures, as at Reims Cathedral, and, indeed, may have been partly responsible for the widespread dissemination in northern Europe of the stylistic character of the larger models. The Pitcairn sculpture comes toward the end of this series, and may be closely linked with one of the wooden angels in the Louvre, formerly in the Timbal collection (Aubert and Beaulieu, 1950, 104, no. 144, repr.). Most of the surviving wooden angels have lost their original wings, exhibiting only the sockets where they were attached. Perhaps the most famous in the series are the five angels in the Louvre and in the churches of Humbert and Saudemont (Pas-de-Calais) (Lestocquoy, 1959). Their wings—as well as those of the angels on the silver-gilt reliquary crown, also in the Louvre (Paris, 1970–71, no. 221, repr.)—extend upward, as the missing wings of the Pitcairn Angel most probably did. Such wings would have greatly enhanced the overall elegance of the figure. The Cloisters owns a pair of smaller walnut angels (52.33.1, 52.33.2) without wings, yet, of the Humbert-Saudemont type. Like the latter, the Cloisters figures each have a sweet facial expression and a smile, *le sourire de Reims*, adapted from the famous angel dating from about 1245–55 by the Joseph master, over the left doorway of the west façade of Reims Cathedral.

Many of the wooden angels—such as those in The Cloisters collection—are thought to have been altar angels and to have stood on the columns, placed about an altar, that supported rods with curtains. Such arrangements appear in several fifteenth-century paintings (Lestocquoy, 1959, 34; Wixom, 1974, fig. 34). It is believed that the five angels divided among the Louvre, Humbert, and Saudemont, and a missing sixth, once decorated the columnal and draped enclosure around an altar at the cathedral of Arras. As shown in the above-mentioned paintings and in some of the preserved sculptures, the angels bore either instruments of the Passion, candelabra, censers, or a combination of these.

W. D. W.

Purchased from Lucien Demotte, Paris, November 5, 1931.

Ex collection: Simon, Paris (until 1922).

Exhibited: Pennsylvania Museum of Art, Philadelphia, 1930.

79

80. The Murder of Three Clerics, from a History of Saint Nicholas Window

France, Burgundy
About 1240–45
Pot-metal glass
Height, 75.5 cm. (29 3/4 in.); width, 58.9 cm.
 (23 3/16 in.)
03.SG.14

Three tonsured clerics, whose heads are made from light red striated glass, lie asleep in a white-draped bed with a yellow coverlet. Behind them, the innkeeper, in a tunic with green hose, raises a white ax, while his wife, dressed in green, holds up a dagger, or a spindle. The background is blue and the scene is surrounded by red and white-pearled fillets. The ornamental field is composed of blue painted quarries with a red trellis. The narrow border has green, blue, and yellow foliage, against a red background, and white edge fillets. There is considerable restoration in this piece, some executed in old glass, including the entire section of the three clerics and the ornament near their heads.

The panel was purchased from Lucien Demotte in 1929, after it was shown in his exhibition of stained glass in New York (Demotte, 1929, no. 12). He said that it came from "the collection of M. Navarre d'Auxerre," and that "it originated in the cathedral of Auxerre." This attribution is erroneous, however, since, though the cathedral contains the remains of two windows devoted to the life and legend of Saint Nicholas, neither reproduces the ornament of this panel. The two windows in Auxerre are clearly divided—one recounting scenes from the saint's life and the other, incidents from his posthumous miracles (Raguin, 1976, 269). The one devoted to the life of Saint Nicholas includes the scene of the murder of the three clerics. Though this panel cannot have originated in the cathedral of Auxerre, it is clearly related to Burgundian art of the thirteenth century and to the influence that emanated from Paris (Raguin, 1974, 29). If this scene is from a Saint Nicholas cycle, there must have been two windows involved, since the curved edge of the panel indicates that it was placed at the top of the window where the death of the saint would normally have been shown. Two windows devoted to this popular saint would not have been unusual, for, in addition to those in Auxerre, there were two Saint Nicholas windows in Chartres. In fact, among the surviving twelfth- and thirteenth-century windows, more are devoted to Saint Nicholas than to any other nonbiblical personage. Saint Nicholas windows are included in the cathedrals of Bourges, Rouen, Le Mans, Tours, Troyes, Chartres, Auxerre, and at the church of Saint-Julien-du-Sault,

to which may be added the former Pitcairn panels from Soissons (no. 51 A, B), as well as this panel.

As the lives of saints became more popular, their legends tended to become amplified. In stained glass, these legendary or posthumous miracles were illustrated separately in windows other than those devoted to the actual life of the saint. In Bourges and in Auxerre, the Translation of the Relics of Saint Stephen, all posthumous incidents, are contained in a separate window, and in Canterbury a whole chapel is devoted to the miracles of Saint Thomas Becket (Caviness, 1977, 141–44).

Restorations in this panel have altered its composition but not its content. A fragment of the tops of the heads of two of the clerics can be seen below the left arm of the innkeeper's wife, indicating their original position in the scene, but the figures, as restored—including the bed—are now much larger than they once were, making the ax of the innkeeper appear too small to be the instrument of their death. The story of the three clerics, sometimes known as the three scholars, or the three orphaned boys, is one of the most frequently represented scenes from the life of Saint Nicholas. It concerns a certain innkeeper who was in the habit of killing children, salting their bodies in brine, and then serving the meat to his guests. Three young scholars, or clerics, who were staying at the inn, met a similar fate in their sleep—the scene shown in this panel. Saint Nicholas heard of this murder, went to the inn, and found the dismembered bodies in the brine tub. He then restored the three youths to life. The story is often illustrated as a series of scenes, as in Chartres (Delaporte, 1926, Plates I, pl. LXXIII), Bourges (Cahier and Martin, 1841–44, II, pl. XIII), and, probably, in the window from which this panel came.

The slender figures, the simplified style of the drapery folds, and the narrow border of this panel are all aspects of Burgundian glass that first made their appearance in Auxerre in the mid-1230s and continued into the 1250s. Reminiscent of the Auxerre style are the soft fluid folds that combine both thin and thick brushstrokes, particularly the horizontal pleats on the sleeves of the innkeeper. Such facial features as the heavy brows and turndown mouths also appear in Auxerre, translated from Parisian work—as seen at Gercy about 1230. Perhaps the most telling connection between this panel and Burgundy, however, is its arrangement and ornament. Burgundian windows in Auxerre and later (in the 1250s) at Saint-Julien-du-Sault maintained an early grid formula of window design that repeated rows of three scenes on a mosaic ground. The shapes of the scenes varied, but they were often edged by pearled fillets and connected vertically by foliate bosses. The Pitcairn panel was probably the left-hand panel at the top of such a window, with the story of the three clerics continued

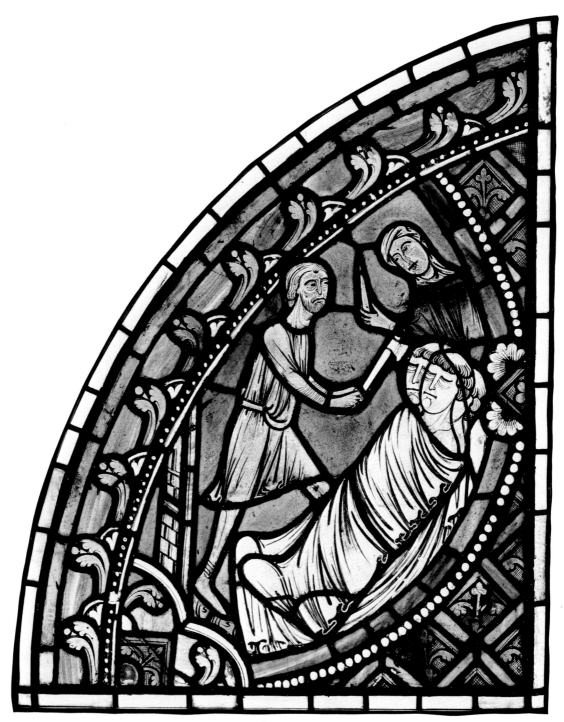

80

in the next two scenes of the row. The small boss near the heads of the clerics is an insertion, but the one below is original. The narrow "broccoli" border was a common type in the second quarter of the thirteenth century, but its Burgundian origin is underscored by the small knob-like bud that pokes from between the leaves; this also appears in the ornament of the Abraham window in Auxerre (Raguin, 1974, fig. 3). Though not attributable to a specific monument, this panel must have been salvaged from a church in Burgundy that was glazed about 1245.

Purchased from Lucien Demotte, Paris, May 14, 1929.

Ex collection: M. Navarre, Auxerre.

Bibliography: Demotte sale cat., 1929, no. 12; Gómez-Moreno, 1968, no. 191.

81. Christ with Apostles, from a Choir Window

France, Parish Church of Saint-Fargeau (Yonne)
About 1250–55
Pot-metal glass
Diameter, 43.2 cm. (17 in.)
03.SG.108

Christ, distinguished by his red, white-crossed nimbus, and wearing a red robe, stands amidst a group of six apostles. The four on the left are dressed in red, yellow, and blue robes with green, red, and yellow nimbi. The two figures on the right have, respectively, a yellow halo with a green robe, and a green nimbus with a red robe and light blue mantle. The background is blue with an edge fillet of red and half-circles of red, blue, and yellow painted ornament at the sides. The missing lower portion of this roundel has been filled with ornament. A piece of blue background was inserted at the edge, near the figures on the left, and there is additional replacement glass below the waist of Christ.

The piece was purchased from Acézat in 1925. It was formerly in the Engel-Gros collection, from which it was sold (together with another fragment from Saint-Fargeau that now belongs to Wellesley College; 1949,19c) in 1922.

The only mention of the windows in situ at the parish church of Saint-Fargeau, located some forty-five kilometers southwest of Auxerre, was a note by Édouard Didron in 1877 (Lafond, 1948, 115–16). In 1878, the parish priest sold all the windows in order to raise funds to repair the church. The glass was apparently sent to Paris, where it remained briefly in the atelier of Alfred Gérente, and was then dispersed. With the exception of the two American panels, most of what is left of the windows from Saint-Fargeau is now in the Musée Ariana in Geneva, acquired in 1891 from the Vincent collection in Constance. The remaining panels all are in fragmentary condition, with evidence of old but incompetent restoration that used original glass as stopgaps to repair missing pieces. According to Lafond (1948, 115–32), who catalogued the Geneva pieces, this restoration probably took place when the windows of the choir at Saint-Fargeau were reinstalled in a new apse that was added to the church in the sixteenth century, and it was there that they were seen by Didron.

On the basis of the Geneva panels, Lafond was able to identify glass from seven different windows, suggesting that the glazing program at Saint-Fargeau was vast. The most extensive remains come from a Passion window, of which there are three identifiable scenes in Geneva, in addition to the Pitcairn panel; the latter is probably a fragment of the Last Supper. The Geneva scenes, more complete than the Pitcairn roundel, indicate the original arrangement of the Passion window. As reconstructed by Lafond, the window adhered to the Burgundian tradition of a grid plan, with continuous rows of three scenes each. Surrounding the window was a narrow border of the broccoli type, similar to, but simpler in design than, that of no. 80. The scenes consisted of circular medallions in the center and somewhat more than half-circles at the sides, framed alike by red bands and pearled edge fillets. Corner bosses filled out the square panels and each scene was joined laterally by yellow, red, and blue painted brooches, two of which are still attached to the sides of the Pitcairn panel, together with a piece of pearled fillet.

Because of its importance in the iconography of Christ's Passion, the Last Supper undoubtedly occupied one of the circular central medallions in the window, but it has since been cut down to some nineteen centimeters less than its original diameter, including the framing fillets. This additional space, however, would have permitted the inclusion of the missing apostles, the table setting, and Judas, in their accustomed places. In its present state, the panel shows four apostles crowded together at the left of Christ and two others seated more comfortably at his right, in space that normally would be occupied by eleven figures. Two more figures probably filled the left area now containing the misplaced piece of blue background. Saint John, a bit of whose yellow mantle is still in place, undoubtedly lay asleep on the tabletop in the repaired area below the bust-length figure of Christ, and two additional apostles were probably shown at the right edge of the panel. Since the entire lower part of the medallion is missing, Judas, usually represented as a diminutive figure in the act of dipping the sop (Matthew 26:23) in front of the table, has been eliminated. The increased space accorded the apostles at the right of Christ was probably designed to give importance to the figure of Peter there. (His facial type is consistent with other examples from Saint-Fargeau [Caviness, 1978, no. 10].)

211

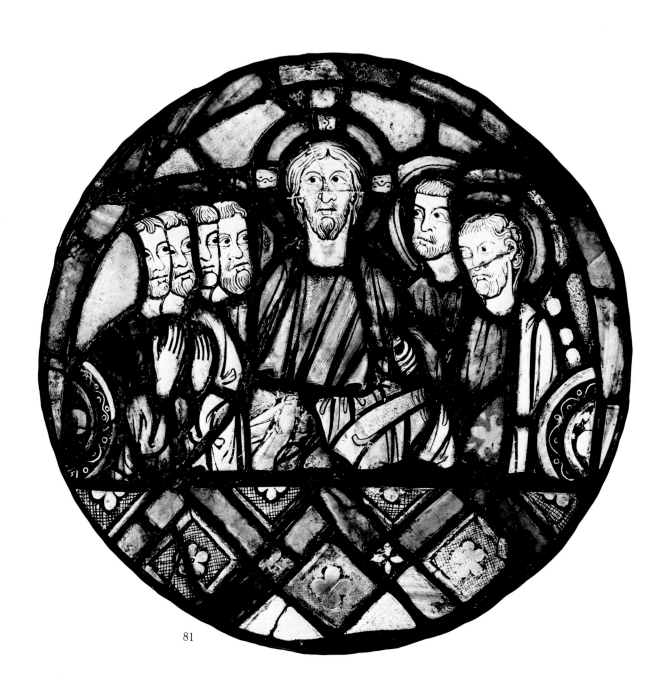

81

A single atelier, directed by a single master, was evidently responsible for the entire glazing program at Saint-Fargeau. Raguin (1982, Chapter IV, section 4) has analyzed the style of this master, as has Lafond. Both have remarked on the simple yet subtle color schemes of his windows and the prominence of a streaked ruby glass, clearly visible in the Pitcairn panel. This, together with a limpid blue and a golden yellow, are the primary colors of his palette, offset with tones of green and yellow. The strong, simply defined heads of this master are generally painted on white glass but the tones of white vary. Christ's head in the Pitcairn panel is cut from yellowish glass, while those of the apostles on the left have a pinkish cast. The head types are very similar in appearance, but there are subtle variations in hairstyles and in the cut of the beards. Saint Peter is distinguished by his close-cropped, curling locks, which are brushed back over his ear. The features of the apostles are characterized by ample noses—broad at the tips, with flared nostrils—and by straight lines to indicate the mouths. The drapery hangs in straight, broad folds, and crumples as it turns back at the wrists. Peculiar to the work of this master is his fondness for grouped figures, as seen in the Pitcairn panel. Monotony is avoided by cutting two heads from the same piece of glass and varying the tones of the flesh, as well as by effecting a rhythmic alternation of the color of the garments.

Raguin has traced the presence of this atelier to several other sites. In her opinion, it originated in Burgundy and first worked at the cathedral of Auxerre in the 1230s. She has christened the head of this atelier the Apocalypse master, after one of his windows there. Perhaps, with a younger painter at the helm, the atelier moved from Auxerre to Saint-Julien-du-Sault in northern Burgundy where, beginning in 1243, it executed three windows, including the Legend of Saint Margaret. Comparisons between the work of the Saint Margaret painter and the Saint-Fargeau glass are striking and undeniable; they provide a probable date for the latter windows. Lafond had suggested a date of about 1250, but Raguin has now determined that 1250–55 is more accurate. Together with the earlier Murder of Three Clerics (no. 80), this panel is an important example of developments in the style of Burgundian stained glass at the middle of the thirteenth century.

Purchased from Michel Acézat, Paris, September 1, 1925.

Ex collection: Engel-Gros, Paris (until 1922).

Bibliography: Engel-Gros sale cat., 1922, no. 7.

82. Grisaille Panel with Zoomorphic Heads, from an Unknown Window

France

About 1270

Grisaille and pot-metal glass

Height, 60.2 cm. (23 $^{11}/_{16}$ in.); width, 37.6 cm. (14 $^{13}/_{16}$ in.)

03.SG.60

A grisaille pattern of acanthus buds and berries on a crosshatched background is entwined by bowed strapwork. Red lions' heads catch the strands of the straps, and blue-trifoliate and yellow-darted fillets overlay the design. This panel is in fair condition, with two modern replacements and several inserts of old glass. Its original pattern, however, is clearly distinguishable.

The panel was purchased from Bacri Frères in 1924, after Lawrence Saint had told the French dealers of Raymond Pitcairn's desire to collect grisaille glass as guides for the glaziers who were designing modern grisaille windows for the cathedral in Bryn Athyn. Two panels with this pattern had appeared earlier the same year in the Heilbronner sale in Paris (Heilbronner, 1924, no. 91), serving as fill below the Angevin figures (no. 64 A, B). The grisaille that filled out all of the figural panels in the Heilbronner collection—transforming them into large, pointed lancet windows—must have been scrapped as worthless and without market value by the dealers who purchased the panels. The glass undoubtedly was carelessly treated, since parts of both Heilbronner panels were leaded together to form this single piece, in which a number of new cracks are present.

The pattern of this panel is distinctive: three separate decorative systems have been superimposed in its design. Overlaying the grisaille patterns are the colored fillets; though they touch the frame of the panel, they do not intersect but remain as separate motifs in the composition. The second element is the strapwork, which curves in two parallel serpentine bands from the top and bottom edges of the panel, is caught by the lions' heads, and then intersects a circle in the middle of the piece. The third element is the leafy vine that begins, independently of the other two systems, as a central vertical stem with parallel branches that curve and sprout leaves beneath the straps. This complex interplay of linear rhythms is characteristic of grisaille in the third quarter of the thirteenth century (Lillich, 1978, 26–29). The decade of the 1260s, as Lillich has observed, was a transitional period for grisaille decoration, a time in which

the entire formula for window glazing was changing. Replacing the earlier, full-color window was the new band window (cf. no. 70), which had two advantages: not only did it let more light into the building, but the enormous expanse of repeated patterns in colorless glass was much cheaper to produce. This emphasis on grisaille encouraged the glass painter to experiment with new patterns and combinations of motifs, and, as in all such experimental phases, old solutions were enhanced by innovations.

As seen in the Pitcairn panel, such traditional elements as the crosshatched ground, acanthus-bud motifs in the foliage, and touches of color, had been employed in grisaille since the beginning of the thirteenth century (Hayward, 1976, 258–62). Yet, the serpentine meanderings of the strapwork and the central stem with foliage growing in one direction mark this piece as transitional, and of the decade of the 1260s. Each area of stained-glass production in France seems to have developed particular patterns and styles of grisaille that varied from window to window.

The circle, as well as the vertical serpentine bands of strapwork in this panel also are found in a grisaille pattern in the choir clerestory at Saint-Urbain in Troyes. In this same window, the vine tendrils branch out from a central stalk and terminate in acanthus buds with berries that are sometimes double and occasionally flower in young leaves. The crosshatched ground is also employed but the angular straps at the sides are colorless, color being reserved for the bosses at the top and bottom of the panel. The date of about 1270 for the glazing of the choir at Saint-Urbain is fairly secure because of the armorials in the windows, and 1270 is equally acceptable, stylistically, for the Pitcairn glass. Although no exact counterpart for this piece can be found at Saint-Urbain, there are similarities in motifs and in the general design that indicate that the Pitcairn panel also came from the Troyes area—noted for its grisaille decoration and for innovations in this type of glazing. Zoomorphic elements were rare in grisaille until the 1280s, when they began to appear in profusion—becoming the dominant motif in the glazing of Saint-Urbain. In the Pitcairn piece their use was hesitant; they occupy those places where, in related grisailles of this type, a cup-shaped boss of color was employed. In other windows at Saint-Urbain, however (Lillich, 1978, fig. 3), this cup-shaped clasp already had been painted with delicate floral motifs. The introduction of lions' heads in the Pitcairn panel, therefore, might be considered an alternative approach to the same design problem.

Purchased from Bacri Frères, Paris, October 30, 1924.

Ex collection: Raoul Heilbronner, Paris (until 1914).

Bibliography: Heilbronner sale cat., 1924, no. 91.

83. Grisaille Panel, from a North Choir Clerestory Window

France, Troyes, Church of Saint-Urbain

About 1270–75

Grisaille and pot-metal glass

Height, 61.6 cm. (24 1/4 in.); width, 66.6 cm. (26 1/4 in.)

03.SG.56H

This grisaille panel, enclosed by pearled fillets at the sides, is composed of diagonal straps, in a diamond-shaped pattern, that cross at a central rosette of yellow glass. In the corners of the piece are quatrefoils outlined in strapwork that are joined by the twisted strap. Centrally located in each of these is a quarry painted with a four-pointed cluster of leaves, surrounded by pink half-circles. Sprays of acanthus buds, some opened and some with berries, grow from the pink bosses. Blue rosettes are centered at the top and bottom edges of the piece. Restorations in this panel are clearly indicated by the grayed tone of the white glass. The upper right-hand quatrefoil is in perfect condition; the other three all have some restoration, and there is considerable loss due to wear in the painted pattern. The pearling is modern.

This is one of a set of ten panels, all of identical design, which were purchased from Bacri Frères in 1923. They came originally from the first bay on the north side of the choir clerestory of the collegiate church of Saint-Urbain in Troyes. Remains of the grisailles still exist in the four-light window there, but most of the originals have been replaced. The windows at Saint-Urbain have been restored many times throughout their history, but most extensively in the nineteenth century, when they were submitted to two drastic campaigns of repairs that are not sufficiently documented in the archives. The first restoration, which began in 1842, though under the direction of the competent art historian Anne François Arnaud, was nevertheless carried out by unknown glaziers who, among other repairs and a general releading of the windows, replaced one panel in the first north bay of the choir. The most extensive restoration took place between 1876 and 1906, in the course of which the upper parts of the nave, which had been left unfinished in the thirteenth century, were finally completed. During this lengthy campaign, Eugène Didron, son of an illustrious restorer (cf. no. 49), and Vincent-Larcher, of questionable ability, were in charge of the stained glass. Neither man survived the long restoration, and the work was finally completed by Anglade between 1902 and 1906. The records are incomplete and it is highly probable that the grisailles, which were less expensive to make anew than to repair, were extensively replaced. Though they sur-

83

vived World War I, they were not even dismounted before the bombardment of World War II—but by that time the Pitcairn panels had long since come to Bryn Athyn.

The church of Saint-Urbain in Troyes was founded in 1262 by Pope Urban IV to honor his birthplace. Unfortunately, the church was hardly begun when the Pope died, and the task of completing the structure fell to his nephew. A disastrous fire in 1266 held up the dedication and necessitated a reorganization of the glazing program. All the grisaille windows probably postdate the fire and it is doubtful whether the side bays of the choir were completed before 1270. The choir and transept were finally opened for services in 1277.

The Pitcairn panel, with its centralized orientation, is atypical of the transitional grisailles that Lillich (1978, 26–29) proposes are related to the decade of the 1260s. There seems to have been a countercurrent to this transitional movement that looked backward to older forms. This counter group, to which the Pitcairn panel belongs, can be said with certainty to date to about 1270. One of its characteristics was the use of a centralized motif organized within a twisted or knotted strap. An early example, of about 1260, comes from one of the side bays at Saint-Martin-aux-Bois, where a knotted strap surrounds stocky acanthus-bud foliage and isolated painted rosettes of the type seen at Saint-Denis (no. 73). That this is an early example of the style is evidenced by the angular pattern of the strap and by the painted rosettes that float on the field. Examples exactly contemporary with the Pitcairn piece are found in the unpainted grisailles in the choir clerestory of Beauvais dated by Michael Cothren (1980, 157) to about 1270, but certainly in place before the fall of the vaults in 1278. The pattern of the knotted or twisted ribbon here is curvilinear. In Troyes, as in the Pitcairn panel, the twisted straps that outline the quatrefoils, while separate from the lozenge-shaped strap that intersects the central rosette, are interlaced by it. The four lateral quarries are placed over the strapwork but the acanthus branches that begin at these quarries pass below the straps, thus setting up an inner tension in the design not seen in earlier work at Saint-Martin. The acanthus buds have begun to open and the cross-hatching is more delicately painted than before, indicating that this example, in spite of its archaic tendencies, was made at the same time, but, perhaps, by a different atelier, as the other transitional grisailles in the clerestory at Saint-Urbain.

Purchased from Bacri Frères, Paris, October 30, 1923.

84. Saint Martin Dividing His Cloak with the Beggar, from an Unknown Window

Western France, possibly Anjou or Tours
About 1250
Pot-metal glass
Height, 66.6 cm. (26 1/4 in.); width, 58.4 cm. (23 in.)
03.SG.162

Saint Martin, riding a white horse with a yellow saddle blanket and a red saddle, wears a light green surcoat, red boots, and a murrey cloak—which he divides with the beggar. The saint's halo is red. The beggar, clothed only in a yellow loincloth, stands before the saint on the murrey and yellow glass that, with the green glass at the left, forms the foreground of the scene. Yellow-and-murrey and red-yellow-and-white trees grow from the tufted ground, against a blue background. The panel, especially the lower part, has been considerably restored, sometimes with old glass—as is the case with the tree in the foreground. The upper part of the saint, his boot, the forepart of the horse, as well as most of the figure of the beggar are original, but there is some evidence of repainting.

This panel was acquired from Bacri Frères in 1935, one of the last purchases made for the Pitcairn collection. Nothing is known of its history, and it can be attributed to the west of France only on stylistic grounds.

Because of Saint Martin's association with Tours—having founded his church there in 370—there is no more-popular saint in the west of France. Saint Martin was elected Bishop of Tours in 371 and when the archdiocese of Tours came to include all of Anjou, Maine, and Brittany, he became its patron saint. Innumerable churches throughout the diocese are consecrated to him. Of all his legends, that of the division of the cloak is the one most often represented. Three cathedral churches in the diocese—Angers, Le Mans, and Tours, itself—each contain the remains of two windows devoted to the saint. It is not surprising, therefore, that an isolated panel of undocumented origin—but depicting a scene from his legend and bearing a strong stylistic relationship to western French glass painting—should appear in the Pitcairn collection.

The division of his cloak with the beggar took place early in the career of Saint Martin, before his conversion to Christianity. The incident is recorded by both of his biographers, Sulpicius Severus in the fifth century and Gregory of Tours in the sixth. Martin was born in Hungary and later became a soldier in the Roman army, serving first in Italy and later in Gaul. In 337, he was stationed in Amiens. One day,

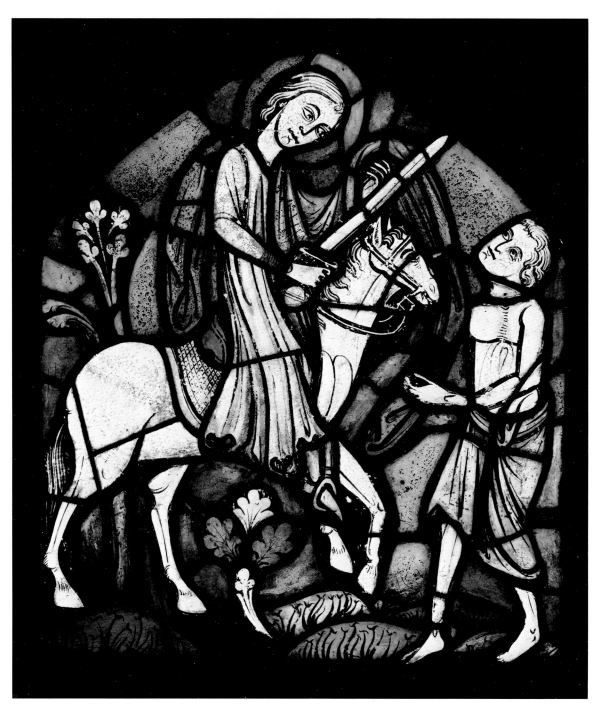

84

during the winter, he noticed a poorly dressed man, shivering with cold, standing at the gate of the town soliciting aid from passersby. Martin took pity on the beggar and, with his sword, cut his military cloak in half, giving a part to the poor man. That night, Christ appeared to Martin in a dream, wearing the cloak and saying, "Martin, though still a novice, you have clothed me." Martin, however, remained in the army until 356—when he was baptized—after which he went to Poitiers, where he studied with the Bishop, Saint Hillary.

The Pitcairn panel could have come from anywhere in western France. Its scale, however, suggests that it was part of a fairly large window. It is hardly likely that the present shape of the panel—which would indicate that it occupied the central portion at the top of a pointed, arched window—is original. The lower portion of the panel is so extensively restored that the scene could have been circular rather than rectangular. Furthermore, since the sequence of scenes usually begins at the bottom of the light and since the Division of the Cloak is an early incident in the Saint Martin story, the scene should have been in the lower portion of the window. This custom was not always observed, however, in the west of France, and both in Angers and in Poitiers windows are often read from the top downward (Hayward and Grodecki, 1966, 21–22). This scene is not divided vertically—an almost unbroken rule in Angers and sometimes in Poitiers (cf. no. 86), but a practice not observed in Le Mans and in Tours.

The simplified drapery and absence of shading in this panel suggest a date of about the middle of the thirteenth century. There is nothing in the painting technique, however, to indicate the influence of the Court Style of Paris, although both Tours and Le Mans were dominated by Parisian influence shortly after mid-century. Angers and Poitiers, on the contrary, developed styles of their own based on their local artistic heritage. It is to the choir windows of Angers that the Pitcairn panel is most closely related. The glazing of this choir spanned the second quarter of the thirteenth century (Hayward and Grodecki, 1966, 33–53). Characteristic of its style is a linear treatment of the drapery, so that it often seems to swing in the air in heavy, ungainly swatches. The features are emphasized by loaded brushstrokes and the noses at times are pinched and pointed like that of the Pitcairn beggar. The heads, also like that of the beggar, are sometimes turned upward and almost appear disjointed at the neck. Anatomical details are quite illogical, as is the neck of the horse and the body of the beggar. Not only did the Angevin painters retain the tiny claw-like hands, such as that of Saint Martin—the beggar's hand is restored—to the very end of the glazing of the choir, almost as a hallmark of their style, but they also perpetuated the spindly fo-

liage, as seen in the tree on the left. The Saint Martin panel, however, in the final analysis, is only a diluted echo of the taut gestures and expressive figures of the Angers Cathedral windows. Perhaps it was painted later, by a glazier trained in the cathedral shop, for one of the many churches in the diocese that still has vestiges of its early glass. It is probably impossible to pinpoint the origin of this panel, but its closest stylistic links seem to be with Anjou.

Purchased from Bacri Frères, Paris, September 13, 1935.

85. The Baptism of Saint Martin, from an Unknown Window

France, possibly Tours
About 1265–75
Pot-metal glass
Height, 68.7 cm. (27 1/16 in.); width, 46 cm.
 (18 1/8 in.)
03.SG.107

A bishop dressed in a white miter, murrey cope, green dalmatic, and yellow and white alb, holds a yellow crosier as he pours a flask of water over the head of the saint. Saint Martin, naked and with his hands clasped in prayer, kneels in the baptismal font, which has a green rim and red and yellow sides. The head of an acolyte is visible behind the left shoulder of the saint. Red and white architectural elements fill the sides of the scene, and the background is blue with painted trefoil designs. The bishop stands on a yellow and white bridge. The shuttle- or vesica-shaped medallion is edged in white and red fillets and the mosaic ground is composed of a red trellis with white quatrefoiled intersections and blue painted quarries. The panel has been heavily restored and some genuine parts, such as the head of the deacon, have been displaced. Replaced areas include the blue painted background (original sections are at the extreme top and bottom of the scene), the tub-like font (the green rim is old), the yellow alb, the green dalmatic, and the feet of the bishop. The most serious loss is the head of Saint Martin, usually shown beardless at the time of his baptism.

The panel was purchased at the sale of the Lawrence collection in New York in 1921 but there is no record as to where Lawrence acquired the piece. On the basis of style, however, the panel may be related to stained glass of the third quarter of the thirteenth century in Tours, located in the diocese of which Martin was titular saint.

Both Sulpicius Severus (ed. Deferrari, 1949, 7) and Gregory of Tours (McDermott, 1949, 24–60) record the baptism of Saint Martin, but there is no mention of who baptized him or where the event took place. He evidently remained in the army for another

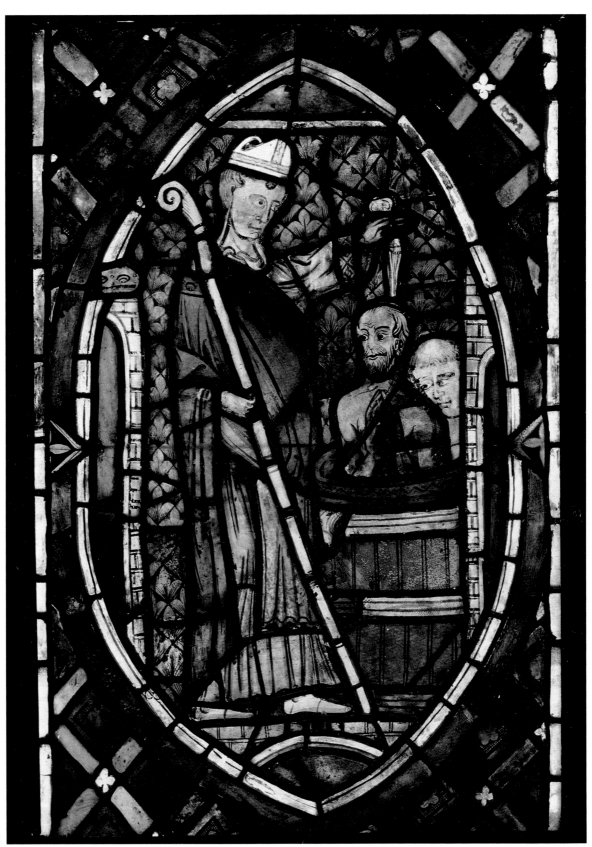

two years before assuming the religious life. This panel repeats the incident in the earlier choir window in Chartres, but there, two additional attendant figures were included. The windows that most closely resemble the Pitcairn panel are two in the cathedral of Tours, in the second ambulatory chapel on the south side, depicting the life and miracles of Saint Martin. In one of them, in which Saint Martin baptizes a convert, the composition is similar to the Pitcairn panel. This window was installed about the middle of the thirteenth century, shortly before the glazing of the clerestory, which contains an extensive cycle of Saint Martin scenes. The window with the scene of the Baptism of Saint Martin, made about 1265, essentially repeats the iconography of the Pitcairn piece. The bishop stands on the left, holding the inverted flask of water over the head of the saint. Martin, with his hands clasped in prayer, kneels in the font. As in Chartres, he is a naked and youthful figure—as he probably originally was in the Pitcairn panel, before the replacement head was added. The font in the Tours scene is chalice shaped, as is the one in the Chartres window. This part of the Pitcairn Baptism has been replaced by a tub-like font, but the circular rim of the original vessel is still in place. The bishop's acolyte stands on the right of the scene in Tours, but only his tonsured head and his neck remain, to the right of Saint Martin, in the Pitcairn piece. The figure once probably occupied the area above, where the architecture has now been inserted. The shuttle-shaped frame of the Pitcairn panel is undoubtedly original but it has been flattened at the sides. It is the same medallion shape that is used in the Saint Martin window in Tours. Linda Papanicolaou (1979, 47–63) has proposed that the iconographic model for this Saint Martin window originated in Tours, as opposed to being imported from Paris. The strong similarity in iconography of the Pitcairn piece and the one in Tours suggests that the former also was of Touraine origin.

Though far cruder in style than the Tours clerestory windows, with their elegant figures, the Pitcairn panel retains certain stylistic characteristics that are related to the Tours Cathedral windows, the most outstanding of which is the pronounced elongation of the bishop. The choir of Tours is a reflection of the Parisian Court Style, to which its own atelier added a marked attenuation of the figures. The Tours style of facial features includes the furrowed brow that is also apparent in the head of the Pitcairn acolyte. It could hardly be suggested, given the amount of restoration in this panel, that its painter had ever worked in Tours Cathedral. Rather, the Pitcairn Baptism appears to represent the style of the cathedral as practiced by a local atelier, perhaps hired to work on small commissions in the province.

It is impossible to determine when this panel left

France or who conducted the brutal restoration to which it was submitted. The painted background, with its design of small trifoliate leaves, is unusual. There are, however, a number of other panels, whose origins can be traced, that have this same background. They are among a miscellaneous collection of French stained glass now installed in the parish church in Wilton, England. The collection, which includes several pieces from Saint-Denis (cf. no. 25), was purchased by the parish priest in 1845. It is Grodecki's opinion (CVMA, 1976, 45–46) that this glass was part of the group removed from the Abbey of Saint-Denis and sold by Alexandre Lenoir and his glass painter Tailleur to the English dealer John Christopher Hampp in 1802–3. Hampp was one of the first of the foreign dealers to buy French glass of all periods, to satisfy the desires of English patrons, in advance of the Gothic revival. Whether Hampp was responsible for the painted backgrounds is impossible to determine, but the presence of this pattern in the Pitcairn panel indicates that the Baptism of Saint Martin came from the same source as the Wilton glass and that at some time in its history it was in England.

Purchased, Lawrence sale, New York, January 28, 1921.

Ex collection: Henry C. Lawrence, New York (until 1921).

Bibliography: Lawrence sale cat., 1921, no. 367, ill.; Gómez-Moreno, 1968, no. 192.

86. The Visitation, from a Clerestory Window

France, Poitiers, Church of Sainte-Radegonde
About 1280
Pot-metal and grisaille glass
Height, 77.5 cm. (30 1/2 in.); width, 60.6 cm. (23 7/8 in.)
03.SG.43

The scene is enclosed by a polylobed frame edged in a white-pearled and a red fillet and cut in half vertically by the central iron of the window. Mary, standing on the left, is dressed in a blue robe and wimple and a yellow mantle. Elizabeth wears a green robe, a white wimple, and a red mantle. The background is blue. The scene is surrounded by an elaborate pattern of grisaille strapwork and acanthus leaves on a crosshatched ground. Attached to the left is a border containing centrally placed green, blue, white, and yellow palmettes, on a red background with blue and white edge fillets. The panel has undergone considerable restoration, both in the scene and in the ornament, and there are a number of stress cracks in the glass, as well. The most noticeable replacement is the head of Mary.

This panel was acquired from Haussaire in Paris, in 1924. In format—including the polygonal shape of the scene, the fillets that surround it, the design

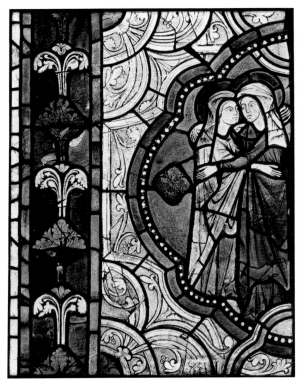

86

ginning with his temptation by the Devil. Since only eight of these scenes could have been accommodated in a single window in Poitiers, the original arrangement of these panels must have involved two windows or one of the twin-light bays. A precedent for two windows of the same composition and ornament still exists at Sainte-Radegonde, in the twin lights of the third bay of the nave (Aubert, 1958, ill. 122) devoted to the life of its patroness. These windows also have grisaille backgrounds and are thought to have been a gift of Alphonse de Poitiers, whose arms appear in the borders and who bequeathed money for windows at his death in 1271. Lillich has suggested an earlier date for these windows—about mid-century—which would agree with the directive in Alphonse's will to "finish" the stained glass (Lillich, 1970, 32, n. 16). The grisaille patterns in the Life of Christ panels and in the Pitcairn piece have a complex pattern of strapwork that follows the undulating frame of the scene, as well as open though still stylized leaves in the foliage. The figure style of the Visitation, with its broad-fold drapery, washes of mat, and summarily drawn features, is related to the Court Style that prevailed in Paris from the mid-1200s onward and that had become distilled in the provinces by the second half of the thirteenth century. It is probable, therefore, that the Pitcairn panel and the other scenes at Sainte-Radegonde comprised one of the windows that were installed after the donation of funds by Alphonse de Poitiers, brother of the king, for the completion of the glazing program, perhaps as late as 1280.

When, and under what circumstances, the Visitation left Sainte-Radegonde can be deduced from the history of the restorations made to the windows and from the iconography of this panel. In 1562, the church was pillaged by the Huguenots, who broke some of the windows, most probably the lowest panels that could be reached from the clerestory passage. The church apparently escaped the destruction of the Revolution, due to local respect for Saint Radegund, whose tomb is in the crypt of the church (Bouralière, 1904, 17). By the 1880s, however, the windows were in serious need of repair, and a general restoration and reorganization of the glass was undertaken by Henri Carot. Carot restored with a heavy hand. Cracked pieces were discarded and new pieces added. Patination on the back of the glass was cleaned off with acid. New panels were made for missing parts. Carot was a clever imitator of medieval painting. He executed two entirely new windows of the Life of Saint Radegund in the style of the original two bays, to complete the glazing of the north wall. In so doing, however, Carot probably found himself with fragmentary remains of more windows than there were bays to accommodate them. For this reason, he must have combined the intact panels from the Infancy of

of the grisaille frame, and even the border—the fragment is the same as the glass now in the lower part of the second bay on the north side of the church of Sainte-Radegonde in Poitiers. These panels are not in their original location, but, currently, they occupy a large, traceried rayonnant window of eight lancets separated by heavy stone mullions. Like the Pitcairn piece, these eight scenes are divided in half vertically, with the images distorted by the thick divisions down the center of the panels. That they were originally set in irons and that a bar in the middle of a scene was normal practice in western French stained glass (cf. no. 64) can be determined by a drawing of one of these panels made by Lawrence Saint in 1911 (Arnold, 1913, pl. XV). Though the specific location of the glass in the church is not mentioned, these eight remaining pieces would have fitted exactly—and must have been installed—in one of the earlier twin-light bays of the nave. These simple, round-arched windows are part of the original construction of the nave at Sainte-Radegonde, dating from the mid-1200s; the rayonnant window was added at the end of the thirteenth century (Bidaut, 1952, 96–117).

The eight scenes still at Sainte-Radegonde are no longer in sequence. The Infancy story is complete from the Nativity to the Flight into Egypt, but two additional scenes—both of which contain old glass—describe incidents from the later life of Christ, be-

Christ and the Public Life of Christ windows into one window of eight scenes. The half-panel of the Visitation, therefore, was unusable, and was probably sold, or retained by Carot in his own collection. Following World War II, during which the windows suffered additional damage (Bidaut, 1952, 113–14), the glass was further consolidated, together with remains from at least three other cycles, in its present location.

While the central iron had necessitated adjustments in the framing of early windows in the west of France—as in the Ascension in Le Mans (Aubert, 1958, pl. IX), where the bar is pushed to the left to allow the Virgin to stand in the center of the scene—the painter of the Infancy window at Sainte-Radegonde made his adjustments in his compositions. In the Flight into Egypt drawn by Saint, Joseph follows rather than leads the donkey, so that only the animal's rear leg, rather than his neck, is cut by the bar. To avoid the awkward placement of the iron in the Visitation scene, both Mary and Elizabeth embrace in the left half of the panel, while the missing right side was probably filled by Elizabeth's house and by landscape. The Visitation and the lost Annunciation were the first two scenes in the otherwise complete, though heavily restored, Infancy cycle at Sainte-Radegonde. (These three lost panels were probably destroyed by the Huguenots.) Carot's original intention may have been to preserve the sequence. However, since two panels depicting the Annunciation—which are obviously by his hand and which duplicate the grisaille framing and the borders of the other scenes—exist in the Pitcairn collection, a change of plan, involving the inclusion of the two original panels from the Public Life of Christ, was probably the reason for ultimately discarding the Visitation.

Purchased from François Haussaire, Paris, January 31, 1924.

see colorplate XII

87. A Group of Canons, from an Ambulatory Chapel Window

France, Sées, Cathedral of Saint-Gervais-et-Saint-Protais (now Notre-Dame)
1270–80
Pot-metal glass
Height, 60 cm. (23 5/8 in.); width, 55.5 cm. (21 7/8 in.)
03.SG.50

The five canons, shown cut off at the waist, face and gesticulate toward the right. They are dressed in blue, green, and brownish-yellow habits with white albs. The background is red and at the sides are borders of yellow quarries and blue glass. The panel is heavily weathered, with some losses of paint, but there are few replacement pieces. A number of

cracks, mended with heavy leads, disfigures the faces of the monks.

There is no record of the purchase of this panel. It was probably acquired early, before such records were kept in Bryn Athyn. Among the dealers from whom Raymond Pitcairn is known to have bought glass in the years before 1920 was Grosvenor Thomas, who had also sold a panel from Sées to the Victoria and Albert Museum in 1909 (Lillich, 1977, 497–500). Given the weathered condition of this piece, it is tempting to believe that it remained in Thomas's collection for some time before being sold. Raymond Pitcairn also purchased Sées glass from Joseph Brummer (cf. nos. 88, 89), but these pieces have all been traced in the records of the collection.

Though the most recent source of this panel is unknown, there is no doubt as to its origin or when it was removed. The panel with the five canons originally came from the cathedral of Sées in southern Normandy, west of Paris. Initially, it was placed in the central bay of the chapel of Saint Augustine, the second radiating chapel on the south side, where it was seen by Guilhermy when he visited Sées and recorded the glass in 1860 (Paris, Bibl. Nat., nouv. acq. fr. 6109, fols. 64–69). In 1880, however, a major restoration was undertaken on the choir of Sées, which involved dismounting the building, stone by stone (Gobillot, 1955, 44). The glaziers in charge of the windows were Steinheil, who made the cartoons, and Leprévost, who repaired the glass. Steinheil died in 1885, leaving the work to Leprévost. The windows were not reinstalled until 1907. The restoration was radical and many panels were not reused; some were in Leprévost's collection at his death (Lafond, 1954, 63–73). Lafond (C.A., 1955) noted that in the lower windows of the chapels most of the figures were half new and that the central bay of the Saint Augustine Chapel was heavily restored. The poor condition and the many breaks in the panel of the canons were probably the reasons for its being replaced with new glass. Leprévost copied the central window again, to fill in the missing scene in the right-hand bay of the chapel, omitting one of the canons and changing the color of the background. Until some time before 1907, therefore, the Pitcairn panel was in Sées, but between then and its purchase its history is unknown.

In medieval art, though there are many single figures of Saint Augustine in all mediums, there are few examples of scenes of the saint's life. A twelfth-century fresco in the church of Saint-Sernin in Toulouse shows the saint giving his rule to two canons but the scene bears no resemblance to the Sées window. In Sées, the scene is divided between the two lights of the bay: Saint Augustine stands on the right, presenting the rule, while the canons stand in attitudes of devotion in the left-hand light. This scene is preceded by one in the left-hand bay showing the

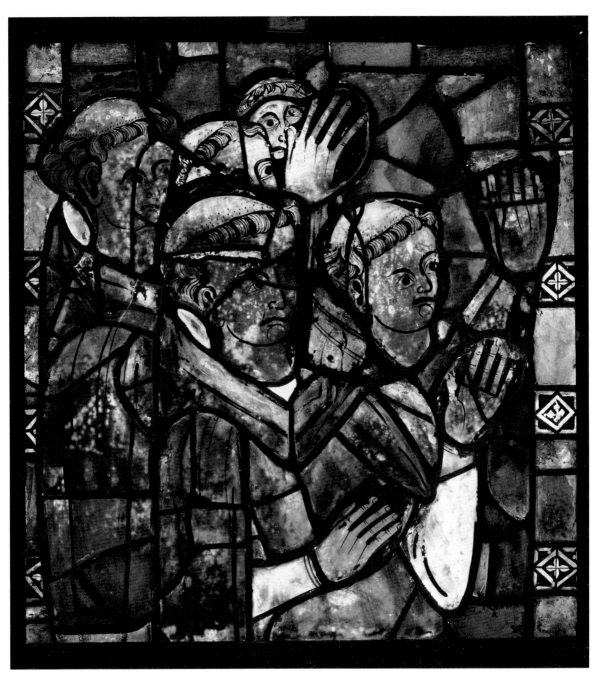

87

saint seated at his writing desk, composing the rule in the right light, with a restored donor figure in the left light. The third scene, in the right-hand bay, is lost. In Sées, the ambulatory windows depict scenes from the legends of the saints to whom the chapels are dedicated. Since the canons in Sées were Augustinian, there was a special reason for devoting a chapel—which contained a window illustrating the giving of the rule—to the founder of the order.

The style of this panel—and of the window from which it comes—marks a change in stained-glass composition that is usually associated with the fourteenth rather than the thirteenth century. Originally, the scene of the canons was composed of two panels, one of which included the lower parts of their figures, with a third panel of canopy work above their heads. Their scale thus was much larger than that of earlier scenes. With Saint Augustine in the other lancet, it was, in fact, the only figural glass in the window. The remainder of the space, above and below the figures, was filled with grisaille. The choir of Sées, glazed between 1270 and 1280, was the first instance of the exclusive use of the band window. The change in scale required a new approach to the concept of the figure and a much broader treatment of form.

Lillich (1978, 69–78) has defined this new style, which prevailed in the west of France, as expressionistic. She has noted, in particular, the bold use of color in Sées, which, because of the increase in the size of the figures, forms larger patches in the window. As shown in the panel of the canons, white plays an important part in the composition and acts as a bridge between the colored scene and the grisaille fill in the bay. The decorative quality of earlier windows thus has been replaced by large, simple forms. The border is a narrow strip of contrasting color at the sides of the panel, ornamented only with widely spaced painted quarries. Detail in the composition is concentrated in the painting of the heads where, as Lafond (C.A., 1955, 65) has remarked, there is a surprising attempt at reality. This is the first glass in the Pitcairn collection in which there was an attempt, in the central figure of the panel, to represent both the pupil and iris of the eye, as well as the stubble of the tonsured heads and individual curls of hair. Only the drawing of the ears, which look very much like shells, is still stylized. The technique of the master who made this panel and the other windows in the ambulatory is much finer than that of most of the painters of western France (cf. no. 95). He was probably trained in Normandy (cf. no. 91), at the end of the thirteenth century, where a new style of superb subtlety and elegance was already developing. The trend toward this new style can be seen in this panel.

Purchased from Grosvenor Thomas, London, before 1920(?).

88. Grisaille Panel with a Fleur-de-Lis Center, from a Chapel Window

France, Sées, Cathedral of Saint-Gervais-et-Saint-Protais (now Notre-Dame)
1270–80
Grisaille and pot-metal glass
Height, 57.5 cm. (22 ⁵/₈ in.); width, 61.9 cm. (24 ³/₈ in.)
03.SG.53

A grisaille pattern of strapwork, with a central quatrefoil partially repeated at the corners, is interlaced by diagonal and circular straps. Underlying the straps are sprays of columbine leaves spreading from a central stem and growing upward. There is a yellow fleur-de-lis on a central blue boss and at the sides of the panel are red borders with yellow painted castles. The condition is excellent, with only two replacements in the grisaille and some wearing away of paint.

The panel was purchased from Joseph Brummer in 1921, together with another (03.SG.54) of the same type but with a design of ivy leaves. Yet another piece, with fig leaves, now in The Cloisters (69.236.10; Houston, 1973–74, 25), was purchased in Paris at the 1969 sale of the Acézat collection.

Each of these panels of glass, which originated in the cathedral of Sées, was recorded by Guilhermy in 1860 as "grisaille, fleurs de lis d'or sur médaillons circulaires d'azur, bordure de gueules à châteaux de Castille d'or" (Paris, Bibl. Nat., nouv. acq. fr. 6109, fols. 64–69). In his description of the glass in Sées, Guilhermy mentioned that these grisailles were in the first radiating chapel on the north side of the choir, which was dedicated to Saint Nicholas. Grisaille panels of this design are still in place there, surrounding the legendary colored glass in the band windows of the chapel, but they are modern. All of the original grisaille panels in the chapels were replaced by modern copies during the restoration of the choir that began in 1880. A few old grisailles of various designs still survive in some of the clerestory windows, but in the extensive restoration program conducted by Leprévost it was probably cheaper to make new pieces than to repair the old glass. Several of the original panels were salvaged from Leprévost's atelier in Paris and catalogued by Lucien Magne (Arch. de la Dir. de l'Arch., "Inventaire," Dossier Vitraux, 1884), inspector general of the Monuments Historiques, and exhibited for a time in the Musée des Monuments Français at the Palais du Trocadéro in Paris, but they are now in storage. Some of the glass at the Trocadéro was published by Jules Roussell (n.d., 3 vols.), but the Sées panels were not among them. The vast majority of the glass not returned to the cathedral after its restoration was bought by dealers.

88

The arms on this panel are the lily of France in the central boss and the castles of Castile in the border. The use of the royal arms in Sées may refer to the fact that Louis IX had given the town to his fifth son, Pierre d'Alençon, in 1268, but this should not be interpreted as a royal donation for the windows. Lafond (C.A., 1955, 59–62) has shown that almost all of the donors of windows in Sées were either members of the Chapter or bishops. There is no evidence of royal patronage. Following the glazing of the Sainte-Chapelle in Paris, where this type of armorial ornament probably originated, its use was widespread throughout France for nearly half a century.

Lillich (1973, 73–75) has called the new approach to the design of grisaille, as shown in this panel, "transitional." The foliage grows upward, or in one direction, as it branches out from the central stem, instead of surrounding the central motif (cf. no. 71), but the most striking transformation here is in the type of foliage represented. In place of the stylized palmettes found in earlier examples, the foliage employed in this panel is readily identifiable as a columbine leaf. Just as the painter of the chapel windows began to represent the faces of the figures in his legendary scenes in a more lifelike manner (cf. no. 87), so also did he begin to differentiate between the botanical species in his ornament. Certain older techniques, such as the crosshatched background, still appear in the panel, but the placement and direction of the foliage is a new characteristic of this style that would continue into the fourteenth century.

Purchased from Joseph Brummer, Paris, March 11, 1921.

89. Grisaille Panel with a Foliate Boss, from a Clerestory Window

France, Sées, Cathedral of Saint-Gervais-et-Saint-Protais (now Notre-Dame)
1270–80
Grisaille and pot-metal glass
Height, 63.8 cm. (25 1/8 in.); width, 61.2 cm. (24 1/8 in.)
03.SG.78

Two vertical branches, from which curving shoots with columbine leaves grow, extend upward at the edges of the panel, on a crosshatched background. The strapwork forms a quatrefoil subscribing a square in the middle of the panel and arcs enclosing rectangles at the corners. At the center of the design is a medallion of yellow glass surrounded by a red fillet painted in a palmette design, from which four blue strawberry leaves project at right angles. The lateral

stems of the grisaille are repeated in the border, in the oak leaves of blue and yellow set on a red field. This is a rare example of stained glass with no replacements. Except for some cracks and discoloration due to corrosion, it is in perfect condition.

Together with another piece of the same design (03.SG.48), this panel was acquired from Joseph Brummer in 1921. The glass was removed from the cathedral of Sées by Leprévost during the restoration of the choir that began in 1880, and was probably sold by him after it had served as a model for new glass. Original glass, close in design to these pieces except that the colors of the central medallion are reversed, still survives in fragmentary condition in one of the transept clerestory bays. An exact duplicate of the Pitcairn pattern is now reproduced in modern glass in the second bay on the south side of the axial chapel in Sées. Another pattern, of which there are a few original sections remaining in the axial chapel, is now represented by four pieces in The Corning Museum of Glass.

Though more complex in its design, the Pitcairn panel, like the previous example, is transitional in type. The stems appear at the edges of the piece instead of in the center, but the branches grow in one direction. The painting style is very delicate, with the veins in the leaves indicated by hair-thin lines. The leaf scars are marked where the stems join the vine. Sometimes the leaves are shown in profile, and, frequently, their stems pass in front of the vine, creating an impression of three dimensionality. The cross-hatching is so fine that it has a tonal effect. The variety and naturalism of the leaves suggest that this grisaille was made near the end of the choir glazing in 1280, rather than at the beginning of the program. Lafond (1953, 350, n. 1) has proposed that the clerestory windows of Sées were glazed before those of the chapels, and the extreme delicacy of its execution signifies that this panel was probably made for one of the lower windows, perhaps the bay in the Lady Chapel where its modern counterpart is located. An unusual feature is the fact that the lateral stems seem to grow from a root-like base at the lower corners of the design. This does not appear in the other grisaille of the same pattern. Was this, perhaps, the first panel in the lancet, and, thus, a display of the ultimate naturalistic subtlety on the part of the painter? The rich, coloristic effect of this panel still represents the taste of the thirteenth century, but the flawless delicacy of technique and the observation of nature revealed by its design places this piece very close to Norman glass of the fourteenth century (cf. no. 93).

Purchased from Joseph Brummer, Paris, March 11, 1921.

89

90. Grisaille Panel, from a Chapter House Window

England, Salisbury, Cathedral Church of Saint Mary
1280–90
Grisaille and pot-metal glass
Height, 85.1 cm. (33 1/2 in.); width, 52.7 cm.
(20 3/4 in.)
03.SG.218

A grisaille pattern of acanthus palmettes on an un-painted ground follows the form of alternating vesica-shaped and circular medallions, edged, respectively, in red and green fillets with painted grisaille borders. Bosses of red and yellow are centrally located in the medallions and, laterally, on the edges of the frame. The grisaille foliage seems to originate in the blue and green palmette at the bottom of the central medallion. Half-circles at the edges of the piece intersect the painted grisaille borders of the medallions. The panel is in good condition, except for replacements at the sides; the edge fillets are modern.

This was the first work of medieval art to be purchased by Raymond Pitcairn. The panel was acquired from Grosvenor Thomas of London in 1916, its provenance given as Salisbury Cathedral. It was also the only piece in the Pitcairn collection ever to be employed in the cathedral at Bryn Athyn. Shortly after its purchase, Winfred Hyatt used the panel as a model for one of the grisaille windows on the south side of the Bryn Athyn nave, incorporating the medieval glass into the design. The panel remained in the window for a number of years, but was later returned to the collection and a copy installed in its place.

The pattern of the grisaille window in Salisbury from which this panel came was published between 1841 and 1844 by Cahier and Martin (II, pl. E, 2)—together with the design of its original border, which was composed of palmettes on a blue background—but without any reference to where in the cathedral the window was located. Cahier and Martin had made their engravings from the earlier drawings of Edward Jones, who was connected with the porcelain factory at Choisy-le-Roi. Westlake (1881, I, 136–45) refers to the grisailles published by Cahier and Martin, stating that they came from the cathedral and its chapter house, but he also infers that no old glass was left in the latter structure. This is confirmed by Winston's statement (1847, I, 41) that the original windows of the chapter house had been replaced. In fact, Winston had made color tracings of the glass as it was being removed in the 1830s. Recent research by Pamela Z. Blum (1978) has not only documented the original appearance of the chapter house windows but also their removal. According to her studies, though the chapter house windows, unlike those in the cathedral,

escaped destruction during the Reformation, they were severely damaged during the civil wars in the 1640s. Patched with clear glass, they remained in place, however, for two more centuries. Beginning in 1820, and continuing until 1840, the chapter house windows were systematically removed. Winston made his tracings at that time, but most of the glass was either broken up, sold to dealers, or stored away in the attic of the chapter house, to be used later in the south transept and in the Lady Chapel of the cathedral. The only record of the windows *in situ* is a series of drawings made in 1802 by John Carter. On folio 12 (fig. 37) of Carter's sketchbook is the drawing of the northwest angle window, showing the Pitcairn panel. A modern copy of the design, made during the restoration of the 1860s under John Birnie Philip, now fills the bay.

The chapter house in Salisbury was begun in 1279 and its windows probably installed in the decade of the 1280s. According to Blum's reconstruction of the windows of the octagonal building, each four-lancet bay was filled with a different grisaille pattern. A horizontal register of colored heraldic shields continued in all eight windows, with figural medallions in the quatrefoils and rosettes in the tracery lights above. The Pitcairn panel is indicative of the type of grisaille used in Salisbury, and of English decorative glazing in general, during the last quarter of the thirteenth century, as opposed to the type developed in France (cf. nos. 88, 89). Westlake (1881, I, 136–40), still the only one to have analyzed the style, pointed to certain features, all of which are present in the Pitcairn piece. Characteristics include the overlapping of motifs, which, in the Pitcairn panel, is indicated by the central vesica that interrupts the circular forms at the top and bottom of the piece. In French glass, one system of ornament, such as the strapwork, frequently overlays another (the foliage), but there is never evidence of overlapped elements. The strapwork, an indispensable feature of French grisailles, is absent in the Salisbury glass. Like the Pitcairn piece, the design is composed in medallions. Cross-hatching, reluctantly abandoned in France, had already been given up in Salisbury by the 1270s, but the Pitcairn panel still employs the palmette that was considered old-fashioned in Sées by 1180. A striking difference between the Salisbury and French glass is the manner in which the foliage is treated within the design. In French windows, the foliage is independent of the confines of the strapwork, and grows from a central stem. In the Salisbury panel, it is confined within the frames of the medallions, and branches out directly from the green palmette at the base of the vesica. Broad, ornamental borders, as seen in the medallions in the Pitcairn panel, were eliminated in France by the middle of the twelfth century (cf. CVMA, 1976, ill. 187). The "disappearing" pearls that frame the vesica are a frequent motif in England,

90

37. John Carter. Folio 12 from a sketchbook, showing details of the northwest angle window of the chapter house, Cathedral Church of Saint Mary, Salisbury. 1802. The British Library, London (Add. ms. 29939, fol. 82)

seen also at Stanton Harcourt (Winston, 1847, I, 52). Westlake has suggested (1881, I, 140) that the overlapping motifs in Salisbury signify a late date for the chapter house glass, while admitting a stylistic resemblance to the windows of the parish churches at Selling (Winston, 1847, I, pl. 8) and Stanton Harcourt (Newton, CVMA, 1979, 183, pl. 43 f). Neither of the windows in these latter churches displays the overlapping present in the Pitcairn piece, but, in both, the vesica-shaped frames, confinement of the foliage, palmette type of leaf, and the growth originating from a colored boss at the bottom of the medallion indicate that all three windows are from a common design family. Peter Newton has dated the Stanton Harcourt glass before 1280, and the Selling date is still in doubt. Thus, the Pitcairn panel, more advanced in style, probably was made well into the decade of the 1280s. This would conform to the dating of the architecture, which was based on the finding of pennies from the reign of Edward I—first minted in 1279—below the foundation of the chapter house.

Purchased from Grosvenor Thomas, London, August 4, 1916.

Bibliography: Cahier and Martin, 1841–44, II, Grisailles, pl. E, 2; Thomas, 1913, II, no. 3, pl. 1.

91. Two Half-Length Figures

France, Normandy, Jumièges(?)
Second quarter of the 14th century
Pot-metal glass and silver stain

(A) **Donor**(?)
 Height, 59.5 cm. (23 7/16 in.); width, 34.2 cm. (13 7/16 in.)
 03.SG.23

(B) **Prophet**
 Height, 59.9 cm. (23 9/16 in.); width, 34.6 cm. (13 5/8 in.)
 03.SG.24

(A) This lancet contains a half-length male figure who wears a brown cowl, murrey cloak, and green robe. His hair and closely cropped beard have been stained yellow with silver oxide. A gauze-like, translucent bonnet cradles the back of his head, covering half of his ear. In his right hand, he holds a phylactery with the inscription SA JOHAN:NES:DIC ✝ in silver stain and grisaille paint. The ground immediately behind and arching above the figure is blue damascene. A yellow rosette floats on red glass in the upper part of the lancet. White fillets frame the entire panel.

(B) This panel also contains a half-length male figure, here dressed in a green robe and a yellow mantle with a white cap. His flesh is colored with silver stain and his hair and beard are white. A phylactery, inscribed SANCTUS: JACOBUS, extends in a diagonal across his garments, at the lower right. The arched background immediately behind and above the figure is red damascene. A yellow quatrefoil is set in the point of the lancet above, on a blue background. As with the previous piece, two white fillets at the sides and one at the bottom frame the panel.

Raymond Pitcairn purchased these two panels as one lot in the January 1921 sale of the Lawrence collection in New York (Lawrence sale cat., no. 360). Nothing certain is known about their provenance, but a close examination of the panels themselves provides a few clues. To say, simply, that they have been heavily restored would not suffice to characterize their current condition. Many of the elements of the panels are actually authentic; it is their compositions that are not. In their present state, these lancets are composed of fragments of medieval glass from two distinct periods, and probably from two different locations, as well as modern-glass fillers and stopgaps. They have been combined, probably by a dealer, to create ensembles that would be more attractive to a prospective buyer than would a series of fragments.

The core of each panel is a fourteenth-century figure. Inscribed phylacteries, concocted of scrubbed and repainted old glass and a single stopgap, were

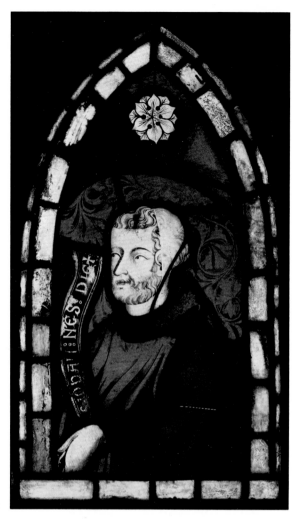

91(A)

attention is paid to the modeling of forms. Lines are of varying thicknesses and intensities. Details are rendered not only by applying paint to the blank glass, but also by removing it from a painted field, which creates a white line against a dark ground—especially noticeable in the hair and beards. This stick-lighting technique is also used to effect the spiraling foliate pattern of the damascene grounds. By using silver stain on the faces of both figures, the artist was able to create two colors on a single piece of glass. Unlike brownish grisaille paint—which modulates the flow of light through the glass but does not, itself, provide or alter the color—silver-oxide stain (i.e., silver sulfate or silver chloride, suspended in a medium of clay or ocher) penetrates the fabric of the glass itself as it is fired, staining it with a transparent yellow or golden pigment (Lafond, 1943). The technical mastery of this new medium, developed or rediscovered by French glass painters about 1310 (Lafond, 1954–55), reached a level of astounding virtuosity in the hands of the artist of the Pitcairn figures. Lighter areas were reserved in the yellow-stained flesh to help model one of the faces (panel B), while a careful control over the intensity of stain in the other panel is as instrumental as the manipulation of delicate grisaille washes in achieving the magical translucency of the bonnet.

On the basis of their technical sophistication, as well as the dry refinement of their style, the Pitcairn panels can be associated with a well-defined group of windows produced by an atelier active in Normandy from about 1310 to 1340. Lafond (1954, 191–209; *idem*, 1955; *idem*, CVMA, 1970, 43–45), who has examined this group most thoroughly, has suggested that the shop may have been centered in Rouen, exporting windows to other sites, such as Évreux and Jumièges. He has further argued that the style of this atelier reflected Parisian art of the same period.

Each characteristic of the Pitcairn figures has an almost exact counterpart in the work of this shop. Stick-lighted damascene grounds appear regularly, the closest parallels being those in the Évreux clerestory and in the chapel windows of Saint-Ouen in Rouen (CVMA, 1970, pl. 10). The head of the figure in panel (A), with its translucent bonnet, angularly defined features, heavy jaw, and impeccably straight hairline, is similar to the head of a donor in the axial chapel of the cathedral of Rouen (Lafond, 1954, pl. XL), as well as to several figures among the chapel narratives at Saint-Ouen (CVMA, 1970, pls. 13, 19, 48). The unusual yellow flesh, as well as the knitted brow, wildly curling hair, and bifurcated beard of the other Pitcairn figure (panel B) is matched by the head of the Baptist in the axial clerestory window in Évreux, in the standing prophets from Saint-Ouen (CVMA, 1970, 184) and Jumièges (Lafond, 1954, 273), and in the proconsul in the Saint Andrew window at Saint-Ouen (Lafond, 1962, 249, colorplate).

added to the figures. The apparent iconographic naïveté of these additions provides further evidence that the lancets are modern assemblages. An Old Testament prophet (panel B) is identified as Saint James and a bearded figure (panel A) as Saint John. Portions of the original damascene ground were maintained around both figures, and an intact fragment of thirteenth-century ornamental glass set in its original leads was incorporated to create a pointed lancet shape for the top of panel (B). Since a comparable fragment was not available for the top of the companion panel, a counterpart was composed of old and new glass, and the double white fillet was extended around both pieces. Because these panels are instructive examples of the sort of confections often created by dealers to render fragmentary panels more palatable to their customers, they have been exhibited here in full, rather than with the extraneous portions masked out.

For the history of medieval stained glass, however, the most interesting component of each panel is the figure. The elegant, if somewhat dry, faces are painted with extraordinary precision. Considerable

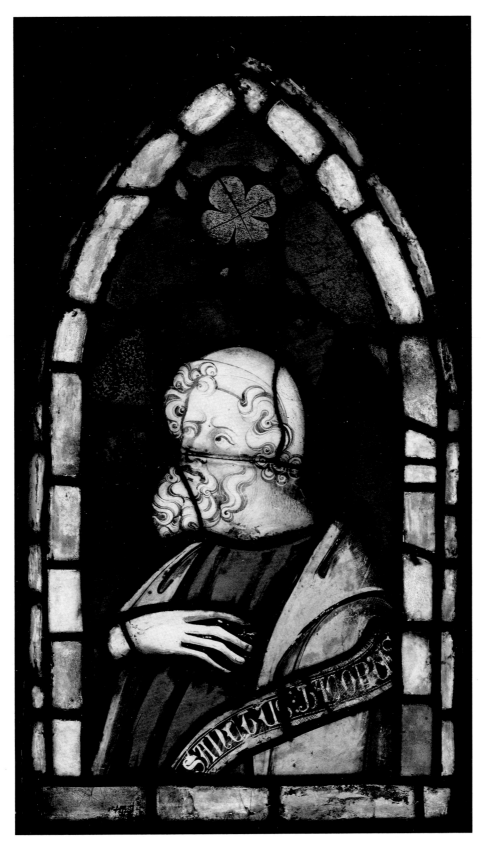

91 (B)

Since it allowed for white hair at the same time that it produced the necessary contrast between hair and flesh, this curious yellow-skinned type seems to have been reserved for figures of advanced age. The style of cap in panel (B) is used with equal discrimination, most frequently appearing on the heads of Old Testament figures, especially prophets (CVMA, 1970, pls. 24, 65). Even the contrast in the Pitcairn figures between the meticulous rendering of faces and the more summary, at times even crude, articulation of drapery and hands is a feature characteristic of this Norman group.

Having established a Norman provenance for the Pitcairn figures, it now may be possible to associate them with a specific site. None of the windows created by the Norman workshop for the Virgin Chapel of the powerful Norman Abbey of Jumièges, under construction after 1325—or for the church of Saint-Pierre in Jumièges, almost completely rebuilt after 1332—remains *in situ*. Although it is not known how and when the windows were removed from their original location (both churches are now in ruins), a few fragments have survived from what was once an elaborate program of standing figures, made for one or both of these architectural additions. The parish church of Saint-Valentin in Jumièges contains fragments of ornamental glass. Six figures and additional ornament from Jumièges once filled the windows of the sixteenth-century chapel of La Mailleraye, until a bomb in 1942 pulverized some of the glass and severely damaged what it did not destroy (Lafond, in Jouen, 1954; Lafond, 1955). Similarities in type and the equivalence of scale make it likely that the Pitcairn panels were once part of this fourteenth-century glazing.

Four of the figures at La Mailleraye were part of a twenty-four figure *Credo prophétique* in Jumièges. In this popular fourteenth-century iconographic scheme, apostles holding phylacteries with phrases from the Christian creed were juxtaposed with prophets who held citations from Old Testament prophecies, in a typological arrangement (Mâle, 1925, 251–53). If it were initially a full-length figure, the Pitcairn Prophet (panel B) would have fit into such a program. In fact, the position of his inserted, identifying phylactery may have taken the place of his prophetic scroll. The figure then would have been similar in design to that of Amos at La Mailleraye (Lafond, in Jouen, 1954, fig. 5), whose upward look of inspiration is equivalent to that of the Pitcairn Prophet.

The incorporation of the other Pitcairn figure into the glazing of Jumièges is more problematical. His bonnet and costume preclude his identification as either prophet or apostle, since they were dressed differently in the work of this Norman shop. This type is generally used for auxiliary figures, and it is possible, based on its use for the donor in the Virgin

Chapel in Rouen, that costume and coiffure reflect contemporary fashion. Is it not possible that the Pitcairn figure was also a donor—perhaps a monk from Jumièges, as suggested by his cowl?

Although it is regrettable that all of the glass from Jumièges has been divorced from its original context, if the Pitcairn panels preserve figures from the glazing of this Norman abbey, it was a fortunate circumstance that placed them securely in Bryn Athyn in 1942, when the panels at La Mailleraye were almost totally destroyed.

M. W. C.

Purchased, Lawrence sale, New York, January 28, 1921.
Ex collection: Henry C. Lawrence, New York (until 1921).
Bibliography: Lawrence sale cat., 1921, no. 360, ill.

see colorplate XIII

92. Fragment of a Border, from a Grisaille Window

France, Sens, Cathedral of Saint-Étienne
About 1310–20
Pot-metal glass
Height, 63 cm. (24 $^{13}/_{16}$ in.); width, 15.6 cm. (6 $^{1}/_{8}$ in.)
03.SG.146

This was once part of an extraordinarily delicate border whose design was based on an organically conceived, ascending vine placed against a streaky red ground. Sprigs with three leaves branching out from a continuous stem are reserved on alternating pieces of emerald green and golden yellow glass. A red fillet parallels the main stem on what was the inner edge of the border. A blue fillet and a white breaking fillet form the outside boundary at the left. The lower of the two green sprigs, one piece of each of the yellow leaves, and portions of the breaking fillet are modern replacements. These restorations can be easily distinguished by the quality of the glass itself and by the bland, measured definition of the foliage, as compared to the spontaneity and liveliness of the fourteenth-century painting.

Raymond Pitcairn purchased this panel in 1921 from Joseph Brummer. Nothing further is known about the fragment's modern history, but it can be identified with a border framing two lancets of grisaille in the first clerestory window from the west, on the north side of the nave of Sens Cathedral. Best known as an Early Gothic church of the second half of the twelfth century, Sens has undergone numerous restorations in the course of its eight-hundred-year history. One of these, involving the enlargement of the clerestory, reconstruction of the southwest tower

(which fell in 1268), and construction of a new western terminal wall, occurred during the thirteenth and fourteenth centuries (Kurmann and von Winterfeld, 1977). The Pitcairn fragment was produced in the course of this extended campaign. Although there is little written documentation of the progression of this restoration, Archbishop Étienne Becquart's donation of money for the construction of two bays of the nave clerestory, recorded in 1308 (Porée, 1907, 567), provides a possible *terminus post quem* for dating the Pitcairn panel. The style of the border is consistent with an early-fourteenth-century date. Although the design is similar to borders in the ambulatory of Saint-Ouen in Rouen (CVMA, 1970; bays 33, 36) from about 1330, the absence of silver stain in the Sens border, the vigorousness of its painting, and the saturated quality of its color argue for a somewhat earlier date.

There is, however, a significant difference between the border, as it is currently installed in Sens, and the Pitcairn fragment. The framing design is simpler in Sens, and neither of the colored fillets flanking the vine in the Pitcairn panel is present. In their place are two white fillets, obviously later additions in modern glass. The authenticity of the arrangement in the Pitcairn panel is confirmed by the even patination of the exterior surface and by the presence of a revealing strip of corrosion, which runs across the bottom of the entire piece, traversing each fillet, the vine, and a portion of the red ground.

It is curious that the fourteenth-century borders in Sens frame grisaille panels whose centripetal patterns, hatched grounds, and stylized foliage indicate a date just before the middle of the thirteenth century. (For the dating of grisaille, see Lillich, 1972; *idem*, 1973.) It is possible that this juxtaposition was created by a fourteenth-century shop, but the extensive restorations in, and alterations to, the border, as well as the appearance of one totally modern panel of grisaille, suggest that a more recent campaign was responsible for creating this composite window. A controversial restoration at the middle of the nineteenth century, notorious for its destruction of the fourteenth-century chapels in the nave aisles (Chartraire, 1928, 35), provides a possible occasion for the extraction of this fragment, the alteration of the remaining border, and its combination with earlier grisaille. This hypothesis can be confirmed only after a careful study of archival documentation and of the actual glass in Sens, but it is the existence of this exquisite Pitcairn fragment, preserving as it does the primitive design of the fourteenth-century border from Sens, which has formulated the questions.

M. W. C.

Purchased from Joseph Brummer, Paris, March 11, 1921.

92

235

93. Grisaille Panel with the Head of a King, from an Unknown Window

France, Normandy, Rouen(?)
About 1330–40
Grisaille and pot-metal glass with silver stain
Height, 65.8 cm. (25 7/8 in.); width, 51.8 cm.
(20 3/8 in.)
03.SG.228

In the center of a panel of grisaille glass is a roundel containing the head of a king in grisaille and silver stain on a red background. The panel is composed of diamond-shaped quarries, outlined in painted and silver-stained strapwork, in which tendrils with oak leaves and acorns branch out from a central stem. At the base of this central trunk is a bird. The foliage and the bird are painted and silver stained. A few of the quarries have been replaced but the design of the foliage has not been significantly altered. The head of the king is an insertion.

This panel was bought from Joseph Brummer in 1921, together with another panel of the same oak-leaf design in the quarries, but with the head of a bishop on a blue ground in the center (03.SG.143) and uninhabited foliage. There is no indication of provenance for either of these pieces, nor can they be traced to any known monument.

The final stage in the development of decorative grisaille glass is represented by this fourteenth-century panel, in which the elegant geometry of thirteenth-century strapwork has been regularized into a simple, evenly spaced trellis outlining the quarries. The central stem that supports the foliage has been maintained but the leaves themselves are much more delicately drawn, with hardly any mat painting. Instead, their forms are defined by silver stain as is the trellis. Clearly evidenced in this panel is an increased interest in nature, both in the clusters of oak leaves and acorns and in the bird that closely resembles a sparrow. Lafond (CVMA, 1970, 39–42) has compared the grisaille ornament of the fourteenth century to the new style of book illumination initiated in Paris in the first quarter of the century by Jean Pucelle. The exquisitely drawn animals and grotesques that inhabit the foliate borders of Pucelle's miniatures and those of his followers probably influenced their appearance in the grisailles and canopy work of stained-glass windows. The grisaille field of the band window, with its strip of colored scenes, is nothing more than the vellum page, with its painted miniature and decorative frame, in giant scale. The color of silver stain ranged from pale yellow to deep amber, making possible the naturalism of fourteenth-century grisaille, so close to the refined style of the miniature, with its touches of gold leaf. Even on the vast field of a window, the sparkle of the silver stain permitted the design to

"read," in spite of its great distance from the spectator and the delicacy of the painting.

Inhabited grisailles were rare but not unknown in the fourteenth century. Among the panels from which Lisch made his tracings—supposedly from Saint-Denis, but more likely among the Parisian debris returned to the abbey after the close of Lenoir's museum (cf. nos. 26, 29)—is one with a trellis of quarries and foliage, and a hybrid monster in the center (fig. 38). Far closer to the Pitcairn panel in style, however, is a piece of grisaille that has been used as a stopgap in one of the lobes of a rosette in the tracery of the choir clerestory at the church of Saint-Ouen in Rouen, completed by 1339 (CVMA, 1970, pl. 59, 238–40). The panel, originally a rectangle with a pearled border, has regular quarried strapwork with fig-leaf foliage sprouting from a serpentine stem. The unusual feature of the piece, however, is that the scrollwork is inhabited by all manner of creatures, both animal and fantastic. Among them is a bird, crested like a jay, but the drawing of its plumage and the angle of its beak bear a close stylistic relationship to the bird in the Pitcairn piece. Lafond

38. Just Lisch. Tracing of an inhabited grisaille window, possibly from Rouen. About 1849. Archives de la Direction de l'Architecture, Paris

93

(CVMA, 1970, 194) has suggested that this panel, more precious in style than the grisailles made for Saint-Ouen, was reused from a domestic building. Very little is known about domestic windows of the fourteenth century but there is ample documentary evidence to prove their existence in the luxurious dwellings of the nobility. The kings of France maintained a château in Rouen and there were other palatial residences, as well. The fineness of detail in the Rouen panel, also observable in the one from Bryn Athyn, indicates that their placement in a window at a distance from the spectator did not present a problem. There is an intimacy of scale in both these examples that suggests that they originated in a window of modest proportions. The center boss in the Rouen panel is filled by a human-headed monster with a club and a shield, surrounded by a fillet and a painted border, as are all the other bosses in Rouen. The king in the Pitcairn panel has no framing and is awkwardly placed in its allotted space. Though the style of the head, with its arbitrary drawing and impossibly lofty crown (which must be a replacement, added onto the original fragment that still rests upon the king's head) is not unlike that of the Thomas Becket window at Saint-Ouen, it must have been inserted in place of the original boss. Bosses in grisaille panels, particularly if they contained figural subjects, were often extracted and sold as roundels while the grisaille background was considered worthless. This is probably what happened to the two Pitcairn pieces; the heads were added before the glass left Rouen to make the panels salable items. Like the panel at Saint-Ouen, which has been dated within the first half of the fourteenth century, a comparable date of about 1330–40 would also be acceptable for the Pitcairn grisailles.

Purchased from Joseph Brummer, Paris, March 11, 1921.

94. Madonna and Child

Eastern France, attributed to Lorraine
Second quarter of the 14th century
Polychromed oak
Height, 73.7 cm. (29 in.); width, 24 cm. (9 7/16 in.); depth, 19 cm. (7 1/2 in.)
12.SP.14

The Madonna wears a long, simple gown, covered at the sides by a mantle that falls over her shoulders in multiple folds extending nearly to her feet. A tasseled button at each side of the mantle connects it with the cord that is suspended in a deep curve across the Madonna's breast. Her veil is held in place by a decorated crown. A narrow, ornamented belt gathers in the folds of her gown at the waist and hangs down, following the fall and downward curve of the drapery folds. The folds about the Madonna's feet bend laterally as they touch the ground, and her feet emerge from these folds while resting upon some of them. The Christ Child is seated in the angle formed by the Madonna's left arm and hand. He turns to look at his mother while he pulls at a cluster of the folds of her veil. The Child's hair is carved in short tight curls, while the Madonna's hair, visible beneath the veil, is rendered in looser, more open ones.

The principal losses are the Madonna's right hand and the Child's lower left arm and hand; they were carved separately and doweled in place. A remnant of the cross-peg used to secure the Child's arm is still evident. The central prong of the Madonna's crown is missing, and there is a break in the curved ridge of the cord of her mantle. The sculpture seems to have been spared any recent recutting. The base, carved in the same block as the figure of the Madonna, though abraded, is original, as is the deep hollow opening at the back of the sculpture, but the two iron clamps placed across it are recent. A hole at the top of the Madonna's head originally aided the sculptor in holding the block of wood in place while he worked.

There are substantial traces of color of an undetermined date. The gown is orange-red. The mantle is pale blue, with areas of a whitish gray from a late repainting. The Child's long tunic is gray, although originally it may have been white. The faces of both figures are painted in flesh tones (now darkened), with pink cheeks and orange-red lips. The pupils and eyebrows of the Madonna are black.

The subject of this sculpture was, indeed, a frequent one in fourteenth-century French, German, and Netherlandish regions, and its widespread popularity as a votive image developed out of the intensity of belief in the cult of the Virgin at that time. Very few of these sculptures are preserved in the locations for which they were originally made, whether a parish church, a great cathedral, an aristocratic oratory, or a monastic chapel. Isolated Madonnas intended for veneration in the open air, as at remote crossroad shrines or at town gateways, have virtually vanished. Therefore, the preponderance of preserved examples—including the Pitcairn Madonna—are without any historical clues as to their provenances, those responsible for commissioning them, and their original settings.

In its general form, the Pitcairn Madonna is similar to several other French fourteenth-century Madonnas. The S-curve and contrapposto stance, with the weight of the larger figure borne on one leg—

which is completely hidden in the enveloping drapery—are characteristic of such sculptures from many different regions. The hip thrust outward to support the Child, the curvilinear meanderings of the cascading edges of the drapery, and the fall of the multiple folds about the feet are features shared by a number of other related sculptures, as is the depiction of the Madonna's long belt, or girdle, with its series of rosettes alternating with crossbars in the manner of actual examples preserved in Cleveland, New York, and Vienna (Fingerlin, 1971, 334–38, nos. 66, 477–478, 547; *The Secular Spirit*, 1975, 77, 279, no. 82).

The diffusion of the traditions of the Île-de-France, with regard to the various types, styles, and even the details of such sculptures of the Madonna, is only one mode of understanding them. Focusing on particularized types, stylistic peculiarities, and distinctive characteristics is another approach, which has been perfected since the 1930s. This second method has allowed for the identification of provincial or broad regional styles and groupings (for bibl., see Wixom, *BCMA*, 1974, 347, n. 9).

It is within one of these regional styles, infused, however, with the conventions of the Île-de-France, that the Pitcairn Madonna may be assigned a natural home—namely, in a portion of Lorraine, in eastern France. This attribution is only possible because of the publication of so many Lorraine sculptures by William H. Forsyth (1936) and J. Adolph Schmoll gen. Eisenwerth (1962; *Aachener Kunstblätter*, 1965; 1969; 1970–72). The proportions, details of drapery, and the physiognomy ally the Pitcairn Madonna with six standing figures in stone from the fourteenth century, which come from—or may be attributed to—central or southern Lorraine. These are the Madonna from Épinal (Vosges) in Boston, two Madonnas from Châtenois (Vosges) in the Metropolitan Museum (17.190.256) and The Cloisters (25.120.365), a Mary Magdalene in the chapel of Gare-le-Col near Toul (Meurthe-et-Moselle), and the Madonna in the Musée de Cluny in Paris (W. H. Forsyth, 1936, figs. 2, 4, 15, 20; Schmoll gen. Eisenwerth, 1965, figs. 22, 39). Since none of these comparative works may be dated with certainty, it is difficult to be more precise about the dating of the Pitcairn Madonna other than assigning it to the second quarter of the fourteenth century.

<div align="right">W. D. W.</div>

Purchased from Lucien Demotte, Paris, November 17, 1928.

Exhibited: Pennsylvania Museum of Art, Philadelphia, 1931 (loan 47.1931.1).

94

95. Three Bishops, from a Choir Window

France, Évron, Cathedral of Notre-Dame
About 1325–35
Pot-metal and grisaille glass with silver stain
(A) Height, 122.5 cm. (48 1/4 in.); width, 48.8 cm.
(19 1/4 in.)
03.SG.28
(B) Height, 120.5 cm. (47 7/16 in.); width, 47.8 cm.
(18 13/16 in.)
03.SG.29
(C) Height, 122 cm. (48 in.); width, 43.5 cm.
(17 1/8 in.)
03.SG.30

(A) In a cusped yellow niche—under a canopied gable of white, filled with red, pink, and green glass—stands a bishop who raises his hand in blessing over a shrouded figure rising from a tomb. The bishop is dressed in a white miter and white vestments, both ornamented with silver stain, and a pink cope. His nimbus is blue, the tomb at his feet is yellow, the foreground is green, and the background is dark red. In general, the condition of the glass is good, but there are many mended cracks. The tops of both pinnacles have been replaced and there is some repair at the bottom of the panel.

(B) This canopy is white, the crockets are yellow, and the architectural filling is red and pink. The standing bishop holds a yellow crosier with which he strikes a white rock in the foreground. He is dressed in a white miter with silver-stained decoration, a yellow chasuble with a blue neckband and a white morse, and a blue dalmatic and white alb. His nimbus is blue and the background is red. In spite of many mended cracks, this panel is also in good condition. The face of the bishop has been repainted on the original glass and the top of the panel has been filled out with a pastiche of old glass.

(C) The framing of the figure is the same as in the first panel. The bishop is shown seated, but his throne has been replaced by an insertion of the red background. He is dressed in a white, silver-stained miter; a green chasuble with a lining and collar of yellow; a white morse; a yellow maniple; and white gloves. His dalmatic is murrey and his alb white. He blesses with his right hand and in his left he holds a yellow crosier, the tip of which he thrusts into a green tuft at the bottom of the panel. A small, net-like object,

perhaps an attribute, is at his feet. The paint is worn and the glass is heavily patinated with a number of cracks. Parts of the edges of the architectural frame have been cut off on both sides of the panel and the green band at the top is a replacement.

These three figures were shown in the autumn of 1913 in New York in the second part of an exhibition of the collection of Grosvenor Thomas (Thomas, 1913, nos. 33, 33a, 33b). It is not certain, however, that Raymond Pitcairn knew of these pieces at that time. Though his first purchase was also from Thomas, it was not made until 1916 (cf. no. 90), and he did not acquire the three bishops until 1923, after they had been returned to London. At the time of their purchase their provenance was unknown, but, in fact, they had not been out of the church in Évron for long when they were acquired by Thomas. In 1900, a general restoration of the glass of the former Abbey of Notre-Dame in Évron was undertaken by Henri Carot. Work began in the apse clerestory but, during the course of the restoration, a heated controversy ensued over Carot's compensation (Lillich, 1978, 78). By 1902, Carot had completed and reinstalled all of the glass in the five turning bays of the apse and in the first straight bay on the north side. Presumably, that was all the glass that he had removed from the windows of the clerestory, since no complaint was made by the authorities at that time. In 1911, Carot, still unsatisfied over the amount of money that he had received, attempted to sell the French government three "groups" of stained glass, which he claimed to have reconstructed from debris in the church. There is no way of knowing what constituted Carot's "groups," but the government refused the offer and ordered him to replace the glass, which was the legal property of the church of Évron, compensating him only for its reinstallation (Lillich, 1969, 189). Believing that the glass that he had found and reconstructed was his own property, Carot, instead, sold the panels to Julien Chappée, the Le Mans glass painter and collector, who, in turn, sold it to dealers. A number of related pieces have since appeared in various collections, but the first to come onto the market were the three bishops, which Thomas must have acquired directly from Chappée. In 1919, the Philadelphia Museum of Art purchased from Grosvenor Thomas (Pa. Mus., 1925, 16–18) a fragment of a panel of Saint Nicholas with the two orphaned boys that has a canopy identical to those of the Pit-

cairn Bishops. Sir William Burrell, in 1928, bought a panel of a bishop saint seated at a writing desk (45.368; Burrell collection, Glasgow) from Jacques Seligmann, who, in 1947, through his American firm, also sold to William Randolph Hearst a Saint John the Evangelist (47.19.7; the Los Angeles County Museum of Art). In 1936, two additional figures were offered to the Metropolitan Museum, but they were not purchased, and there is no record of their subjects. The latest of the group to surface were two pieces—a Saint Michael and a Trinity with God the Father holding in veiled hands a crucified Christ, similar in type to that in the central light of the axial window in Évron—that appeared in the sale of the Acézat collection in Paris in 1969. By withdrawing them from sale and returning the pieces to the town of Évron, the government provided an initial confirmation of the provenance of all of these widely scattered remains.

Though the Évron provenance has been established, it is by no means certain in which window, or windows, of the church the Pitcairn Bishops were placed. Old photographs of the choir show the northwest bay of the clerestory, a six-light window, boarded up. Lillich (1969, 198) has suggested that the same blinding occurred on the south side, perhaps because the crossing spire, removed in 1901, was on the verge of collapse. It is quite possible that the original stained glass was removed to storage at the first signs that the spire might fall and that this was the "debris" found by Carot. These windows are now set in modern grisaille. In a letter of 1953 to the Metropolitan Museum, Grodecki proposed that the axial chapel was formerly glazed in fourteenth-century glass that has since disappeared. This five-light window now contains glass that appears to be of the nineteenth century and the windows of the other chapels are glazed in clear glass. Lafond (1954, 212), in discussing the windows of the clerestory at Évron, noted the absence of silver stain. These windows have been dated 1310–20 by Lillich (1978, 72) on the basis of style. The group to which the Pitcairn Bishops belong, on the contrary, is all detailed with silver stain and, therefore, must be somewhat later in date, since this technique did not become firmly established in western France until the beginning of the third decade of the fourteenth century. There are, however, iconographic similarities between the Pitcairn Bishops and the figures in the side bay of the Évron clerestory.

The iconographic program in Évron consisted of three windows of standing figures under enormously tall canopies that reached to the top of the light. These were interspersed with two narrative windows of superimposed scenes that recount the legend of the Pilgrim of Évron and the founding of the abbey. In the remaining side bay of five lights are five apostles, each with an attribute, who stand under short canopies that are similar in form to those of the Pitcairn Bishops. The apostles, like the other canopied figures at Évron, are ranged at the bottom of the light. The grisaille that completes the short canopies of the apostles fills the rest of the space. Though the bar divisions of the apostles are different from those of the bishops, the figures are similar in size. It is tempting, therefore, to suggest that the Pitcairn Bishops occupied the lancets in the five-light bay on the opposite side of the choir that are now set with modern grisaille glass. It is more reasonable to suppose, however, that this bay was once filled with five more apostles that have since vanished, and that the Pitcairn Bishops were placed in the northwest bay, known to have been boarded up before Carot began his restoration. Two of these bishops have been tentatively identified on the basis of their attributes (Gómez-Moreno, 1968, nos. 193, 194). The Pitcairn Bishop (95 A) who makes a gesture of exhortation over a diminutive resurrected figure wrapped in a grave sheet in the tomb at his feet may be Saint Aubin, Bishop of Angers, venerated throughout the archdiocese of Tours to which Évron belonged. According to his legend, which was recounted by Fortunatus (Paris, Bibl. Nat., ms. 1390), the saint resuscitated a dead child. The bishop (95 B) who strikes a rock with his crosier and causes a spring to gush forth is Saint Julian of Le Mans, performing his most famous miracle. Évron belonged to the diocese of Le Mans, and Saint Julian, whose life is recorded in the Acta of the bishops of Le Mans (Ledru, 1900, 420–21), was its patron saint. The third bishop saint (95 C) is unidentified, but one would expect that Saint Hadouin, Bishop of Le Mans, who inspired the Pilgrim's vow to build the Abbey of Évron, would be among these honored bishops. Six figures could have been accommodated in the northwest bay of Évron and the Saint Nicholas fragment now in Philadelphia was probably among them. In the fragment, Saint Nicholas is dressed as Bishop of Myra in his episcopal robes. The two additional bishops who would have

95 (A)

95 (B)

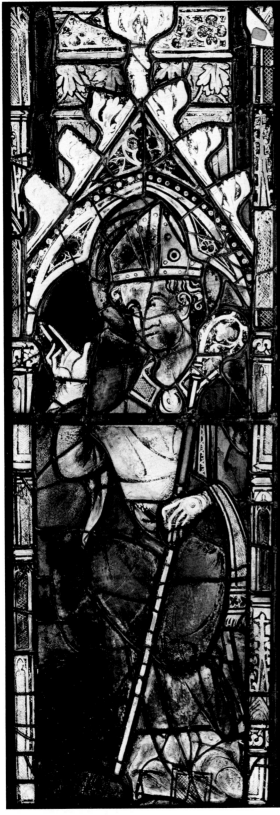

95 (C)

completed the roster are lost but the Pitcairn panels and the Philadelphia fragment are evidence enough to suggest that in addition to the apostles window there was also one devoted to those bishops who were especially venerated in Évron.

Lillich (1969, 195–98) has compared the style of the Pitcairn Bishops to scenes of the Legend of the Pilgrim of Évron, suggesting that this style originated in Vendôme. There are, however, significant differences that must be taken into account, not the least of which is the use of silver stain in the figures of the bishops. Silver stain is limited in these figures to specifics of costume and to hair, but it had not been used in Évron before. Furthermore, details such as the brows, which, in the Pilgrim figures, thicken in the middle and sweep upward away from the outer corners of the eyes, curve downward in the faces of the bishops, closely following the lines of the upper lids. In the Pilgrim figures and in Vendôme, the lines of the noses in three-quarter view break between the tips and the nostrils, while in the faces of the bishops the lines are continuous. The curves of the cheeks are delineated by a line in Évron, but not in the faces of the bishops. The proportions of the figures provide the most striking differences between the two groups. Those in the Pilgrim legend are stocky, with large heads; the bishops are more attenuated and their postures more mannered and exaggerated. The canopies of the bishops are more refined, the fretwork shaded by fine cross-hatching, and the cusps of the arches filled with delicately painted tracery. Lillich's description of the vigor and power of the Western Style of French glass painting has all but vanished in the bishops. They are not by the same hand as the earlier Évron glass but, rather, mark the return of the glaziers to the abbey after a hiatus of perhaps ten years in the glazing program. Perhaps a lack of funds held up the installation of stained glass in the side bays of the choir. Because of the differences in style between the windows in the turning bays and those of the apostles, the choir might have been glazed in several campaigns. In any case, a younger follower of the Pilgrim master undoubtedly had learned the new art of silver stain and returned to Évron to paint the window that contained the bishops.

Purchased from Grosvenor Thomas, London, May 4, 1923.

Bibliography: Thomas sale cat., 1913, nos. 30, 30a, 30b; Thomas, 1922, pl. op. 4; Pa. Mus., 1925, 16–18; Gómez-Moreno, 1968, nos. 193–195.

see colorplate XIV

96

96. Head of an Angel

France

First half of the 15th century

Limestone

Height, 17.5 cm. (6 7/8 in.); maximum width, 23 cm.
 (9 1/16 in.); depth, 13.7 cm. (5 3/8 in.)

09.SP.132

The origin of this elegant head of an angel is a puzzle,
since stylistically similar examples with which to com-
pare it are lacking. Nevertheless, the dealer Lucien
Demotte wrote to Raymond Pitcairn in 1931, inform-
ing him that "the angel's head comes from Clermont-
Ferrand," and that there was a head of the Virgin,
in the identical style, in the same collection. Because
there are just two angels' heads in the Pitcairn col-
lection, the reference presumably is to this one, yet
not enough is known of Gothic sculpture from the
Clermont region to confirm the attribution.

The fine-grained limestone from which this frag-
ment was carved allowed the sculptor to achieve a
crispness in the richly mannered treatment of the hair

and in the sharp, slit-like eyes. The S-shaped, coiled locks of hair spring to life in a wonderfully abstract way, giving the head great individuality. This expressive treatment of the hair is a characteristic feature of International Style angels, but it already is evident in the apostles from the Rieux Chapel in the church of the Cordeliers in Toulouse, executed from about 1325–30, and it continues through the fifteenth century. In general, the style of the head developed from Burgundian angels, such as those on Claus Sluter's Well of Moses, of 1395–1403, made for the Chartreuse de Champmol in Dijon, and is still clearly manifest in the mid-fifteenth-century angels on the keystone bosses of the chapel in the Hôtel Jacques-Coeur in Bourges.

The back of the head has a short, narrow ridge on the right side and a ninety-degree cut on the left. Because of its orientation—turning toward the left and looking down—it is tempting to interpret the Pitcairn carving as Saint Michael, assuming that the ridge is the remains of a sword raised over his head. These ridges, however, might be the points at which the angel's wings were connected, thus supporting the alternate identification.

C. T. L.

Purchased from Lucien Demotte, Paris, 1931(?).

97. The Crucifixion, from an Unknown Window

Central England
1460
Grisaille glass with silver stain
Height, 66.2 cm. (26 1/16 in.); width, 35.3 cm.
　(13 7/8 in.)
03.SG.19

This lancet-shaped panel, with its round, arched top, depicts the Crucifixion against a background of plain quarries. The scene is made entirely of white glass with silver stain. Christ is affixed to the cross with three nails, his eyes partly open and his knees only slightly bent. The bars of his cruciform nimbus widen at the edges to form a four-petaled shape. The Virgin, with clasped hands, stands to the left of the cross; Saint John, holding a book, is to the right. The skull in the tufted grass at the foot of the cross is a reference to Calvary, the "Place of the Skull," and also to the ancient legend in which it was said that when the cross was erected Adam's skull was dug up. Nailed to the top of the shaft of the cross is the title, in/ri (Iesus Nazarenus Rex Iudaeorum) which was set up by Pilate's order. The cross, Christ's hair and loincloth, the Virgin's halo and robe, and the hair and robe of Saint John are silver stained. Some replacements have been made in the quarries at the top of the arch and at the sides of the panel, but the Crucifixion, itself,

97

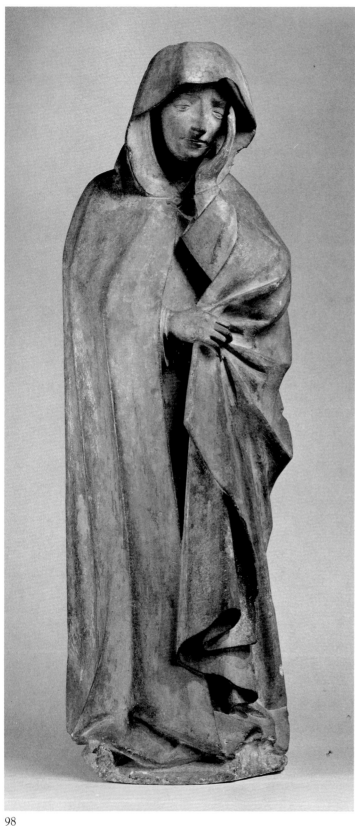

is intact, and the paint is in good condition.

The panel was purchased at the sale of the Lawrence collection in New York in 1921. Lawrence had acquired the piece at P. W. French and Co., New York, in 1914; before World War I, it had been in the Heilbronner collection in Paris.

Though this panel came from the collection of a French dealer, it is probably of English origin. The background of diamond-shaped quarries is common to glass from all parts of England during the fifteenth century, probably deriving from the trellis grisailles (cf. no. 93) of fourteenth-century band windows, a type of glazing used in France and in England. These quarry windows, in which the subject was placed directly upon a field of lozenges without any intervening background, usually included some sort of painted design on the diamonds. In small parish churches, where money was a problem, the quarries were usually left undecorated—the case in domestic windows, as well.

This type of Crucifixion is also typical of English windows of the fifteenth century (Le Couteur, 1978, 118–20). The treatment of the scene is comparatively simple and its naïve, rather crude drawing is a further indication that its origin was a modest parish church or, perhaps, the chapel of a country manor house. The large heads, small features, and slender bodies of John and Mary give them a child-like appearance. Color is provided only by the touches of silver stain, applied as a single layer without the nuances of tone achieved with additional applications. Yet, certain aspects of its painting style relate this panel to other examples of English glass of the fifteenth century and help to localize its origin: The enormous feet of Christ, which hang straight downward without any indication of bone structure, and his facial features—such as the half-closed eyes, flat nose, drooping mouth, and, above all, the cleft-shaped beard, modeled with silver stain at the edge—are also idiosyncrasies of drawing found in a Crucifixion in Llandyrnog in northern Wales (Read, 1973, fig. 20). These characteristics emphasize the provincial qualities of the Pitcairn panel.

The piece is even closer in style, however, to a series of Passion roundels from a private house in Leicester, now the property of the local museum, and other examples of domestic glass in the same town are equally naïve in character. The features of Christ in the Passion series are related stylistically to the figure in the Pitcairn panel, though not enough to indicate the same origin. Until more studies of English provincial glass are made, the exact source of the Pitcairn Crucifixion must remain uncertain.

Purchased, Lawrence sale, New York, January 28, 1921.

Ex collections: Raoul Heilbronner, Paris (before W.W. I); P. W. French and Co., New York (until 1914); Henry C. Lawrence, New York (until 1921).

Bibliography: Lawrence sale cat., 1921, no. 359, ill.

98

98. Mourning Virgin from a Crucifixion Group

France, Northern Languedoc (Rouergue)(?)
Late 15th century
Polychromed limestone
Height, 107.1 cm. (42 3/16 in.); width, 34.7 cm.
 (13 5/8 in.); depth, 22.4 cm. (8 13/16 in.)
09.SP.88

The head and shoulders of this erect figure of the Virgin Mary are almost completely covered by the heavy mantle that envelops her like a shroud, and which she pulls tightly around her body with her right hand. The Virgin's left hand is raised to her face in a traditional gesture of mourning. A wimple—worn during the Middle Ages by married and older women—covers the Virgin's neck and the lower part of her face.

The principal restorations include the front part of the mantle, draped over the forehead; a portion of the left hand, in front of the face; and the lower section of the left sleeve.

There are vestiges of color of an undetermined date on various portions of the sculpture. The mantle shows traces of blue, the bodice has remnants of dark red, and the lips have a hint of red. Two old wrought-iron rings for attachment are affixed to the back of the figure. Above these may be seen a round, modern ring, held in place with cement.

The monumental effect of the loose, heavy drapery, with its thick, simple folds; the slightly bowed head; and the gesture of mourning, imbue the figure with restrained grief or pathos, in keeping with the subject of the ensemble of which it was originally a part—the Virgin and Saint John the Evangelist standing on either side of the crucified Christ. While the ultimate source of the Virgin's naturalism and massive form may derive from Burgundy and the pervasive influence of Claus Sluter's sculpture, made for the Chartreuse de Champmol, the sculptor of the Pitcairn Virgin, perhaps, responded more directly to such late Burgundian works as the highly expressive Entombment group in Tonnerre (Yonne) by Jean Michel and Georges de la Sonnette, dating from about 1453 (W. H. Forsyth, 1970, 65–82). The emphasis on expressiveness in presenting grief in such works has given way, in the Pitcairn sculpture, to a more remote manner and a greater objectivity.

William H. Forsyth (in literis, 9-18-81) has suggested that this Pitcairn sculpture reflects the "influence of the Rouergue (northern Languedoc)" and that it is "generally comparable to aspects of a Pietà at Beaulieu (Cantal) and to a mourning Virgin at Luc (Aveyron), the only example actually in the Rouergue." The latter work and the accompanying Saint John (Trésors, 1961, nos. 104–105, pl. XVIII; Bou, 1971, 77, fig. 35) are, indeed, similar, in terms of their heavy and enveloping draperies, even though

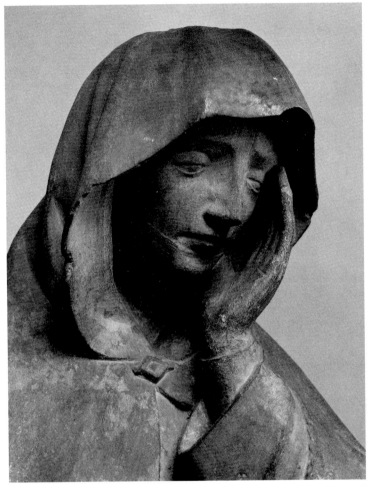

98 detail

their facial expressions tend toward caricature—as is also evident in the Entombment group in the cathedral of Rodez (Bou, 1971, figs. 22–33). The facial type of the Pitcairn Virgin, in its remoteness, seems closer to the mourning women in the Entombment groups in Carcenac-Salmiech (Aveyron) and in Rodelle (Aveyron) (Bousquet, 1961, figs. 8–9; Bou, 1971, 103–4, 116–28, figs. 48, 50, 51, 60, 62, 63, 65, 66).

W. D. W.

99. Head of Christ, from a Deposition Window (?)

Northern France, or Normandy
1500–1510
Pot-metal glass with silver stain and Jean Cousin
Height, 33.7 cm. (13 1/4 in.); width, 26.6 cm.
 (10 1/2 in.)
03.SG.9

The head of Christ, with closed eyes and wearing a crown of thorns, is placed against a blue damascened background. A piece of red drapery cuts across the lower edge of the panel. Both the crown of thorns and the nimbus are silver stained and the lips are painted with reddish-brown enamel. There is some replacement in the upper portion of the halo, largely with old glass, and the red drapery below the left shoulder is also an insertion, but most elements are original.

This head was purchased from Haussaire in Paris in 1922. There is, however, no further information on its provenance. Lafond (Grodecki, Notes, 1967) has attributed it to Normandy or northern France, in the first decade of the sixteenth century.

The influence of panel painting, clearly indicated in this head, caused a change in window design and in glass-painting techniques toward the end of the fifteenth century. This change resulted in the return of brilliantly colored glass to windows and a consequent marked decrease in the amount of grisaille employed. The band window, with its vast field of grisaille quarries and somber color, went out of fashion. The inclusion of canopies continued until the end of the century but they were conceived more as three-dimensional, shallow stages in which to place the figures rather than as architectural frames without depth. To delineate space, a curtain imitating the patterns of actual textiles was hung behind the figure, which is probably the effect intended by the blue damascened background behind the head of Christ in this panel. It is most likely a fragment of a Crucifixion, which was probably staged as a tableau before

a cloth of honor that was hung as a backdrop, as in the painting by Rogier van der Weyden in the John G. Johnson Art Collection in Philadelphia (Panofsky, 1953, pls. 210–211). Silver stain continued to be used, as in the halo and crown of thorns in the Pitcairn panel, but the brilliant yellow that it provided was employed as a color rather than as decoration. Improvements in manufacture allowed for thinner and bigger sheets of glass, which, in turn, permitted larger pieces to be cut, with less leading to destroy the desired illusionistic effects, characteristic of panel painting, that were being imitated in stained glass. The modeling techniques employed by panel painters were used by the glass painters, whose craft was simultaneously undergoing new technical innovations.

The head of Christ is painted in two different colors: a brownish-black, iron-oxide paint for the trace lines and a reddish-brown copper-oxide mat for the modeling. The lips are tinted a brownish pink with an enamel called Jean Cousin that was invented at the end of the fifteenth century and named after its so-called inventor. Successive layers of mat are floated on the surface of the glass and then removed with a stiff brush to achieve the subtle gradations of shadow required by the new naturalism of sixteenth-century art. Each application of mat had to be fired separately, but, by then, firing techniques and kilns also had improved.

The halo of Christ in this example no longer has the cross that distinguished him from the saints in representations throughout the Middle Ages. This is not without parallels in northern France at the end of the fifteenth century, since Christ's nimbus is also uncrossed in the Coronation in Caudebec in Normandy, which dates from about 1475 (Aubert, 1958, ill. 156), and he is shown without any nimbus at all in the Passion scenes in La Ferté-Milon (Aisne) of about 1528 (Aubert, 1958, ill. 172). What is even more unusual in the Pitcairn panel is that the nimbus has a shadowed edge on the right, indicating that it was conceived by the painter as having depth, like a disk set behind the head. The blue damask background is designed as an elegant variant of the pomegranate pattern, so common in the Italian cut and voided velvets of the fifteenth century that were imported in quantity to the North. If this head is from a Crucifixion, the red drapery has been added from another figure in the scene—as has the blue background to the right of the vertical lead above the halo, which would define the edge of the cross. There are, however, other explanations for the subject of this panel. The head may be that of a Man of Sorrows, a new iconographic type that became popular in the fifteenth century (Mâle, 1925, 98–104), in which the figure was often shown with drooping head and closed eyes, set against a backdrop with the cross behind

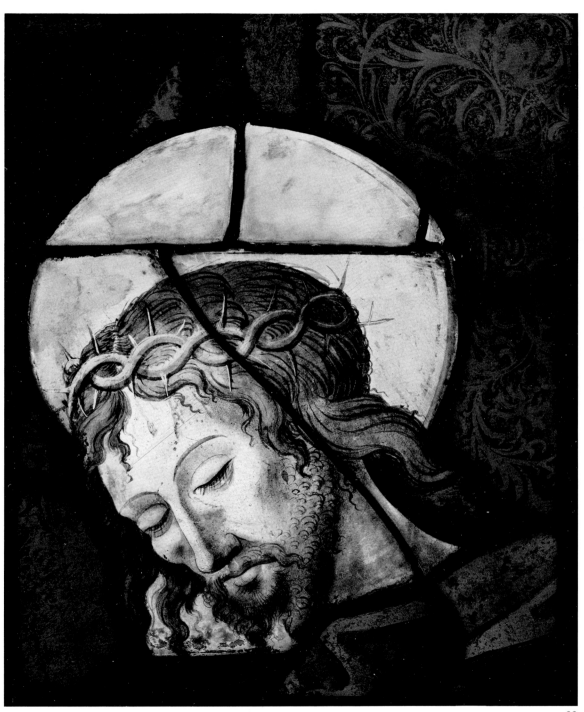

him. Christ is usually portrayed as a semi-nude figure displaying the wound in his side, but he frequently wears an open cloak across his shoulders. Mâle (1925, 68) often has remarked that, perhaps under the influence of stained glass in the fifteenth century, the color of Christ's cloak changed from purple to red in the scenes following the Crucifixion. This iconographic type would explain both the background and the red drapery that covers the shoulder of the Pitcairn figure. It is also possible that this may be a fragment of a Deposition, with part of the back of Joseph of Arimathea—as he takes Christ down from the cross—visible below the head. Though each of these possibilities has validity, perhaps the last is the most convincing explanation of the red glass, which, without question, is original, and related, stylistically, to the head.

Characteristics in the drawing of this head recall several glass shops active in Normandy at the turn of the fifteenth century. The mat washes are exceedingly thin and watery, providing translucency in the shadows. The nose is thin and delicately drawn, as are the eyes and mouth. Fine lines of trace indicate the brows, though they are thickened by practically invisible strokes at right angles to the dominant ones. The lashes, beard, and tendrils of hair that cling to the forehead are also delineated by fine brushstrokes. The mouth is exceptionally sensitively drawn and delicately highlighted, as are the cleft of the lip and the bridge of the nose, and the reflected light at the back of the neck. This watery mat is repeated in the drapery of the red mantle, as well as in the delicate lines that edge the folds. These are elements of the style of Arnoult de Nimègue, a Flemish glass painter who worked in Tournai in the latter part of the fifteenth century and then transferred his atelier to Rouen (Lafond, 1926–27, 5–22). One would hardly attribute the Pitcairn head to this accomplished master for, though it lacks the plasticity of his mature style, it is closer to the newly arrived Renaissance ideals than is the earlier work of the Master of Saint John the Baptist (Perrot, 1972, 29–31) and his many followers among the glass painters of Rouen. While the painter of the Pitcairn head was probably a native of Rouen, and was certainly trained in its astonishingly productive school of glass painters that flourished at the end of the fifteenth century, the attitudes expressed in his work herald a new vitality that proclaims the Renaissance.

Purchased from François Haussaire, Paris, April 5, 1922.

Bibliography

Published works cited in the Catalogue

ABBAYES NORMANDES, 1979
Trésors des abbayes normandes, Rouen and Caen, 1979.

ABRIAL-ARIBERT, 1976
Abrial-Aribert, Françoise, "Le Cloître de Saint-Sernin de Toulouse," *Actes du 96ᵉ Congrès des Sociétés Savantes, Toulouse*, 1971–76, II, 157–74.

ACÉZAT, 1969
Ancienne collection de M. Michel Acézat, Vitraux français gothiques et de la Renaissance (sale cat.), Paris, Hôtel Drouot, November 22, 1969.

ALTET, 1980
Altet, Xavier Barral i, "Les mosaïques de pavement médiévales de la ville de Reims," *Congrès archéologique de France* (CIIIVᵉ session, 1977, Champagne), Paris, 1980, 79–108.

ANAL. BOLL., 1893
Gregorii Turonensis, "Passio VII Dormientium apud Ephesum," Bruno Krush, ed., *Analecta Bollandiana*, XII, 1893, 371–87.

ANFRAY, 1951
Anfray, Marcel, *L'Architecture religieuse du Nivernais au moyen âge; les églises romanes*, Paris, 1951.

ANON., 1886
"Bas-relief de Saint-Vincent-lèz-Digne," *Bulletin de la Société scientifique et littéraire des Basses-Alpes*, II, 1886, 438–47.

ARNAUD, 1837
Arnaud, Anne François, *Voyage archéologique et pittoresque dans le département de l'Aube et dans l'ancien diocèse de Troyes*, Troyes, 1837.

ARNAULD, 1843
Arnauld, Charles, *Monuments religieux, militaires et civils du Poitou*, Niort, France, 1843.

ARNOLD, 1913
Arnold, Hugh, and Saint, Lawrence B., *Stained Glass of the Middle Ages in England and France*, London, 1913.

ART NEWS, March 1, 1930
"Demotte Shows French Sculpture of Six Centuries," *The Art News*, XXVII, March 1, 1930, 1, 6–7.

ART NEWS, November 1, 1930
"Early Carvings, Glass and Furniture in Monell Sale," *The Art News*, XXVIII, November 1, 1930, 4.

ART NEWS, 1931
"Romanesque and Gothic Sections Now Open to the Public at the Pennsylvania Museum," *The Art News*, XXIX, March 21, 1931, 28–34.

ART NEWS, 1938
"Medieval Art," *The Art News*, XXXVI, December 6, 1938, 22.

THE ARTS, 1931
Taylor, Francis Henry, "The Art of the Middle Ages," *The Arts*, XVII, 1931, 454–90.

AUBERT, 1927
Aubert, Marcel, "La cathédrale," *Congrès archéologique de France* (LXXXIXᵉ session, Rouen, 1926), Paris, 1927, 11–71.

AUBERT, 1930
Aubert, Marcel, *La Bourgogne: La Sculpture*, Paris, 1930.

AUBERT, 1946
Aubert, Marcel, *La Sculpture française au moyen-âge*, Paris, 1946.

AUBERT, 1958
Aubert, Marcel, et al., *Le Vitrail français*, Paris, 1978.

AUBERT and BEAULIEU, 1950
Aubert, Marcel, and Beaulieu, Michèle, *Description raisonnée des sculptures du moyen-âge, de la Renaissance et des temps modernes, I: Moyen-âge*, Paris, Musée National du Louvre, 1950.

AVRIL, 1978
Avril, François, *Manuscript Painting at the Court of France: The Fourteenth Century*, New York, 1978.

BARI, 1975
Alle sorgenti del Romanico Puglia XI secolo (exhib. cat.), Pina Belli d'Elia, ed., Bari, Pinacoteca Provinciale, 1975.

BARNES, 1967
Barnes, Carl F., Jr., "The Architecture of Soissons Cathedral: Sources and Influences in the Twelfth and Thirteenth Centuries," Ph.D. dissertation, Columbia University, 1967.

BARNES, 1971
Barnes, Carl F., Jr., "The Location of the 'Sainte-Chapelle' Stained Glass in the Cathedral of Soissons," *The Art Bulletin*, LIII, 1971, 459–60.

BAUCH, 1970
Bauch, Kurt, "Die 'Madonna' aus St. Gangulf," *Zeitschrift für Kunstwissenschaft*, XXIV, 1970, 13–17.

BEENKEN, 1924
Beenken, Hermann, *Romanische Skulptur in Deutschland*, Leipzig, 1924.

BÉGULE, 1880
Bégule, Lucien, *Monographie de la cathédrale de Lyon*, Lyons, 1880.

BESSERMAN, 1979
Besserman, Lawrence L., *The Legend of Job in the Middle Ages*, London, 1979.

BIDAUT, 1952
Bidaut, Jacques M., "Église Sainte-Radegonde de Poitiers," *Congrès archéologique de France* (CIXᵉ session, Poitiers, 1951), Paris, 1952, 96–117.

BILSON, 1906
Bilson, John, "Amiens Cathedral and Mr. Goodyear's 'Refinements'. A Criticism," *Journal of the Royal Institute of British Architects*, 3rd ser., XIV, 1906, 397–417.

BLUM, 1978
Blum, Pamela Z., "The Salisbury Chapter House and Its Old Testament Cycle. An Archaeological and Iconographic Study," Ph.D. dissertation, Yale University, 1978.

BOINET, 1922
Boinet, Amédée, "Le vieux Metz," *Congrès archéologique de France* (LXXXIIIᵉ session, Metz, Strasbourg et Colmar, 1920), Rennes, 1922.

BONY, 1957–58
Bony, Jean, "The Resistance to Chartres in Early Thirteenth-Century Architecture," *Journal of the British Archaeological Association*, XX–XXI, 1957–58, 35–52.

BOU, 1971
Bou, Gilbert, *La Sculpture en Rouergue à la fin du gothique, XVᵉ siècle et début du XVIᵉ siècle*, Rodez, France, 1971.

BOURALIÈRE, 1904
de la Bouralière, M. A., "Guide archéologique du Congrès de Poitiers," *Congrès archéologique de France* (LXXᵉ session, Poitiers, 1903), Paris and Caen, 1904, 1–85.

BOUSQUET, 1961
Bousquet, Jacques, "La Sculpture rouergate et la fin du style gothique, positions et propositions," *Bulletin du Musée Ingres*, July 9, 1961, 9–15.

BOUSQUET, 1973
Bousquet, Jacques, "La Sculpture romane à Saint-Pons-de-Thomières et ses liens avec l'art du Roussillon," *Cahiers de Saint-Michel de Cuxa*, IV, 1973, 77–95.

BOUXIN, 1976
Bouxin, Marc, *Les Chapiteaux romans de la salle capitulaire de l'abbaye Saint-Remi de Reims*, Reims, 1976.

BRANNER, 1965
Branner, Robert, *St. Louis and the Court Style in Gothic Architecture* (Studies in Architecture, VII), London, 1965.

BRANNER, 1977
Branner, Robert, *Manuscript Painting in Paris during the Reign of Saint Louis*, Berkeley, 1977.

BRISAC, 1974
Brisac, Catherine, "Le sacramentaire ms. 63 de la Bibliothèque Municipale de Clermont-Ferrand: nouvelles données sur l'art figuré à Clermont-Ferrand autour de 1200," *Bulletin historique et scientifique de l'Auvergne*, LXXXVI, 1974, 303–15.

BRISAC, 1978
Brisac, Catherine, "La Peinture sur verre à Lyon au XIIIᵉ siècle," *Dossiers de l'archéologie*, 26, January–February 1978, 38–49.

BRUZELIUS, 1981
Bruzelius, Caroline, "St. Louis, St.-Denis and the Court Style" (Paper delivered at the College Art Association Annual Meeting, San Francisco, February 1981).

BUCHER, 1979
Bucher, François, *Architector: The Lodge Books and Sketchbooks of Medieval Architects*, I, New York, 1979.

CABANOT, 1974
Cabanot, Jean, "Le décor sculpté de la basilique Saint-Sernin de Toulouse," *Bulletin monumental*, 132, 1974, 99–145.

CAHIER and MARTIN, 1841–44
Cahier, Charles, and Martin, Arthur, *Monographie de la cathédrale de Bourges, Première partie: Vitraux du XIIIᵉ siècle*, 2 vols., Paris, 1841–44.

CAHN, 1977
Cahn, Walter, "Romanesque Sculpture in American Collections. XVI. The Academy of the New Church, Bryn Athyn, Pa.," *Gesta*, XVI/2, 1977, 69–79.

CAHN, 1978
Cahn, Walter, "Romanesque Sculpture in American Collections. XVII. The Glencairn Foundation, Philadelphia Museum of Art," *Gesta*, XVII/1, 1978, 77–80.

CAHN and SEIDEL, 1979
Cahn, Walter, and Seidel, Linda, *Romanesque Sculpture in American Collections. I. New England Museums*, New York, 1979.

CAMPBELL, 1960
Campbell, Gerald J. "The Attitude of the Monarchy toward the Use of Ecclesiastical Censures in the Reign of Saint Louis," *Speculum*, XXXV, 1960, 535–55.

CAMUS, 1976
Camus, Marie-Thérèse, "Deux témoins de la sculpture romane du Bas-Limousin en Poitou: les chapiteaux de la chapelle de Saulgé," *Bulletin monumental*, 134, 1976, 93–106.

CAVINESS, 1977
Caviness, Madeline Harrison, *The Early Stained Glass of Canterbury Cathedral*, Princeton, 1977.

CAVINESS, 1978
Caviness, Madeline Harrison, ed., *Medieval and Renaissance Stained Glass from New England Collections* (exhib. cat.), Cambridge, Mass., Busch-Reisinger Museum, Harvard University, 1978.

CAVINESS, 1982
Caviness, Madeline Harrison, "Saint-Yved of Braine: A Note on the Documented Dates for the Gothic Church," 1982, in press.

CAVINESS and RAGUIN, 1981
Caviness, Madeline Harrison, and Raguin, Virginia Chieffo, "Another Dispersed Window from Soissons: A Tree of Jesse in the Sainte-Chapelle Style," *Essays in Honor of Harry Bober (Gesta, XX/1)*, 1981, 191–98.

CHARTRAIRE, 1928
Chartraire, Étienne, *La Cathédrale de Sens*, Paris, 1928.

CONNICK, 1937
Connick, Charles J., *Adventures in Light and Color, an Introduction to the Stained Glass Craft*, New York, 1937.

COTHREN, 1978
Cothren, Michael, "A Re-evaluation of the Iconography and Design of the Infancy Window from the Abbey of Saint-Denis," *Gesta*, XVII/1, 1978, 74–75.

COTHREN, 1980
Cothren, Michael Watt, "The Thirteenth and Fourteenth-Century Glazing of the Choir of the Cathedral of Beauvais," Ph.D. dissertation, Columbia University, 1980.

CRAPLET, 1977
Craplet, Bernard, *Cathédrale de Clermont: Dossiers du visiteur*, Le Puy, France, 1977.

CROSBY, 1953
Crosby, Sumner McKnight, *L'Abbaye royale de Saint-Denis*, Paris, 1953.

CROSBY, 1966
Crosby, Sumner McKnight, "An International Workshop in the Twelfth Century," *Journal of World History*, X, 1, 1966, 19–30.

CROSBY, 1972
Crosby, Sumner McKnight, *The Apostle Bas-Relief at Saint-Denis*, New Haven and London, 1972.

CRUVELLIER, 1881
Cruvellier, Jean-François, "Note sur la chapelle de Saint-Vincent et sur quelques bas-reliefs du moyen âge provenant de cet ancien édifice," *Bulletin de la Société scientifique et littéraire des Basses-Alpes*, I, 1881, 200–211.

CVMA, 1956
Beer, Ellen J., *Die Glasmalereien der Schweiz vom 12. bis zum Beginn des 14. Jahrhunderts* (Corpus Vitrearum Medii Aevi, Switzerland, I), Basel, 1956.

CVMA, 1959
Aubert, Marcel, et al., *Les Vitraux de Notre-Dame et de la Sainte-Chapelle de Paris* (Corpus Vitrearum Medii Aevi, France, I), Paris, 1959.

CVMA, 1970
Lafond, Jean, *Les Vitraux de l'église Saint-Ouen de Rouen* (Corpus Vitrearum Medii Aevi, France, IV/2, t. I), Paris, 1970.

CVMA, 1976
Grodecki, Louis, *Les Vitraux de Saint-Denis, I: Histoire et restitution* (Corpus Vitrearum Medii Aevi, France, "Études," I), Paris, 1976.

CVMA, 1978
Grodecki, Louis, et al., *Les Vitraux de Paris, de la région parisienne, de la Picardie et du Nord-Pas-de-Calais* (Corpus Vitrearum Medii Aevi, France, Série complémentaire, Recensement des vitraux anciens de la France, I), Paris, 1978.

CVMA, 1979
Newton, Peter A., *The County of Oxford. A Catalogue of Medieval Stained Glass* (Corpus Vitrearum Medii Aevi, Great Britain, I), Oxford, England, 1979.

DEFERRARI, 1949
Sulpicius Severus, "The Life of St. Martin, Dialogues and the Epistle to Bassila," *The Fathers of the Church*, Roy J. Deferrari, ed., New York, 1949.

DEHIO, 1911
Dehio, Georg Gottfried, *Handbuch der deutschen Kunstdenkmäler, IV, Südwestdeutschland*, Berlin, 1911.

DELAPORTE, 1926
Delaporte, Yves, and Houvet, Étienne, *Les Vitraux de la cathédrale de Chartres*, 4 vols., Chartres, 1926.

DELETTRE, 1849
Delettre, François Antoine, *Histoire de la province du Montois*, Nogent-sur-Seine, 1849.

DEMOTTE, 1929
Demotte, Lucien, *Catalogue of an Exhibition of Stained Glass from the XIth to the XVIIIth Centuries* (exhib. cat.), New York [1929].

DEMOTTE, 1932
Demotte, Lucien, "The Pitcairn Collection," *Formes*, 28–29, 1932, 307–8.

DESCHAMPS and THIBOUT, 1963
Deschamps, Paul, and Thibout, Marc, *La peinture murale en France au début de l'époque gothique de Philippe-Auguste à la fin du règne de Charles V (1180–1380)*, Paris, 1963.

DESHMAN, 1971
Deshman, Robert, "Otto III and the Warmund Sacramentary: A Study in Political Theology," *Zeitschrift für Kunstgeschichte*, XXXIV, 1971, 1–20.

DEUCHLER, 1967
Deuchler, Florens, *Der Ingeborgpsalter*, Berlin, 1967.

DORMAY, 1663–64
Dormay, Charles, *Histoire de la ville de Soissons*, 2 vols., Soissons, 1663–64.

DOYEN, 1953
Doyen, Henri, *Guide du visiteur de la cathédrale de Soissons*, Soissons, 1953.

DUMAIL and BERNAT, 1976
Dumail, A., and Bernat, E., "Une inscription romane et une Vierge à l'enfant sur un même marbre provenant de Saint-Gaudens," *Revue de Comminges*, 89, 1976, 301–8.

DuMÈGE, 1834–36
DuMège, Alexandre, "Mémoire sur l'église de Saint-Gaudens," *Histoire et Mémoires de l'Académie des sciences, inscriptions et belles-lettres de Toulouse*, IV, 2, 1834–36, 96–116.

DURAND, 1901–3
Durand, Georges, *Monographie de l'église Notre-Dame, cathédrale d'Amiens*, 2 vols., Paris, 1901–3.

DURLIAT, 1959
Durliat, Marcel, *La Sculpture romane en Roussillon*, 3rd ed., rev., Perpignan, France, 1959.

DURLIAT, 1969
Durliat, Marcel, "Le Prieuré de Serrabone," *Les Monuments historiques de la France*, nouvelle série, XV/2, 1969, 5–26.

DURLIAT, 1972
Durliat, Marcel, "Histoire et archéologie: l'exemple de Sainte-Marie de Besalú," *Bulletin monumental*, 130, 1972, 225–30.

DURLIAT, 1973
Durliat, Marcel, "Les cloîtres romans du Roussillon," *Cahiers de Saint-Michel de Cuxa*, IV, 1973, 68–76.

DURLIAT, 1974
Durliat, Marcel, "Alexandre Dumège ou les mythes archéologiques à Toulouse dans le premier tiers du XIXᵉ siècle," *Revue de l'art*, 23, 1974, 30–41.

DURLIAT, 1977
Durliat, Marcel, "Découverte d'une sculpture romane à Saint-Gaudens," *Bulletin monumental*, 135, 1977, 151–56.

DURLIAT and RIVÈRE, 1979
Durliat, Marcel, and Rivère, Gérard, "Le Cloître de la collégiale de Saint-Gaudens," *Revue de Comminges*, 92, 1979, 17–32.

DU SOMMERARD, 1822
Du Sommerard, Alexandre, *Vues de Provins dessinées et lithographiées en 1822 par plusieurs artistes avec un texte par M. D.*, Paris, 1922.

EGBERT, 1964
Egbert, Virginia Wylie, "St. Nicholas and the Fasting Child," *The Art Bulletin*, XLVI, 1964, 68–70.

EISEN, 1940
Eisen, Alois, *Der Dom zu Regensburg, I, Die Bildfenster*, Berlin, 1940.

ENGEL-GROS, 1922
Catalogue des vitraux anciens, collection Engel-Gros (sale cat.), Paris, Hôtel Drouot, December 7, 1922.

ERDMANN, 1977
Erdmann, Carl, *The Origin of the Idea of Crusade*, Marshal W. Baldwin and Walter Goffart, trans., Princeton, 1977.

ERLANDE-BRANDENBURG, 1971
Erlande-Brandenburg, Alain, "Les Remaniements du portail central à Notre-Dame de Paris," *Bulletin monumental*, 129, 1971, 241–48.

ERLANDE-BRANDENBURG, 1974
Erlande-Brandenburg, Alain, "Nouvelles remarques sur le portail central de Notre-Dame de Paris," *Bulletin monumental*, 132, 1974, 270–96.

ERLANDE-BRANDENBURG, 1977
Erlande-Brandenburg, Alain, "Le septième colloque international de la Société française d'Archéologie. La façade de la cathédrale d'Amiens," *Bulletin monumental*, 135, 1977, 254–93.

FARCY, 1910
de Farcy, Louis, *Monographie de la cathédrale d'Angers, I: Les immeubles*, Angers, 1910.

FINGERLIN, 1971
Fingerlin, Ilse, *Gürtel des hohen und späten Mittelalters*, Munich, 1971.

FISCHER, 1969
Fischer, Hans, "The Iconography of the West Rose at Chartres" (Graduate Seminar paper, Columbia University, 1969).

FLEURY, 1879
Fleury, Édouard, *Antiquités et monuments du département de l'Aisne*, Paris, 1879.

FLOUEST, 1882
Flouest, A. C. N., "Notice," *Bulletin de la Société Nationale des Antiquaires de France*, 1882, 181–86.

FORSYTH, 1936
Forsyth, William H., "Medieval Statues of the Virgin in Lorraine Related in Type to the Saint-Dié Virgin," *Metropolitan Museum Studies*, V, 1936, 235–58.

FORSYTH, 1970
Forsyth, William H., *The Entombment of Christ: French Sculptures of the Fifteenth and Sixteenth Centuries*, Cambridge, Mass., 1970.

FORSYTH, 1972
Forsyth, Ilene H., *The Throne of Wisdom. Wood Sculptures of the Madonna in Romanesque France*, Princeton, 1972.

GARTON, 1973
Garton, Tessa, "Islamic Influences in Early Romanesque Sculpture of Apulia," *AARP*, 4, 1973, 101–16.

GASKILL, n.d.
Gaskill, Jennie, *Biography of Raymond Pitcairn*, Bryn Athyn, Pa., n.d.

GILMORE-HOUSE, 1974
Gilmore-House, Gloria, "The Miracles of the Virgin Window: Atelier and Sources" (Graduate Seminar paper, Columbia University, 1974).

GIMPEL, 1963
Gimpel, René, *Journal d'un collectionneur, marchand de tableaux*, France, 1963.

GLASS, 1970
Glass, Dorothy, "Romanesque Sculpture in American Col-

lections. V. Baltimore and Washington," *Gesta*, IX/1, 1970, 46–59.

GLENN, 1971
Glenn, E. Bruce, *Bryn Athyn Cathedral, the Building of a Church*, Bryn Athyn, Pa., 1971.

GOBILLOT, 1955
Gobillot, René, "Sées," *Congrès archéologique de France* (CXI^e session, Orne, 1953), Paris, 1955, 39–58.

THE GOLDEN LEGEND
de Voragine, Jacques, *The Golden Legend or the Lives of the Saints as Englished by William Caxton*, F. S. Ellis, ed., London, 7 vols., 1931–35.

GOLDKUHLE, 1954
Goldkuhle, Fritz, *Mittelalterliche Wandmalerei in St. Maria Lyskirchen*, Düsseldorf, 1954.

GOLDSCHMIDT, 1914–18
Goldschmidt, Adolph, *Die Elfenbeinskulpturen aus der Zeit der karolingischen und sächsischen Kaiser, VII.–XI. Jahrhundert*, Berlin, 1914–18.

GÓMEZ-MORENO, 1961
Gómez-Moreno, Carmen, "The Apse from San Martin at Fuentidueña. History, Stylistic Analysis and Dismantling," *The Metropolitan Museum of Art Bulletin*, new ser., XIX, 1961, 268–89.

GÓMEZ-MORENO, 1968
Gómez-Moreno, Carmen, *Medieval Art from Private Collections* (exhib. cat.), New York, The Metropolitan Museum of Art (The Cloisters), 1968.

GOODYEAR, 1907
Goodyear, William H., "Architectural Refinements, A Reply to Mr. Bilson," *Journal of the Royal Institute of British Architects*, 3rd ser., XV, 1907, 107–10.

GRAVES, 1838
Graves, Louis, *Précis statistique sur le canton de Clermont, Arrondissement de Clermont (Oise)*, Beauvais, 1838.

GRIVOT and ZARNECKI, 1961
Grivot, Denis, and Zarnecki, George, *Gislebertus, Sculptor of Autun*, New York, 1961.

GRODECKI, 1951
Grodecki, Louis, "Les vitraux de la cathédrale de Poitiers," *Congrès archéologique de France* (CIX^e session, 1951, Poitiers), Orléans, 1951, 138–63.

GRODECKI, 1953
Grodecki, Louis, "Un vitrail démembré de la cathédrale de Soissons," *Gazette des Beaux-Arts*, VI ser., XL, 1953, 169–76.

GRODECKI, Vitraux, 1953
Grodecki, Louis, *Vitraux de France du XI^e au XVI^e siècles* (exhib. cat.), Paris, Musée des Arts Décoratifs, 1953.

GRODECKI, 1958
Grodecki, Louis, "Une scène de la vie de St. Benoît provenant de Saint-Denis au Musée de Cluny," *La Revue des Arts*, 8, 1958, 161–71.

GRODECKI, Bull. Mon., 1958
Grodecki, Louis, "Chronologie de la cathédrale de Chartres," *Bulletin monumental*, 116, 1958, 91–119.

GRODECKI, 1960
Grodecki, Louis, "Les vitraux soissonnais du Louvre, du Musée Marmottan et des collections américaines," *La Revue des Arts*, 10, 1960, 163–78.

GRODECKI, 1961
Grodecki, Louis, "Une groupe de vitraux français du XII^e siècle," *Hans R. Hahnloser, zum 60. Geburtstag, 1959*, Ellen J. Beer, ed., Basel and Stuttgart, 1961, 289–98.

GRODECKI, C.A., 1961
Grodecki, Louis, "Les vitraux de la cathédrale du Mans," *Congrès archéologique de France* (CXIX^e session, 1961, Maine), Paris, 1961, 59–99.

GRODECKI, 1963
Grodecki, Louis, "Problèmes de la peinture en Champagne pendant la seconde moitié du XII^e siècle," *Studies in Western Art: I. Romanesque and Gothic Art, Acts of the Twentieth International Congress of the History of Art*, Princeton, 1963, 129–41.

GRODECKI, 1965
Grodecki, Louis, "Le maître de Saint Eustache de la cathédrale de Chartres," *Gedenkschrift Ernst Gall*, Munich, 1965, 171–94.

GRODECKI, 1969
Grodecki, Louis, "Le psautier de la reine Ingeburge et ses problèmes," *Revue de l'art*, 5, 1969, 73–78.

GRODECKI, 1973
Grodecki, Louis, "Nouvelles découvertes sur les vitraux de la cathédrale de Troyes," *Intuition und Kunstwissenschaft, Festschrift für Hanns Swarzenski*, Peter Bloch et al., eds., Berlin, 1973, 191–203.

GRODECKI, 1975
Grodecki, Louis, "Les plus anciens vitraux de Saint-Remi de Reims," *Beiträge zur Kunst des Mittelalters, Festschrift für Hans Wentzel*, Berlin, 1975, 65–77.

GRODECKI, Sainte-Chapelle, 1975
Grodecki, Louis, *Sainte-Chapelle*, 2nd ed., Paris, 1975.

GRODECKI, 1977
Grodecki, Louis, et al., *Le Vitrail roman*, Fribourg, Switzerland, 1977.

GRODECKI, 1978
Grodecki, Louis, "Les problèmes de la peinture gothique et le 'Maître de Saint Chéron' de la cathédrale de Chartres," *Revue de l'art*, 40–41, 1978, 43–64.

GRODECKI and CAVINESS, 1968
Grodecki, Louis, and Caviness, Madeline Harrison, "Les vitraux de la Sainte-Chapelle," *Revue de l'art*, 1, 1968, 8–16.

GUEY and LAFOND, 1931
Guey, Fernand, and Lafond, Jean, *Catalogue de l'exposition d'art religieux ancien*, Rouen, 1931.

HAMANN, 1935
Hamann, Richard, "Das Lazarusgrab in Autun," *Marburger Jahrbuch für Kunstwissenschaft*, VIII–IX, 1935, 182–328.

HAYWARD, 1970
Hayward, Jane, "The Seven Sleepers from Rouen," *Bulletin of the Worcester Art Museum*, XXXV, March 1970, n.p.

HAYWARD, 1976
Hayward, Jane, "The Choir Windows of Saint-Serge and Their Glazing Atelier," *Essays in Honor of Sumner McKnight Crosby* (Gesta, XV/1&2), 1976, 255–64.

HAYWARD, 1981
Hayward, Jane, "The Redemption Windows of the Loire Valley," *Études d'art médiéval offertes à Louis Grodecki*, Sumner McKnight Crosby, et al., Paris, 1981.

HAYWARD and GRODECKI, 1966
Hayward, Jane, and Grodecki, Louis, "Les vitraux de la cathédrale d'Angers," *Bulletin monumental*, 124, 1966, 7–67.

HEILBRONNER, 1924
Catalogue des sculptures . . . et . . . vitraux . . . Collections de M. Raoul Heilbronner (sale cat.), Paris, May 17, 1924.

HÉLIOT, 1966
Héliot, Pierre, "Les églises de Servon, Villeneuve-le-Comte, Vaudoy et leur famille monumentale," *Bulletin de la Société de l'histoire de Paris et de l'Île-de-France*, 1966, 55–78.

HINKLE, 1965
Hinkle, William M., *The Portal of the Saints of Reims Cathedral. A Study in Medieval Iconography*, New York, 1965.

HITCHCOCK, 1968
Hitchcock, Henry Russell, *Architecture of the Nineteenth and Twentieth Centuries*, Baltimore, 1968.

HITCHCOCK, Art of the U.S., 1968
Hitchcock, Henry Russell, "Art of the United States. Architecture," in "Americas: Art since Columbus," *Encyclopedia of World Art*, I, 1968, 246–77.

HOTZ, 1965
Hotz, Walter, *Handbuch der Kunstdenkmäler in Elsass und in Lothringen*, Munich and Berlin, 1965.

HOUSTON, 1973–74
Gray Is the Color: An Exhibition of Grisaille Painting, XIIIth–XXth Centuries (exhib. cat.), Houston, Rice University, Institute for the Arts, Rice Museum, 1973–74.

HUCHER, 1864
Hucher, Eugène, *Calques des vitraux peints de la cathédrale du Mans*, Paris and Le Mans, 1864.

INTERNATIONAL STUDIO, 1929
[Demotte, Lucien], "Medieval Art, A Thirteenth-Century Glass Panel," *International Studio*, March 1929, 40–41.

JOUBERT, 1979
Joubert, Fabienne, "Le jubé de Bourges, remarques sur le style," *Bulletin monumental*, 137, 1979, 341–69.

KEUNE, 1907
Keune, Johann Baptist, *Metz, seine Geschichte, Sammlungen, und Sehenswürdigkeiten*, Metz, 1907.

KOCH, 1879
Chardry Josaphaz, Set dormanz und Petit plet, Dichtungen in der anglo-normanische Mundart des XIII. Jahrhunderts, John Koch, ed., Heilbronn, 1879.

KRAUS, 1888
Kraus, Franz Xaver, "Karolingisches Madonnenbild in Metz," *Zeitschrift für christliche Kunst*, I, 1888, 17.

KRAUS, 1889
Kraus, Franz Xaver, *Kunst und Alterthum in Elsass-Lothringen*, Strasbourg, 1889.

KREY, 1921
Krey, August C., *The First Crusade. The Accounts of Eyewitnesses and Participants*, Princeton, 1921.

KUPFER, 1977
Kupfer, Vasanti, "The Iconography of the Tympanum of the Temptation of Christ in The Cloisters," *Metropolitan Museum Journal*, XII, 1977, 21–31.

KURMANN and VON WINTERFELD, 1977
Kurmann, Peter, and von Winterfeld, Dethard, "Gautier de Varinfroy, en 'Denkmalpfleger' im 13. Jahrhundert," *Festschrift für Otto von Simson zum 65. Geburtstag*, Berlin, 1977, 101–59.

LABARTE, 1864
Labarte, Charles-Jules, *Histoire des arts industriels au Moyen âge et à l'époque de la Renaissance*, 6 vols., Paris, 1864–66.

LAFOND, 1926–27
Lafond, Jean, "Études sur l'art du vitrail en Normandie. Arnoult de Nimègue et son oeuvre," *Bulletin de la Société des amis des monuments rouennais*, 1926–27, 137–54.

LAFOND, 1943
Lafond, Jean, "Essai historique sur le jaune d'argent," *Trois études sur la technique du vitrail*, Rouen, 1943, 39–116.

LAFOND, 1946
Lafond, Jean, "Lincoln Cathedral. The Stained Glass Decoration of Lincoln Cathedral in the Thirteenth Century," *The Archaeological Journal*, CIII, 1946, 119–56.

LAFOND, 1948
Lafond, Jean, "Les vitraux français du Musée Ariana et l'ancienne vitrerie de Saint-Fargeau (Yonne)," *Genava. Bulletin du Musée d'Art et d'Histoire de Genève et du Musée Ariana*, XXVI, 1948, 115–32.

LAFOND, 1953
Lafond, Jean, "Le Vitrail en Normandie de 1250 à 1300," *Bulletin monumental*, 111, 1953, 317–58.

LAFOND, 1954
Lafond, Jean, "Le vitrail du XIV^e siècle en France, étude historique et descriptive," in Louise Lefrançois-Pillion, *L'Art du XIV^e siècle en France*, Paris, 1954, 187–238.

LAFOND, in JOUEN, 1954
Lafond, Jean, "Les vitraux de Jumièges," in Léon Alfred Jouen, *Jumièges: Historiques et légendes, ruines et reliques*, 3rd ed., Rouen, 1954, 261–96.

LAFOND, 1954–55
Lafond, Jean, "Un vitrail du Mesnil-Villeman (1313) et les origines du jaune d'argent," *Bulletin de la Société nationale des Antiquaires de France*, 1954–55, 93–95.

LAFOND, 1955
Lafond, Jean, "La peinture sur verre à Jumièges," *Jumièges. Congrès scientifique du XIII^e centenaire*, II, Rouen, 1955, 529–36.

LAFOND, C.A., 1955
Lafond, Jean, "Les vitraux de la cathédrale de Sées," *Congrès archéologique de France* (CXI^e session, Orne, 1953), Paris, 1955, 59–83.

LAFOND, 1957
Lafond, Jean, "Les vitraux de la cathédrale de Saint-Pierre de Troyes," *Congrès archéologique de France* (CXIII^e session, Troyes, 1955), Orléans, 1957, 28–63.

LAFOND, 1962
Lafond, Jean, "La technique du vitrail: aperçus nouveaux," *Art de France*, II, 1962, 246–49.

LAFOND, 1964
Lafond, Jean, "The Traffic in Old Stained Glass from Abroad during the 18th and 19th Centuries in England," *Journal of the British Society of Master Glass Painters*, XIV/ 1, 1964, 58–67.

LAFOND, 1975
Lafond, Jean, "La Verrière des Sept Dormants d'Ephèse et l'Ancienne Vitrerie de la Cathédrale de Rouen," *The Year 1200: A Symposium*, New York, 1975, 399–416.

LAFONTAINE-DOSOGNE, 1977
Lafontaine-Dosogne, Jacqueline, *Sculptures du haut moyen-âge sur ivoire, sur bois, et sur pierre*, Guide des visiteurs, Brussels, 1977.

LAPEYRE, 1960
Lapeyre, André, *Des Façades occidentales de Saint-Denis et de Chartres aux portails de Laon; études sur la sculpture monumentale dans l'Île-de-France et les régions voisines au XII^e siècle*, Mâcon, 1960.

LA PRAIRIE, 1858
de La Prairie, "Notice sur la rose du transept septentrional de la cathédrale de Soissons," *Bulletin de la Société archéologique de Soissons*, I, 1858, 95–168.

DE LASTEYRIE, 1857
de Lasteyrie, Ferdinand, *Histoire de la peinture sur verre d'après ses monuments en France*, 2 vols., Paris, 1857.

LAWRENCE, 1921
Collection of a Well-Known Connoisseur, A Noteworthy Gathering of Gothic and other Ancient Art Collected by the Late Mr. Henry C. Lawrence of New York (sale cat.), New York, American Art Association, January 28, 1921.

LE COUTEUR, 1978
Le Couteur, John Dolbel, *English Mediaeval Painted Glass*, 2nd ed., London, 1978.

LEDAIN, 1876
Ledain, Bélisaire, *La Gatine historique et monumentale*, Paris, 1876.

253

LEDICTE-DUFLOS, 1850
Ledicte-Duflos, "Mémoire sur les vitraux peints de l'arrondissement de Clermont (Oise)," *Mémoires de la Société des Antiquaires de Picardie*, X, 1850, 93–119.

LEDRU, 1900
Ledru, Ambroise, *La cathédrale Saint-Julien du Mans*, Mamers, France, 1900.

LEFÈVRE-PONTALIS, 1912
Lefèvre-Pontalis, Eugène, "Cathédrale de Soissons, Monuments religieux," *Congrès archéologique de France* (LXXVIIIᵉ session, Reims, 1911), Paris, 1912, 318–37.

LEFÈVRE-PONTALIS, "Braine," 1912
Lefèvre-Pontalis, Eugène, "Saint-Yved de Braine," *Congrès archéologique de France* (LXXVIIIᵉ session, Reims, 1911), Paris, 1912, 428–40.

LEMEUNIER, 1981
Lemeunier, Frédéric, "A propos de deux Vierges du 12e siècle d'origine mansaise à Philadelphie et à Baltimore," *La Province du Maine*, LXXXIII, fasc. 37, 1981, 1–3.

LENOIR, 1818
Lenoir, Alexandre Albert, *Atlas des monuments, des arts libéraux, mécaniques et industriels de la France, depuis les Gaulois jusqu'au règne de François Iᵉʳ*, Paris, 1818.

DE LÉPINOIS, 1874
de Lépinois, E. "Recherches historiques et critiques sur l'ancien comté et les comtes de Clermont en Beauvaisis du XIᵉ au XIIIᵉ siècles," *Mémoires de la Société académique de l'Oise*, IX, 1874, 11–122, 277–388, 545–640.

LEROQUAIS, 1927
Leroquais, Victor, *Les Livres d'Heures manuscrits de la Bibliothèque Nationale*, 2 vols., Paris, 1927.

LESTOCQUOY, 1959
Lestocquoy, J., "Quelques anges artésiens du XIIᵉ siècle," *Les Monuments historiques de la France*, nouvelle série, 5, 1959, 31–34.

LILLICH, 1969
Lillich, Meredith Parsons, "The Stained Glass of Saint-Père de Chartres," Ph.D dissertation, Columbia University, 1969.

LILLICH, 1970
Lillich, Meredith Parsons, "The Band Window: A Theory of Origin and Development," *Gesta*, IX/1, 1970, 26–33.

LILLICH, 1972
Lillich, Meredith Parsons, "A Redating of the Thirteenth-Century Grisaille Windows of Chartres Cathedral," *Gesta*, XI/1, 1972, 11–18.

LILLICH, 1973
Lillich, Meredith Parsons, "Three Essays on French Thirteenth-Century Grisaille Glass," *Journal of Glass Studies*, XV, 1973, 69–78.

LILLICH, 1977
Lillich, Meredith Parsons, "A Stained Glass Apostle from Sées Cathedral (Normandy) in the Victoria and Albert Museum," *The Burlington Magazine*, CXIX, 1977, 497–500.

LILLICH, 1978
Lillich, Meredith Parsons, *The Stained Glass of Saint-Père de Chartres*, Middletown, Conn., 1978.

LITTLE, 1979
Little, Charles T., "Ivoires et art gothique," *Revue de l'art*, 46, 1979, 58–67.

LITTLE, 1981
Little, Charles T., "Membra Disjecta: More Early Stained Glass from Troyes Cathedral," *Essays in Honor of Harry Bober (Gesta, XX/1)*, 1981, 119–27.

LORRAIN, 1874
Lorrain, M., *Musée de la ville de Metz. Catalogue de la galerie archéologique*, Metz, 1874.

LOS ANGELES and CHICAGO, 1970
The Middle Ages: Treasures from The Cloisters and The Metropolitan Museum of Art (exhib. cat.), written by Vera K. Ostoia, Los Angeles County Museum of Art, and The Art Institute of Chicago, 1970.

LOWENSTEIN, 1953
Lowenstein, Milton D., "Serrabone: The Church and the Sculpture," *Journal of the Society of Architectural Historians*, XII, 1953, 7–12.

LUGAND, 1975
Lugand, Pierre, et al., *Languedoc roman; le Languedoc méditerranéen* (la nuit des temps, 43), Zodiaque, 1975.

MABILE, 1969–71
Mabile, Alain, "Notice sur Breuil-le-Vert," *Comptes-rendus et mémoires de la société archéologique et historique de Clermont-en-Beauvaisis*, XXXIII, 1969–71, 1–32.

MACARY, 1966
Macary, Marie-Madeleine, *Sculpture romane en Bas-Limousin*, Périgueux, 1966.

MAILLÉ, 1939
Maillé, Geneviève Aliette, Marquise de, *Provins, les monuments religieux*, 2 vols., Paris, 1939.

MAINES, 1979
Maines, Clark, *The Western Portal of Saint-Loup-de-Naud*, New York, 1979.

MÂLE, 1925
Mâle, Émile, *L'art religieux de la fin du Moyen âge en France*, Paris, 1925.

MÂLE, 1951
Mâle, Émile, "L'apôtre Saint André dans l'art," *Revue des Deux-Mondes*, October 1951, 412–21.

MÂLE, 1978
Mâle, Émile, *Religious Art in France, The Twelfth Century, A Study of the Origins of Medieval Iconography*, Harry Bober, ed., Princeton, 1978.

MARSAT, 1977
Marsat, André, *Cathédrale de Troyes; Les Vitraux*, Troyes, 1977.

McDERMOTT, 1949
Gregory, Saint, Bishop of Tours, *Gregory of Tours: Selections from the Minor Works* (Translations and Reprints from the Original Sources of History Published by the Department of History of the University of Pennsylvania, John L. LaMonte, ed.), 3rd ser., IV, William C. McDermott, trans., Philadelphia, 1949.

McKEAN, 1980
McKean, Hugh F., *The Lost Treasures of Louis Comfort Tiffany*, New York, 1980.

MEISS, 1967
Meiss, Millard, *French Painting in the Time of Jean de Berry. The Late Fourteenth Century and the Patronage of the Duke*, 2nd ed., London, 1967.

MESPLÉ, 1958
Mesplé, Paul, "Chapiteaux du cloître de Lombez au Musée des Augustins de Toulouse et au Victoria and Albert Museum de Londres," *La Revue des Arts*, 8, 1958, 177–84.

MESPLÉ, 1961
Mesplé, Paul, *Toulouse. Musée des Augustins. Les sculptures romanes* (Inventaire des collections publiques françaises, 5), Paris, 1961.

VAN DER MEULEN, 1965
van der Meulen, Jan, "Die Baugeschichte der Kathedrale Notre-Dame de Chartres," *Mémoires de la Société archéologique d'Eure-et-Loir*, XXIII, 1965, 79–126.

MONELL, 1930
Collection of the Late Ambrose Monell, Tuxedo Park, N.Y., New York, American Art Association, November 28, 1930.

MONTFAUCON, 1729
de Montfaucon, Dom Bernard, *Les monumens de la monarchie françoise qui comprennent l'histoire de France avec les figures de chaque règne que l'injure des tems a épargnées*, 5 vols., Paris, 1729–39.

MÜLLER-DIETRICH, 1968
Müller-Dietrich, Norbert, *Die romanische Skulptur in Lothringen*, Munich and Berlin, 1968.

MUNDÓ, 1971
Mundó, Anscari M., "Monastic Movements of the East Pyrenees," *Cluniac Monasticism in the Central Middle Ages*, Noreen Hunt, ed., Camden, Conn., 1971, 98–123.

MUSSAT, 1963
Mussat, André, *Le style gothique de l'Ouest de la France*, Paris, 1963.

NOT. ACQ., 1981
Notable Acquisitions, 1980–1981, New York, The Metropolitan Museum of Art, 1981.

OPOIX, 1823
Opoix, Christophe, *Histoire et description de Provins*, Provins, 1823.

PAILLARD-PRACHE, 1958
Paillard-Prache, Anne, "Têtes sculptées du XIIᵉ siècle provenant de la Cathédrale de Reims," *Bulletin monumental*, 116, 1958, 29–40.

PA. MUS., 1925
Catalogue of the Collection of Stained and Painted Glass in the Pennsylvania Museum, Philadelphia, Pennsylvania Museum and School of Industrial Art, 1925.

PA. MUS. BULL., 1936
Benson, E. M., "Enjoying Your Museum," *The Pennsylvania Museum Bulletin*, XXXI, March 1936, 3–15.

PANOFSKY, 1953
Panofsky, Erwin, *Early Netherlandish Painting, Its Origins and Character*, Cambridge, Mass., 1953.

PAPANICOLAOU, 1979
Papanicolaou, Linda Morey, "Stained Glass Windows of the Choir of the Cathedral of Tours," Ph.D. dissertation, New York University, Institute of Fine Arts, 1979.

PARIS, 1970–71
La France de Saint Louis (exhib. cat.), Paris, Palais Royal, Salles des gens d'armes du Palais, 1970–71.

PAT. GR.
Migne, Jacques Paul, *Patrologiae Cursus Completus, seu bibliotheca universalis . . . omnium S.S. Patrum, Doctorum, Scriptorumque ecclesiasticorum sive latinorum, sive graecorum, qui ab aevo apostolico ad aetatem Innocentii III floruerunt . . . Series graeca. Accurante J. P. Migne*, 159 vols., Paris, 1857–66.

PAT. LAT.
Migne, Jacques Paul, *Patrologiae Cursus Completus, sive bibliotheca universalis . . . omnium S.S. Patrum, Doctorum, Scriptorumque ecclesiasticorum qui ab aevo apostolico ad usque Innocentii III, tempora floruerunt . . . Series (Latina) prima. Accurante J. P. Migne*, 221 vols., Paris, 1844–64.

PERROT, 1970
Perrot, Françoise, "La rose de Donnemarie-en-Montois," *Provins et sa région (Bulletin de la Société d'histoire et d'archéologie de Provins)*, 124, 1970, 53–69.

PERROT, 1972
Perrot, Françoise, *Le Vitrail à Rouen*, Rouen, 1972.

PERROT, 1973
Perrot, Françoise, *Vitraux de France* (exhib. cat.), Amsterdam, Rijksmuseum, 1973.

PIJOÁN, 1944
Pijoán, José, *Summa artis*, IX, Madrid, 1944.

PITA ANDRADE, 1950–51
Pita Andrade, José Manuel, "Una escultura del estilo de Maestro Mateo," *Cuadernos de estudios Gallegos*, VI, 1950–51, 389–436.

PITCAIRN, 1920
Pitcairn, Raymond, "Christian Art and Architecture for the New Church," *New Church Life*, October 1920, 611–24.

PLANCHER, 1739
Plancher, Dom Urbain, *Histoire générale et particulière de Bourgogne*, I, Dijon, 1739.

PONSICH, 1976
Ponsich, Pierre, "Chronologie et typologie des cloîtres romans roussillonnais," *Cahiers de Saint-Michel de Cuxa*, VII, 1976, 75–98.

PONTAL, 1965
Pontal, Odette, "Le différend entre Louis IX et les évêques de Beauvais," *Bibliothèque de l'École de Chartes*, CXXIII, 1965, 5–34.

POPESCO, 1970
Popesco, Paul, *La cathédrale de Chartres*, Paris, 1970.

PORÉE, 1907
Porée, Charles, "Les Architectes et la construction de la cathédrale de Sens," *Congrès archéologique de France* (LXXIVᵉ session, 1907, Avallon), Paris and Caen, 1907, 559–98.

PORTER, 1912
Porter, Arthur Kingsley, *Medieval Architecture, Its Origins and Development*, 2nd ed., 2 vols., New Haven, 1912.

PORTER, 1915–17
Porter, Arthur Kingsley, *Lombard Architecture*, 4 vols., New Haven, 1915–17.

PORTER, 1923
Porter, Arthur Kingsley, *Romanesque Sculpture of the Pilgrimage Roads*, 10 vols., Boston, 1923.

PRACHE, 1978
Prache, Anne, *Saint-Rémi de Reims, l'oeuvre de Pierre de Celle et sa place dans l'architecture gothique* (Bibliothèque de la Société française d'archéologie, 8), Paris, 1978.

PRACHE, 1981
Prache, Anne, "Le vitrail de la Crucifixion de Saint-Rémi de Reims," *Études d'art médiéval offertes à Louis Grodecki*, Sumner McKnight Crosby, et al., eds., Paris, 1981, 145–54.

PRACHE, et al., 1981
Prache, Anne, et al., *Champagne romane* (la nuit des temps, 55), Zodiaque, 1981.

PRÉ, 1947
Pré, Madeleine, "Romanesque Wall Painting in Maine and on the Borders of Maine and Anjou," *Gazette des Beaux-Arts*, VI ser., XXXI, 1947, 129–44.

PRESSOUYRE, 1963
Pressouyre, Léon, "La colonne dîtes 'aux trois chevaliers' de Châlons-sur-Marne," *Bulletin de la Société nationale des Antiquaires de France*, 1963, 76–81.

PRESSOUYRE, 1964
Pressouyre, Léon, "Fouilles du cloître de Notre-Dame-en-Vaux de Châlons-sur-Marne," *Bulletin de la Société nationale des Antiquaires de France*, 1964, 23–38.

PRESSOUYRE, 1967
Pressouyre, Léon, "Quelques vestiges sculptés de l'abbaye de Nesle-la-Reposte (Marne)," *Bulletin de la Société nationale des Antiquaires de France*, 1967, 104–11.

PRESSOUYRE, 1970
Pressouyre, Léon, "Réflexions sur la Sculpture du XIIème Siècle en Champagne," *Gesta*, IX/2, 1970, 16–31.

PRESSOUYRE, 1973
Pressouyre, Léon, "St. Bernard to St. Francis: Monastic Ideals and Iconographic Programs in the Cloister," *Gesta*, XII, 1973, 71–92.

PRESSOUYRE, 1978
Pressouyre, Léon, "Un chapiteau en marbre du Musée du Louvre et la diaspora de l'art roman 'languedocien' en Aquitaine," *La Revue du Louvre*, XXVIII, 1978, 236–41.

PRIOUX, 1859
Prioux, Stanislas, *Monographie de l'ancienne abbaye royale Saint-Yved de Braine avec la description des tombes royales et seigneuriales renfermées dans cette église*, Paris, 1859.

PUIG i CADAFALCH, 1949–52
Puig i Cadafalch, José, *L'escultura romanica a Catalunya* (Monumenta Cataloniae, V–VII), 3 vols., Barcelona, 1949–52.

RAGUIN, 1974
Raguin, Virginia Chieffo, "The Genesis Workshop of the Cathedral of Auxerre and Its Parisian Inspiration," *Gesta*, XIII/1, 1974, 27–38.

RAGUIN, 1976
Raguin, Virginia Chieffo, "Windows of Saint-Germain-lès-Corbeil: A Traveling Glazing Atelier," *Essays in Honor of Sumner McKnight Crosby* (Gesta, XV/1&2), 1976, 265–72.

RAGUIN, 1977
Raguin, Virginia Chieffo, "The Isaiah Master of the Sainte-Chapelle in Burgundy," *The Art Bulletin*, LIX, 1977, 483–93.

RAGUIN, 1982
Raguin, Virginia Chieffo, *Stained Glass in Thirteenth-Century Burgundy*, Princeton, 1982, in press.

RANDALL, 1959
Randall, Richard H., Jr., "Thirteenth-Century Altar Angels," *Records of the Art Museum, Princeton University*, XVIII, 1959, 2–16.

RANDALL, 1979
Randall, Richard H., Jr., "Medieval Jewelry," *Jewelry: Ancient to Modern* (exhib. cat.), Baltimore, The Walters Art Gallery, 1979, no. 469b, 167.

DU RANQUET, 1913
du Ranquet, Henri, *La Cathédrale de Clermont-Ferrand* (Petites monographies des grands édifices de la France), Paris, 1913.

DU RANQUET, 1932
du Ranquet, Henri, *Les vitraux de la cathédrale de Clermont-Ferrand*, Clermont, 1932.

READ, 1973
Read, Herbert, *English Stained Glass*, 1926, reprint ed., New York, 1973.

RÉAU, 1930
Réau, Louis, *Collection Demotte: La Vierge en France, XIIe–XIVe siècle*, New York, 1930.

RÉAU, 1955–59
Réau, Louis, *Iconographie de l'art chrétien*, 3 vols., Paris, 1955–59.

REVOIL, 1873
Revoil, Henri, *Architecture romane du midi de la France*, 3 vols., Paris, 1973.

RHODE ISLAND, 1969
The Renaissance of the Twelfth Century, An Exhibition Organized by Stephen K. Scher (exhib. cat.), Providence, Museum of Art, Rhode Island School of Design, 1969.

RITTER, 1926
Ritter, Georges, *Les vitraux de la cathédrale de Rouen, XIIIe, XIVe, XVe, et XVIe siècles*, Cognac, 1926.

RIVÈRE, 1978
Rivère, Gérard, "Le Cloître de la collégiale de Saint-Gaudens et autres cloîtres commingeois," *Revue de Comminges*, 91, 1978, 161–79, 329–40, 459–77.

ROHAULT DE FLEURY, 1883–89
Rohault de Fleury, Ch[arles], *La Messe, études archéologiques sur ses monuments*, 8 vols., Paris, 1883–89.

RORIMER, 1930
Rorimer, James J., "A Monumental Catalan Wood Statue of the Fourteenth Century," *Metropolitan Museum Studies*, III, 1930, 100–173.

RORIMER, 1952
Rorimer, James J., "Two Gothic Angels for The Cloisters," *The Metropolitan Museum of Art Bulletin*, XI, 1952, 105–7.

RORIMER, 1972
Rorimer, James J., *Medieval Monuments at The Cloisters as They Were and as They Are*, New York, 1941; rev. ed. by Katherine Serrill Rorimer, New York, 1972.

ROSEROT DE MELIN, 1970
Roserot de Melin, Joseph, *Bibliographie commentée des sources d'une histoire de la cathédrale de Troyes*, II, *Ameublement*, Troyes, 1970.

ROUSSELL, n.d.
Roussell, Jules, *Les Vitraux*, 3 vols., Paris, n.d.

DE ROUVROY, 1934
de Rouvroy, Raoul, *Ordinaire de l'église Notre-Dame, Cathédrale d'Amiens* (Mémoires de la Société des antiquaires de Picardie, 22), Paris and Amiens, 1934.

SAHUC, 1908
Sahuc, Joseph, *L'art roman à Saint-Pons-de-Thomières*, Montpellier, 1908.

SAINT-DENIS, 1981
The Royal Abbey of Saint-Denis in the Time of Abbot Suger (1122–1151) (exhib. cat.), New York, The Metropolitan Museum of Art (The Cloisters), 1981.

SAINT-JEAN, 1976
Saint-Jean, Robert, "Le cloître supérieur de Saint-Guilhem-le-Désert," *Cahiers de Saint-Michel de Cuxa*, VII, 1976, 45–60.

SALET, 1932
Salet, Francis, "L'architecture religieuse dans le Comté de Brie du XIIe au XVIe siècles," *Thèse*, École de Chartes, Paris, 1932.

SALET and ADHÉMAR, 1948
Salet, Francis, and Adhémar, Jean, *La Madeleine de Vézelay*, Melun, 1948.

SAUERLÄNDER, 1963
Sauerländer, Willibald, *Die Skulptur des Mittelalters*, Frankfort on the Main, 1963.

SAUERLÄNDER, 1972
Sauerländer, Willibald, *Gothic Sculpture in France, 1140–1270*, Janet Sondheimer, trans., New York, 1972.

SCHAPIRO, 1973
Schapiro, Meyer, *Words and Pictures: On the Literal and Symbolic in the Illustration of a Text* (Approaches to Semiotics, 11), The Hague and Paris, 1973.

SCHILLER, 1971–72
Schiller, Gertrud, *Iconography of Christian Art*, 2 vols., Janet Seligman, trans., Greenwich, Conn., 1971–72.

SCHILLER, 1980
Schiller, Gertrud, *Ikonographie der christlichen Kunst*, Bd. 4.2, *Maria*, Gütersloh, Germany, 1980.

SCHMID, 1973
Schmid, Alfred A., "Faldistorium," *Reallexikon zur deutschen Kunstgeschichte*, VI, Munich, 1973, 1212–26.

SCHMOLL GEN. EISENWERTH, 1962
Schmoll gen. Eisenwerth, J. Adolph, "Lothringische Madonnen-Statuetten des 14. Jahrhunderts," *Festschrift für Friedrich Gerke*, Baden-Baden, 1962, 119–48.

SCHMOLL GEN. EISENWERTH, 1965
Schmoll gen. Eisenwerth, J. Adolph, "Sion-Apokalyptisches Weib-Ecclesia Lactans," *Miscellanea Pro Arte, Herman Schnitzler zur Vollendung des 60. Lebensjahres am 13. Januar, 1965*, Düsseldorf, 1965, 91–110.

SCHMOLL GEN. EISENWERTH, *Aachener Kunstblätter*, 1965
Schmoll gen. Eisenwerth, J. Adolph, "Neue Ausblicke zur hochgotischen Skulptur Lothringens und der Champagne, 1290–1350," *Aachener Kunstblätter*, XXX, 1965, 49–99.

SCHMOLL GEN. EISENWERTH, 1969
Schmoll gen. Eisenwerth, J. Adolph, "Lothringen und die Rheinlande. Ein Forschungsbericht zur Lothringischen Skulptur der Hochgotik (1280–1340)," *Rheinische Vierteljahresblätter*, Bonn, 1969, 60–77.

SCHMOLL GEN. EISENWERTH, 1970–72
Schmoll gen. Eisenwerth, J. Adolph, "La Sculpture gothique en Lorraine et ses relations avec les régions voisines (Bourgogne, Champagne, Alsace, Rhénanie)," *Bulletin de la Société des amis du musée de Dijon*, 1970–72, 23–36.

SCHRADER, 1979
Schrader, J[ack]. L. "George Grey Barnard: The Cloisters and The Abbaye," *The Metropolitan Museum of Art Bulletin*, new ser., XXXVII, 1979, 2–52.

SCHÜRER, 1944
Schürer, Oskar, *Das alte Metz*, Munich, 1944.

SCOTT, 1964
Scott, David W., "A Restoration of the West Portal Relief Decoration of Saint-Sernin at Toulouse," *The Art Bulletin*, XLVI, 1964, 271–82.

THE SECULAR SPIRIT, 1975
The Secular Spirit: Life and Art at the End of the Middle Ages (exhib. cat.), introd. by Timothy B. Husband and Jane Hayward, New York, The Metropolitan Museum of Art (The Cloisters), 1975.

SÉNANQUE, 1977
Art roman de Provence (Les alpes de lumière, 60), Sénanque, France, 1977.

SENLIS, 1977
Senlis: un Moment de la sculpture gothique (exhib. cat.), written by Diane Brouillette, Senlis, Hôtel de Vermandois, 1977.

SIMON, 1959
Simon, Jacques, "Restauration des vitraux de Saint-Rémi de Reims," *Les Monuments historiques de la France*, nouvelle série, 5, 1959, 14–25.

SIMON, 1975
Simon, David, "Daniel and Habakkuk in Aragon," *Journal of the British Archaeological Association*, XXXVIII, 1975, 50–54.

STAATSMANN, 1911
Staatsmann, Karl Arnold Bernhard, *Volkstümliche Kunst aus Elsass-Lothringen*, Esslingen a. N., Germany, 1911.

STRATFORD, 1976
Stratford, Neil, "Autun," *Bulletin monumental*, 134, 1976, 59.

THIEME-BECKER
Thieme, Ulrich, and Becker, Felix, et al., *Allgemeines Lexikon der bildenden Künstler von Antike bis zur Gegenwart*, Leipzig, 1907–50.

THIRION, 1972
Thirion, Jacques, "Sculptures romanes de Haute-Provence," *Bulletin monumental*, 130, 1972, 7–43.

THIRION, 1980
Thirion, Jacques, et al., *Alpes romanes* (la nuit des temps, 54), Zodiaque, 1980.

THOMAS, 1913
Drake, Maurice, *The Grosvenor Thomas Collection of Ancient Stained Glass* (sales cat.), New York, Charles Gallery, 1913.

THOMAS, 1922
Thomas, Roy Grosvenor, *Stained Glass, Its Origin and Application*, New York, 1922.

TOURNEUR, 1856
Tourneur, Victor, "2e séance du 22 mai 1955," *Congrès archéologique de France* (XXIIe session, Châlons-sur-Marne, Aix, and Avignon, 1855), Paris, 1956, 88–90.

TOURNEUR, 1862
Tourneur, Victor, "Visite de l'église de Saint-Remy," *Congrès archéologique de France* (XXVIIIe session, Reims, 1861), Paris, 1862, 87–97.

TRÉSORS, 1961
Trésors d'art gothique en Languedoc (exhib. cat.), Musée Ingres, Montauban, June–September 1961, Toulouse, 1961.

URSEAU, 1929
Urseau, Charles, *La cathédrale d'Angers* (Petites monographies des grands édifices de la France), Paris, 1929.

VERDIER, 1957
Verdier, Philippe, "A Clasp for a Queen," *The Bulletin of the Walters Art Gallery*, X, 1957, 1–2.

VERDIER, 1958
Verdier, Philippe, "A Stained Glass from the Cathedral of Soissons," *The Corcoran Gallery of Art Bulletin*, 10/1, 1958, 4–22.

VERDIER, 1962
Verdier, Philippe, *The International Style: The Arts in Europe Around 1400* (exhib. cat.), Baltimore, The Walters Art Gallery, 1962.

VERDIER, 1981
Verdier, Philippe, "A Romanesque Corpus," *The Bulletin of the Cleveland Museum of Art*, LXVIII, 1981, 66–74.

VERGNET-RUIZ and VANUXEM, 1945
Vergnet-Ruiz, Jean, and Vanuxem, Jacques, "L'église de l'abbaye de Saint-Martin-aux-Bois," *Bulletin monumental*, 103, 1945, 136–73.

VIDAL, 1959
Vidal, Marguerite, et al., *Quercy roman* (la nuit des temps, 10), 2nd ed., Zodiaque, 1959.

VIEILLARD-TROÏÉKOUROFF, 1960
Vieillard-Troïékouroff, May, "La cathédrale de Clermont du Ve au XIIIe siècles," *Cahiers archéologiques*, XI, 1960, 199–247.

VIOLLET-LE-DUC, 1854–68
Viollet-le-Duc, Eugène-Emmanuel, *Dictionnaire raisonné de l'architecture française du XIe au XVIe siècle*, 10 vols., Paris, 1854–68.

VLOBERG, 1954
Vloberg, Maurice, *La Vierge et l'enfant dans l'art français*, Paris and Grenoble, 1954.

VÖGE, 1899
Vöge, Wilhelm, "Über die Bamberger Domskulpturen," *Repertorium für Kunstwissenschaft*, XXII, 1899, 94–104; reprinted in *Bildhauer des Mittelalters: Gesammelte Studien von Wilhelm Vöge*, Berlin, 1958, 130–200.

WALKER, n.d.
Walker, Cynthia Hyatt, "Winfred Sumner Hyatt—In Retrospect," unpublished manuscript.

WEBSTER, 1938
Webster, James Carson, *The Labors of the Months in Antique and Medieval Art to the End of the Twelfth Century,* Princeton, 1938.

WEISBERG, 1980
Weisberg, Gabriel P., *The Realist Tradition: French Painting and Drawing, 1830–1900,* Cleveland, 1980.

WELLS, 1965
Wells, William, *Stained and Painted Glass: Burrell Collection, Figural and Ornamental Subjects,* Glasgow, 1965.

WERNER, 1979
Werner, Ferdinand, *Aulnay-de-Saintonge und die romanische Skulptur in Westfrankreich,* Worms on the Rhine, 1979.

WESTLAKE, 1881
Westlake, Nathaniel H. J., *A History of Design in Painted Glass,* 4 vols., London, 1881–94.

WILLET and VERDIER, 1967
Willet, Henry Lea, and Verdier, Philippe, "Inventory of the Stained Glass Collection of Raymond Pitcairn," unpublished manuscript, Glencairn Museum, Bryn Athyn, Pa., 1967.

WINSTON, 1847
Winston, Charles, *An Inquiry into the Difference of Style observable in Ancient Glass Paintings, especially in England, with Hints on Glass Painting, by an Amateur,* 2 vols., Oxford, England, 1847.

WIXOM, 1967
Wixom, William D., *Treasures from Medieval France* (exhib. cat.), The Cleveland Museum of Art, 1967.

WIXOM, 1970
Wixom, William D., "The Greatness of the So-Called Minor Arts," *The Year 1200: A Background Survey,* II, Florens Deuchler, ed., New York, 1970, 93–99.

WIXOM, 1974
Wixom, William D., "Two Thirteenth-Century Walnut Angels," *The Bulletin of the Cleveland Museum of Art,* LXI, 1974, 81–96.

WIXOM, BCMA, 1974
Wixom, William D., "A Gothic Madonna from Lorraine," *The Bulletin of the Cleveland Museum of Art,* LXI, 1974, 343–49.

WIXOM, 1979
Wixom, William D., "Eleven Additions to the Medieval Collection," *The Bulletin of the Cleveland Museum of Art,* LXVI, 1979, 85–152.

WOLFRAM, 1905
Wolfram, Georg Karl, *Geschichte der Stadt Metz,* Strasbourg, 1905.

THE YEAR 1200, I, 1970
The Year 1200: A Centennial Exhibition at The Metropolitan Museum of Art (exhib. cat.), I, written and ed. by Konrad Hoffmann, New York, 1970.

Primary Source Material Cited in the Catalogue
BRYN ATHYN, PENNSYLVANIA
GLENCAIRN MUSEUM
The Glencairn Museum now houses the correspondence of Raymond Pitcairn that concerns the collection and its formation. This material is organized in letter books, containing all the collector's correspondence from 1916 to 1923, and in separate files devoted to his communications with art dealers, which began in 1921. The catalogue refers to these two collections as "letter books" and "Raymond Pitcairn's correspondence files with art dealers."

PARIS
ARCHIVES DE LA DIRECTION DE L'ARCHITECTURE
CLERMONT-FERRAND
Clermont-Ferrand, Notre-Dame, Victor Marie Charles Ruprich-Robert, Dossier de l'Administration, 1910.
DONNEMARIE-EN-MONTOIS
Donnemarie-en-Montois, Notre-Dame, Fabric Accounts, 1883.
SÉES
Sées, Saint-Gervais-et-Saint-Protais, Lucien Magne, "Inventaire," Dossier Vitraux, 1884.

TROYES
Troyes, Saint-Pierre, Eugène Millet, Dossier de l'Administration, 1849, no. 74.
TROYES
Troyes, Saint-Pierre, Eugène-Emmanuel Viollet-le-Duc, Dossier de l'Administration, 1853, no. 74.

BIBLIOTHÈQUE NATIONALE
GUILHERMY, SAINT-DENIS
Guilhermy, Baron François de, Détails historiques, Saint-Denis, 1840–72, Ms. nouv. acq. fr. 6121, 6122.
GUILHERMY, SÉES
Guilhermy, Baron François de, Notes sur diverses localités de la France, Sées, Ms. nouv. acq. fr. 6109, fols. 64–69.
GUILHERMY, SOISSONS
Guilhermy, Baron François de, Notes sur diverses localités de la France, Soissons, Ms. nouv. acq. fr. 6109, fols. 254–57.
GUILHERMY, TROYES
Guilhermy, Baron François de, Notes sur diverses localités de la France, Troyes, Ms. nouv. acq. fr. 6111, fols. 6117–19.

BIBLIOTHÈQUE SAINTE-GENEVIÈVE
HERBELIN, DREUX and BRAINE
Herbelin, Mathieu, Les anciennes et modernes généalogies, épitaphes et armoiries de tous les feus comtes et comtesses de Dreux et de Braine, ms. 855.
GRODECKI, NOTES
Grodecki, Louis, Unpublished notes made for the Inventory of the Stained Glass Collection of Raymond Pitcairn, 1967, private files of Louis Grodecki, Paris.

REIMS
BIBLIOTHÈQUE
CHASTELAIN, SAINT-REMI
Chastelain, Dom Pierre, Histoire abrégée de l'église de Saint-Remi de Reims et des raretés qu'on y voit, XVIIIe siècle, Ms. 1828–1829.

Index

Numbers in italics refer to pages with illustrations

Photograph Credits

Unless otherwise noted, photographs are by Lynton Gardiner and Walter J. F. Yee of the Photograph Studio, The Metropolitan Museum of Art.

Bildarchiv Foto Marburg, fig. 4; The British Library, London, fig. 37; Caisse Nationale des Monuments Historiques et des Sites, Paris, figs. 22, 23, 25, 27, 28, 29, 30, 32, 33, 36, 38; Cincinnati Art Museum, fig. 14; Cothren, Michael, Swarthmore, Pa., fig. 34; Farghan, George, Philadelphia, fig. 9; Hirmer Fotoarchiv, Munich, fig. 21; Little, Charles T., New York, 42, 96; Musée de Cluny, Paris, fig. 35; Perrot, Françoise, Paris, fig. 26; Philadelphia Museum of Art, 5(B), 8(B), 8(C), 40, 41; Pitcairn, Michael, Bryn Athyn, Pa., figs. 1, 3, 24; Rose, Donald F., Philadelphia, fig. 2; Victoria and Albert Museum, London, fig. 11.